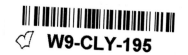

The
Peale Family

~

Creation of a Legacy
1770–1870

The
Peale Family

~

Creation of a Legacy
1770–1870

~

Lillian B. Miller

Editor

Published by Abbeville Press
in association with
The Trust for Museum Exhibitions,
and the National Portrait Gallery, Smithsonian Institution

Table of Contents

~

~

Acknowledgments

~

I N DECEMBER 1990, I approached Lillian B. Miller, cultural and social historian and editor of the Peale Family Papers, with the suggestion of developing an exhibition on the ten most prolific Peale family painters and the world they created for a full century, 1770 to 1870. Lillian herself had had such an idea, as her work on the Peale Family Papers produced a virtual avalanche of new materials and information about this significant family, its creations and influence—evidenced not only through works of art, but also through the political, cultural, and economic contexts, and the natural and social history illuminated by the art and the collections of the Peale museums. So my suggestion was met with enthusiasm.

The subject of the exhibition is so varied and complex that I believe no scholar other than Lillian Miller could have addressed it in its entirety and done full justice to its dynamic richness. Everyone who contributed to it, from The Trust for Museum Exhibitions to the host museums, as well as each individual who views it will be in her debt. She deserves full credit for crafting this magnificent presentation, and I express deepest gratitude to her for devoting endless hours over the past three years to its realization.

It was Lillian's idea to invite nine other scholars whom she selected to contribute essays to this book. So I owe a debt of gratitude to Brandon Brame Fortune, Kenneth Haltman, Sidney Hart, Ann Sue Hirshorn, William T. Oedel, Paul D. Schweizer, Linda Crocker Simmons, David Steinberg, and David C. Ward. Each chose suitable works to illuminate their subjects and wrote highly informative essays while adhering to many tight deadlines. They are a terrific group! I am also indebted to Alan Fern, director of the National Portrait Gallery, for allowing Lillian Miller and her staff to participate in this project. Marianne Gurley, photographer at the same institution, was of great assistance, as was the staff of the library of the National Portrait Gallery/National Museum of American Art.

But what would we have without our seventy-two lenders? Actually nothing. For, without their generous contributions, a splendid idea would have remained just that. I extend my deepest thanks to each and every one. Mr. Robert McNeil, Jr. of the Barra Foundation, and its curator, Ms. Susan Detweiler, deserve special recognition for their extraordinary contributions to the exhibitions's success.

And even with the scholarship assured and the works for the exhibition secured, what then would we have had if we could not receive the necessary assistance to afford the immense costs of such a project? Again, nothing.

So it takes no imagination to see how indebted we are to the National Endowment for the Humanities; the Henry Luce Foundation, Inc.; and the three host museums.

But the Philadelphia Museum of Art, the Fine Arts Museums of San Francisco, and the Corcoran Gallery of Art did far more than help defray the costs of the exhibition. Each museum was a partner, guiding us in ways unfamiliar or untried, and lending countless staff members to thoroughly realize the exhibition at each venue. Elroy Quenroe and Charles Mack created an exhibition design on paper which could be adjusted for each museum's space, if the museums so desired.

And then, with the necessary elements for the exhibition resolved, one more crucial aspect of the project remained to be considered. How would this monumental effort live and become available to the many interested individuals who would never see it? And how would the academic community refer to this important body of scholarship for years to come? Through the book accompanying the exhibition. Thanks to the stellar talents gathered by Abbeville Press—particularly editors Abigail Asher and Leslie Bockol, copyeditor Leslie Yudell, designer Maria Learmonth Miller and proofreader Ann Shields—we have a book far more magnificent than I could ever have hoped for—a glorious permanent record of *The Peale Family: Creation of a Legacy.*

Last but not least, I would like to offer my deepest gratitude to the best staff with which any organization could be blessed: Karla Cosgriff, Anne Palumbo, Susan Peacock, Vincent Fazio and the other hardworking, creative, and dedicated members of the Trust for Museum Exhibitions.

Ann Van Devanter Townsend
President
The Trust for Museum Exhibitions

~

Editor's Preface

~

*T*HE PEALE FAMILY OF ARTISTS has captivated the imagination of Americans since their first group exhibition in 1923 at the Pennsylvania Academy of the Fine Arts, but as a group their works have been exhibited only four times since—in Cincinnati (1954), Baltimore (1965, 1975), and Detroit (1967). Individually, Charles Willson Peale, Rembrandt Peale, Raphaelle Peale, Sarah Miriam Peale, and Charles Peale Polk have received recognition in museum exhibitions for their contribution to American life and culture, but other artist members of the family—James Peale, Rubens Peale, Titian Ramsay Peale, and Anna Claypoole Peale, in particular—have not enjoyed this kind of public attention.

With the publication of the Peale family papers at the National Portrait Gallery, the Peales as both talented artists and important American cultural figures have begun to arouse the interest of both scholars and the larger public. The time is ripe for a new look at the art of this gifted family, whose extensive work has now been more clearly identified and located, and is in the process of being interpreted. I am grateful, therefore, to Ann Van Devanter Townsend, president of The Trust for Museum Exhibitions, for suggesting a Peale family exhibition, and to Alan Fern, Director of the National Portrait Gallery, for approving the participation of me and members of my staff in this large and exciting undertaking. I am also grateful for the response of a new generation of Peale scholars to our invitation to contribute their advice and research to the project. Their various interpretations of the art of individual members of the Peale family not only illuminate the Peales' work in a new way, but also suggest useful ways of studying, in general, portraiture, still life, landscape painting, and institutions such as the family and museums. Their enthusiastic cooperation has made this project an especially pleasant one, despite the enormous amount of work it has entailed, and I appreciate their continuing interest.

Staff members of The Trust for Museum Exhibitions have been very helpful during some tense days of meeting deadlines. In particular, I am appreciative of the unstinting efforts of Anne Palumbo, Karla Cosgriff, and Susan Peacock. And for their helpful encouragement I am deeply grateful to Darrel Sewell of the Philadelphia Museum of Art, Robert McNeil and Susan Detweiler of the Barra Foundation, Elise Peale Gelpi, and the many collectors and museum curators who have volunteered their Peale treasures to enable the American public to share with them the visual pleasure and intellectual stimulation that is, finally, the function of great art.

The Creation of a Legacy focuses on two major historical subjects: family history, with its corollaries involving the quest for personal identity within a family relationship and intergenerational and sibling interactions; and the development of American art over time—from the colonial period to the Gilded Age (1770–1870). Study of two generations of artists within a single family such as the Peales offers an excellent means of examining these two related phenomena, for just as generational change in family structures frequently demonstrates a pattern of action and reaction—insistence on traditional methods, values, or responses, and rebellion against these—so does the rise and fall of artistic tastes and styles. We see this pattern of acceptance and rejection of tradition occurring in the work of the Peale artists. Learning from each other and assimilating each other's stylistic and ideological biases, the Peales also reflected and influenced, and were influenced by, new or innovative ways of expressing American life and nature visually over the hundred-year period in which they pursued their artistic activities. That the second generation of Peales did not depart radically from the artistic principles and attitudes of the family's foremost member, Charles Willson Peale, suggests not simply that the children were conservative or traditional, but—more interestingly—that change occurs slowly over time, and sometimes imperceptibly, especially in such a close-knit group as a family, where values are imparted, and influence forcefully exerted, in the period of early development.

In subject matter, the Peales' work followed changes in taste that took place in America in the nineteenth century, from portraiture to history, which in some works approached anecdotal or genre art, to landscape and still life, as Americans discovered the nature of their land and its rich promise. Through a study of the Peales' art, we can trace the course of American painting as it made its way out of its colonial, British-oriented beginnings to a more national expression under the impact of political and social change in America. The Peales seem to encapsulate characteristics we have come to associate with America; Charles Willson Peale's early radicalism and democratic inclinations, his willingness to innovate and experiment, his optimistic sense of unlimited opportunity, his commitment to republican ideology and principles, his interest in natural history, public education and the museum, and his familial relationships—all were transferred to his children, who dared new horizons and new artistic and scientific practices.

Many questions arose as we began discussions concerning the artistic activities of a family of artists, questions that underlay and directed the course of our inquiry, even if they were not immediately answerable. For instance, how did the idea of being a member of an artistic family influence or shape a particular aesthetic point of view, as each member sought to define his/her aesthetic identity? How did each family member respond to the family heritage as well as to the artistic demands of his/her own time, patronage, and tastes? What did each family member take or absorb from another, either consciously or unconsciously, so as to continue traditional practices while departing from them? What was the effect of changing social and aesthetic ideals on the individual members of the family, and how were they influenced by the times in which they lived and the experiences they

encountered, to continue or depart from the Peale tradition? And what, finally, constitutes this tradition, what we may call "the Peale legacy"? Is it an idealistic attitude toward the role of art in a republic? a belief in the social value of art? or a particular style or taste? Is it a definition of public service, or a sense that knowledge of the artistic elements in nature and the operation of the natural world would contribute to a better society? Or is it just a collection of bright and colorful portraits of both heroes and ordinary Americans, landscapes of rural and wild American places, and exquisite still-life paintings that are pleasing to study and stimulating to think about? We hope that this exhibition and book will begin to suggest answers or approaches that will provide delight for the eye and food for thought, and in doing so will further illuminate the Peale legacy.

Lillian B. Miller
National Portrait Gallery, 1996

~

Peale Family Genealogy

~

I. CHARLES PEALE (1709–1750), son of Charles Peale (1688–1734), rector of Edith Weston, Rutlandshire, England, and Elizabeth Camparl (died 1735); arrested for embezzlement, 1735; arrived in Virginia, c. 1736; master of King William's School, Annapolis, Maryland, 1739; master of Free School, Queen Anne's County, 1741; master of Kent County School, Chestertown, 1742; married 1740, Margaret Triggs (1709–1791); died Chestertown, November 1750.

Children:
1. *Charles Willson,* born Queen Anne's County, April 15, 1741 (see below).
2. *Margaret Jane,* born Chestertown, 1743; married c. 1760, James McMordie (died c. 1767); married 1771, Nathaniel Ramsay (1741–1817); no children; died Carpenter's Point, near Charlestown, Maryland, 1788.
3. *St. George,* born Chestertown, April 23, 1745; married c. 1773, Elizabeth Emerson Callister (died 1786); two daughters, both unmarried; died July 13, 1778.
4. *Elizabeth Digby,* born Chestertown, January 20, 1747 (see below).
5. *James,* born Chestertown, 1749 (see below).

II. CHARLES WILLSON PEALE (CWP), born Queen Anne's County, Maryland, April 15, 1741; married January 12, 1762, Rachel Brewer (May 14, 1744–April 12, 1790), daughter of John Brewer (1709–1754) of Anne Arundel County, Maryland, and Eleanor Maccubbin (1708–1779); married May 30, 1791, Elizabeth DePeyster (July 10, 1765–February 19, 1804), daughter of William DePeyster, Jr., (1735–1803) of New York City and his first wife, Elizabeth Brasher; married August 12, 1805, Hannah Moore (July 10, 1755–October 10, 1821), daughter of Mordecai Moore and Elizabeth Coleman; died Philadelphia, February 22, 1827.

Children:
1. *Margaret Jane,* born Annapolis, 1763; died 1763.
2. *James Willson,* born Tuckahoe, Queen Anne's County, 1765; died 1767.
3. *Eleanor,* born Annapolis, March 20, 1770; died 1770.
4. *Margaret Van Bordley,* born Annapolis, January 13, 1772; died 1772.
5. *Raphaelle (RaP),* born Annapolis, February 17, 1774; married May 25, 1797, Martha (Patty) McGlathery (1775–1852); died Philadelphia, March 5, 1825.
6. *Angelica Kauffmann (APR),* born Charlestown, Maryland, December 20, 1775; married July 15, 1794, Alexander Robinson (1751–1845); died Baltimore, August 8, 1853.
7. *Rembrandt (ReP),* born Bucks County, Pennsylvania, February 22, 1778; married June 12, 1798, Eleanor Mae Short (1776–1836); married November 6, 1840, Harriet Cany (died 1869); died Philadelphia, October 3, 1860.
8. *Titian Ramsay (1) (TRP [1]),* born Philadelphia, August 1, 1780; died New York, September 18, 1798.

9. *Rubens (RuP),* born Philadelphia, May 4, 1784; married March 6, 1820, Eliza Burd Patterson (1795–1864); died Philadelphia, July 17, 1865.

10. *Sophonisba Angusciola (SPS),* born Philadelphia, April 24, 1786; married September 23, 1805, Coleman Sellers (1781–1834); died October 26, 1859.

11. *Rosalba Carriera,* born Philadelphia, October 25, 1788; died Philadelphia, October 3, 1790.

12. *Vandyke,* born Philadelphia, September 19, 1792; died 1792.

13. *Charles Linnaeus,* born Philadelphia, March 20, 1794; married February, 1816, Christiana Runyon (died 1839); died Philadelphia, May 22, 1832.

14. *Benjamin Franklin (BFP),* born Philadelphia, October 15, 1795; married April 24, 1815, Eliza Greatrake; marriage annulled, 1820; married May 4, 1839, Mrs. Caroline E. Girard Haslam (died 1875); died Philadelphia, May 5, 1870.

15. *Sybilla Miriam,* born Philadelphia, October 27, 1797; married November 9, 1815, Andrew Summers (1795–1843); died August 27, 1856.

16. *Titian Ramsay (2) (TRP [2]),* born Philadelphia, November, 1799; married October 10, 1822, Eliza Cecilia Laforgue (died 1846); married August 24, 1850, Lucinda MacMullen; died Philadelphia, March 13, 1885.

17. *Elizabeth DePeyster,* born Philadelphia, April 16, 1802; married November 2, 1820, William Augustus Patterson (1792–1833); died July 25, 1857.

III. Elizabeth Digby Peale Polk, born Chestertown, January 20, 1747; married 1765, Robert Polk (1744–77), son of Robert Polk and Alice Nutter of Accomac County, Virginia; died c. 1776.

Children (surnamed Polk):

1. *Margaret Jane,* born June 4, 1766; married April 13, 1788, James Stewart; married March 17, 1793, William Keith (born c. 1765).

2. *Charles Peale (CPP),* born Maryland, March 17, 1767; married c. 1785, Ruth Ellison of New Jersey; married c. 1811, Mrs. Brockenbrough of Fredericksburg, Virginia; married December 25, 1816, Ellen Ball Downman; died Warsaw, Virginia, May 6, 1822.

3. *Elizabeth (Betsy) Bordley,* born August 1, 1770; married c. 1790, Septimus Claypoole (died 1798); married April 22, 1807, Rev. Dr. Joseph Grove John Bend, Baltimore (died 1812).

IV. James Peale (JP), born Chestertown, 1749; married November 14, 1782, Mary Claypoole (1753–1829); died May 24, 1831.

Children:

1. *Jane Ramsay,* born 1785 or 1786; married June 7, 1806, Dr. Samuel Simes (died 1813); died 1834.

2. *Maria,* born 1787; unmarried; died March 27, 1866.

3. *James, Jr.,* born March 6, 1789; married December 18, 1813, Anna Dunn (died 1814); married May 11, 1822, Sophonisba Peale (1801–1878), daughter of RaP; died October 27, 1876.

4. *Anna Claypoole (ACP),* born March 6, 1791; married August 27, 1829, Rev. Dr. William Staughton (1770–1829); married June 10, 1841, Gen. William Duncan (1772–1864); died December 25, 1878.

5. *Margaretta Angelica,* born October 1, 1795; unmarried; died January 17, 1882.

6. *Sarah Miriam (SMP),* born May 19, 1800; unmarried; died February 4, 1885.

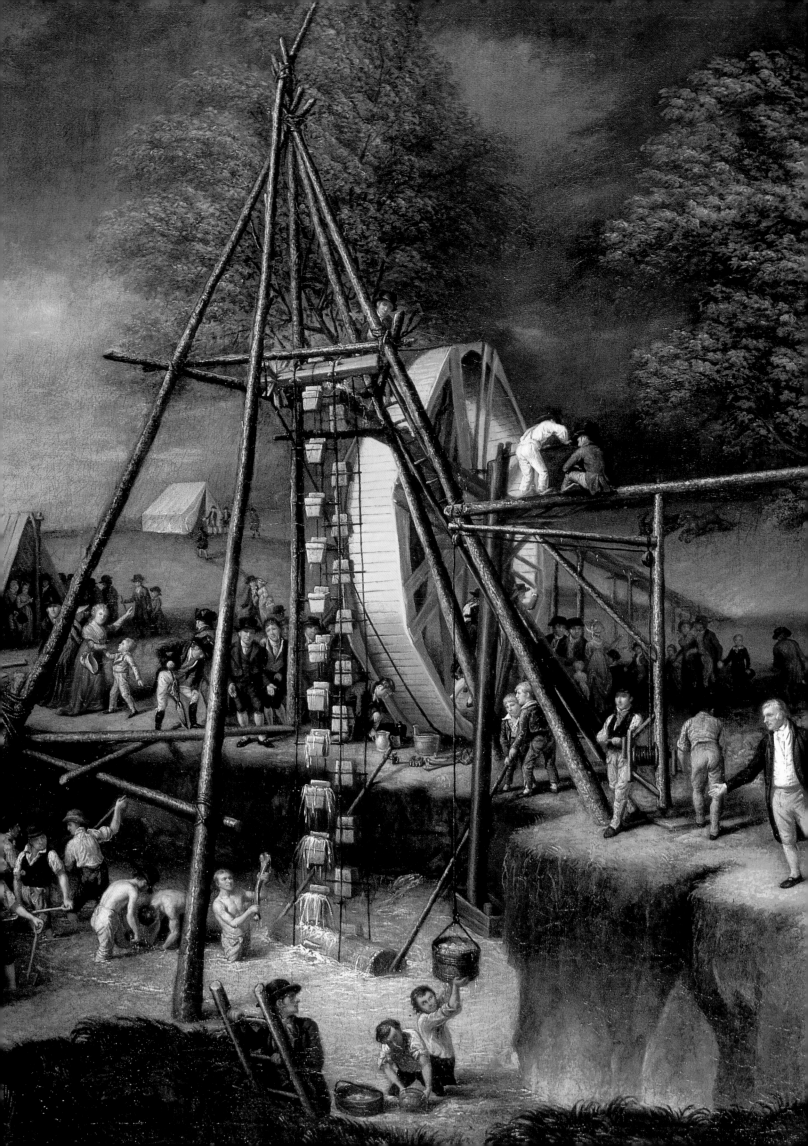

Part 1

The Peales and Their Legacy, 1735–1885

Lillian B. Miller

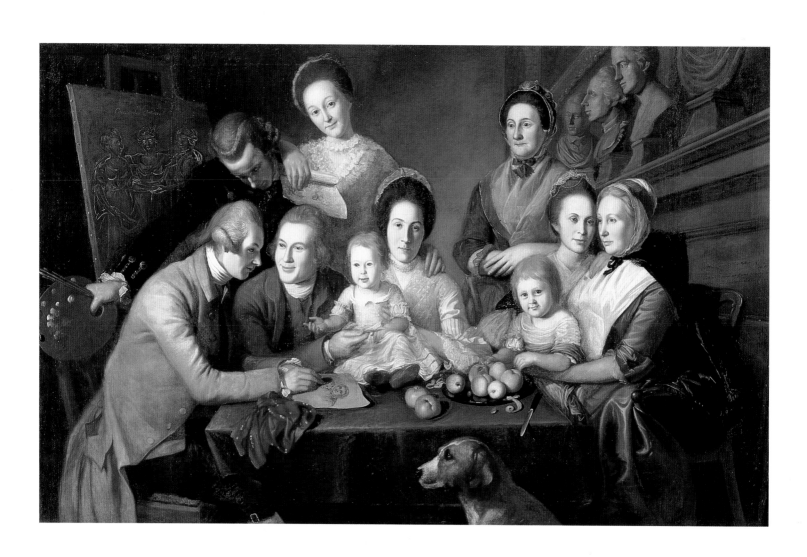

Biography of a Family

SOMETIME AROUND 1770, Charles Willson Peale (1741–1827), Maryland portrait painter, arranged his family around a table for a group portrait (plate 1). Having recently returned from London where he had been privileged to work in the studio of the expatriate Pennsylvania artist Benjamin West, he had acquired artistic skills that made him confident of the "prospect of puting himself into a more comfortable situation." As a matter of "duty," he invited his entire family to join him and his wife Rachel in their Annapolis house—his mother, her companion Peggy Durgan, and brothers St. George, register of the Land Office for Western Maryland, and James, a carpenter's apprentice. Sometime later, when Peale's sister Margaret Jane suffered the loss of her husband, she too was invited to join the family group. So pleased was Peale at the sight of such a "happy family" living "in the utmost harmony together" that he decided to paint "the Portraits of the whole in one piece, emblematical of family concord."[1] To complete the family circle, Peale later included his other sister, Elizabeth Digby Peale Polk, who was then living in Accomac County, Virginia, using for her image an earlier miniature (plate 2).

For over thirty years, *The Peale Family* remained unfinished in Peale's painting room. Only two of its characters were still alive when he dusted off the canvas in 1808 and brought it to completion. The painting now assumed a different meaning: whereas in 1771 it had marked the beginning of Peale's career, by 1808 it celebrated a career successfully sustained through war and peace, births and deaths, expectations and fulfillment. In 1771, Peale had felt obligated to bring his family into his artistic world by teaching his two brothers how to paint; in 1808, Peale was able to look with satisfaction on the completion of that effort.[2] His brother James had found his vocation as an artist; his own children—Raphaelle and Rembrandt—were successfully pursuing artistic careers; and he had established his own reputation in both art and science. He had also succeeded as an educator, his museum, publications, lectures, and institutional efforts having encouraged cultural interests in the community. Now preeminent as an intellectual as well as cultural leader, he had achieved a respectable position based on merit rather than birth as befitted a member of a republican society. Thus, in its thirty–year history, the group portrait encapsulated Peale's biography—his origins, his artistic and social beliefs, and the influences that shaped his art and life and contributed to his achievement.[3]

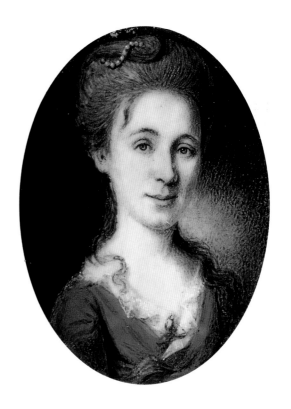

PLATE 1
Charles Willson Peale
The Peale Family, 1771–73, 1809
Oil on canvas, 56 ½ x 89 ½ in. (143.5 x 227.3 cm)
Collection of The New-York Historical Society

PLATE 2
Charles Willson Peale
Elizabeth Digby Peale (Mrs. Robert) Polk, c. 1771
Watercolor on ivory, 2 x 1 ⅜ in. (5.1 x 3.1 cm)
Private collection; Courtesy of Earle D. Vandekar of Knightsbridge, Inc.

Charles Willson Peale

The saga of the Peale family begins with Charles Peale (1709–1750), a member of England's landed gentry and possible heir to extensive properties. After attending Cambridge University for a short time, Charles Peale obtained a position as clerk in the British Post Office, where he became trapped in an embezzlement scheme. Found guilty of the capital crime of forgery, he was sentenced to death but was saved by the intervention of highly placed friends. The young felon was exiled to America in 1735 and found his way to Maryland, where he became a schoolmaster, married the widow Margaret Triggs, and fathered five children. His early death left an impoverished family, who treasured, however, his pretensions to a high social status.[4] For his eldest son, Charles Peale remained an image of the effective teacher; he would remember his father as a good schoolmaster, outstanding in a profession that was frequently disparaged for its "low and dissolute [practitioners] . . . drunken in habits, severe and capricious in discipline, and teaching in a rude, irregular way."[5] Education within a family context became, therefore, an influential ideal in Peale's intellectual life, along with the conviction that family members were responsible for and to each other. The family portrait pictures Peale as his father's surrogate, responsible for ensuring the family's prosperity and social position in America by making available to its members instruction in a profession that he believed would guarantee both.

From the time of his father's death, Charles Willson had carried the burden of family responsibilities, whether as a young boy drawing patterns for his mother's embroideries or supporting his younger brothers and sisters by his labors.[6] At age thirteen, he was apprenticed to a saddler for seven years, a period that he later described as "bondage."[7] In December 1761, free of his indentures, he opened his own saddler's shop in Annapolis with borrowed funds.[8] Almost immediately—on January 12, 1762—he married Rachel Brewer (1744–1790), daughter of an Anne Arundel County landowner and member of a large family of wealthy and socially prominent planters and merchants (figure 1). His marriage introduced Peale into elite Annapolis society, whose patronage would later prove useful.[9]

Peale became an artist almost accidentally. On a visit to Norfolk, Virginia, to obtain leather for his saddles, he was attracted by some "miserably done" landscapes and a portrait and decided that he could do better. He bought instruction books and art materials and arranged to have three sessions in the studio of the portraitist John Hesselius (1728–1778) (see figure 2.2).[10]

Debts incurred in establishing his saddlery hastened Peale's artistic development. Forced to flee from his creditors, he found refuge aboard his brother-in-law's merchant vessel on its way to Boston. Here he met John Singleton Copley (1738–1815), foremost American colonial artist, who was hospitable and gave him a candlelight portrait to copy. Peale also visited the former studio of the British artist John Smibert (1688–1751), whose paintings and copies of European masterpieces were "in a stile vastly superior to any [Peale] had seen before."[11] As Peale later remarked, the debts that

FIGURE 1
James Peale
Rachel Brewer (Mrs. Charles Willson) Peale, c. 1769
Watercolor on ivory, 2¼ x 1 ¹³/₁₆ in. (5.6 x 4.5 cm)
The Metropolitan Museum of Art, New York;
Gift of Mr. J. William Middendorf II, 1968

sent him into temporary exile produced "great blessings," for they forced him to make "exertions to acquire knowledge in more advantageous Professions, than that in which he first set out with."[12]

Impressed by Peale's artistic promise, a group of Maryland planters and merchants contributed to a fund that enabled the young man to travel to England and study art with Benjamin West. In London from 1767 to 1769, Peale developed the artistic versatility that would characterize his entire career: full-size oil portraiture, miniature painting (watercolor on ivory), sculpture, and mezzotint engraving. He returned to Maryland schooled in the major elements of the British portrait tradition, which with some modifications to conform to American taste and changing social expectations, he passed on to his brother and children, and through them and their influence, to a younger generation of American artists.

From 1769 to December 1775, Peale worked primarily in Annapolis, with occasional trips to Williamsburg, Virginia, and the surrounding countryside to paint portraits (figure 2). Eighteenth-century Annapolis was an influential environment for Peale. Its Homony Club provided him with literary stimulation—books and conversation that conveyed Enlightenment aesthetic and philosophical principles which were physically expressed in the symmetry, uniformity, and simplicity of the city's architecture and urban organization. Through symbolic design and furnishings, Annapolis mansions, built on streets radiating outward from the Statehouse like the spokes of a wheel, represented gentility and refinement as well as rational principles fundamental to social order (plate 3). Classically designed gardens and freshly washed sidewalks were considered signs of moral and social worth, and also reflected a social, political, and economic stratification of families. That it was

FIGURE 2
Charles Willson Peale
Warner Lewis, c. 1772
Oil on canvas, 31 x 26 in. (78.8 x 66 cm)
Colonial Williamsburg Foundation, Virginia;
Gift of Alice Ball

PLATE 3
Charles Willson Peale
A Front View of Statehouse at Annapolis, n.d.
Engraving

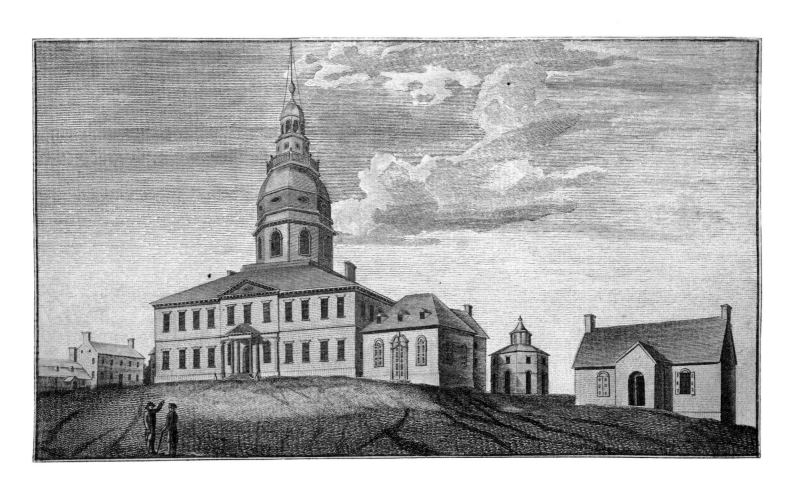

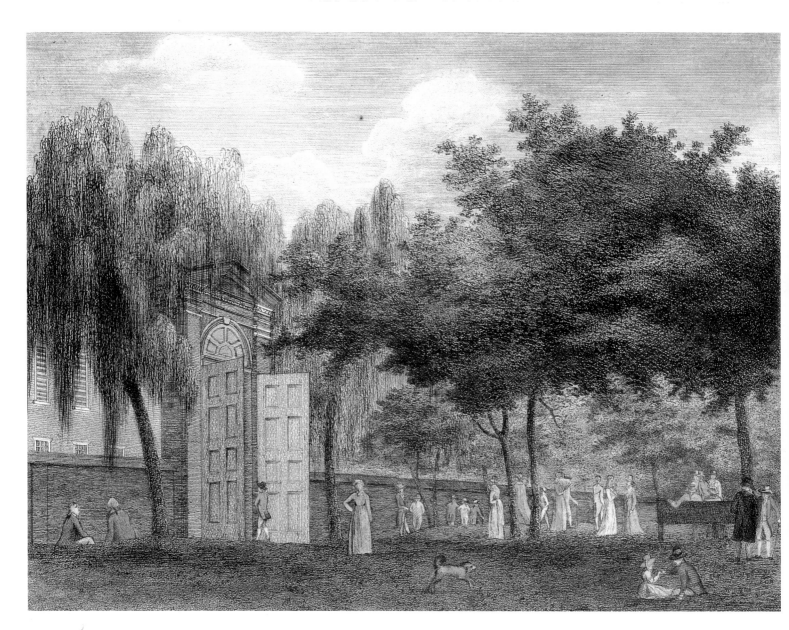

PLATE 4
William Russell Birch (1755–1854)
State-House Gardens, Philadelphia, 1799
Color engraving, 12 ¾ x 15 ⅜ in. (32.4 x 39.1 cm)
Maryland State Archives, Annapolis, MSA SC 194,
Bond Collection

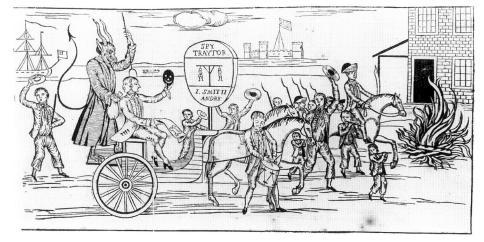

FIGURE 3
The Devil and General Arnold
Woodcut. (Printed in *Americanischer Haus-und
Wirthschafts-Calendar Auf das 1781ste. Jahr Christi*
[Philadelphia, 1780], based on transparent painting
by Charles Willson Peale.)
Historical Society of Pennsylvania, Philadelphia,
on deposit at the Library Company of Philadelphia

a world built on a slave economy did not diminish Peale's aspirations to enter it, and *The Peale Family* in its inception expressed that aspiration.

With all of its wealth and social claims, Annapolis did not provide sufficient patronage to maintain a resident artist. In December 1775, Peale moved to Philadelphia to take advantage of that city's preeminence in population, trade, and culture. Settled largely by Quakers, Philadelphia had early in its history become a great market town, where farmers from New Jersey or Lancaster brought their produce for shipment to Atlantic port cities, the Caribbean, and southern Europe. Trade invited the immigration of skilled artisans, who provided a cosmopolitanism highly significant for the cultivation of the fine arts. The city's institutions represented the interests of merchants and craftsmen alike; educational and philanthropic in nature, these included a library, learned society, theater, hospitals, and printing houses, fulfilling the age's requirements that man's duty was self-improvement and charity to others. The presence of these institutions in Philadelphia as early as 1728 suggested to poets that the city would become "the Athens of mankind"[13] (plate 4).

When Peale arrived in Philadelphia, its residents were preparing for war—building warships, enforcing nonimportation and nonconsumption provisions of the Continental Association, and organizing the militia for battle. Peale participated in the American Revolution both militarily and politically. He painted battle flags for volunteer companies and created effigies of "traitors" for noisy political parades (figure 3), transparencies for public displays, designs for nationalistic publications, and celebratory arches broadcasting revolutionary ideology through classical symbolism. He experimented with the manufacture of gun powder and telescopic sights for rifles, and he joined the Philadelphia militia as a "common soldier"(figure 4).[14] Promoted to captain, he fought with General Washington's army at Trenton and Princeton. After leaving the militia, he joined "The Furious Whigs," a radical political group whose program included defense of Pennsylvania's unicameral constitution of 1776 and agitation against the excessive profiteering and escalation of prices by the city's merchants and legislators. For a short while, Peale served as agent for confiscating the estates of British sympathizers, and then as a representative for one term in the Pennsylvania legislature. He also found time to paint miniature portraits of army personnel (plate 5) and civilian leaders that in many instances constitute the only images we have of participants in the Revolution.

FIGURE 4
Charles Willson Peale
Self-Portrait in Uniform, 1777–78
Oil on canvas, 6 x 5 ½ in. (15.3 x 14 cm)
American Philosophical Society, Philadelphia

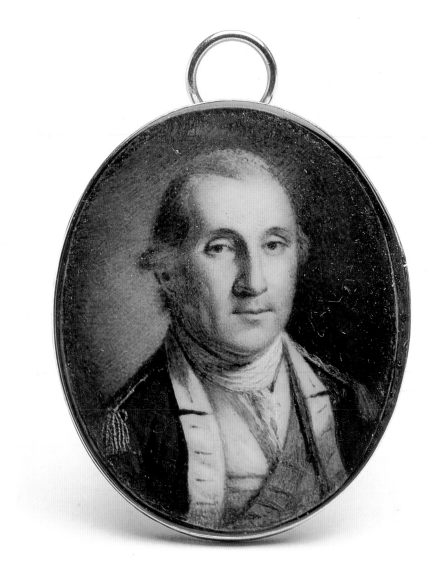

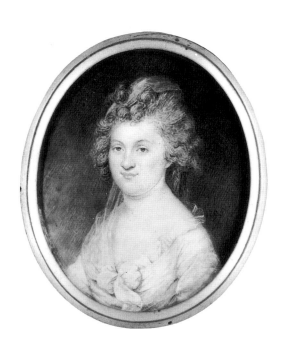

With peace, Peale turned to the problem of supporting his family, which by 1787 included six living children—Raphaelle (1774–1825), Angelica Kauffmann (1775–1853), Rembrandt (1778–1860), Titian Ramsay (the first of that name) (1780–1798), Rubens (1784–1865), and Sophonisba Angusciola (1786–1859). He also had the responsibility for bringing up the three children of his sister Elizabeth Polk, who had died sometime around 1776. With his brother James's help, in 1785 he created and exhibited what he called "moving pictures," an ingenious but economically unrewarding effort. He attempted the production of mezzotints from his collection of portraits (plates 6, 7, 8, 9), but engraving without proper tools and materials, and especially without trained assistance, was tedious and provided little in the way of financial return. And he painted some beautiful portraits, frequently traveling to Maryland's Eastern Shore and Baltimore for commissions that would enable him to earn a living as well as express his artistic talents.[15]

When Rachel Brewer Peale died in April 1790, Peale was faced with the responsibility for the health and welfare of a large brood of youngsters. Marrying Elizabeth DePeyster (1765–1804) of New York City in 1791 (figure 5), he decided to cease traveling and devote his time to developing the enterprise that was to occupy the remainder of his life and shape his work— the Philadelphia Museum. The museum became the center of the Peale

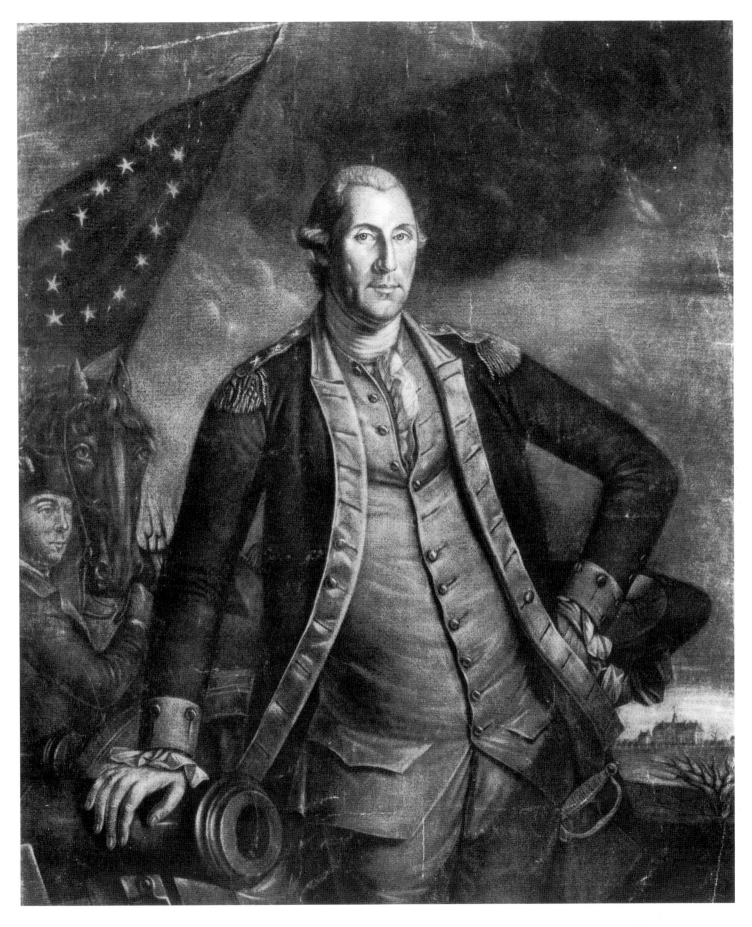

PLATE 6
Charles Willson Peale
His Excellency George Washington Esquire,
Commander in Chief of the Federal Army, 1780
Mezzotint, 14 x 10 ⅛ in. (35.5 x 25.7 cm)
National Portrait Gallery, Smithsonian Institution,
Washington, D.C.; Gift of the Barra Foundation

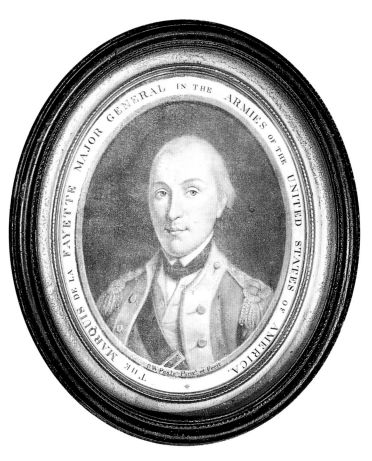

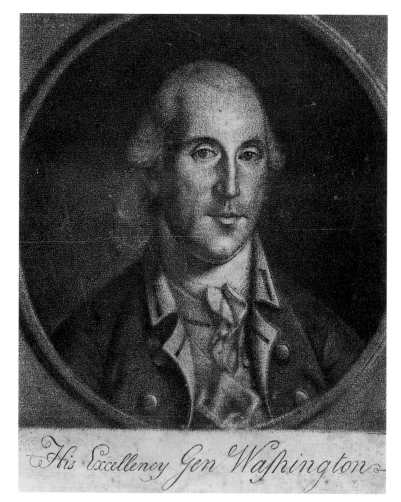

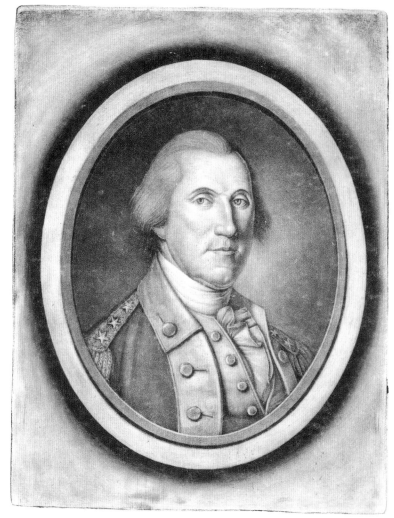

PLATE 7 *(Above)*
Charles Willson Peale
The Marquis de Lafayette, 1787
Mezzotint, 6 ⅛ x 5 ³⁄₁₆ in. (15.6 x 12.9 cm)
Private collection

PLATE 8 *(Top right)*
Charles Willson Peale
His Excellency Genl. Washington, c. 1778
Mezzotint, 5 ⁹⁄₁₆ x 4 ⁵⁄₁₆ in. (14.1 x 11 cm)
National Portrait Gallery, Smithsonian Institution,
Washington, D.C. Gift of Robert L. McNeil, Jr.

PLATE 9 *(Bottom right)*
Charles Willson Peale
His Excellency G. Washington, Esq.:
L.L.D. Late Commander in Chief of the Armies
of the U.S. of America and President of the
Convention of 1787, 1787.
Mezzotint, 7 ³⁄₁₆ x 5 ⅞ in. (18.3 x 14.9 cm)
The Metropolitan Museum of Art, New York;
Bequest of Charles Allen Munn, 1924 (24.90.185)

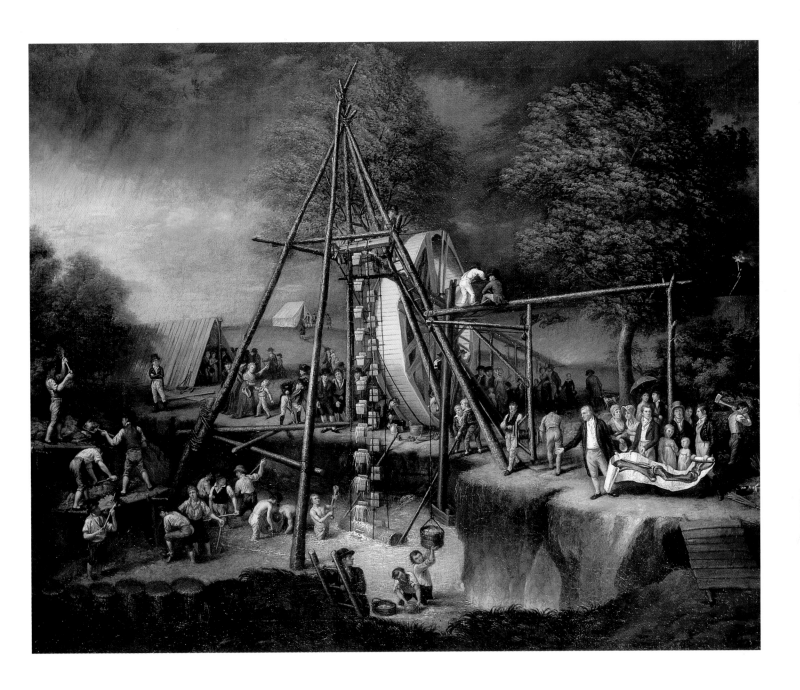

PLATE 10
Charles Willson Peale
Exhumation of the Mastodon, 1805–08
Oil on canvas, 50 x 62 ½ in. (127 x 158.8 cm)
The Peale Museum, Baltimore City Life Museums

family's life. The family lived in the museum building—Philosophical Hall—sharing the space with the animals, plants, and minerals Peale had collected for exhibition. Peale spent his second honeymoon on a bird-hunting expedition; his daughter was married in the museum; the children were initiated into the art of taxidermy and museum management; his son—Benjamin Franklin—was born and named there, and the museum became not only "a world in miniature" for the public, but Peale's private world as well.

The necessities of the museum encouraged Peale's major achievement in natural history—the exhumation of the bones of prehistoric mammoth animals in the marshes of Newburgh, New York, in 1801, and their reconstruction into two skeletons (plate 10). Peale's discovery provided scientists in the United States and abroad with a new understanding of prehistoric life

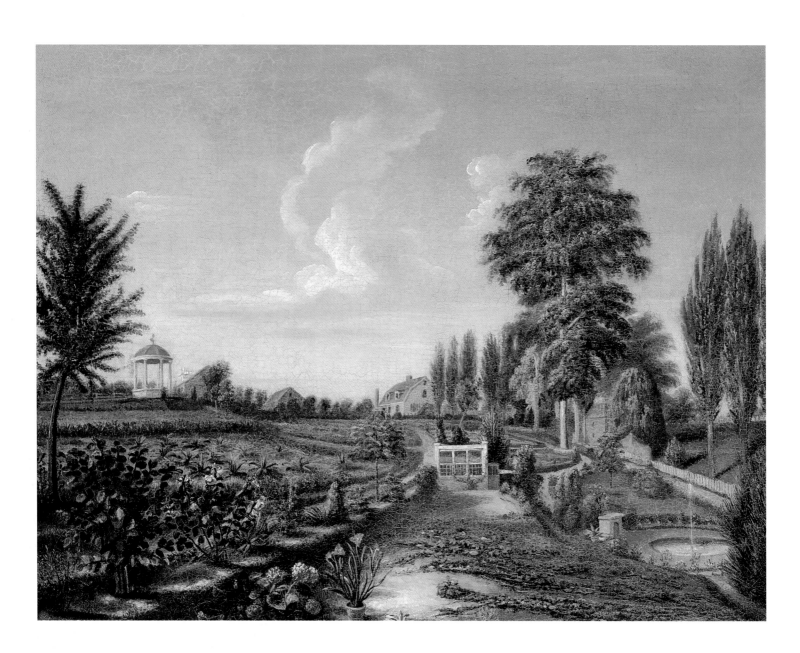

Charles Willson Peale
View of the Garden at Belfield, 1816
Oil on canvas, 11 x 16 in. (27.9 x 40.6 cm)
Private collection

on the continent as well as a new conception of the development of life on earth. For Peale, the mastodon, as his mammoth creature came to be called, was an important missing link in the "Great Chain of Being;" for scientists like the French zoologist Georges Cuvier, it was proof that species could become extinct, a necessary acknowledgment in the development of the concept of organic evolution.[16]

At the death of Elizabeth DePeyster, Peale married a third time, and with the Quakeress Hannah Moore by his side (figure 6), retired in 1810 from the management of the Philadelphia Museum to Belfield, a farm outside Philadelphia. Intrigued by the possibilities of agriculture, he entered upon what he perceived as the bucolic life of a gentleman-farmer, but his major achievement at Belfield was the development of a new kind of museum— a pleasure garden that eventually drew large numbers of visitors from Philadelphia and elsewhere as its fame spread (plate 11). Life as a farmer amused Peale for ten years, but his delight in Belfield ceased at Hannah's death in 1821. He moved back to Philadelphia, resumed management of the museum and renewed his artistic interests; during these last years, he painted some of his most impressive works.

Peale's Children

Eleven of Peale's children survived into adulthood, ranging in age at the time of Elizabeth's death in 1804 from two to thirty. Like many eighteenth-century fathers, Peale assumed that it was his duty to provide his children with occupations. In his studio, he instructed his sons and his nephew Charles Peale Polk in drawing and painting from nature. The museum offered a facility for training Raphaelle and the first Titian in taxidermy, and Rubens in museum management—programming, preserving birds, and painting habitat scenery. Later, after they had served apprenticeships in a machinery factory, Franklin and the younger Titian (born in 1799 and named for his deceased half-brother) learned museum management there. Peale introduced his oldest daughter Angelica Kauffmann to drawing and taught Sophonisba how to paint still life and print labels in a neat hand explaining the exhibits. By 1793, he was able to take satisfaction in the fact that he had successfully instructed his children "to be industrious and careful that they may help themselves and be useful members of the community."[17]

He also made efforts to provide his children with institutional experiences beyond the confines of the museum, for in England he had seen the importance of art academies for young artists' development. In 1795, Peale helped establish the Columbianum in Philadelphia—a university-styled organization designed to provide training for young artists as well as to encourage patronage of the arts. The entire family showed their work at the first and only exhibition of the society in May 1795 (plate 12, figure 7; also see plates 23, 27). The Columbianum, however, was short lived: after a year of rancorous ideological debates among its members, the organization fell apart, and not until ten years later, with the founding of the Pennsylvania Academy of the Fine Arts, did Peale realize his vision of an art institution.

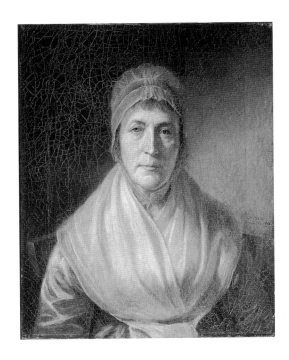

FIGURE 6
Charles Willson Peale
Hannah Moore (Mrs. Charles Willson) Peale (3), 1816
Oil on canvas, 24 x 20 in. (61 x 50.8 cm)
Museum of Fine Arts, Boston; Gift of Mrs. Reginald Seabury Parker in memory of her husband

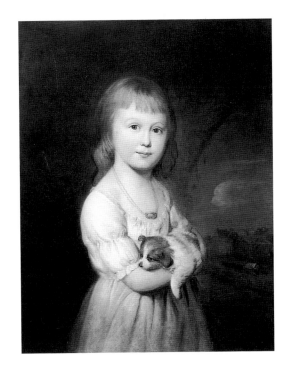

FIGURE 7
Rembrandt Peale
Samuel Buckley Morris (Portrait of a Child and Lap-Dog), 1795
Oil on canvas, 26 ¼ x 21 ⅞ in. (66.7 x 55.6 cm)
Independence National Historical Park;
On loan to Deshler-Morris House

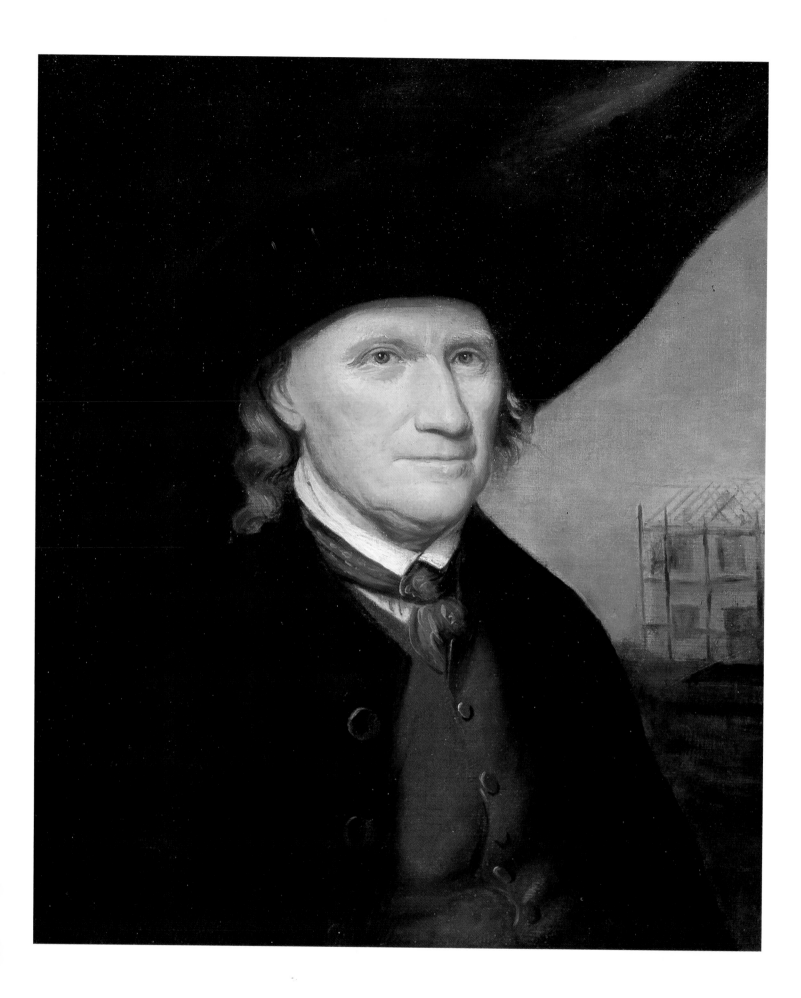

With its collection of classical casts imported from Paris and its annual exhibitions, the Academy played a central role in Philadelphia's cultural life, as well as in the Peales' artistic practice.

Such educational efforts came easily to Peale. What he found more difficult was the supervision of his children's behavior and molding of their tastes. Once out of the range of his direct influence, Peale's sons followed their own inclinations, choosing, like Raphaelle, to paint still lifes instead of portraits or, like Rembrandt, nude figures of which Charles Willson Peale disapproved. But whether the children maintained their father's values or confronted them, Charles Willson Peale's ideals and purposes remained dominant. The varied ways in which the Peale children responded to their father's training may be seen in a comparison of Raphaelle and Rembrandt as artists, and Rubens and the second Titian Ramsay as museum managers.

Raphaelle and Rembrandt Peale

Most of Peale's children demonstrated artistic and/or mechanical skills, but the two who made the most significant contributions to the nation's artistic life were Raphaelle (see plate 71) and Rembrandt (see plate 74). Peale was most severely challenged by Raphaelle; he found a more receptive response in Rembrandt. Both young men were enormously talented artists, but their careers and lives took separate directions as a result of different childhood experiences and because of intrinsically different temperaments and capacities. Raphaelle, the first surviving child after the early deaths of two babies, had been pampered by the women of the household. Undoubtedly highly sensitive to his external environment, he had experienced while still very young many of the anxieties caused by war and threats of British reprisal.[18] In the crowded household of his extended family, there were frequent comings and goings, births and deaths, arrivals and departures. Perhaps the worst blow for the boy was the death of his gentle mother in 1790.

At a young age, Raphaelle worked closely with his father as an assistant in the museum, arranging exhibits, caring for its live animals, and engaging in simple efforts at taxidermy; he also assisted his father on portrait painting excursions to Baltimore and Annapolis, carrying messages and running errands, always at his father's beck and call. Rembrandt, on the other hand, was left undisturbed as a child. Born on George Washington's birthday in the midst of the American Revolution, Rembrandt took the accident of his birthdate as a talisman for his destined greatness. He began to draw at an early age, and showed such artistic promise that he was given the freedom of his father's studio and permitted to work among its paints and carpentry materials. He freely wandered throughout Philadelphia and observed the rituals and parades that marked the establishment of the new nation. From a perch on a wall, he could observe Benjamin Franklin's funeral services and marvel at the attention paid to heroes; he could look forward to occasionally meeting on Philadelphia streets such famous men as George Washington, who would pat him on the shoulder and ask after his father; and—what was of most significance for his development—he was able to visit as frequently

PLATE 12
Raphaelle Peale
Matthew McGlathery, 1795
Oil on canvas, 26 x 22 in. (66 x 55.9 cm)
Carpenters' Company of Philadelphia

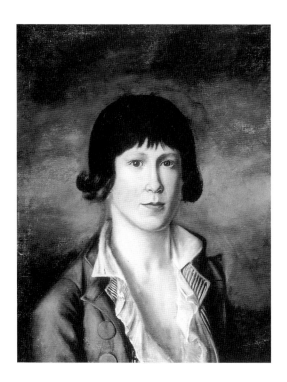

FIGURE 8
Rembrandt Peale
Self-Portrait at Thirteen, 1791
Oil on canvas, 20 ½ x 16 ¾ in. (52.1 x 42.5 cm)
Private collection

as he wished the dazzling collection of European paintings on view in his father's gallery.[19] Impressed by his father's position in the community and his many achievements, Rembrandt regarded Charles Willson Peale as a role model and mentor rather than a judgmental master.

Young Rembrandt took advantage of the many opportunities offered to watch his father at work; he stood behind his father, for example, in July 1787, when Peale painted still another portrait of George Washington preparatory to making a mezzotint for public distribution, and he actually assisted his father in the preparation of the copper plate (see plate 9). At age thirteen, he painted a highly respectable self-portrait (figure 8), and for the next few years, he continued to practice drawing, study the chemistry of pigments, and experiment with lighting and painting effects, as—for example—in his *Self-Portrait by Candlelight* (Wadsworth Athenaeum, Hartford, Connecticut). By 1794, he was receiving portrait commissions and had established himself in the Philadelphia community as a professional artist.[20]

Raphaelle also was prepared to undertake professional commissions in 1794. That year, he signed his name as an artist to the charter establishing the Columbianum.[21] He joined Rembrandt and his uncle James in 1795 in his father's studio to paint a portrait—perhaps a miniature—of President Washington (unlocated; see Rembrandt's portrait, figure 4.13). Throughout that fall, he and Rembrandt copied sixty of their father's portraits of great men to exhibit in Charleston and Savannah (plate 13). In these southern cities far from home, the two brothers were left to their own devices. Rembrandt wrote romantic verses, studied the work of British artists resident in Charleston, and painted a few portraits. Raphaelle helped manage their exhibition, fulfilled various requests of his father for specimens of local flora and fauna, and may have frequented Charleston's waterfront.[22]

Returning North, the young men continued their exhibition in Baltimore where they attempted to establish a museum similar to Charles Willson Peale's. Their effort failed, unable to survive the economic depression resulting from the European wars. The brothers soon parted ways: Raphaelle to Philadelphia to paint portraits and miniatures, assist his father in the museum, and experiment with inventions, and Rembrandt to New York City to exhibit "The American Pantheon or Peale's Collection of Portraits of American Patriots."[23]

The Baltimore experience did not encourage brotherly love. Never again did Raphaelle and Rembrandt join forces; their permanent estrangement challenged the elder Peale's ideal of the need for sibling affection and mutual support. Raphaelle's volatile personality offended his brother's rational approach to experience, while Rembrandt's assiduous attention to his responsibilities must have been a constant irritant to the restless older brother.

Raphaelle's life was marked by frequent illness and mood swings, as he alternated between high spirits, humorous antics and moments of great creativity, and depression and a sense of incapacity. He constantly sought social stimulation and seemed unable to control his appetites. Rembrandt, by contrast, lived and worked deliberately to achieve his purposes, favoring the intellectual elements in his art, as did his father, and intent upon acquiring technical proficiency.

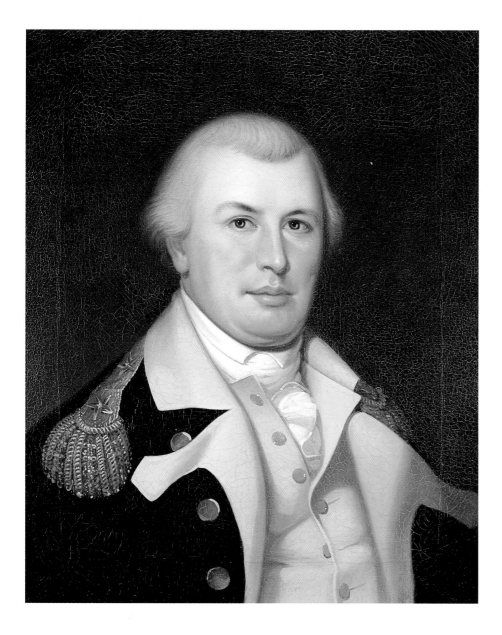

PLATE 13
Rembrandt Peale, after Charles Willson Peale
Nathanael Greene, 1795–96
Oil on canvas, 23 5/16 x 19 7/16 in. (59.2 x 49.4 cm)
Maryland Historical Society, Baltimore

In 1802, accompanied by his wife and baby and by eighteen-year-old
Rubens, Rembrandt traveled to England in the first of a sequence of
European residencies that would expand his understanding of art and help
him hone his skills.[24] Whether Raphaelle felt deprived of opportunities for
study abroad is not known; already burdened with a growing family—he had
been married on May 25, 1797, to Martha (Patty) McGlathery (d. 1852),
daughter of the master builder Matthew McGlathery (see plate 12)—he was
forced to limit his travels to the eastern seaboard.[25] With the newly developed
physiognotrace, which allowed for a rapid and inexpensive production of
profiles or silhouettes, Raphaelle began the first of many trips to the South;
by cutting thousands of profiles (plate 14) and painting miniatures and
possibly oil portraits, he earned enough money to buy a house for his family
in Philadelphia. His initial success, however, was followed by periods of
failure, which resulted in intemperance, illness, poverty, and despair.[26]

From 1811 on, Raphaelle began to ignore his father's advice to paint
portraits and concentrated his artistic energies instead on still life. Portraiture
was not to his liking. Perhaps he found it difficult to fulfill his sitter's
requirements; still life, which made no demands of him personally, proved
a more satisfactory kind of expression. Although Raphaelle's small panels

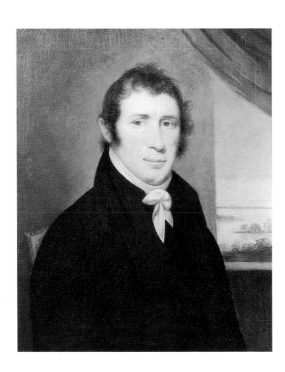

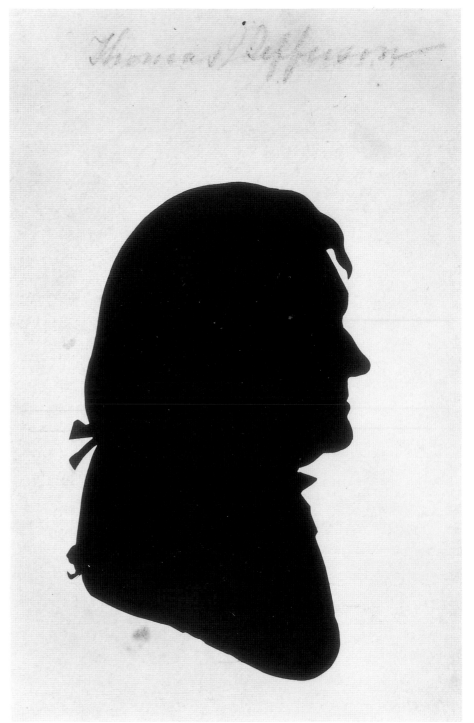

were praised as "pictures of uncommon merit," he received little remuneration for them. Year after year many of the same paintings, if we can judge from their titles, were offered "for sale," suggesting that although they were admired, they were not purchased (plate 15).[27] His economic dependency provided his father with opportunities to criticize what he perceived as Raphaelle's unsocial behavior, offer unwelcome advice, and intervene in Raphaelle's personal life.[28]

Disabled by painful gout, Raphaelle frequently found it impossible to work for extended periods of time, although he made valiant efforts to do so. In 1817, he made a long and disastrous visit to Norfolk, Virginia, in search of patronage, returning at the end of 1818 much weakened by illness. He made another trip in 1820, this time to Annapolis, Baltimore, and Maryland's Eastern Shore, where he painted a number of portraits (figure 9). From 1821

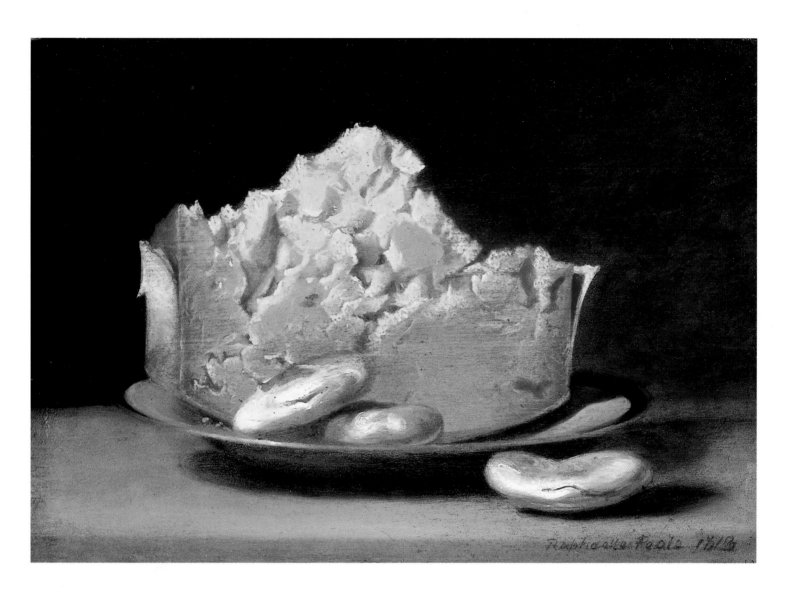

PLATE 15
Raphaelle Peale
Cheese with Three Crackers, c. 1813
Oil on wood panel, 7 x 10 in. (17.8 x 25.4 cm)
Schwarz Gallery, Philadelphia

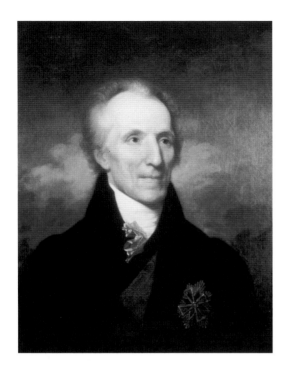

until his death in 1825 from "an infection of his lunges,"[29] Raphaelle struggled physically and economically to survive as an artist in a world that showed little appreciation of his kind of art.

Peale found more satisfaction in Rembrandt's career. As a result of study and travel, Rembrandt developed independent aesthetic ideas and moved beyond his father artistically, but his father applauded his achievement and willingly took lessons from him.[30] After London, Rembrandt set his sights on Paris, and Charles Willson, eager to assist him, commissioned fifty portraits of France's scientists, artists, and literary luminaries for the Philadelphia Museum. The generous arrangement permitted Rembrandt to study in Paris from June to September, 1808, and October 1809 to November 1810 (figure 10).

His Parisian experiences prompted Rembrandt to try again to encourage the arts in Philadelphia by means of an art institution. He hoped that by devoting his Apollodorian Gallery to subjects that would have "powers to dignify man" he would be able to convert Philadelphians to the Parisian approach to art as an important life experience, and not simply an adjunct of natural history or religion.[31] But Rembrandt had not gauged Philadelphians' taste adequately, and his gallery was not a success. Discouraged, he moved his enterprise to Baltimore.

Despite the ongoing War of 1812 and the imminent possibility of a British invasion, Rembrandt founded his Baltimore institution with high hopes. By 1799 Baltimore had become the third largest commercial port in the United States. A younger generation of businessmen, intent upon pursuing culture along with wealth, were ready to lend their support to his project. It seemed a good time to attempt such an experiment.

For almost ten years, Rembrandt labored to create a museum and art gallery in Baltimore that would encourage a taste for the fine arts by a continuous art exhibition. After a few prosperous years, however, the museum was beset by economic difficulties as a result of the Panic of 1819, an epidemic of yellow fever, and pressure from the Baltimore businessmen who had invested in the museum primarily for profit and were seeking a high rate of return. Whereas his father had insisted upon maintaining sole ownership of his institution, Rembrandt was persuaded by the new trend toward capitalization and incorporation of business to open his enterprise to public investors. However, the priorities of shareholders were not his. By 1822, Rembrandt was anxious to rid himself of his burden; he invited his brother Rubens to take over the museum's management, while he resumed his artistic practice in New York City. Rubens continued Rembrandt's innovative practice of exhibiting the work of contemporary artists in the museum's gallery, and introduced various scientific as well as popular presentations, but he, too, failed to resolve the institution's financial problems.[32]

Despite its economic failure, the Baltimore Museum was not without its influence. Of special importance was its art gallery which not only introduced the public to the work of American artists, but became a model for similar institutions in other American cities. Bostonians, for instance, influenced by Baltimore's effort and anxious to ensure "the prosperity of the town and the enlargement of polished society in it," in 1822 established an art gallery in their Athenaeum.[33]

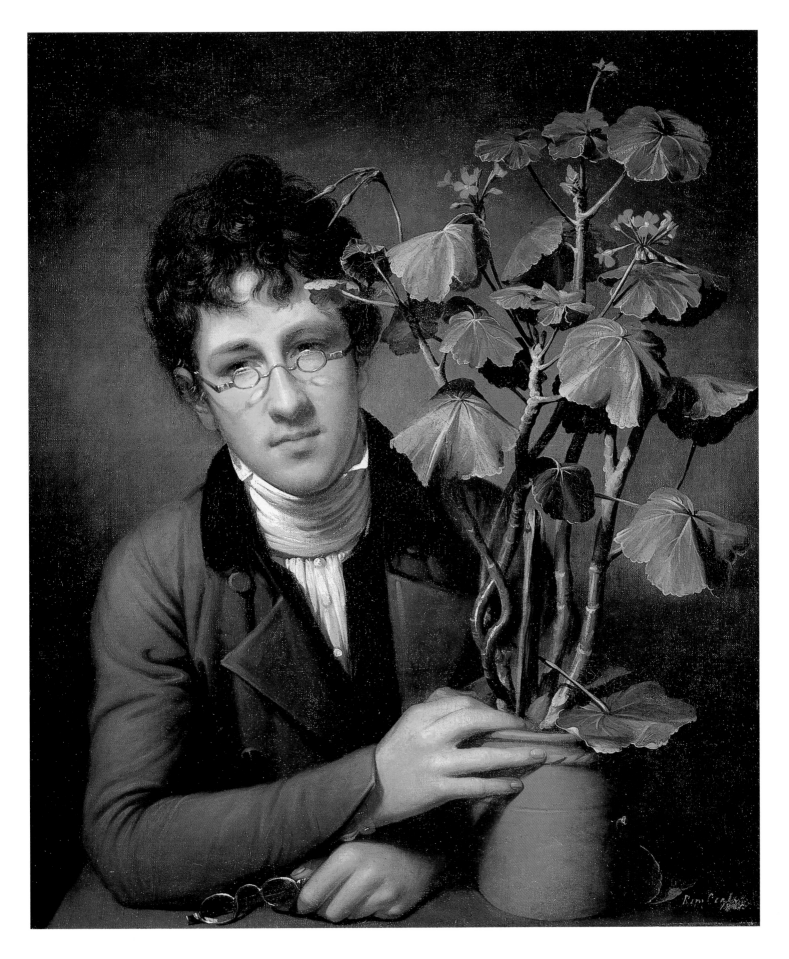

PLATE 16
Rembrandt Peale
Rubens Peale with Geranium, 1801
Oil on canvas, 28 ¼ x 24 in. (71.8 x 61 cm)
National Gallery of Art, Washington, D.C.;
Patrons' Permanent Fund

Rubens and the Second Titian Ramsay Peale

Rubens Peale was very much the product of his father's instruction; he shared the elder Peale's temperament and goals, but as a second generation entrepreneur he could not avoid being influenced by the concentrated concern of his society for economic development and profit. Because of poor eyesight and a deep interest in botany, he was directed to museum work at an early age (see plate 16). To learn more about museum management, he accompanied Rembrandt to London in 1802, where he took charge of the exhibition of the mastodon skeleton while Rembrandt pursued his studies at the Royal Academy. He also gave attention to the organization and programs of British museums, which, upon his return, he adapted to his father's Philadelphia institution. When Charles Willson Peale retired in 1810, Rubens took complete charge of the museum, strengthening its programs and collections, introducing gas lights and hiring traveling exhibitions. When his father decided to return to the direction of the institution in 1822, Rubens assumed the management of Rembrandt's Baltimore Museum. An innovative

PLATE 17
Raphaelle Peale
Titian Ramsay Peale (1), 1798
Watercolor on ivory, 2 3/16 x 1 7/8 in. (5.4 x 4.8 cm)
Private collection

director, Rubens expanded the Baltimore Museum's programs by conducting scientific experiments in public and introducing into its art exhibitions works borrowed from the city's private collections. Experiencing the same difficulties with stockholders that Rembrandt had, Rubens moved his enterprise to the more populous New York City, where he opened Peale's Museum in 1825, in an environment that promised success as a result of the opening of the Erie Canal.

The second Titian Ramsay—named after Peale's third son (plate 17) who had died of yellow fever at the age of eighteen at the beginning of a promising career as artist/naturalist—followed in his brothers' footsteps, as a successful museologist like Rubens and accomplished artist/naturalist like his namesake. Titian's youthful restlessness found release from his father's anxious supervision in travel. Unlike Rubens who remained soberly at home introducing small innovations and trying to steer a course for the museum between entertainment and education, Titian sought scholarly knowledge in the field on expeditions that would furnish new specimens and insights into the natural world and the American land. In 1819, Titian joined the Long Expedition to the Rocky Mountains (see plate 86),[34] returning in 1821 as a respected member of Philadelphia's scientific community. Rubens's museum efforts were those of an amateur scientist and businessman; Titian's work, on the other hand, marked the beginning of a new professionalism in the sciences, signalled by his participation, with other young naturalists, in the founding of the Academy of Natural Sciences in the city. While working in the Philadelphia Museum, Titian continued his scholarly investigations into nature by drawing plates for Thomas Say's *American Entomology* (1824–1828) and Charles Lucien Bonaparte's ornithological volumes (1825–1833) (see figures 6.2, 6.8, 6.9).[35]

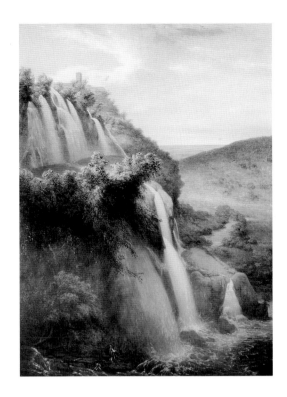

FIGURE 11
Rembrandt Peale
Cascatelles of Tivoli, 1830
Oil on canvas, 38 ½ x 28 ½ in. (99.8 x 72.4 cm)
Private collection

The Family after Peale

Charles Willson Peale died in 1827. Although no longer subject to his direct intervention in their activities, family members were never free of his influence. Having experienced Boston's admiration for Italy's old masters, Rembrandt had yearned to visit that country but had been deterred by his father's disapproval of his wanderlust. Following Peale's death, Rembrandt borrowed funds and, accompanied by his son Michael Angelo, embarked on that pilgrimage. His residence in "Heavenly Italy" from 1829 to 1831 was more inspirational than educational. He studied the work of the seicento masters Domenichino and Guido Reni (see plate 58); painted the *Cascatelles of Tivoli* (figure 11), and in Florence made copies of works by Raphael and Cristofano Allori (see plate 57).[36] Four years after the death of his wife Eleanor Short Peale (figure 12) in April 1836, he remarried, and with Harriet Cany, an artist who shared her husband's devotion to painting, he established a studio in Philadelphia. Here he undertook to paint over seventy replicas of his 1824 *Washington*, now featured as *Patriae Pater* (see plate 78). His small pamphlet *Graphics: A Manual of Drawing and Writing, for the Use of Schools and Families* (1835) was published in many editions, enlarging its scope as it gained in popularity. Used well into the century by high school teachers of

FIGURE 12
Rembrandt Peale
Eleanor Mae Short (Mrs. Rembrandt) Peale, c. 1811
Oil on canvas, 28 ⅜ x 23 ¼ in. (72.1 x 59.1 cm)
Mead Art Museum, Amherst College, Amherst, Massachusetts; Gift of Edward S. Whitney, Class of 1890

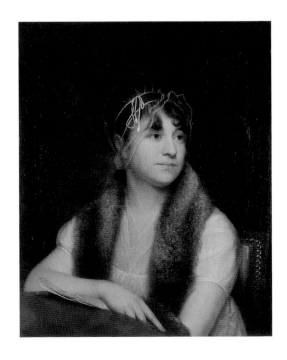

drawing, it became an important document in the campaign to introduce art studies into the American public school curriculum. He continued to write and publish articles on art and his experiences as an artist in America, and, during the last decade of his life, he delivered at many public forums a popular illustrated lecture on "Portraits of Washington." By this time he was respected as a "venerable" artist. In 1836, he was elected for a short term as president of the American Academy of Fine Arts in New York, and in 1855, he assumed the mostly honorary presidency of the Washington Art Association, a loose confederation of American artists whose purpose was to persuade Congress to patronize American art.[37]

Upon his father's death, Rubens expanded his museum interests from New York City to Utica, placing the branch under the guidance of his brother Charles Linnaeus. Until the Panic of 1837 and the depression that followed, Rubens prospered in New York, but his enterprises failed during the difficult years of economic stringency. Unable to pay the rent for his building, in 1842 he was forced to relinquish his museum, and in 1849 Phineas Barnum purchased its collections. Rubens retired to his wife's family's farm in Pottsville, Pennsylvania, to raise fruits and vegetables. In 1855, now over seventy years old, he undertook art lessons, and with the help of his daughter Mary Jane, he produced a good-sized oeuvre of still lifes and landscapes.[38]

Except for periods of travel and exploration,[39] Titian continued to work in the Peale Museum in its new location in Philadelphia's Arcade until August 1838, when he joined the Scientific Corps of the Navy for the Wilkes Expedition to the South Seas as artist/naturalist, returning to the United States in the spring of 1842. Frustrations in the field as a result of insufficient funding and confusion of purposes—whether the expedition was to be scientific or political (diplomatic) in nature—were not as significant as the frustration Titian was to experience later, upon returning to the United States. Ordered to Washington, D.C. to organize the expedition's collections, he worked in the nation's capital until 1848, writing a report from his carefully kept journals and illustrating it with drawings made on the spot; the report was published that year as volume eight of *United States Exploring Expedition During the Years 1838, 1839, 1840, 1841, 1842. Under the Command of Charles Wilkes, U.S.N.: Mammalia and Ornithology.* Alleging that Titian's report was not sufficiently scientific, Wilkes stopped the publication of the book soon after it went into print. The assignment was given to John Cassin, whose volume, published in 1858, drew largely on Titian's work and included many of Titian's drawings and illustrations (see figure 6.14). Titian was also to be disappointed at not receiving the position of curator at the Smithsonian Institution, the final repository of the Wilkes Expedition's collections, despite all his efforts to identify and arrange the items scientifically. Many years later, in 1859, when invited by the Smithsonian's Secretary, Joseph Henry, to write an essay for the institution's staff on the art of preserving animals, Titian noted his earlier disappointment as well as the irony of Henry's request. "Many years Since," he wrote,

> I felt it was a great misfortune to be obliged to abandon the experience
> of a life devoted to what I still believe was a good cause. And now to write

on the Subject Solicited would arouse painful memmory of hopes long deferred and gone. I am willing that the world of visitors to public Museums shall gape at rampant, grinning ruminants and other monstrocities prepared for their inspection by some bungling laborer, or mechanic, who may not be able to gain a living by his legetimate labors . . . but for my part, I retire from Such collections with a feeling of disappointment that the beauties of nature can be so tortured and the torture tolerated.[40]

In 1846, Titian secured a position as Assistant Examiner in the United States Patent Office in Washington, and with his second wife Lucinda MacMullen (his first wife, Eliza Laforgue, having died in 1846), he lived in Washington until 1873, becoming an accepted member of Republican society. He earned a reputation as a noted photographer, fascinated, as had been his father, by mechanical processes capable of replicating art (figure 13); he continued to paint in oil scenes that he had sketched during his expedition days, and he also tried his hand at original landscapes. In the fall of 1873, he and Lucinda moved to Holmesburg, Pennsylvania, and four years later, to Philadelphia, where the couple spent their retirement years in straitened circumstances. Ensconced in the library of the Academy of Natural Sciences, they devoted themselves to writing the patriarch's biography, but succeeded only in making transcriptions of Charles Willson Peale's letters and diaries.[41]

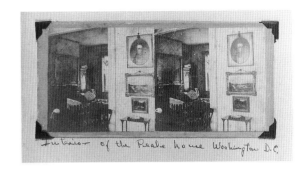

Having experienced an unfortunate marriage and divorce, Franklin remarried, left the museum and took a position as chief coiner in the United States Mint. A musician as well as a scientist, he composed songs for the Spanish guitar and carried on experiments in steam. From 1831 to 1833, he lectured at the Franklin Institute in Philadelphia, until appointed in 1833 assistant assayer of the United States Mint; he published various articles on technological subjects relating to coinage and minting procedures and, later in life, on the archaeology of Indian remains. In 1873, his study of *Specimens of the Stone Age of the Human Race . . . Copied in Photography with Catalogue and Introduction* was published posthumously.[42]

Peale's daughters, all married, bore many children who scattered throughout the expanding country. Some of their children participated in the Civil War, while others entered various professions, from farming to dentistry, photography, engineering, business—and some, like Sophonisba's daughter Anna Sellers, became artists.

James Peale's daughters, except Anna Claypoole, remained unmarried, either by choice or for lack of opportunity. After the death of her first husband, the Reverend Doctor William Staughton (1770–1829), Anna had resumed painting, but a second marriage to General William Duncan (1772–1864) brought an end to her career, perhaps in response to social expectations. Maria and Margaretta remained at home to assist their aging parents, but Margaretta resumed painting during the late 1820s and thirties, occasionally exhibiting at the Pennsylvania Academy (see plate 111). Sarah Miriam seems to have made a conscious decision to pursue a career as a single woman. Moving to Saint Louis in 1846, she established a reputation there as a portraitist and still-life painter, exhibiting her work at regional fairs and winning first- and second-place medals. In 1877, she returned to Philadelphia where she spent her last years.

In 1846, economic stringencies forced the Philadelphia Museum into bankruptcy, and many of Peale's collections, which he had hoped to keep intact as a "world in miniature," were acquired by the ubiquitous Phineas T. Barnum and the Boston museum entrepreneur, Moses Kimball, at a sheriff's sale in 1848. In 1850, fire engulfed the Philadelphia building that housed Barnum's vast collections, and most of the specimens that Peale had so industriously accumulated were consumed by flames.

Eight years later, Peale's portrait gallery also was put on the block. The city of Philadelphia purchased a substantial group of his paintings—106 of them—and installed them in the now historicized Independence Hall (the old Statehouse) in a far-sighted move to preserve the images of America's worthies. Peale's portrait gallery is to a large extent reconstructed today in the city's Independence National Historical Park, a bureau managed by the Interior Department of the federal government—a result which would have pleased its founder.[43]

The Legacy

W HAT MAKES THE PEALES exceptionally interesting to us today is their firm commitment to national ideals, without chauvinism, and their sense of purpose and faith in the social utility of their activities. Peale's family picture, which clearly represents an American family with their simple clothing and furnishings and cheerful optimism, epitomizes these qualities. The idea of the painting, however, and the form it takes, reveal its origin in eighteenth-century British portraiture. Like so many artists in their time, the Peales learned from and accepted British and European cultural achievements and adapted these to American tastes and purposes.

Charles Willson Peale's eighteenth-century belief in the rational order and hierarchical structure of the universe was also a European import, emanating from his reading of such French philosophes as Jean-Jacques Rousseau and the Swedish naturalist Charles Linnaeus. Applied to society, these Enlightenment concepts provided the underpinnings of his republicanism. Republicanism confronted serious challenges by the second decade of the nineteenth century, when economic growth and social change erupted in democratic protest and religious and spiritual reform efforts. Peale, however, remained steadfast against the changing tastes and manners of Jacksonian America, even to the wearing of eighteenth-century knee breeches instead of nineteenth-century trousers.

Rembrandt Peale was more conflicted; dedicated to eighteenth-century principles, he was aware of the emerging democratic demands of his age. He carried his Enlightenment ideology into the Victorian era, maintaining a code of reason, restraint, social benevolence, and progress—but added to that mixture just enough sentiment and religious feeling to make him a participant in the Romantic age. The younger Peales, too, retained most of the artistic principles of their forebear, but their later art reveals a mixture of Peale's neoclassicism with nineteenth-century modes. The Peale legacy— a collection of artistic ideas and attitudes as well as paintings—illuminates the path the Peales traveled, from the Enlightenment to Victorianism—a path that in many respects parallels the direction of American thought and culture at the time.[44]

Portraits

Portraiture was the art form through which the Peales were introduced to the American public. It was the medium most congenial to American colonial requirements and most useful to members of the early Republic. In the late eighteenth and early nineteenth centuries, Americans could claim only a short national history, and, in any case, history paintings required more time and expense than an undeveloped society could encourage. Probably of most significance, however, in securing the place of the portrait in early American culture was the British preference for portraiture rather than landscape, genre, or still-life painting as pursued in the Netherlands, or history painting as practiced on the Continent. As a result, portraiture continued to dominate American art until the third decade of the nineteenth century, and portraits constituted the bulk of the Peale artistic achievement. However, as the function of portraiture changed during these years, so did styles and emphases; Charles Willson Peale's elaborate eighteenth-century grand-manner groups, replete with symbolic allegory and colorful detail, compare markedly with Rembrandt's simpler character studies painted with an eye to color, texture, and expression rather than story. In their most characteristic work, the two men present a contrast between the classical and the romantic approaches to portraiture.

Certainly, the most important influences on Charles Willson Peale and, through him, on other members of his painting family were the lessons he learned in England about art generally and the portrait in particular. English practices provided him with the necessary techniques he had to master: how to achieve perspective and provide the illusion of space and projection, render rich satins and laces to emphasize status and wealth, design fabric folds, formalize costumes, paint landscape or marine backgrounds appropriate to the sitter, pose his subjects fashionably, balance a composition, draw a clear outline with attention to strong chiaroscuro or patterns of light and shadow, and make symbolic use of accessories such as classical urns, gardens, statuary, books, flowers, and fruit (figure 14). From available books and discussions with London artists, Peale also absorbed the classical theory that dominated eighteenth-century British art, with its emphasis on idealism, naturalism, and rational order. He became aware of the hierarchy assigned to the various genres, the importance of history painting, the heightened social position of the artist, and the social and moral functions of art. The definition of painting as a liberal art akin to poetry ("ut pictura poesis") appealed to his literary tastes, which also responded to the idea that art's social usefulness lay in its capacity to teach a moral lesson, to elevate the mind, as Sir Joshua Reynolds urged in his "Sixth Discourse." In England, Peale learned more about the use of emblems to narrate a story or develop a theme than he did about the chemistry of pigments or the possibilities of brush strokes to achieve texture and fluidity, or evoke atmosphere. Once home, he had to acquire this kind of information empirically—like Reynolds—on an ad hoc basis through trial and error; and he had to rely on his eye rather than on theory when it came to the use of color to integrate the elements of a composition. What Peale learned is clearly illustrated in *The Peale Family,* which in subject and

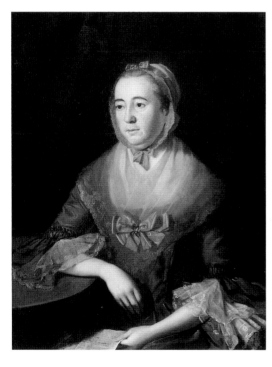

FIGURE 14
Charles Willson Peale
Anne Catherine Hoof (Mrs. Jonas) Greene, c. 1770
Oil on canvas, 36 ¼ x 28 in. (92.1 x 71.1 cm)
National Portrait Gallery, Smithsonian Institution,
Washington, D.C.; Museum purchase with funding
from the Smithsonian Collections Acquisition
Program and Gift from the Governor's Mansion
Foundation of Maryland, Mrs. Hilda Mae Snoops,
Executive Director

treatment encapsulates Peale's colonial aesthetic; indeed, its completion in 1809 may be regarded as marking the end of Peale's personal as well as artistic colonialism.[45]

The Self-Portrait as History: The Peale Family

The Peale Family (see plate 1) describes the happiness of members of a family in shared experiences. In the work, as we have noted, Peale communicates to his siblings the lessons he learned in England and his enthusiasm for the artistic profession which enabled him to rise both socially and economically. Fresh in his memory when he began the work were English conversation pieces, intimate and informal group portraits showing their subjects in habitual surroundings engaged in customary pursuits. Such full-length portraits, frequently in miniature, traditionally conveyed images of privilege, family background, and class; their popularity resulted from the "cult of family" and pride in genealogy observed by the British aristocracy, provincial gentry, and merchants that also formed the basis for the Chesapeake planter's emphasis on family as an important social and economic entity.[46]

Along with celebration of family or group harmony, conversation pieces offered the artist an opportunity to exhibit technical skills and, especially, his connoisseurship or scholarly learning and capacity to employ appropriate precedents in either art or literature as a comment on the sitters' relationship, social position, or political values. For instance, in *Benjamin and Eleanor Ridgely Laming* (plate 18), Peale demonstrated his familiarity with sixteenth-century literature by having the couple enact the love story of Rinaldo and Armida from the long epic poem of the Italian Tarquato Tasso (1544–1595). In *The John Cadwalader Family* (see plate 64), he called attention to the Cadwaladers' privileged socioeconomic status with details of dress, jewelry, posture, and fruit. The clasped hands of the old couple in *Mr. and Mrs. James Gittings and Granddaughter* (figure 15), Mrs. Gittings's protective arm around her granddaughter, the prosperous farm, the ground squirrel, and the plants reflect Peale's republican belief in the importance of posterity, the virtues of a life lived close to the soil, and the relation of work to nature. And in *The Edward Lloyd Family* (see figure 1.2), Peale emphasized the power of music in cementing family relationships or creating the harmony necessary for those relationships, or the harmony of the domestic relationship itself.[47]

As a portrayal of a family in an informal moment enjoying a respectable pastime, *The Peale Family* meets the definition of a conversation piece; it functions, too, as a history painting that celebrates Peale's family. And it is also a self-portrait that asserts the intellectual dignity of Peale's artistic calling and his role as the family educator.

When Peale left Annapolis to travel to London, he identified himself, as did many of his Maryland neighbors, as an artisan; art, as John Singleton Copley complained, regarding its reception in Boston, was considered by the colonists as simply another craft, like shoemaking. Peale's ambiguous class position, as the son of a low-paid schoolmaster and a man forced by economic circumstances to work at mechanical occupations, probably caused him some

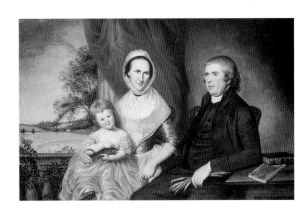

FIGURE 15
Charles Willson Peale
Mr. and Mrs. James Gittings and Granddaughter, 1791
Oil on canvas, 40 x 64 in. (101.6 x 162.5 cm)
The Peale Museum; Baltimore City Life Museums

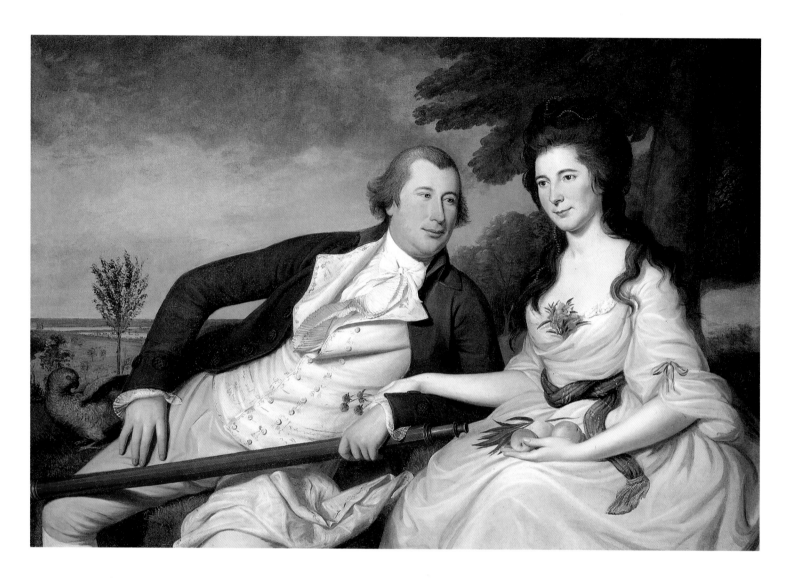

PLATE 18
Charles Willson Peale
Benjamin and Eleanor Ridgely Laming, 1788
Oil on canvas, 42 x 60 ¼ in. (106.7 x 153 cm)
National Gallery of Art, Washington, D.C.;
Gift of Morris Shapiro

discomfort, especially when he found himself in the society of his wife's wealthier and socially established relatives. In England, however, Peale discovered that his artistic occupation elevated him above the social level of artisan or mere mechanic. In England, the artist's status was more exalted, due partly at least to the efforts of the artists Peale most admired—William Hogarth, Benjamin West, and Sir Joshua Reynolds—men who labored to raise their profession in the public eye to the genteel position among the liberal arts it had occupied in earlier times. Their self-portraits asserted their identity with artistic scholarship and the great artists of the past, and proclaimed the genius that was responsible for their rise to fame and fortune.[48] Peale returned to America more confident in his social position and eager to claim social recognition. Aware of the function served by the self-portrait and the family portrait in establishing social status, he also learned the means by which these kinds of portraits proclaimed their message. There are compositional details in the self-portraits of West, Reynolds, and Hogarth that appear in *The Peale Family* and testify to Peale's familiarity with these artists' practice. The use of the sculptured bust is one example—Michelangelo's in Reynolds's *Self-Portrait* of 1773 (Royal Academy, London), identifying the artist with the great Renaissance master; the cast of the Belvedere Torso in West's *Self-Portrait* of 1792 (Royal Academy, London), signaling that he was a connoisseur of classical art; and the profile bust of George III, West's patron, in his 1793 *Self-Portrait* for the Society of the Dilettanti in London.[49]

The similarity between Peale's family group and West's *Self-Portrait with the Artist's Family* (figure 16) is especially striking. In his family painting, West narrates his rise from the plain environment of his Pennsylvania relatives, who are distinguished by their Quaker clothing, to a position of wealth and prominence as a result of his artistic success, visualized by his and his wife's elaborate dress.[50] Peale's siblings and mother convey their family history also, while Peale's wife, Rachel, seated in the center of the canvas like Mrs. West, presents her child as an emblem of the family's continuing prosperity. Peale himself flanks the group on both sides: on the left, self-effacing, he leans over his brother as the family teacher, his palette, like West's, testifying to his role as visual historian; on the right, his profiled bust placed between those of his mentor Benjamin West and his patron Edmund Jenings establishes him as the group's intellectual and spiritual father. The classical busts that identify him with the great artists of antiquity serve essentially the same purpose as those in Reynolds's and West's self-portraits.

Stylistically, *The Peale Family* demonstrates some of the lessons Peale learned in England. Peale shows his brother the "Line of Beauty"—the serpentine line that William Hogarth recommended in his *Analysis of Beauty* (1753) as the basis of all beauty in nature and in art.[51] The three graces drawn on the easel, the artist's homage to Raphael, not only declare Peale's knowledge of the old masters, but manifest the balance and harmony that mark Peale's definition of both the family and the beautiful. The smiling faces of his sitters reflect the advice of the early eighteenth-century aesthetic philosopher, Jonathan Richardson, that "A Painter ought to have a Sweet, Happy, turn of Mind, that Great and Lovely Ideas may have a reception there."[52] The bowl of oranges or lemons on the table—exotic and expensive

fruits—describes the family's economic status as prosperous, while asserting symbolically, along with the babies, the fertility—and therefore continuity—of the family. Together with the peel—the family's signature image—the fruit also demonstrates Peale's skill at painting still life. The dog, which Peale added later, is a traditional symbol of family loyalty, and the children represent the family's posterity. These elements connect the artist's individual accomplishments with the family's future in an idyllic vision of harmony created by the jointure of art and nature.[53]

None of Peale's children essayed such complicated works. His brother James, however, absorbed the lessons of Peale's London studies in his full-length but delicately miniaturized portrait of himself with his family (see plate 94). James took his conversation group out of doors and integrated its members into their natural surroundings, thus stamping the work with his own special affinity for landscape as well as picturing members of his family with their individual characteristics and with pleasant humor. If he were at all aware that self-portraits conveyed an ideological message, he may have thus pictured himself and his family in order to attribute the development of his artistic genius to both his family and nature, for it was soon after his marriage in 1782 to Mary Claypoole, daughter of the painter James Claypoole (1720–c. 1796), that he began to emerge as a serious independent artist rather than simply an assistant in his brother's studio.[54]

Rembrandt attempted self-portraits at various times in his career, but in these his motivation differed from his father's eighteenth-century conceptually driven effort. Beginning with his 1791 *Self-Portrait,* painted at age thirteen (see figure 8), and continuing into old age, Rembrandt used the self-portrait as a way of experimenting pictorially rather than establishing status or telling a story. His 1791 *Self-Portrait* was a trial in portraiture generally; he took himself as a model, as he later wrote, so that he "could blunder unseen and not fatigue the sitter sooner than the painter."[55] Straightforward and serious, it was a harbinger of his mature artistic method. Borrowing compositional suggestions—pose, lighting, shading—from established portraitists Joseph Wright (1756–1793) and his father, Rembrandt added lively bright colors, revealing at this early age his sensitivity to the dramatic possibilities of pigment. Red, black, and white, set off by masses of light and shade, for instance, contribute to the drama of his *Self-Portrait by Candlelight* (c. 1793; Wadsworth Athenaeum, Hartford, Connecticut); light and shadow, again, become the interesting components of his 1828 attempt, which he painted for his wife before leaving for Italy (figure 17). His 1856 *Self-Portrait* (see plate 74) is a highly private image, portraying the artist as thinker and poet, a man engaged in an intense scrutiny of his interior world. In its private nature, it summarizes Rembrandt's more complicated Victorian world and stands as contrast to the open and inviting republican image of Charles Willson Peale's later self-portrait *The Artist in His Museum* (see figure 10.2, plate 133).[56]

The remarkable difference between Rembrandt's motivation and his father's in painting self-portraits points up other changes that occurred between the two generations. Like his father, Rembrandt aspired to fame as an American old master. Although he experienced frustration with his society's unwillingness or incapacity to grant him the recognition he sought,

FIGURE 17
Rembrandt Peale
Self-Portrait, 1828
Oil on canvas, 19 x 14 ½ in. (48.3 x 36.8 cm)
Detroit Institute of Arts; Founders' Society Purchase, Dexter M. Ferry, Jr. Fund

he never entertained doubts about his social status in Philadelphia society comparable to those his father experienced upon returning from England to the structured society of Annapolis, nor did he feel the necessity to prove the social worth of his calling. His extended family of Brewers and Peales, together with his father's many prominent clients and acquaintances, provided him with a sense of security and identity—at times what appeared to be social arrogance—and his early artistic successes proved his talent. By the mid-nineteenth century, artists were no longer regarded as mere craftsmen; if not well patronized, they nevertheless were admired as valuable members of society. The nineteenth century, in fact, sentimentalized artistic genius and elevated the artist to a special social position that suited Rembrandt's heroic conception of himself, transforming the struggle for economic security into a courageous effort to spiritualize a materialistic community.[57] Until his death, Rembrandt played the artist's role, especially during his last years, when his flowing black cape and equally flowing white hair singled him out as a particularly romantic figure.

Raphaelle, as far as we know, never painted a self-portrait.[58] Titian painted a self-portrait later in his career, sometime around 1850, perhaps with the help of Rembrandt (American Museum of Natural History, New York). A preparatory sketch (see plate 90) presents the middle-aged Titian amiably, with a benign but lively gaze and slight smile, a man who seems to have thoroughly incorporated his father's earlier admonition "to keep an even temper of mind" and "never to return an injury."[59]

The daughters of James Peale experimented with the genre at various times. Both Anna Claypoole and Sarah Miriam painted fairly traditional self-portraits around 1818, which seem to be primarily practice efforts (the former is unlocated, but a photograph exists in the Peale-Sellers collection, American Philosophical Society, Philadelphia; for the latter, see plate 118). Confronting a public that may have considered them unwomanly for following public careers, they depicted themselves in an acceptable mode of genteel respectability. Both self-portraits reveal a feminine sensibility; especially charming is Sarah Miriam's flirtatious image of herself, suggesting her playful humor. Later, in 1830, Sarah painted herself more seriously as befitted an artist who had more than a decade of distinguished professional life behind her (see figure 8.8).

Family Portraits

In his lectures, Sir Joshua Reynolds had emphasized the necessity for the portraitist to convey ideas,[60] and throughout his career Peale remained convinced that great art was a product of the mind and could influence moral behavior and promote the political and social values of a community through the strength of its imagery. Republicanism not only provided a political ideology susceptible to classical illustration, but in its civic formulation, and especially in its emphasis on the importance of the family in the moral education of children and transfer of values from one generation to the next, it provided Peale with the larger rationale he required to justify his vocation.

His paintings of the 1780s and 1790s are replete with details depicting republican abstractions. For instance, by including legal papers and books, and a courthouse or statehouse crowned by a statue of Justice, Peale presents Governor Thomas McKean—at the time a forceful proponent of both the federal Constitution of 1787 and a revised, more conservative, state constitution—as both the bulwark of republican law and order and good government and a responsible parent. Portrayed with his son, Thomas McKean, Jr., McKean becomes a father figure as well as political leader, passing on to his own (and the state's) posterity the principles of federalism and republicanism, guarantors of justice and progressive policy (plate 19).

Just as Thomas, Jr., is included as a symbol of the future, so Peale pictured children, not only as charming little adults, but as their family's posterity, to whom the community's well-being was entrusted. Portraits of siblings (plate 20), parents and children (plate 21), grandparents and grandchildren (plate 22), and husbands and wives (see plate 18) express visually such central tenets of civic republicanism as the mutual respect and affection family members owe each other, their obligations to each other and to the maintenance of harmony and order, and the responsibility of one generation for the next.

PLATE 19
Charles Willson Peale
Governor Thomas McKean and His Son, Thomas, Jr., 1787
Oil on canvas, 50 ⅝ x 41 ⅛ in. (128.6 x 104.5 cm)
Philadelphia Museum of Art; Bequest of Phebe Warren McKean Downs

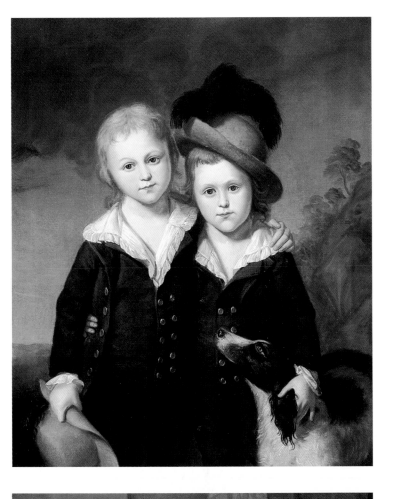

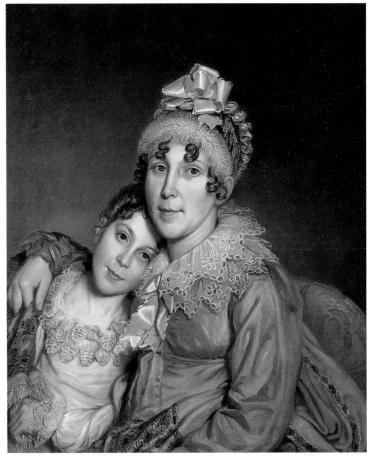

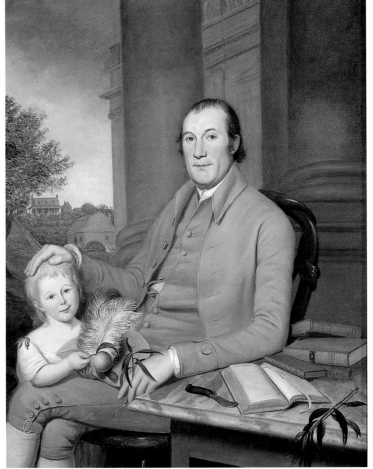

PLATE 20
Charles Willson Peale
Thomas and Henry Sergeant, c. 1787
Oil on canvas, 35 ½ x 29 in. (90.2 x 73.7 cm)
Lent by Jay Pierrepont Moffat,
Courtesy Museum of Fine Arts, Boston

PLATE 21
Charles Willson Peale
*Mother Caressing her Convalescent Daughter
(Angelica Peale [Mrs. Alexander] Robinson
and her Daughter Charlotte)*, 1818
Oil on canvas, 30 x 24 ⅞ in. (76.2 x 63.2 cm)
Private collection

PLATE 22
Charles Willson Peale
William Smith and His Grandson, 1788
Oil on canvas, 51 ¼ x 40 ⅜ in. (130.2 x 102.6 cm)
Virginia Museum of Fine Arts, Richmond; Museum
Purchase with Funds provided by The Robert G.
Cabell III and Maude Morgan Cabell Foundation,
and The Arthur and Margaret Glasgow Fund

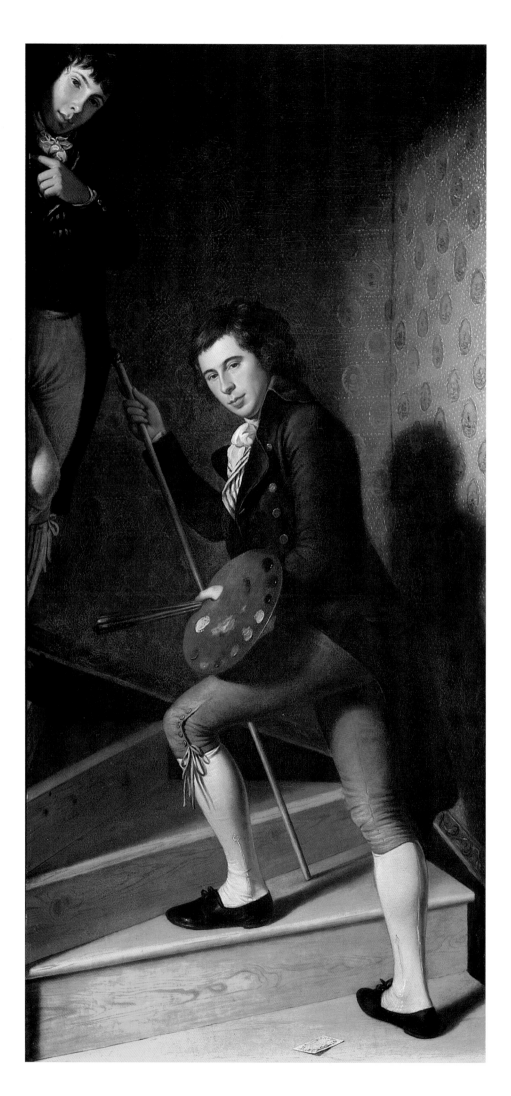

PLATE 23
Charles Willson Peale
"The Staircase Group": Raphaelle and Titian Ramsay Peale, 1795
Oil on canvas, 69 x 39 ½ in. (175.3 x 100.3 cm)
Philadelphia Museum of Art; The George
W. Elkins Collection

Peale's portraits of members of his own family, although affectionate, are more prescriptive. A double portrait of Raphaelle and the first Titian Ramsay (plate 23) is an illustrated lecture that the road to artistic success is an upward climb, involving effort. The sunrise in his portrait of Rembrandt (figure 18) symbolizes his expectation of the young artist's eventual success, while the shining gold star on the collar of Titian Ramsay's elegant uniform in his portrait of the young assistant naturalist on Major Long's exploring expedition (see plate 86) expresses Peale's hope that the expedition will mark the beginning of a promising career. By picturing his children's goals, as he defined these, Peale was, in effect, telling his sons visually what he expected of them. He was never reluctant to do this; his duty toward his offspring was clear: to "give to [his] Children . . . good advice," and "to lead those dependant on me, never to drive them."[61]

Charles Willson Peale was the most explicit of the family artists in painting such messages into his work; his lessons, however, were not lost on his brother or children. In the informal composition and depiction of gestures in the *Ramsay-Polk Family* (figure 19), James Peale demonstrated his understanding of the British conversation group tradition learned in his brother's studio. He also showed the influence of his brother's style in his elegant presentations of Mr. and Mrs. Hebberton (see plates 24, 25); in the charming miniature of little Mary Mitchell (figure 20), however, we find a romantic element that does not characterize Charles Willson's work.

Rembrandt Peale was his father's best pupil. In Charles Willson's studio, he learned the importance of good draftsmanship and chiaroscuro, the possibilities of rich colors, the "management of light," and the necessity to achieve close likeness in portraiture along with expression of character. His father's insistence that portraits be addressed to the sober mind and not to "wild imagination" and that they mirror "the forms, the colours, and the finish of Nature" surely influenced his *Rubens Peale with a Geranium* (see plate 16), a painting completed in 1801 just before he and Rubens left for London.[62] Rembrandt's affectionate study of his younger brother is full of ideological

FIGURE 18
Charles Willson Peale
Rembrandt Peale, 1805–18
Oil on canvas, 27 x 20 7/8 in. (68.6 x 53 cm)
National Portrait Gallery, Smithsonian Institution, Washington, D.C.; Gift of Donald Hamilton Workman in memory of his father James Clark Workman and his grandfather, James Henry Workman

FIGURE 19
James Peale
Ramsay-Polk Family
Oil on canvas
Private collection

FIGURE 20
James Peale
Mary Mitchell, 1798
Watercolor on ivory, 3 3/16 x 2 9/16 in. (7.6 x 6.4 cm)
Cincinnati Art Museum; Charles Fleischmann Collection

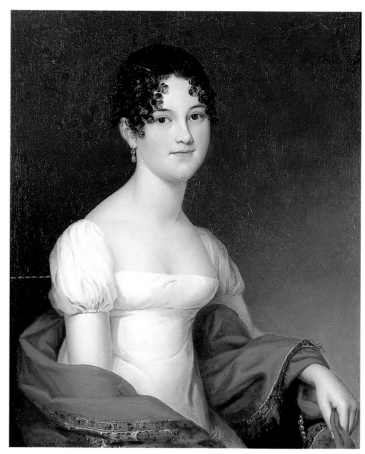

PLATE 24
James Peale
William Young Heberton, 1816
Oil on canvas, 29 ½ x 24 ½ in. (74.9 x 62.2 cm)
Private collection

PLATE 25
James Peale
Anna Sophia Alexander Robertson (Mrs. William Heberton), 1816
Oil on canvas, 29 ½ x 24 ½ in. (74.9 x 62.2 cm)
Private collection

content as well as natural symbolism, designed to celebrate Rubens's botanical skills and, in a larger way, call to the attention of skeptical Europeans the health and richness of American flora and, by inference, the American land—just the mixture of nationalism, nature, and artistic narrative in which the elder Peale delighted.[63]

Rembrandt's English experiences confirmed his father's aesthetic principles. The British influence on his compositional arrangements is clear: in the portrait of his wife Eleanor as muse (figure 21), he has clearly based Eleanor's pose on works by Angelica Kauffmann or Sir Joshua Reynolds,[64] while he was surely influenced in painting the portrait of Sir Joseph Banks (figure 22) by the painting technique of such British portraitists as Thomas Lawrence or Thomas Gainsborough.

Rembrandt painted few double or group portraits. Either commissions for such works were lacking or he was unsuccessful in composing them. All the more surprising, therefore, is the handsome double portrait of *Alida Livingston (Mrs. John) Armstrong and Daughter* (plate 26), the wife and child of the American ambassador to France, John Armstrong, whose portrait Rembrandt also painted in Paris about 1810 (Independence National Historical Park Collection, Philadelphia). The affectionate relationship between mother and daughter suggests Charles Willson Peale's influence.[65]

Raphaelle's portrait of *Rubens Peale as Mascot* (see plate 27) reflects his father's conception of the portrait as narrative. The painting marks an episode in Raphaelle's young brother's life. The crack outfit of "McPherson's Blues," in which Raphaelle was an officer, was on its way to the western counties of Pennsylvania to subdue the insurrection that had risen to protest the tax on

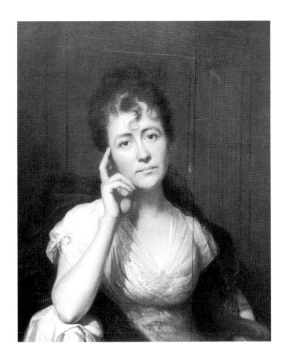

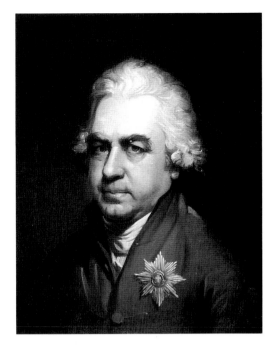

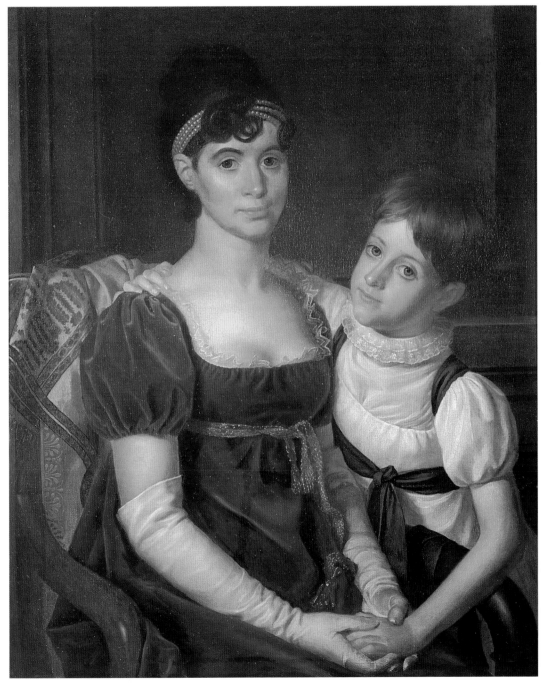

FIGURE 21
Rembrandt Peale
Eleanor May Short (Mrs. Rembrandt)
Peale as Muse, 1803–05
Oil on panel, 28 ¼ x 25 ⅛ in.
(71.8 x 59.4 cm)
Private collection

FIGURE 22
Rembrandt Peale
Joseph Banks, 1803
Oil on canvas, 23 ½ x 19 ½ in.
(59.7 x 49.5 cm)
Library, The Academy of Natural
Sciences of Philadelphia;
Gift of Joseph Harrison, Jr., 1855

PLATE 26
Rembrandt Peale
Alida Livingston (Mrs. John)
Armstrong and Daughter, c. 1810.
Oil on canvas, 31 ½ x 25 in.
(80 x 63.5 cm)
Neville-Strass Collection

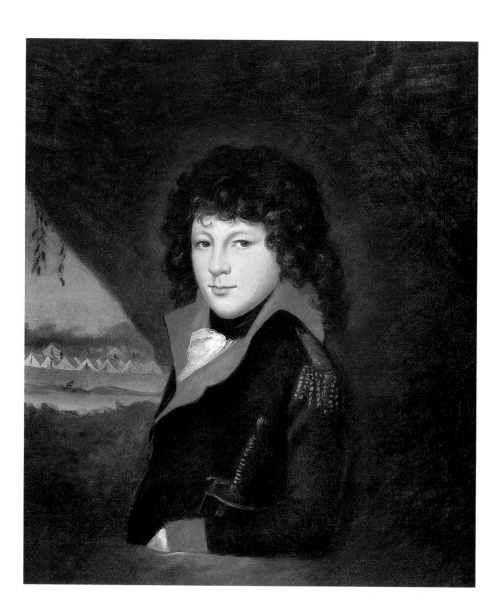

PLATE 27
Raphaelle Peale
Rubens Peale as Mascot, 1795
Oil on canvas, 26 x 22 in. (66 x 55.9 cm)
Private collection

whiskey. In its threat of anarchy, the Whiskey Rebellion created anxiety even among the Republican Peales, along with a temporary military excitement. Ten-year-old Rubens, who caught the martial fever and enjoyed playing soldier, had accompanied Raphaelle to camp as mascot. Pictured in a regimental uniform, with the soldiers' white tents lined up behind the mass of trees that serve as a curtain in a traditional composition, the young boy smiles shyly as he hugs his sword to his side.

Portraits of Friends and Neighbors

By the second decade of the nineteenth century, the idea of the portrait as narrative or the equivalent to poetry was weakening, if not entirely disappearing. The format of Charles Willson Peale's early portraits, full of emblematic details and background landscapes, was outdated by the 1820s, as was Raphaelle's in his affectionate study of his younger brother. The test of the great portrait now resided in its revelation of character more than in its narrative capability; the use of symbols was disparaged along with allegory. Background scenery gave way to simple dark paint, brownish or black, with emphasis on light. Raphaelle reflected the change in taste in 1821 or 1822 with his melancholy *Osborne Sprigg* (plate 28), where the sitter is pictured

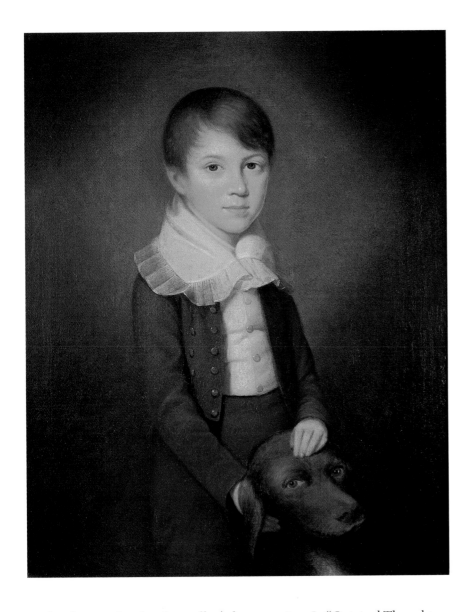

PLATE 28
Raphaelle Peale
Osborne Sprigg, 1820
Oil on canvas, 30 ¼ x 24 ½ in. (76.8 x 62.2 cm)
Maryland Historical Society, Baltimore

with a dog as a loyal and equally sad companion. In "Original Thoughts on Allegorical Painting" (1820), Rembrandt rejected the use of what he called "arbitrary emblems." Programming the *Court of Death* (see figure 4.1) two years later, he determined to tell his story through gesture and expression rather than through classical emblems, which he believed favored an elite audience—the kind that the eighteenth-century theorists had hoped to draw to portraiture in order to elevate it as an art form. Rembrandt's generation of artists, on the other hand, aimed for an audience of "the unlearned and the learned" in keeping with the democratization characteristic of Jacksonian America.[66] "Just expression" and significant movement that rendered a painting immediately intelligible required no recourse to a classical education.[67]

Although he wrote poetry and considered himself an essayist of some merit, Rembrandt was primarily an artist immersed in his craft. He displayed his imagination in color relationships, composition, and expression rather than detailed symbolic signification. He separated the arts of literature and painting, whereas his father attempted to unite them. Much of this change in his artistic practice resulted from his residence in Paris between 1808 and 1810 where he immersed himself in "the works of the best French Artists, and . . . the Masterpieces of Rubens, Raphael, Titian, Vandyke, Corregio, Paul Veronese & c."[68] He particularly was influenced by the work of Jacques-Louis David (1748–1825), France's foremost portraitist and history painter, who in 1808

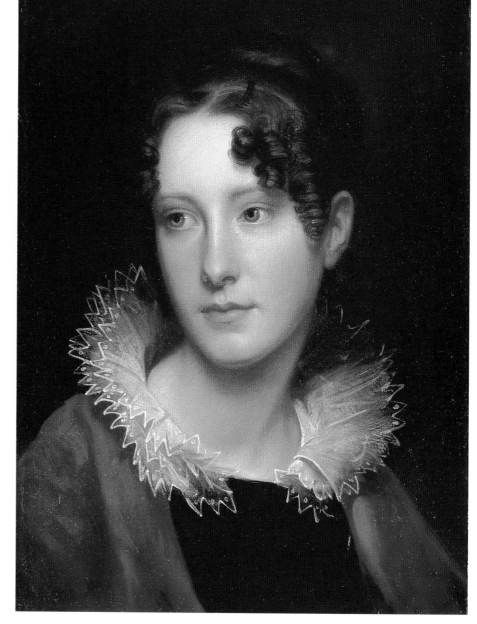

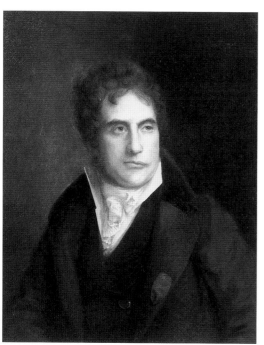

FIGURE 23
Rembrandt Peale
Jacques-Louis David, 1808
Oil on canvas, 28 ½ x 23 in. (72.4 x 58.4 cm)
Courtesy of the Museum of American Art of
The Pennsylvania Academy of the Fine Arts,
Philadelphia, General Fund

PLATE 29
Rembrandt Peale
Portrait of Rosalba Peale, c. 1820
Oil on canvas, 20 x 14 ⅝ in. (50.8 x 37.1 cm)
National Museum of American Art, Smithsonian
Institution, Washington, D.C.

PLATE 30
Rembrandt Peale
*Boy from the Taylor Family (George Taylor, Jr.?
of Philadelphia),* c. 1812.
Oil on canvas, 57 ⅛ x 36 ¼ in. (145.1 x 92.1 cm)
The Brooklyn Museum, New York; Gift of the
Estate of Eliza Herriman Griffith

was at the "height of his artistic career" (figure 23).[69] David's naturalism, emphasis on character and lively expression, high finish and careful drawing of details were qualities that had been urged also by Charles Willson Peale, but beyond these, David's capacity to render three-dimensional form as a result of his study of classical sculpture proved most important in Rembrandt's development. From the French master, Rembrandt learned how to project forms in space, convey the anatomical structure of the head, and create highly individualized portraits based on close examination of the character and psychology of his sitters. By emphasizing the pictorial elements in portraits over narrative, Rembrandt moved his work out of the British eighteenth-century tradition and into a more contemporary idiom.

Rembrandt also had the opportunity in Paris to study Rubens's gorgeous, often flamboyant, colors and Van Dyck's mellow, harmonious tones, and he was stimulated to develop his own coloristic schemes—he particularly liked the combination of red, black, and crisp white (plates 29, 30). He experimented with pigments in order to achieve richness as well as a range of values, and

PLATE 31
Rembrandt Peale
Michael Angelo and Emma Clara Peale, c. 1826
Oil on canvas, 30 x 25 in. (76.2 x 63.5 cm)
Richard York Gallery, New York

also learned how to incorporate color in light so as to pick up warm flesh tones and create a unified image. Later, after studying the Baroque masters, Rembrandt began to paint bright oranges and reds side by side, and to emphasize textures, like satin against velvet, in paintings that spoke primarily of art rather than story (plate 31).

On the other hand, Raphaelle continued to paint portraits that show the early influence of his father. Without the benefit of foreign travel and stimulation, his approach to portraiture remained rooted in the eighteenth century until toward the end of his life, when he made a valiant effort to follow Rembrandt's lessons as conveyed by his father. Raphaelle's more usual composition featured a seated figure leaning on a table on which rested associative accessories such as a bible or book, against a background of draped curtain and/or window opened to reveal a general landscape (see figure 9). Both his father and Rembrandt had discarded such a format earlier; after 1815, when picturing their sitters indoors, Charles Willson and Rembrandt (with a few exceptions, such as plates 32, 33) concentrated on the head, emphasizing expression and character in response to physiognomic theories, and also probably in response to their sitters' desire for less expensive bust portraits that were accurate likenesses. Nineteenth-century patrons sought portraits that would convey status through force of character, rather than aristocratic position.[70] In commissions requiring a landscape background, Charles Willson and Rembrandt tended to integrate the figure into the landscape rather than separate it from the environment by a window or a curtain, as in the earlier tradition. They also became concerned with the play of shadow and light on the face and depended heavily on chiaroscuro to model features and suggest skin folds, fleshiness, and wrinkles (see plates 34, 35; figures 24, 25).

PLATE 32
Rembrandt Peale
Jacob Gerard Koch, c. 1817
Oil on canvas, 34 x 29 in. (86.4 x 73.7 cm)
Los Angeles County Museum of Art; Museum purchase with funds provided by Mr. and Mrs. William Preston Harrison Collection, Mary D. Keeler Bequest, and Dr. Dorothea Moore

PLATE 33
Rembrandt Peale
Jane Griffith (Mrs. Jacob Gerard) Koch, c. 1817
Oil on canvas, 34 x 29 in. (86.4 x 73.7 cm)
Los Angeles County Museum of Art; Museum purchase with funds provided by Mr. and Mrs. William Preston Harrison Collection, Mary D. Keeler Bequest, and Dr. Dorothea Moore

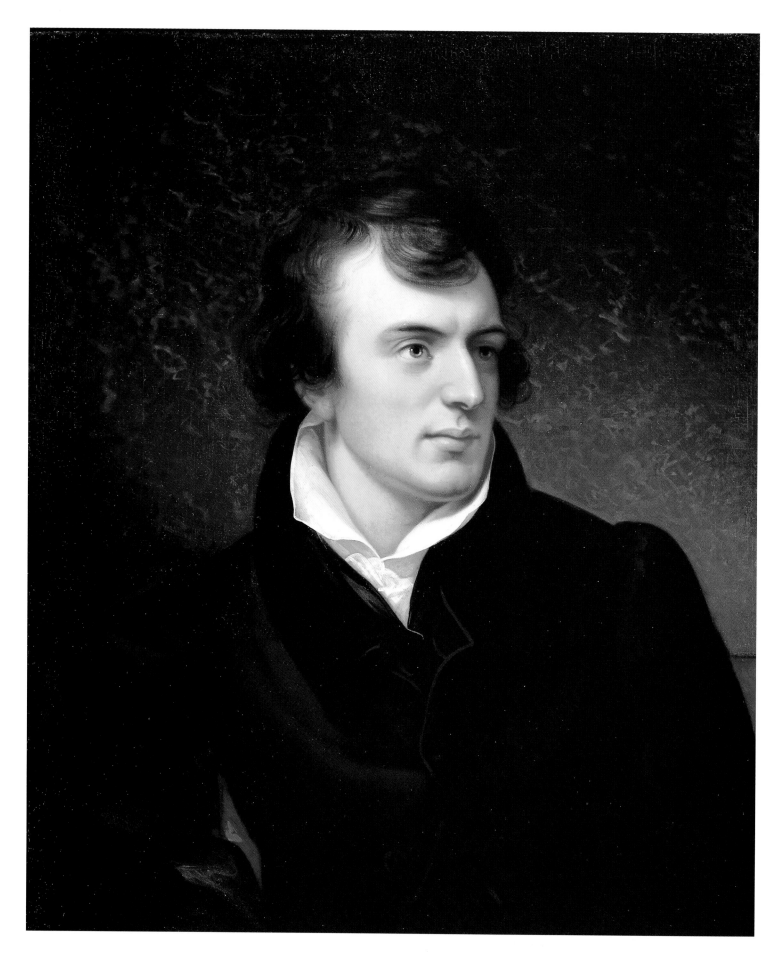

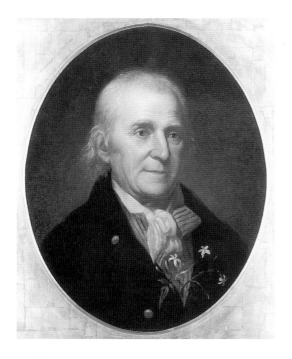

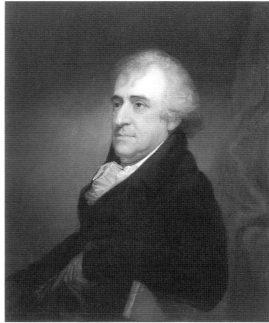

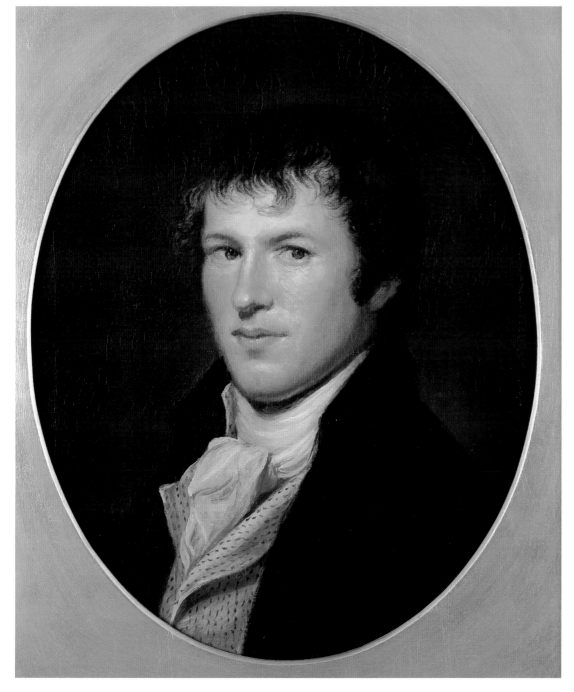

FIGURE 24
Charles Willson Peale
William Bartram, 1808
Oil on canvas, 23 x 19 in.
(58.4 x 48.3 cm)
Courtesy, Independence National
Historical Park Collection

FIGURE 25
Rembrandt Peale
Judge Moses Levy, 1808
Oil on canvas, 29 ½ x 24 ½ in.
(74.9 x 62.2 cm)
Collection of the Montclair Art
Museum. Museum purchase
Unappropriated Surplus Funds,
60.20

PLATE 35
Charles Willson Peale
*Friedrich Heinrich Baron von
Humboldt*, 1805
Oil on canvas, 23 ½ x 19 in.
(59.6 x 48.2 cm)
The College of Physicians of
Philadelphia

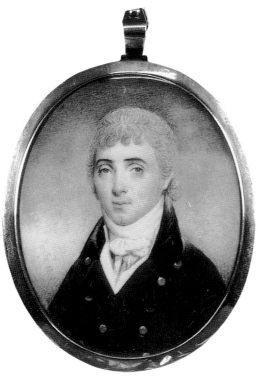

FIGURE 26
Raphaelle Peale
Andrew Ellicott, Jr., 1801
Watercolor on ivory, 2 ¾ x 2 ³⁄₁₆ in. (6 x 5.5 cm)
Museum of Fine Arts, Boston; Ellen Kelleran
Gardner Fund 1964

PLATE 36
Raphaelle Peale, after Charles Willson Peale
Henry Moore, 1809
Watercolor on ivory, 2 ¼ x 1 ¹³⁄₁₆ in. (5.7 x 4.5 cm)
White Taylor Walker Collection

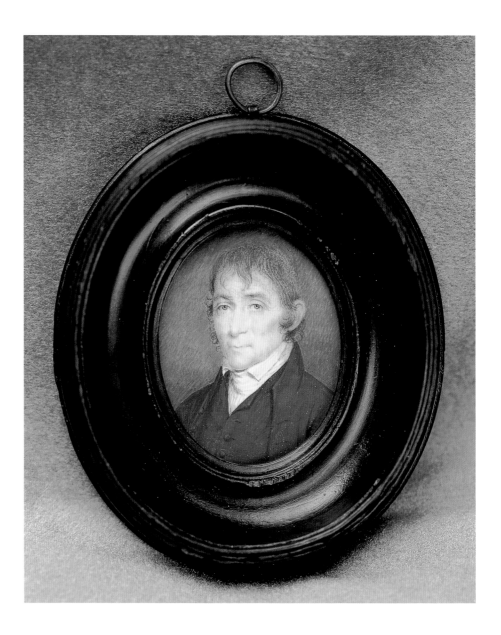

Raphaelle's portraits remained linear, two-dimensional, and fully illu-
minated, with hardly any shadows, except when he tried to adopt Rembrandt's
techniques for applying pigments and glazes and to incorporate light and
shade, as his father directed, as in *Osborne Sprigg* (see plate 28). Yet Raphaelle's
best portraits have the charm of his miniatures (plate 36; figure 26). Their
delicate color, finely drawn line, loose or free brushstrokes, full light, and
pleasant—although slightly melancholic—expression recall the miniatures of
the Elizabethan limners. Perhaps the old-fashioned format that characterized
both his still lifes and miniatures provided a stabilizing element in Raphaelle's
troubled life, or perhaps he found it too difficult, intellectually and psycho-
logically, to change a technique he had mastered when a young man.

The daughters of James Peale learned their art from their father, with
some influences emanating from their uncle's work. Anna Claypoole Peale's
miniatures were more ambitious than Raphaelle's in their inclusion of sky and
cloud backgrounds and greater emphasis on light and shadow (plate 37).[71]
The portraits Sarah Miriam painted in Baltimore and Philadelphia are more
linear, although Sarah made what appears to be a conscious effort to create
projection through shading. Her portraits partake of the two traditions,
perhaps depending on the specific commission. Occasionally, she included

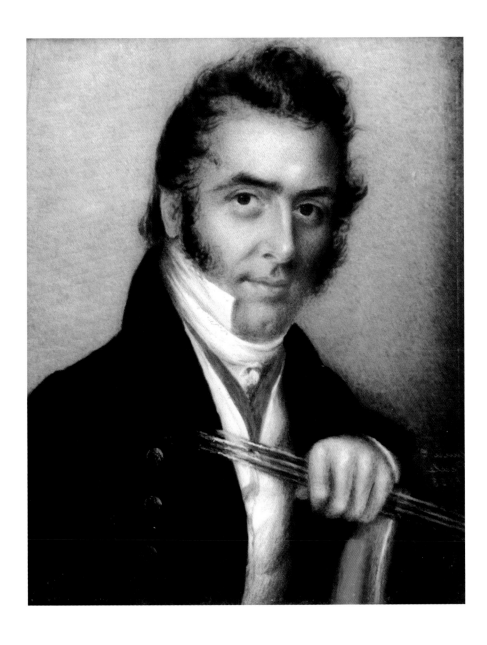

PLATE 37
Anna Claypoole Peale
Rembrandt Peale, 1823
Watercolor on ivory, 2 ⅞ x 2 ¼ in. (7.3 x 5.7 cm)
The R. W. Norton Gallery, Shreveport, Louisiana

columns, landscape, and draped curtains in portraits that suggest the grand
manner of her uncle Charles Willson's early work (see plate 122); at other
times her portraits seem modeled on her cousin Rembrandt's nineteenth-
century approach—simple, bust-sized images that emphasize character rather
than narrate a story (see figure 8.9). Her portraits of women for the most
part demonstrate her sensitivity not only to feminine beauty, but also to the
accoutrements used to enhance that beauty: elaborate hairdos, smiling eyes,
fancy shawls, bared shoulders, richly textured garments, and frontal gazes
in which the sitters unabashedly confront the viewer (see plate 38).

Figures in the Public Eye: The Portrait as History Painting

Unable to devote time and effort to large and expensive history paintings
while seeking portrait commissions or, later, managing his museum, Peale
reconciled himself to making his portraits serve the cause of history.[72]
Early in his artistic career, he had shaped his art to meet the most demanding
public and social issues of the day. In such allegorical works as *William Pitt*
(1768; Westmoreland County Museum of Art, Virginia) and *John Beale*

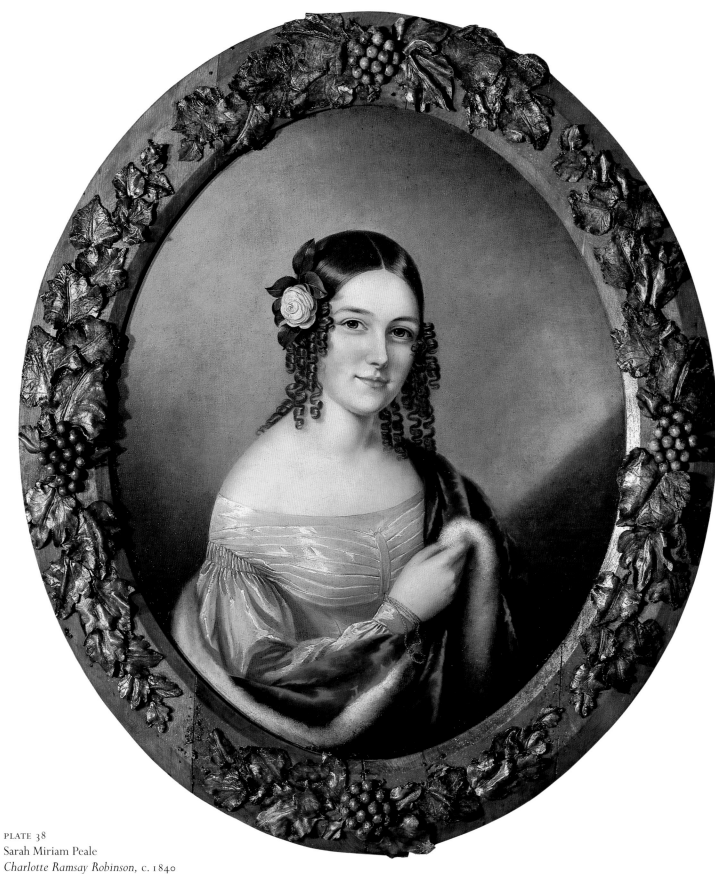

PLATE 38
Sarah Miriam Peale
Charlotte Ramsay Robinson, c. 1840
Oil on canvas, 38 x 26 in. (96.5 x 66 cm)
The Peale Museum, Baltimore City Life Museums

Bordley (figure 27), he defended Americans' resistance to British imperial policies based on British legal tradition.[73] Colorful presentations of Revolutionary war heroes such as General Joseph Bloomfield (see plate 39) reveal the persistent influence of British heroic portraiture through the decade of the 1770s. Once American independence was established and republican ideology expanded to meet the new nation's civic needs, however, his art responded to republican principles. Especially from 1781 on, Peale's portraits of military heroes, legislators, statesmen, writers, and philosophers—"worthies of the revolution"— were designed not as grandiose presentations of military heroism, but as lessons in social and personal morality. Bust-size gallery portraits— neatly labeled with biographical and historical data—through their images alone told the story of America's fight for independence and efforts to establish a new nation. Highly individualized—despite Peale's tendency to stylize facial shapes and eyes—these portraits reveal their sitters' physical flaws as well as their personal virtues.[74] Peale did not disguise John Hazlewood's warts (see figure 28) or Richard Henry Lee's scar (1795–1805; Independence National Historical Park Collection, Philadelphia; replica, National Portrait Gallery, Washington, D.C.). Even in such idealizations as the 1795 *George Washington* (see figure 4.11) or *Thomas Jefferson* (see plate 40), both of whom Peale presents classically, with their gaze fastened on a distant vision, the sitters appear as strong individuals. Compare, for instance, Gilbert Stuart's iconic Athenaeum *Washington* (see figure 29) or his sweet *Jefferson* (see figure 30) with Peale's vigorous images.

Republicanism prescribed a portrait style. Simple, almost severe neoclassical images reminiscent of Roman medals, Peale's gallery portraits expressed the essential moral and intellectual qualities demanded by a self-governing community.[75] Presented without adornment or background, and with emphasis on the head, physical features, and benevolent expression, the images convey character as Peale interpreted it, based on his increasing familiarity with the scientific literature of his day, especially the writings on physiognomy of theorists Johann Kaspar Lavater and James Beattie.[76] Although Peale had always demonstrated what he called "a good eye" for details or natural facts, under these writers' influence he advanced beyond observation to hypothesizing about the characterological significance of head shapes and expression, hypotheses that infused his portraits.

Peale's series of portraits of George Washington that resulted from the 1779 commission of the Pennsylvania Supreme Executive Council (see figure 31) illustrate how the artist made the portrait serve historical purposes. In the original work, designed to honor Washington for his defense of Philadelphia, Peale portrayed the general in the midst of battle and filled the canvas with details narrating his victorious efforts at Princeton and Trenton: two cannon symbolizing two battles, captured flags of Hessian and British companies, and red-coated prisoners being escorted from the battlefield marking the battles' outcome. Washington's relaxed posture suggests that he is pausing in the midst of his victory, but only for a few moments; horses behind him are ready to be mounted. The massed bayonets indicate—if there was any question—that the fight will continue. Washington has not passed into history, but is, even at the moment of being portrayed, still very much an

FIGURE 27
Charles Willson Peale
John Beale Bordley, 1770
Oil on canvas, 84 ½ x 58 ½ in. (214.6 x 148.5 cm)
The National Gallery of Art, Washington, D.C.;
Gift of the Barra Foundation, Inc.

PLATE 39
Charles Willson Peale
General Joseph Bloomfield, 1777
Oil on canvas, 30 x 25 in. (76.2 x 63.5 cm)
The Hendershott Collection

PLATE 40
Charles Willson Peale
Thomas Jefferson, 1791
Oil on canvas
Diplomatic Reception Rooms, United States Department of State;
Replica of Independence National Historical Park portrait; Gift of
Mrs. Henry S. McNeil, in memory of Mr. Henry S. McNeil

active participant. Although the work captures a historical event, it is more a life portrait than a history painting.

In a later, more academic, version of this painting (1783), done on order from Princeton College, showing *Washington after the Battle of Princeton* (see plate 67), Washington and his victories have entered into history. His pose is more theatrical, and at his feet lies the stricken body of General Mercer. The painting now commemorates the battle and its heroes as an historical event rather than portraying a single individual. In *Washington and His Generals at Yorktown* (figure 32), a commission from the Maryland legislature later that year, Peale expanded his original Washington portrait into a full-fledged history painting that celebrates not just the crucial final victory in the conflict but the end of the war itself. He substituted a sketch of the battlefield taken by his brother James for Princeton College's buildings and added a French soldier carrying the fleur-de-lis banner of America's ally, as well as a parade of British soldiers laying down their arms and portraits of Lafayette and Colonel Tench Tilghman (a Marylander who served as Washington's aide-de-camp and who carried the news of Cornwallis's surrender to Annapolis). With these changes, Peale portrayed the victorious conclusion of the American Revolution. The addition of the various figures served, as he wrote about a similar work, "to tell the Story at first sight."[77]

James shared his brother's ambitions to be a history painter. His equestrian portrait of *Horatio Gates* (n.d.; Maryland Historical Society, Baltimore) and the various copies he made of Charles Willson's historical portraits— especially the different versions of Peale's *Washingtons*—were trials in this genre. Raphaelle does not seem to have been tempted by the desire to achieve fame through painting heroes, but Rembrandt at a very young age aspired to that role. At age seventeen, he sought his father's help in persuading the aging president, George Washington, to sit (see figure 4.13). Although this early effort displays the earmarks of the unsophisticated novice, it also exhibits Rembrandt's keen observation and strength of expression, such as appear in the later portraits of *Thomas Jefferson* (see figure 33; plate 41), *William Findley* (see figure 34), and *John Calhoun* (see plate 42). After his return from Paris, Rembrandt's heroic portraits assumed even more clearly the aspect of history paintings, especially the series of heroes of the War of 1812 that he painted on commission from the city of Baltimore (see plate 43). Through stance, expression, uniform, and symbolic skies these portraits tell their story without further embellishment.

History Painting

Historical portraits, however, were not history paintings in the grand manner, to which classical theory assigned the highest artistic rank. With the American Revolution behind him, Charles Willson Peale put aside ideas of painting such ambitious works until 1805. In the intervening decades, work in his museum provided him with new conceptions of history and ways in which historical information could be conveyed. Convinced that the most important lessons for mankind were to be found in "the awesome totality and grand design of nature," Peale developed the concept of the museum as a place where this

FIGURE 28 *(Top left)*
Charles Willson Peale
John Hazlewood, c. 1785
Oil on canvas, 22 ⅝ x 19 ⅜ in. (57.5 x 49.2 cm)
Courtesy, Independence National Historical Park

FIGURE 29 *(Center left)*
Gilbert Stuart
George Washington, 1796
Oil on canvas, 48 x 37 in. (121.9 x 94 cm)
National Portrait Gallery, Smithsonian Institution, Washington, D.C.; owned jointly with the Museum of Fine Arts, Boston (NPG.80.115)

FIGURE 30 *(Bottom left)*
Gilbert Stuart
Thomas Jefferson, 1805
Oil on panel, 26 ⅛ x 21 in. (66.3 x 53.3 cm)
National Portrait Gallery, Smithsonian Institution, Washington, D.C.; Gift of the Regents of the Smithsonian Institution, The Thomas Jefferson Memorial Foundation, and the Enid and Crosby Kemper Foundation; Owned jointly with Monticello (NPG.82.97)

FIGURE 31 *(Top right)*
Charles Willson Peale
Washington at Princeton, 1779
Oil on canvas, 94 x 59 in. (238.8 x 149.9 cm)
The Pennsylvania Academy of the Fine Arts, Philadelphia; Gift of Maria McKean Allen and Phebe Warren Downes through the bequest of their mother, Elizabeth Wharton McKean

FIGURE 32 *(Bottom right)*
Charles Willson Peale
Washington and His Generals at Yorktown, 1784
Oil on canvas, 96 x 36 ½ in. (243.8 x 92.7 cm)
The State of Maryland, Courtesy of the Maryland State Archives, Special Collections

FIGURE 33 *(Top left)*
Rembrandt Peale
Thomas Jefferson, 1800
Oil on canvas, 23 ⅛ x 19 ¼ in.
(58.7 x 48.9 cm)
White House Historical
Association

FIGURE 34 *(Top right)*
Rembrandt Peale
William Findley, 1805
Oil on canvas, 23 ¹³/₁₆ x 19 ¾ in.
(60.5 x 50.2 cm)
Courtesy, Independence
National Historical Park

PLATE 42 *(Bottom)*
Rembrandt Peale
John C. Calhoun, 1834
Oil on canvas, 30 ⅞ x 25 ⅞ in.
(78.4 x 65.7)
Gibbes Museum of Art, Carolina
Art Association, Charleston,
South Carolina; Bequest of
Eugenia Calhoun Frost

PLATE 43
Rembrandt Peale
General Samuel Smith, c. 1817
Oil on canvas, 37 ½ x 30 ⅜ in. (95.3 x 77.2 cm)
The Peale Museum, Baltimore City Life Museums

grand design was displayed and knowledge about it disseminated. In their arrangement, his exhibits illustrated natural history: the chain of life or organization of the universe from its simplest forms of animal and plant life to its highest form—mankind. The museum collection presented, in effect, a history of the natural world, and in the process Peale renewed his interest in grand-manner history painting. He now had a meaningful subject: the diffusion of "a knowledge of the wonderful works of creation."[78]

The first opportunity to present this cosmological history in paint came after Peale had successfully exhumed the bones of America's prehistoric animal from its New York burial grounds. In this episode, Peale himself was the victorious hero, and nature, in the form of sliding mud and threatening thunderstorms, was the enemy or obstacle to be overcome, not nation states or human armies. *The Exhumation of the Mastodon* (see plate 10), a history painting, was also a self-portrait, much as *The Peale Family* was three decades earlier, with Peale appearing again as educator, but this time explaining to all mankind the divine meaning of his discovery. Just as his museum held all the elements necessary for understanding the history of the universe, so did the *Exhumation:* the fossil bone that established the historical subject; the landscape (or habitat context) in which the event unfolded; and portraits of worthy individuals, such as the ornithologist Alexander Wilson, as well as family members, workers from the neighboring villages, and visitors, scholars, or pleasure seekers, all of whom were engaged in the enterprise.[79]

Charles Catton's *Noah and His Ark* (see plate 134), a work midway between genre and history, appealed to Peale as a history painting. He believed its subject, a biblical event, was suitably historical, and its theme of domestic harmony as a reflection of God's pacifistic world plan was appropriately moral. With its assemblage of animals, such as those he exhibited in his museum, and portraits of Noah and his family, the painting was, in Peale's estimation, "a Museum in itself."[80]

Peale again saw an opportunity to create a museum in paint in 1822, when the museum's directors asked him to paint his portrait for the museum. *The Artist in His Museum* (see figure 10.2; plate 133) includes significant objects that provide the context as well as the moral dimension required of a history painting: the original fossil bones, which gave rise to the initial idea for the establishment of the museum; the completed skeleton of the mastodon that marked the museum's ascendancy; the skin of the turkey awaiting preservation that Titian had only recently brought back from his Western explorations on the Long Expedition, and an audience that conveyed wonder at the display.

James Peale's most imaginative effort in history painting was *The Ambush of Captain Allan McLane* (see plate 98), which verges on anecdote in its portrayal of small figures on horseback in flight and pursuit. The work seems to have been an adjunct to his brother's portrait of McLane and was painted in response to the captain's wish to have his revolutionary adventure perpetuated on canvas.

Like his father, Rembrandt was convinced that history painting held his ticket to immortality. Upon his return from Paris, he essayed two such works, *The Roman Daughter* (see plate 75) and *Napoleon on Horseback* (unlocated), scenes which pictured different kinds of heroism than that defined by his

father and told their stories by different means. In *The Roman Daughter* Rembrandt conceived of heroism in terms of domestic or filial relationships rather than as martial or public valor of universal import. A popular subject, the story of the Roman daughter who saved her father through somewhat unusual means had been widely dramatized by the time Rembrandt exploited it for his new Apollodorian Gallery. Charles Willson Peale had earlier painted a theatrical subject; in 1771, soon after his return from England, he had portrayed the famous actress Nancy Hallam in a scene from Shakespeare's *Cymbeline* (plate 44), in which Hallam as Imogen, a virtuous heroine, disguises herself as the boy Fidele in order to defy a wicked stepmother, a foolish father, and the stepmother's greedy son and gain her way to marry a poor but honorable man. In contrast to Rembrandt's republican *Roman Daughter,* family sentiment played no part in Peale's colonial painting, which emphasized the actress's beauty and intelligent disguise, and, in its story, suggested the superiority of virtue over riches—perhaps an allusion to Peale's personal situation at the time. Rembrandt's republican work, demonstrating the change in generational interests, was bathed in religious sentiment, its moral theme of filial duty spelled out conspicuously in the attitude of the players and the symbolism of the various elements.[81]

David's heroic depiction of French leaders, especially Napoleon, fired Rembrandt's ambition to achieve similar artistic fame, and influenced him to paint a similar work immediately upon his return from Paris. Unfortunately, both *Napoleon on Horseback* and *The Roman Daughter* dismayed and amazed the Philadelphia public, as much for their subject as for their treatment. The near nudity of *The Roman Daughter* and the idealized heroism of the controversial Napoleon, both rendered in a superb technique, provoked criticism as well as skepticism that the works were really by Rembrandt. Although this criticism drove him out of Philadelphia to Baltimore, the desire to create dramatic historical portraits of American leaders, notably George Washington, remained strong; Rembrandt's composite *Patriae Pater* (see figure 4.10) of 1824 and the subsequent *Washington Before Yorktown* (1824; Corcoran Gallery of Art, Washington, D.C.) resulted from this commitment.

Rembrandt's large panorama of *The Court of Death* (see figures 4.1, 4.2, 4.3, 4.4, and 4.5) was not a traditional history painting, but as a moral tract it served history's purposes. Narrating through expressive figures an abstract history of humankind, like a medieval morality play, it drove home its universal message of life and death. Its size and complicated assemblage of figures promised the artist the renown he was seeking, as well as financial return—and Rembrandt was always desperately in need of cash. The cost, however, of exhibiting the huge canvas consumed its income, and Rembrandt soon discovered that large traveling shows did not pay. Like his father, he found that he would have to make the historical portrait satisfy his ambitions.[82]

Whether Sarah Miriam Peale harbored ambitions for such large-scale history works is not recorded. Certainly, she had career goals, but she undoubtedly realized that she could never undertake such works: neither the time required, the necessary models, nor the funds were available to her, and as a woman she would have encountered market and exhibition problems. Her portraits of Washington legislators—*Thomas Hart Benton* (see plate 124),

PLATE 44
Charles Willson Peale
Nancy Hallam as Fidele in Shakespeare's Cymbeline, 1771
Oil on canvas, 50 x 40½ in. (127 x 102.9 cm)
The Colonial Williamsburg Foundation, Virginia

Lewis Fields Linn (see figure 8.9), and *Henry Wise* (see plate 122)—as well as her Civil War portrayals, probably based on engravings or photographs, of Generals Custer and Sheridan (National Museum of Women in the Arts, Washington, D.C.), were efforts to achieve through portraiture the higher status of the history painter.

Nature, Naturalists, and the Land

Charles Willson Peale's early oeuvre did not include landscape painting, although while in London he studied a few such works. At West's studio he made copies of George Barrett's and Sawrey Gilpin's *Landscape with Cows* and Francis Swaine's *Storm at Sea,*[83] and from engravings he knew the work of such popular continental artists as Claude Lorraine and Salvator Rosa.[84] Landscape was, however, still a new taste as well as a new art form in England in 1767. It was hardly practiced until the return from Italy of Richard Wilson in 1760 and the relocation of Thomas Gainsborough from Suffolk to Bath soon after. Whatever taste for landscape existed in England during the eighteenth century tended to concentrate on scenes with literary associations. A few British collections included the work of seventeenth-century Netherlandish painters or the panoramic views of Annibale Carracci or Antonio Canaletto, together with topographical views of family estates.[85] Landscapes were sought as decorative elements for wealthy homes, along with wallpaper and mirrors in fancy frames; these were usually assigned to migrant house decorators who utilized a pattern or an engraving to produce stylized, frequently imaginary, views. They were not regarded seriously as works of art with intellectual, moral, or religious content. That they were relegated specifically to trained artisans explains Jonathan Richardson's and Sir Joshua Reynolds's dismissal of the genre as a legitimate art form, because, as Richardson wrote, "these cannot improve the Mind, they excite no Noble Sentiments."[86]

In the fall of 1772, Peale was asked by John Cadwalader to paint two landscapes for the panels above the fireplaces in the main parlors of the luxurious mansion Cadwalader was building in Philadelphia. Untrained in landscape technique, and dissatisfied with the results he achieved with the aid of his homemade perspective machine or quadrant, Peale did not complete Cadwalader's commission, perhaps because to copy an engraving would have reduced him to the status of artisan. "One rude line from Nature," he wrote, "is worth an hundred from coppys, enlarges the Ideas and makes one see and feel with such sencesations—as are worthy of the auther."[87] Instead, he sought "views that will look well in painting," and he explained his failure to fulfill Cadwalader's commission with the fact that by the time he was ready to paint such a scene, "nature had lost her green mantle."[88]

Peale's effort to locate "views that will look well in painting" suggests that he was seeking a scene that met the requirements of the picturesque as defined by either the Reverend William Gilpin in various tracts on picturesque travel or Edmund Burke in his inquiry into the sublime and the beautiful.[89] Among other instructions to the artist—many quite specific—Gilpin discussed

the necessity for the painter to manipulate nature for aesthetic purposes—to "cull from various scenes such parts as best create one perfect whole."[90] This was a lesson that Peale had to learn before he could create successful landscapes.

Peale had developed his art from an aesthetic of naturalism as defined by such eighteenth-century British artists as his mentor William Hogarth (1697–1764) or later, William Constable (1776–1837). "Truth is most preferable tho' dressed in a course garb," Peale wrote in 1797 to the French scientist Étienne Geoffroy Saint-Hilaire.[91] In his early portraits, however, Peale modified such a direct approach to nature, shaping heads, eyes, and expressions to meet conceptual requirements.[92] To apply his training in portraiture to landscape, he had to learn how to discard, reorder, shape, and recompose natural elements to make the scene conform intellectually as well as artistically to a preconception of its meaning—to manipulate nature, as Gilpin had suggested, and bring it into the realm of art.

Landscape functioned primarily as background or emblem in Peale's early work. For instance, in his first attempt at a historical portrait—*William Pitt* (1768; Westmoreland County Museum, Virginia)—Peale included a panoramic view of the Banqueting House of Whitehall, the place from which Charles I, an earlier British tyrant, was led to his execution, as a warning to those who would similarly attempt to subvert American liberties. For the *John Beale Bordley* that followed (see figure 27), he composed a fairly specific rural landscape of Maryland's Eastern Shore as appropriate to Bordley's Wye Island estate and his position as a gentleman-farmer devoted to agrarian reform and the development of American self-sufficiency.[93] Landscape became a more specific political symbol in the portrait of *John Dickinson* (1770) (figure 35), in which the falls of the Schuylkill marks the site where Dickinson's important contribution to the Revolutionary movement was first recognized. The small building in the background of the portrait has been identified by Karol Ann Lawson as Dickinson's fishing club, the Fort of Saint David's, whose members' testimonial honoring Dickinson had called public attention to his authorship of the famous *Letters of a Pennsylvania Farmer*. The falls of the Schuylkill, an actual part of the landscape, provided Peale with the meaning he required for the depiction of natural phenomena: just as the sheep and peach tree in the *Bordley* denoted American self-sufficiency, the falls of the Schuylkill represented the danger or turbulence that Dickinson in his *Letters* had warned Americans to expect if they delayed responding to the British effort to curtail their liberties in 1767.[94]

In the background of *William Smith and His Grandson* (see plate 22), Peale carried the idea of landscape as symbol to its extreme expression in a number of jarring elements—columns reminding us of Roman virtue, a large classical building representing Smith's election to the first Congress of the United States, and a barn or mill and farmhouse showing "Eutaw," the country estate of General Otho Holland Williams, father of Smith's grandson. As Brandon Fortune has pointed out, Smith retired to Eutaw to enjoy the pleasures of the rural life, symbolized by the books on the table, the pruning hook, and peach branch.[95]

As Peale advanced in his understanding of landscape, however, he began to make his backgrounds more general, only hinting at specific details rather

FIGURE 35
Charles Willson Peale
John Dickinson, 1770
Oil on canvas, 49 x 39 in. (124.5 x 99 cm)
Historical Society of Pennsylvania, Philadelphia

View of West point from the side of the mountain

PLATE 45
Charles Willson Peale
View of West Point from the Side of the Mountain
(in sketchbook, "Highlands of the Hudson"), 1801
Pen and watercolor on paper, 6 ¼ x 7 ⅝ in.
(15.9 x 19.4 cm)
American Philosophical Society, Philadelphia

than elaborating on them, a change that suggests Gilpin's instruction that "General ideas only must be looked for [in landscape]; not the peculiarities of portrait."[96] In his double portrait of the Lamings, for instance (see plate 18), Peale included just enough of the view from the Lamings' garden of the port of Baltimore to suggest the extent of the merchant's rural estate as well as the site of his business activities.[97]

Like Gilpin, who recommended a mechanical method for achieving perspective based on the establishment of a horizontal line and a point of sight, or vanishing point, Peale attempted to design a machine or develop a mechanical method that would assist him in drawing topographical or panoramic views. He also followed Gilpin's advice that he use a notebook during his travels to make small, rough drawings of buildings or scenes he visited (plate 45) which he might later wish to work into a finished landscape; his brother James kept a more formal sketchbook for that purpose.[98] James's *Pleasure Party by A Mill* (see plate 95) conforms to many of Gilpin's instructions about what to keep and what to discard in a natural scene, including the minute figures that provide the necessary, but not significant, human element.

Peale's interest in nature as an aesthetic source increased as he plunged more deeply into his work at the museum and later at his farm, Belfield. In the museum, he painted habitat backgrounds for his stuffed birds and animals similar to those he had incorporated into his portraits, but the necessity to enlarge these—because viewers standing in close proximity to the scenes would be likely to look for authentic detail—compelled him to recognize that habitat scenery required a verisimilitude and specificity that backgrounds in portraits did not.

During the second decade of the nineteenth century, when Peale was exerting himself as a gentleman-farmer, the American attitude toward landscape was changing. Partly as a result of the acquisition of the huge Louisiana Territory and such explorations of the interior as the Lewis and Clark Expedition, Americans were discovering a vast and untrammeled land, varied in appearance and rich in resources as well as beauty. The country's unique natural environment became a substitute for a national history— a way of manifesting the nation's destiny and conveying a spiritual as well as political significance.

PLATE 46
James Peale
View on the Wissahickon, 1830
Oil on canvas, 20 ⅛ x 27 in. (51.1 x 68.6 cm)
Philadelphia Museum of Art;
Gift of T. Edward Hanley

Charles Willson and James Peale responded to this new interest in landscape, but restricted themselves to scenes and gardens near home, and continued to paint in the neoclassical format established by such revered artists as Claude Lorraine and Gaspard Poussin. They exercised conceptual control over their scenes, and did not allow the scene to determine the painting; in this they were not too distant in method from the Hudson River School painters (plates 47, 48, 49). Charles Willson Peale's later landscapes, painted as independent canvases rather than as backgrounds for portraits, are free of allegory or metaphor; instead, he concentrated on the picturesque, finding sufficient aesthetic satisfaction in the juxtaposition of trees, water, low-lying buildings, and sunlight and its effect on color.[99]

Charles Willson Peale's major effort at manipulating nature for artistic purposes was expended in the pleasure garden he created at Belfield. The garden's purpose was almost completely didactic, designed to educate visitors and friends in the morality of nature so as to encourage a refinement of taste and behavior. The garden included a summer house—a hexagon with six pillars supporting a circular top and dome on which rested a bust of George Washington—and a structure "in the Chinese taste," in which the visitor was advised to "Meditate on the Creation of Worlds which perform their

PLATE 47
James Peale
Landscape, c. 1830
Oil on canvas, 25 ½ x 31 ½ in. (64.8 x 80 cm)
Private collection

PLATE 48
Charles Willson Peale
Millbank, 1818
Oil on canvas, 15 x 21 in. (38.1 x 53.3 cm)
Private collection

PLATE 49
Charles Willson Peale
Landscape Looking Towards Sellers Hall from
Mill Bank, c. 1818
Oil on canvas, 15 x 21 in. (38.1 x 53.3 cm)
Collection of Mrs. James W. Glanville

FIGURE 36
Charles Willson Peale
Country Lane, Belfield Farm from the Road to Germantown, 1818
Oil on canvas, 11 x 16 in. (28 x 40 cm)
Private collection

evolutions in prescribed periods!" Transforming his toolbox into a seat, Peale built steps to mount it and an archway behind it to create a passage pointing to a western sky. Several board sculptures represented America, while around the garden such symbols as the beehive of industry supported by Truth and Temperance on one side, and Industry with her staff and cornucopia on the other, spelled out their messages. Above the whole arrangement, Peale proclaimed the pacifistic maxim: "A wise policy will do away with wars. Hence Mars is fallen." Finally, at the end of the walk behind the house, he erected an obelisk intended to "transmit to posterity precepts of philosophy. . . and to immortalize the great actions of heroes, and the memory of persons beloved." On the pedestal of the structure he inscribed such aphorisms as "never return an injury, it is a noble triumph to overcome evil by good; Labour while you are able, it will give health to the body, and peaceful content in the mind; He that will live in peace and rest, must hear and see and say the best . . . Neglect no duty" (figure 36; see also plate 11).[100]

In the garden at Belfield, Peale structured nature to meet human ends as he defined these ends. In this sense, he became the architect of nature, and having organized the landscape to meet Gilpin's definition of the picturesque, he re-created it in a painting.[101] Peale thus shaped nature into art and then created art from manipulated nature.

In 1811, Rembrandt made a first attempt in landscape painting, and in typical fashion chose for his subject a national icon, *Harper's Ferry* (The Peale Museum, Municipal Museums of Baltimore), a site made famous by Jefferson's description in his *Notes on Virginia* (1784). Transforming a wild scene of steep precipices and uncontrolled nature into a placid mountain view through a rational rendition of conflicting elements, Rembrandt revealed himself to be his father's son.[102] Twenty years later, he again selected as his subject a national icon and tourist attraction—Niagara Falls (see plates 50, 51). He took as his model Salvator Rosa's *Wild Scene* (of which he had made a copy while in Europe); more sensitive now to ways of representing sublimity, he included anthropomorphic branches of trees to suggest human passions, a tree stump to mark the passage of time, small figures to set off the immensity

PLATE 50
Rembrandt Peale
Falls of Niagara, Viewed from the American Side,
1831
Oil on canvas, 18 ¼ x 24 ⅛ in. (46.4 x 61.3 cm)
Collection of Mrs. Deen Day Smith

PLATE 51
Rembrandt Peale
The Canadian Side of Niagara Falls, Platform Rock, 1831
Oil on canvas, 18 ¼ x 24 ¼ in. (46.4 x 61.6 cm)
Private collection

of the falls or the expanse of the panoramic view, and dark clouds offset by bright light to suggest the presence of a supernatural power behind the great torrents of water dominating the canvas. Rembrandt's landscapes of Niagara express the romantic view of the sublime, the conviction that in nature's immensity man recognizes God's great power.[103]

In his travels to the American West as artist-naturalist on the Long Expedition of 1819–1820, the second Titian Ramsay Peale made realistic sketches of Western landscape. When, however, he turned them into more formal works of art, he idealized the wild region and native peoples, creating a more idyllic picture of the American West (see plate 91). Titian's drawings of birds for such ornithological publications as Charles Bonaparte's *Ornithology* look like stuffed museum specimens compared to John James Audubon's more lively renditions, but they are accurate representations; many are nicely composed and beautifully colored (see figure 6.9). Much of Titian's Wilkes Expedition art—his finished landscapes and watercolors of unexplored regions and native peoples—reflects his training in the painting of habitat scenery for his father's exhibits (figure 37). Precise, accurate renditions of an exotic world, they also illustrate the anthropological and cultural biases of mid-nineteenth-century America. His late beach paintings, on the contrary, are simply personal responses to the aesthetic quality of sky, sand, and ocean (plate 52), just as *Quails in a Landscape* (figure 38) is a response to a familial scene.[104]

Rubens Peale, who began painting late in life, preferred small domestic scenes when he was not copying James's or his father's landscapes; the large panoramic landscapes of the mid-century were beyond his capacity and, indeed, his interest. His *Landscape with Quail, Cock, Hen, and Chickens* (plate 53) is a homely scene of nature painted with charming detail, akin to but not directly influenced by the Pre-Raphaelite school. More likely, his propensity to paint in such specific detail derived from his association with the museum and the necessity to concentrate on accurate natural facts in developing its collections.[105]

The Fruits of Nature

Curiosity about the national landscape stimulated widespread interest in the flowers and fruits of the new land. Raphaelle Peale and James Peale adapted the Dutch still-life tradition and format to the depiction of local fruits and vegetables, cakes, and wines. Sarah Miriam Peale followed suit, as did Margaretta and Maria Peale, and later Rubens, with copies of both Raphaelle's and James's work as well as original compositions. Their approaches to still life reflected their different artistic personalities. James's luxuriant approach described his pleasure in nature and its fruits (plate 54), while Raphaelle's sparse and controlled renditions represented an assertion of temperance and discipline in the face of nature's temptations; it may be, too, that the simplicity of Raphaelle's still lifes resulted from the necessity to turn them out quickly and plentifully because they earned so little income (plate 55).[106]

Impersonal still lifes were, in a very special way, the most personal art form for Raphaelle, and they convey his response to the world of nature. *Covered Peaches* (see plate 72), for example, presents nature in the form of ripe fruit, rendered inaccessible by the covering napkin; the fruit itself, although lusciously beckoning, is made less appetizing by the presence of a wasp feeding on it. Forbidden the indulgence of sensory pleasures, Raphaelle finds his father's idyllic nature either unavailable or unappetizing.

PLATE 55
Raphaelle Peale
Still Life with Jug and Fish, c. 1810
Oil on canvas, 12 x 13 in. (30.5 x 33 cm)
Hirschl & Adler Galleries, Inc., New York

PLATE 56
Raphaelle Peale
Venus Rising from the Sea—A Deception
(After the Bath), c. 1822
Oil on canvas, 29 ¼ x 24 ⅛ in. (74.3 x 61.3 cm)
Nelson-Atkins Museum of Art, Kansas City, Missouri;
Purchase Nelson Trust

Similarly, in his *Venus Rising from the Sea—A Deception* (plate 56), Raphaelle draws a curtain or a sheet over the sensuous experiences offered by nature— as represented by the figure of Venus, goddess of love—preventing access to her. Perhaps confronting his own difficult marriage, he wished to deface the goddess of love; or perhaps he tried to oppose in this way his father's optimistic view of nature as the source of family affection. In any case, in this painting, and in his still lifes as well, Raphaelle portrays himself as alienated from nature, able to picture it objectively but unable to participate joyously in it.[107]

For an artist whose life was marked by rebellion against the social mores and physical prescriptions of his father, Raphaelle's still lifes appear more traditional than revolutionary, although they are beautifully painted with deep colors, jewel-like in their glistening light. His paintings follow the Dutch formula of a simple group of objects laid out on a table accompanied by a glass of wine or decanter, and they frequently include the Peale insignia of a fruit peel. Some of the still lifes reveal his and his father's delight in "deceptions" or trompe l'oeils, which were so popular in Holland during the eighteenth century and continued to be so in the United States in the late nineteenth, partly because they displayed the artist's skill at naturalistic reproduction and partly because of their innate humor and expression of pleasure in the material world. Despite his objections to Raphaelle's concentration on still life, Charles Willson Peale admired his son's artistry and skill in this kind of subject. He himself indulged in the painting of still life only occasionally, reserving such efforts for portraits, as for instance in *Sarah and Mary Callahan* (figure 39). His desire that Raphaelle turn his talents to the painting of portraits reflected Charles Willson's immersion in British aesthetic theory and the conviction that still life was simply a first step in an artist's education; he believed that as a mature artist, Raphaelle should progress to the more intellectually significant, as well as remunerative, art of portraiture. A contentious subject between the two men, it was never resolved satisfactorily for either.

FIGURE 39
Charles Willson Peale
Sarah and Mary Callahan, 1791
Oil on canvas, 26 ½ x 20 ¼ in. (67.3 x 51.4 cm)
Hammond-Harwood House, Annapolis, Maryland

Peale's Museum

Peale's didactic proclivities found their most productive expression in his museum, which he called not only a world in miniature but "a school . . . in the Science of Nature."[108] The museum influenced his art, providing the artist with subject matter for portraits, history painting, and landscape. As he removed skins of birds and animals in order to preserve and stuff them, and as he experimented with habitat settings and compositional effects, he also became acquainted with the anatomy of animal forms, which made him sensitive to human anatomy. Progress in museology and art proceeded simultaneously; his museum was his studio, and the more he worked in the studio, the more skilled he became at his art and the more imaginative in his museum programs. *The Artist in His Museum* (see figure 10.2, plate 133) narrates his dual role of active artist and museum educator.

Peale believed that nature could and should be probed; his method was scientific empiricism, his goal was "to encrease the comforts of Life." A Deist, he believed that the natural universe was created by an omnipotent and

benevolent Creator; thus, all of man's needs could be met through the manipulation of nature once man had learned nature's way or encompassed nature's meaning. The penetration of nature resulted in technological development, and Peale realized that America's future lay in industrialization—in machines such as energy-saving stoves, polygraphs for duplicating writing, vapor baths for the improvement of health, gadgets like the draisiana (a simple bicycle) and fan chair, windmills and plows for improving agriculture, and bridges to facilitate transportation and bind the country together. All of Peale's efforts to modify and improve these inventions emerged from his belief that nature should be harnessed to enhance the quality of life, and this was the message he tried to convey to the public through his museum exhibitions.[109]

The Legacy

Charles Willson Peale's view of art, the family, the museum, education, and history mirrored his social view. Influenced by the Linnaean system, with its hierarchy of species and natural order, he applied its organizing principles not only to his museum exhibits, but also to his domestic arrangements and social philosophy. His sense of hierarchy was conservative, but his emphasis on reason and the individual's capacity to make appropriate decisions based on experience allowed for a social mobility that was in essence democratic.

Although Peale's cosmology was no longer tenable in the nineteenth-century Darwinian world that his children inhabited, his ideas continued to influence their behavior and artistic purposes even as their art underwent change. Rembrandt, Rubens, Titian Ramsay, and Peale's niece Sarah Miriam continued their work as artists up to the Civil War and (except for Rembrandt) beyond the conflict, into post–Civil War America—all steadfast in their conviction that the work they pursued was socially meaningful and important. The world of art expanded in the nineteenth century, and the second generation of Peales had to compete with more highly trained and younger artists who approached their work with new ideas emanating from London, Paris, and Germany. But the younger Peales remained largely bound by the classicism of their training in Charles Willson's studio. None of them fell under the influence, for instance, of Transcendentalism, despite their genuine feelings for nature and efforts to depict it; none was influenced by the style or subject matter advocated by Düsseldorf-trained artists, or French Salon masters, and only Sarah Miriam seemed to succumb to the Ruskinian apostles of nature.

Yet they could not remain immune to current taste. Rembrandt's delight in Italian seicento painting, especially the work of Guido Reni and Cristofano Allori, was shared by many of his contemporaries. He copied a few of these works during his European travels (plate 57), and continued to adapt their compositions to his own work in such "fancy" pictures, or generalized portraits, as *Pearl of Grief* (plate 58) or *Day Dreams* (plate 59).

Sarah Miriam Peale was perhaps most influenced by new artistic approaches. Her later portraits demonstrated a change from her earlier concern with a particular likeness to Victorian "fancy" pictures, such as her

PLATE 57
Rembrandt Peale, after Cristofano Allori
Judith with the Head of Holofernes, 1830
Oil on canvas, 55 5/16 x 44 1/8 in. (140.5 x 112.1 cm)
Princeton University Art Museum, Princeton,
New Jersey; Gift of Mr. and Mrs. Stuart P. Feld

PLATE 58 *(Opposite)*
Rembrandt Peale
Pearl of Grief, 1848
Oil on canvas, 24 5/16 x 18 1/4 in. (61.6 x 46.4 cm)
Milwaukee Art Museum, Milwaukee, Wisconsin;
Gift of Mr. Frederick L. Pierce

PLATE 59 *(Above)*
Rembrandt Peale
Day Dreams, 1837
Oil on canvas, 28 1/2 x 36 1/2 in. (72.4 x 92.7 cm)
Collection of Mrs. Deen Day Smith

PART 11

~

The Artists

~

Charles Willson Peale and the Theory and Practice of the Eighteenth-Century American Family

~

S I D N E Y H A R T

CHARLES WILLSON PEALE'S LIFE spanned an era of revolutionary changes in American society and politics. Born in a proprietary colony of Great Britain's North American empire, Peale spent his childhood and early adult years on the Eastern and Western shores of Maryland. By the middle of the eighteenth century, society in this Chesapeake region was becoming Anglicized and hierarchical. The gentry was consolidating its power, position, and wealth, although centrifugal forces, such as the varied religious and ethnic groups and the open land, kept this region more mobile and fluid than England. Institutions such as the church, courts, and local governments were increasing in strength, and families were becoming more stable. Among the gentry, strong patriarchal families with elaborate kinship networks formed political and social alliances which served as linchpins in local and provincial government.[1]

From age thirty-five until his death, Peale lived mainly in Philadelphia, for a time the capital and for years afterwards a cultural and financial center of the United States, a dynamic city in which democracy, capitalism, and individualism were rapidly becoming dominant traits of the larger culture. From 1770 to 1820, in Philadelphia as well as in many areas of the United States, the Anglicized institutions that had been powerful during Peale's boyhood were losing their authority. Relationships on all levels—among classes, sexes, and generations—were affected by the democratization of society. The family changed from a patriarchal and extended institution in which kinship and household associations often predominated over relationships between husband and wife and parents and children, to one we would recognize as the modern American family of the companionate marriage and the child-centered home.[2]

However, just as it would be wrong to overstate the extent of hierarchy, deference, and Anglicization in the mid-eighteenth century, we should not exaggerate the degree and extent of democratization in the late eighteenth century. As Lawrence Stone has written, Anglo-American society during this time was still characterized by a great deal of obedience, social cohesion,

PLATE 62
Charles Willson Peale
The Artist's Mother, Mrs. Charles Peale, and Her Grandchildren, c. 1783
Oil on canvas, 29¼ x 25 in. (74.3 x 63.5 cm)
Private collection

and deference to "legitimate authority." Within the family, two of the strongest aspects of this obedience and deference "were the subordination of children to parents, and of women to men." Perhaps the general acceptance of the social order and the "underlying unity of the elites" made it possible to relax authoritarian relationships within mainly "well-to-do" families.[3]

It is within the context of these generalizations that this essay analyzes Peale's theory and practice of family. There are two caveats. First, there is always a degree of continuity and unevenness in the rate of change in social institutions. Changes in the family during this period were never as clear-cut and rapid as the popular culture made them appear. Novels, essays, and advice books of the eighteenth century popularized works on education and parenting by writers such as John Locke and Jean-Jacques Rousseau, and preached the virtues of companionate marriage and a less patriarchal family structure. Family portraiture of the late eighteenth century also expressed the close ties of affection in the nuclear family (see plate 62). But changes in the family were not abrupt. Rather, these expressions represent the assertion of "certain fictions and ideals" that perhaps aided in the transition of the family to its new form.[4]

Secondly, the biographical dimension of Charles Willson Peale himself must not be overlooked. However we categorize Peale in respect to the extended patriarchal or privatized nuclear family, he was a strong individual who tended to exert control over people and situations. Peale, who at times was aware of his behavior and outlooks, recognized his desire to control as an impulse to reform mankind. He expressed it explicitly in a letter to his son Raphaelle, who more than anyone had experienced his father's propensity to change the behavior of those around him: "I have moralized a little which I hope will not be unexceptable, since my age gives me a more general view of things and their consequences than younger Men can have. I scru[t]ninize the actions of Men and know from what impulse they moove, and w[h]ere I can do no good I am silent. But if I could, I have the desire to reform *the bulk of my fellow creatures.*"[5] [Emphasis added.]

Charles Willson Peale's public life is as well known as that of anyone who lived in early America, but almost all of the time he spent with his family is unrecorded.[6] We do not know, for instance, what Peale and his wife talked about at meals, or if they spoke at all. There are letters from Peale to his second and third wives, but none from his wives to him; and no letters are extant from Peale to his first wife, Rachel Brewer. We have only glimpses into the internal life of the family—journals and letters to his children—a paucity of facts with which to construct a pattern of family life.

In his letters to his children, especially in his later years, and in his unpublished autobiography, Peale seemed determined to present himself, as he was later portrayed by his descendant and biographer, Charles Coleman Sellers, as a good and caring husband and father who continually sought to promote happiness and harmony within his family.[7] It is not easy, however, to know exactly what is meant by the terms "good parent," "good husband," or "family harmony" in Peale's lifetime. For an eighteenth-century Chesapeake gentleman, for example, family harmony was not inconsistent with, and indeed was seen as deriving from, a strong and orderly patriarchalism. Taking

Peale's assertions literally will not reveal much about his theories of family life or the operation and structure of the Peale family in the early Republic. Such terms do not transpose well into our late-twentieth-century language of the family. The purpose of this essay is not to argue that Peale was a good or bad parent or husband, but to analyze instead his definition of those terms— his theory of family—and to view his actual behavior as a husband and father —his practice of family.

Charles Willson Peale married Rachel Brewer in 1762, but severe financial difficulties prevented him from sustaining a household of his own until after completing his painting studies with Benjamin West in London. When he arrived in Annapolis in June 1769, his two most pressing concerns were to paint portraits and "prosper by his labours" so that he could "once more" begin "Housekeeping." By "housekeeping," Peale meant living in his own house, rather than in rented rooms. In seventeenth- and eighteenth-century America the term conveyed an independent household, headed by a self-sustaining member of society.[8] In taking up housekeeping Peale did not mean establishing a separate dwelling for himself, his wife, and children; his sense of household and family during this time was extended. He considered it his duty to take in his mother, two younger brothers, and Margaret Durgan, his mother's orphaned niece.

Peale considered the restoration of his father's family as a significant act in his life. In his autobiography, he described with evident satisfaction the bringing together of the various family members, and how they "lived in the utmost harmony together." Peale was so proud of his achievement, "that he began the Portraits of the whole in one piece, emblematical of family concord"—his "family picture" (see plate 1).[9] Since his family portrait was not a commissioned work, Peale did not have to compose it according to conventional or fashionable tastes, and it may thus better reflect his own idea of the family.

A salient aspect of the painting's composition is that Peale's sense of family is not nuclear.[10] While historians of the family mark the eighteenth and early nineteenth century in Anglo-America as the period that witnessed the emergence of the modern family, Peale placed in his portrait all seven members of his father's family; only Charles Peale (1709–1750), the father, is absent, his place now taken by his son, Charles Willson.[11]

Despite Charles Peale's absence from the painting, its theme—a drawing or painting lesson—connects with him and his role as a teacher or educator. In all of Peale's writings about his father, it is this quality that he emphasized and praised.[12] For Charles Willson Peale as a young man, family harmony thus meant assuming the position of patriarch in his father's family. In the early 1770s he had no hesitancy assuming parental responsibility and control over his brothers. He was pleased that he was able to teach them how to draw, and wrote his teacher Benjamin West how the oldest, St. George, "never discovered the least inclination to drawing altho he is 25 year[s] old till this Winter, and began from a very trifeling incident. Vizt. my saying he could not draw such a line which amused him for one or two evenings then he coppyed some drawings." The incident is harmless enough; Peale challenged his brother to do a simple task, then had him drawing from "Busts" and then

painting "several pieces in Crayons." In all probability, St. George enjoyed himself, but it was Peale who arranged the "lesson" and who in good Rousseauian fashion manipulated the pupil to want to learn what the master wanted to teach him.[13]

It would appear that when Peale took his brothers into his household he thought of them as dependents in his family. He succeeded in turning James (1749–1831), his youngest brother, into a painter (see plate 93). He also had James making frames and doing odd jobs for him. Even St. George (1745–1778) (figure 1.1) was swept along; not only was he included in Peale's family art lessons, but he married one of Peale's drawing pupils, Elizabeth Emerson Callister. We have just a glimpse of Peale's treatment of one of his brothers. In 1773 Peale sold some "ornamental glasses" for the English sculptor Thomas Allwood, but had not forwarded the money. He wrote the sculptor that he had "left orders" with his brother (probably James, who worked for Peale during these years) to send the money and explained the delay by writing that his brother was "a thoughtless young fellow." It was what we would expect of an eighteenth-century patriarch explaining the failings of a member of his extended family.[14]

The most pertinent fact in the brief life of Charles Willson Peale's father, Charles Peale, is his conviction of forgery and embezzlement, a capital offense. Exiled to the North American colonies, he spent the remainder of his life in America, largely in a struggle to sustain himself, to support a family, and to regain the stature he had enjoyed as a rising civil servant in London. He became a teacher in the new world.[15]

From Charles Peale's extant letterbook, covering a few years of his life in Chestertown, Maryland, in the mid-1740s, we know that he frequently and unsuccessfully sought patronage. Notwithstanding his strained economic situation and prospects, he aspired to live as a member of the Chesapeake gentry, and to a limited extent he succeeded. Charles Willson Peale wrote that while his father was alive, the family lived in a "Genteel and Creditable manner."[16] According to his son's recollection, Charles Peale "had a liberal Education; was a polite, agreable Man companion, & great[ly] esteemed by all his acquaintance . . . truly a good man." His father's "qualifications," Peale wrote, "had recommended him to the Mastership of the Chester-Free School; where he lived many years an admirable Teacher." Peale was aware, however, of the economic strains in the household. It is a "Pity," he complained, "that the Teachers of our Children are not more generally respected and their incomes more liberal than they generally are."[17] In a letter to President Jefferson, he contrasted his own poor spelling and grammar to that of his father, and regretted that because of his father's early death he had not received a "liberal" education.[18]

In Charles Peale's time, a Chesapeake planter or gentleman's family was patriarchal. In the words of Daniel Blake Smith, the family was "characterized by a series of power relationships between husbands and wives and parents and children that underscored the belief in order and authority in the family."[19] The husband was considered superior and ruled in all areas of family life, including household management and child-rearing, as well as head of the

household in all civic and political matters. In return for accepting subordinate roles, wives expected not only economic support and protection, but a certain degree of affection. With wealth, such theoretical harmony was more likely to be realized by wives and children, when servants and slaves were available to reduce the workload of the family members.[20]

However tenuous Charles Peale's status as a member of the Chesapeake gentry, it was probably believable in the mind of the nine-year-old Charles Willson. His father provided the family with a certain level of material comfort: there were tea tables, armchairs, an elegant riding chair (light carriage), and even a fox-hunting horse.[21] Perhaps more important than such amenities, which in the mid-eighteenth century Chesapeake region were indicative of gentry status, Peale's associates and friends, as Charles Willson later wrote Jefferson, were considered gentlemen in that century. They included such important figures as Adam Thompson, a respected physician and prominent Maryland literary figure; George Scott, a deputy commissary of Prince George's County; William Carmichael, a wealthy landowner and officeholder in Queen Anne's County; John Bordley, the well-established Annapolis lawyer; James Sterling, an Eastern Shore clergyman and poet; and Jonas Green, the printer for the Maryland colonial government, publisher of the *Maryland Gazette,* and poet laureate of the Annapolis social and literary society, the Tuesday Club; with all of these, Charles Peale seems to have been on friendly terms.[22] Intellectually and socially, Charles Peale's was a "Genteel" household, one that Charles Willson remembered with pride. While in London, he did not hesitate to call, without a formal introduction, on another of his father's acquaintances, Benjamin Franklin.[23]

Notwithstanding all of Charles Willson Peale's pride in his father's attainments, Charles Peale's life in colonial America contains a strong theme of dissatisfaction. His letters reveal a man whose ambitions were unfulfilled. He believed that he was living below his social station, and had been abandoned by his friends and family when forced to leave England. Designed by nature for a certain place and station in life, this design, he came to believe, was being continually "diverted" by "Dame Fortune," "ill Fate," and "the want of a good Friend"—thus trapping him in his current status.[24] Writing to his sister, Jane Peale Digby, in the spring of 1747, he imagined how much better off he might be if he "were out of debt or had no Family"; but he "must submit to the Will of God & trust in him alone."[25] There is in almost all of his letters a tone of complaint, misfortune, and self-pity. He complained that his friends in England had not used their influence with the governor of Maryland to obtain a comfortable office for him. Not even the satisfaction he took in writing about his children could divert him from recognizing that he had not achieved wealth and status in the new world. He was blessed with "Children inferiour to no man in any Respect." His daughter Margaret Jane was "for dutifulness, & good manners equal to any of her Age even in Britain"; "Charly" was "a fine fair-skinn'd but manly straight Boy, & gives me hopes of being a good Genius being very docile"; St. George "is an exceeding beautiful fair Boy." But he prefaced these remarks with the reservation, "if God has not thought fit to bless me with Wealth," reminding his sister of his failure to achieve economic success.[26]

Living in a modest household in which modern notions of privacy and separate living spaces for children did not exist, Charles Willson undoubtedly was aware of his father's unhappiness about feeling trapped in a situation that included responsibility for a young family.[27] To this uncertainty was added the trauma of confronting Charles Peale's sudden death—"my Father who I lost before I could know the Loss of so good a Father."[28] He vividly remembered his grief-stricken mother and the family's sudden poverty and dislocation. His father's financial inadequacy "left his Widow to support his five Children by her Industry alone"; her "distress was great. . . . And in her excess of Grief she could not, for some time, take any measure to assist herself & Children."[29] Charles Willson Peale's eagerness to create a strong and secure family environment and to bring his father's family under his roof are to a considerable degree explained by these vivid memories, which complemented a natural inclination to dominate and control; such a compulsion dovetailed nicely with the still strong institution of the patriarchal family in the Chesapeake region. Peale's patriarchal impulse, however, would run up against massive changes in Anglo-American society that would begin to alter fundamentally the family as an institution.

The American family was transformed in the latter third of the eighteenth century. The change, according to Daniel Blake Smith, was from the patriarchal model to a "more openly affectionate intimate family environment in which emotional attachments were deeply valued, indeed cherished . . . [resulting in] more privatistic, affectionate, individualistic family forms."[30] Patriarchy was weakened as children became the center of the household, and the role of women, although perhaps more confined than previously to the "domestic sphere" in which they managed the household and took primary responsibility for rearing children, improved markedly.

The emergence of capitalism, democracy, and individualism provides a larger context for explaining the change in the family in this era. The growing affluence of the middle class, greater secularization, and an increase in literacy also contributed to this change. Affluence, for example, freed women to devote more time to child-raising, which altered the perspective and position of children in the family and elevated the domestic sphere by making the child-care role a more central concern, both within the family and in society at large. This development, in turn, was one of the elements that helped form a more definite demarcation of the modern family, with women, theoretically, given authority and control over household management and child care while the men were positioned as the primary breadwinners outside the home.[31] Improving literacy rates for women created a large audience for romantic and sentimental novels such as Samuel Richardson's *Clarissa or The History of a Young Lady* (1748), along with family advice and child-care books; all of these works emphasized closer emotional ties among family members and contributed to the decline in patriarchalism.[32]

The Enlightenment in Europe and America also promoted changes in the family. At the root of what Stone has termed a "reorientation of culture" was a secular attitude, a belief that in a freer society, man could create happiness in this world and not resign himself to its enjoyment in the next.

Man would be able to use his reason to relieve the misery and harshness of life and to make the world a better place. "The pursuit of happiness," in Jefferson's condensed phrase, meant that men could reform and improve society—its institutions, and on an even a deeper level, relations between classes, sexes, and generations.[33]

Changes in the family, in part, were tied to this belief in improvement. Reformers no longer viewed the family as merely a necessary institution that provided orderliness and protection in a chaotic and hostile world. When faith in man's capacity to control and direct events replaced resignation to his fate, it became possible to expand the role and function of institutions, such as government, schools, hospitals, and the family, to maximize human happiness and eliminate misery.[34]

By the late eighteenth century, these Enlightenment ideas had been absorbed into the stylized Romantic image of the Man of Sentiment, epitomized in the Henry Mackenzie novel *The Man of Feeling* (1771) or in Laurence Sterne's *Tristram Shandy* (1759–1767). Peale read Sterne and other English and French authors who wrote novels and essays about the affectionate nuclear family and man's innate moral sense and compassion.[35] It became fashionable for women and men to express their feelings with open outbursts of emotion and tears. Behind the bathos and sentimentality, serious Enlightenment themes for the improvement of society and its institutions helped to generate reform movements designed to end wife-beating and mistreatment of servants and apprentices, to abolish the slave trade, blood sports, and flogging, and to protect domestic animals.[36] In family relationships, besides promoting better treatment of wives and children, this view encouraged the expression of kindness and consideration between husband and wife, and parents and children, and led to the further attenuation of the patriarchal family.[37] Such a view, in the exaggerated rhetoric of the "sentimental," had a profound impact on the Anglo-American elite, and is evident in the paintings, writings, and behavior of Charles Willson Peale.

Peale's early portraits of his first wife, Rachel Brewer (figure 1), flowed with a thick "sentiment" of affection and emotion for his wife and children, "feelings" that were now correct to display publicly. In 1771 Peale painted and placed in his studio a portrait of his wife and daughter Eleanor (unlocated). A poem, probably written by Peale, appeared in the "Poet's Corner" of the *Maryland Gazette* (April 18, 1771), which praised the "soft Emotion" evoked by the subject of the picture, "the Mother and the Wife . . . in sweetest Union join'd." Even more directly tied to the new ideas of "sentiment" and the family was Peale's 1772–1776 painting, *Rachel Weeping* (see plate 63), a portrait of his wife and their dead infant daughter. In 1772 Peale painted the dead infant; later, perhaps as a result of reading such books as Jean François Marmontel's *Contes Moreaux* (1761), which dwelled on the strong emotions existing between parents and children, he added the figure of his grieving wife. John Adams, who visited Peale's painting room in 1776, wrote that he was "prodigiously" affected by the painting.[38] Intensity of affection for one's spouse and deep mourning for a dead child are two clear characteristics, according to Stone, of the modern family.[39]

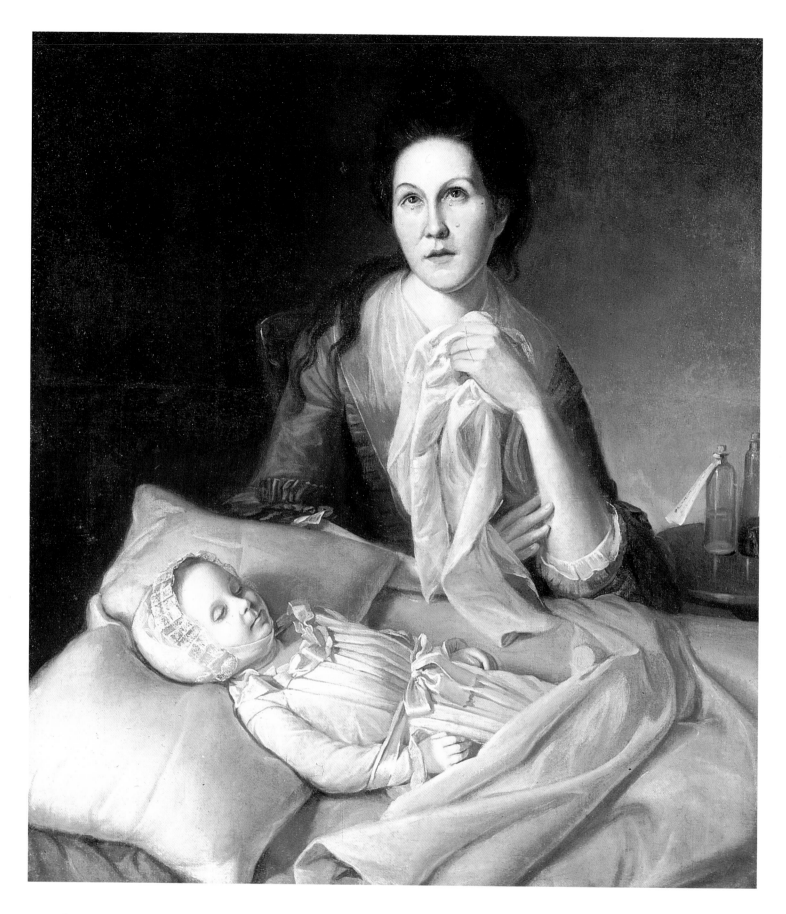

PLATE 63
Charles Willson Peale
Rachel Weeping, 1772 and probably 1776
Oil on canvas, 37 ⅛ x 32 ¼ in. (94.3 x 81.9 cm)
Philadelphia Museum of Art; Given by the
Barra Foundation, Inc.

Peale painted five family portraits, not including the two of his own family, works which included a father, mother, and at least one child. The paintings partially employ what Margaretta M. Lovell has termed the "matricentric" composition which became fashionable among urban elites in Anglo-America after 1760.[40] In this composition, the husband and wife are depicted as equal partners in an affectionate family setting, with the interaction of the mother and children occupying the center of the picture. The father is moved to the side, somewhat marginalized in regard to the action of the painting, indicative of his partial removal from the central family circle. This new fashion in family portraiture presented a visual analogue to the rhetoric of sentiment and the new family.

Older arrangements in family paintings represented a patriarchal family structure, showing a standing or "vertical" father and sitting, or "horizontal," wife and children, with the latter appearing as inanimate, stiff, and dutiful. In the new composition of the companionate family, the father leans toward and sometimes touches other members of the family. The mother in the center of the painting with the children is seen in her new and idealized role in control of the "domestic sphere." Even more significant is the depiction of the children as central to the action of the painting, playful, reaching out to their parents, much less restrained than in earlier family portraits.

Peale's portraits depicting the Lloyds (figure 1.2) and Johnsons (figure 1.3) employed this new arrangement of figures, with the father leaning toward his wife and child in the center of the painting. *The John Cadwalader Family* (see plate 64) has the father in profile handing the child a peach. In all three of these paintings there is no sense of the dominance of the patriarch that characterized the pre-1760 family compositions. On the other hand, when Peale painted the Valettes in 1774 (figure 1.4), his last colonial family portrait, he may have arranged the figures in the way he believed that family would expect—husband and wife on an equal plane left and right, with their two children between them—to create what Lovell terms the "naive family painting." These were portraits by either untrained artists, or accomplished painters such as Ralph Earl, who worked in geographical areas outside of the more cosmopolitan urban centers. Such "two-dimensional" compositions lacked the complex "affectionate" family interaction of the new model and gave to the figures an "evenness of emphasis." Perhaps Peale thought this traditional composition, with greater division between the father and mother, more appropriate for Valette, a provincial bureaucrat in Annapolis, as opposed to the family portraits he painted for his more fashionable Philadelphia patrons. Peale's last family portrait was his 1789 piece of the Goldsboroughs (plate 65), the most "horizontal" of his family paintings, with all family members seated on an equal plane.[41]

In all of the Peale family groups there is, contrary to Lovell's model, not only interaction between the father and children, but less marginalization of the father. In the Lloyd family group, Edward supports his young daughter Anne as she stands on the sofa next to her mother. His wife Elizabeth does not interact with the child, but plays a guitar. In the Cadwalader family portrait, John stands proudly, dressed in lace sleeves and gold embroidery, his appearance in profile not marginalizing him but accentuating his prosperous extended

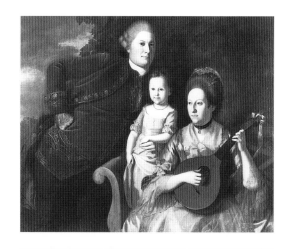

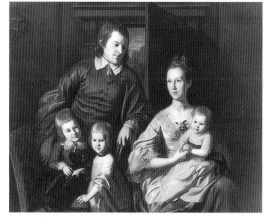

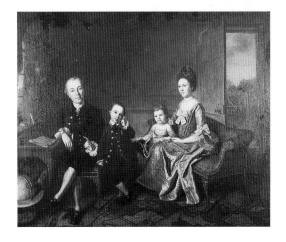

FIGURE 1.2
Charles Willson Peale
The Edward Lloyd Family, 1771
Oil on canvas, 48 x 57 ½ in. (116.8 x 146.1 cm)
The Henry Francis du Pont Winterthur Museum, Delaware

FIGURE 1.3
Charles Willson Peale
Thomas Johnson Family of "Rose Hill," 1772
Oil on canvas, 48 x 58 ½ in. (116.8 x 148.6 cm)
Collection of C. Burr Artz Trust, Frederick, Maryland, all rights reserved; on loan to Baltimore Museum of Art

FIGURE 1.4
Charles Willson Peale
The Family of Elie Valette, 1774
Oil on canvas, 30 ½ x 38 ⅛ in. (76.5 x 96.8 cm)
Private collection

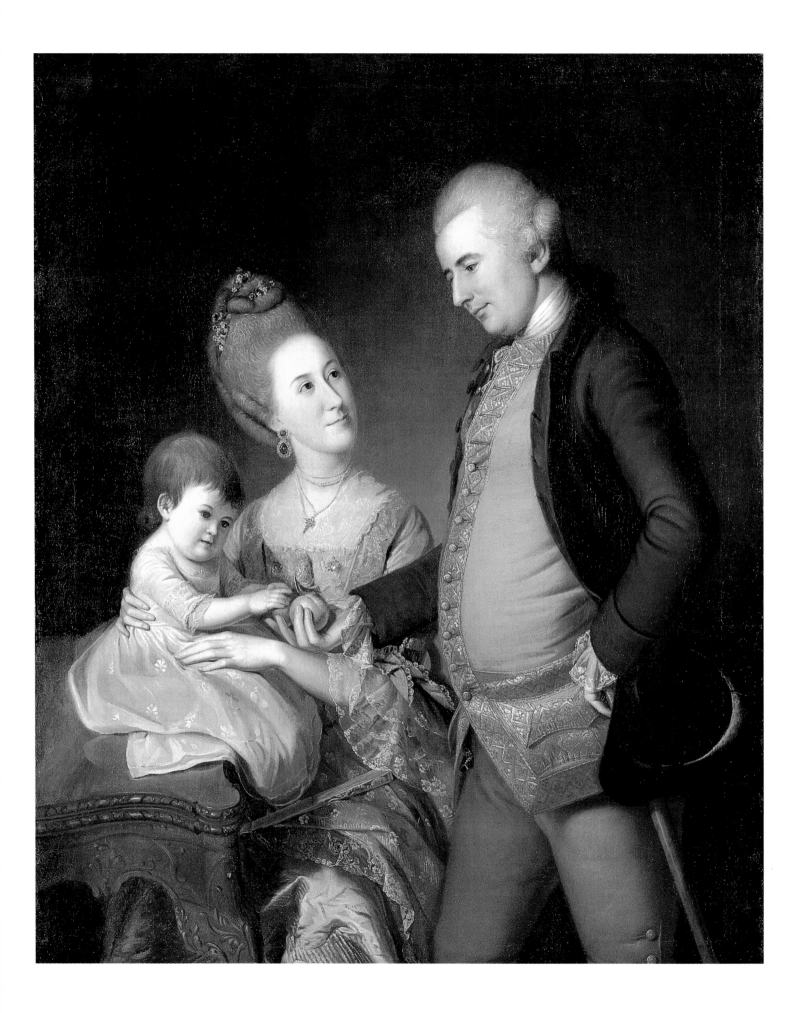

stomach. His wife, Elizabeth Lloyd, sister of Edward, looks up to him admiringly as he offers his young child a symbol of his prosperity, a fresh peach. Peale placed Thomas Johnson's two older children close to their father, with the oldest boy standing on a chair, braced by his father's arm. In the Valette family painting, Peale made the father and son more central by placing them slightly in the foreground with the son leaning against his father. In the Goldsborough family painting the son, Robert Henry, leans his arm on his father's shoulder. In all of these works Peale placed the "vertical" and aloof patriarch within the family and gave him a more active role, more consistent with his still strong sense of patriarchy in an era of transition in the history of the family.

Peale's writings also portray him as a man of sentiment. Most revealing is a nine-page section of his diary kept in December 1778 that constitutes the only sustained narrative in the document and is situated near the middle of the journal. The fragment, narrating his encounters on a three-day "journey to Maryland," seems almost out of place in a diary that consists mainly of memoranda relating to Peale's activities in Philadelphia as an agent for the confiscation of Tory estates.[42] Unlike the discrete and hurried entries of the rest of this diary, Peale's account of his trip appears to have been written in one sitting. It is possible that Peale embellished or telescoped events to identify himself as a man of "sentiment."

During this brief trip, Peale encountered soldiers from Philadelphia, one of whom bragged about "his many feats in the Wars of Venus," and "those Houses of nightly revel in the City of Phi:a [and] also the Secret History of

PLATE 64
Charles Willson Peale
John Cadwalader Family, 1772
Oil on canvas, 51 ½ x 41 ⅛ in. (130.8 x 104.4 cm).
Philadelphia Museum of Art; The Cadwalader Collection; Purchased for the Cadwalader Collection, funds contributed by the Pew Memorial Trust and a gift of an anonymous donor

PLATE 65
Charles Willson Peale
Robert Goldsborough and Family, 1789
Oil on canvas, 40¾ x 63 in. (103.5 x 160 cm).
Private collection

the debauchery of some Marryed men amongst my Acquaintance . . ." Peale was horrified to learn that such men who had families where they "might find all the Enjoyments of a Domestic Life, should go abroad . . . with [a] sett of Prostatutes."

The next day he met a "young Woman," who told him of her sister who had been married ten years but had no children. Peale wondered about the "fault" in the marriage. The woman, however, believed that her sister, "was better without [children and] that she would have a great deal of Trouble with them." Peale drew the moral of the tale by noting that the sister said she "did not care how much Trouble she had provided she could have one."

Later that day he was followed by a dog to whom he had given scraps of food. In his hurry to catch a ferry, he forgot about the animal, and continued his journey to an inn. After "some time . . . this Dog came Running onto the House panting and trembling with the fateague & Cold. [He] . . . had swam the River which is one mile & quarter wide—Poor Animal! I feed him and took him into the bed Room with me, he certainly deserves to be loved & made much of, I will use him like a good friend, he never shall want a good meal while I have it myself."[43]

The following day Peale encountered a group of cavalry officers from Virginia who "are much adicted to swearing much more so than any of the more northern states." Peale "Conjecture[d]" that the swearing was because of the "great number of Slaves" they were "accustomed to tyranize & domineer over . . . to Lord it over these unhappy Wreches." The Virginia slave owners had become "Laisy . . . and of Course dissipated." The result was a society of the "very rich & very poor . . . [in which] the Rich are without Controul the Lords & Masters." Where there is "greater equality," men are "more circumspent in the[ir] Words and Actions." To Peale the Virginia officers appeared to be brutal patriarchs.

The diary records what Peale thought was important, what he wished to remember, or how he wished to be remembered. It is significant for showing his acceptance of many of the new ways of viewing the world. However, it is also necessary to view this diary—especially because of its abstracted nature and its heuristic tone—as part of Peale's construction of himself as a man of sentiment. That Peale's projection of himself could jar with reality is apparent from memoranda following the fragment. Just below his denunciation of slavery are two entries in which he, as an agent of confiscated estates, took possession of two slaves and appraised them for future sale. Although Peale often condemned slavery and manumitted at least one of his own slaves, as a man who grew up in a slave society he owned several slaves himself. The point is not that Peale was a hypocrite, but that his assertions and expression of ideals cannot be taken at face value.[44]

When we move from the ideals portrayed in Peale's family paintings to the reality of Peale's family life in the 1770s, we glimpse a somewhat mixed picture of Peale's relationship with his wife and children. His family seemed to fit neither the patriarchal model of his father's generation nor the modern affectionate family, but contained elements of both, which might be expected in this era of change and transition.

In the mid-1770s Peale decided to move his family from Annapolis to Philadelphia. For several years he had made painting trips to Philadelphia, but complained that he could not "stay so long from my Wife and use her well."[45] In the fall of 1775 Peale began a lengthy, two-stage relocation of his family to Philadelphia.[46] In October 1775, while still with his family in Annapolis, his diary shows him involved with his "only child," the twenty-two-month-old Raphaelle, staying up with the young child "every night" for an upset stomach.[47] In November, he sent his family to Charlestown, Maryland, to live with his sister, Margaret Jane, and brother-in-law, Nathaniel Ramsay. He reunited with his family on November 27 in Charlestown, stayed there for almost three weeks, but made no entries concerning his family; he had become preoccupied with the Revolutionary crisis and filled his diary with notes on his experiments in making gunpowder.[48] On December 18, he set out for Philadelphia, just two days before his wife Rachel gave birth to their daughter, Angelica Kauffmann. On December 29, Peale received the news of the birth in a letter from his brother James, and noted in his diary, in sequence, that he continued work on a miniature, received a letter from James, "acquaintg me that he walked from . . . [Philadelphia] in 2 Days and a good deal of Snow on the Ground. And that Mrs. Peale was delivered of a fine Girl on 20th."[49]

Peale returned to his family in Charlestown on February 3, 1776, spent the entire week making gunpowder and experimenting with his rifle, but did not mention the new baby or any family matters until the eleventh, and even then only to mention his brother-in-law.[50] During the following week, the diary is filled with similar entries, and not until February 19 does another entry discuss his family: "made Raphiel a fur cap."[51] On June 17, after more traveling to Philadelphia, Peale returned to Charlestown, and packed the family up for the move to Philadelphia. His diary entry of that day gives Peale's first mention of his new daughter since hearing the news of her birth, as well as the first mention of Angelica by name.[52] What separates this account of Peale's family life from the ideal picture of the new nuclear family is Peale leaving his family two days before his wife gave birth, and, after learning of the event, not returning to Charlestown for more than a month. Nor is there any indication that he wrote to the family during that time. Perhaps he could not leave Philadelphia; possibly he sent his brother James to Charlestown to look after them.[53] It is possible, also, his paintings and writings notwithstanding, that Peale's level of involvement with his nuclear family was not what historians have described in their models of the modern family.

The birth of Peale's second son, Rembrandt, on February 22, 1778, presents a similar situation. In September 1777 the British invaded and occupied Philadelphia, and Peale and other prominent republican radicals were forced to flee the city with their families. During the winter of 1777–78 Peale placed his family on a farm in Bucks County, Pennsylvania, a location of only relative safety, but as far as he would travel, Rachel being in the late stages of pregnancy.[54] Peale was concerned about this birth because Rachel was not close to family and friends, and it might be necessary to stay with her. He was, however, anxious to obtain a horse so that he could ride to Washington's encampment at Valley Forge and paint miniatures.[55] On

February 13, with his new horse, Peale set out for Valley Forge; Rembrandt was born nine days later. Peale had changed his mind about being present at the birth. He probably found a suitable midwife for Rachel, but his diary entry for the thirteenth is silent about any arrangements made for the family. He returned to Bucks County on March 5 and set out with his family to Lancaster on March 23. He did not mention the birth of his son in any of his diary entries for March.[56]

Peale's absences during the deliveries of his daughter and son bring us sharply back from the rhetoric to the reality of the eighteenth-century family. His absences do not seem to fit the ideal of the affectionate nuclear family but are really unexceptionable when viewed in the context of the patriarchal family in eighteenth-century America. Giving birth in this premodern era has been termed "a female ritual and rite"—an event from which males were excluded and in which female midwifes were utilized for all classes of women. Although childbirth was a dangerous and painful experience, it was not considered a "'Great Urgent Cause'" necessitating the attendance of a male physician, but was viewed as part of the natural course of a woman's life; an event which could happen with regularity from within a year or two after a woman's marriage until her menopause.[57] Other female family members, the midwife, or women in the neighborhood would often be present. Neither was a birth an event that took place in a nuclear family setting. A wife might return home to be with her mother if she was not too far away. Mrs. John Dickinson, for example, whose portrait was postponed until after the birth of her daughter, is portrayed with the baby against a background of her family's estate (plate 66). Peale's role during the birth of his children seems to have ended once he located his wife in a safe place.[58]

Peale's patriarchalism is also evident in his sense of extended kinship.[59] In many instances he made little distinction between his nuclear family and members of his extended family: adult siblings, nieces and nephews, servants, and slaves.[60] This extended sense of family is evident and illustrated in another family painting Peale did later in life, *The Exhumation of the Mastodon* (see plate 10). Although only his son Rembrandt was actually involved in the episode, Peale placed numerous family members in the painting, including two wives, nine children, a daughter-in-law and son-in-law, his brother James, and his second wife's sister and her husband. Other well-dressed men, women, and children in the painting are not identified, but may have been members of his extended family.[61]

Peale's strong sense of patriarchy persisted into the later decades of his life, as did his earnest desire to adopt the sentiments of the modern family. Peale's transitional status—the push and pull of both family models— is evident in the important role he played in the marriage of his children. In the patriarchal model, the selection of marriage partners was made to the advantage of both families by the fathers, with practical and financial considerations given priority. Romantic love was not supposed to be an important factor; children at most had a veto power. By the late eighteenth century, romantic love was viewed *ideally* as the most important, if not the *only* basis of marriage selection, and parents played much less of a role in the process.[62]

PLATE 66
Charles Willson Peale
Mrs. John Dickinson and Her Daughter, Sally, 1772
Oil on canvas, 49 x 39 in. (124.5 x 99.1 cm)
Historical Society of Pennsylvania, Philadelphia

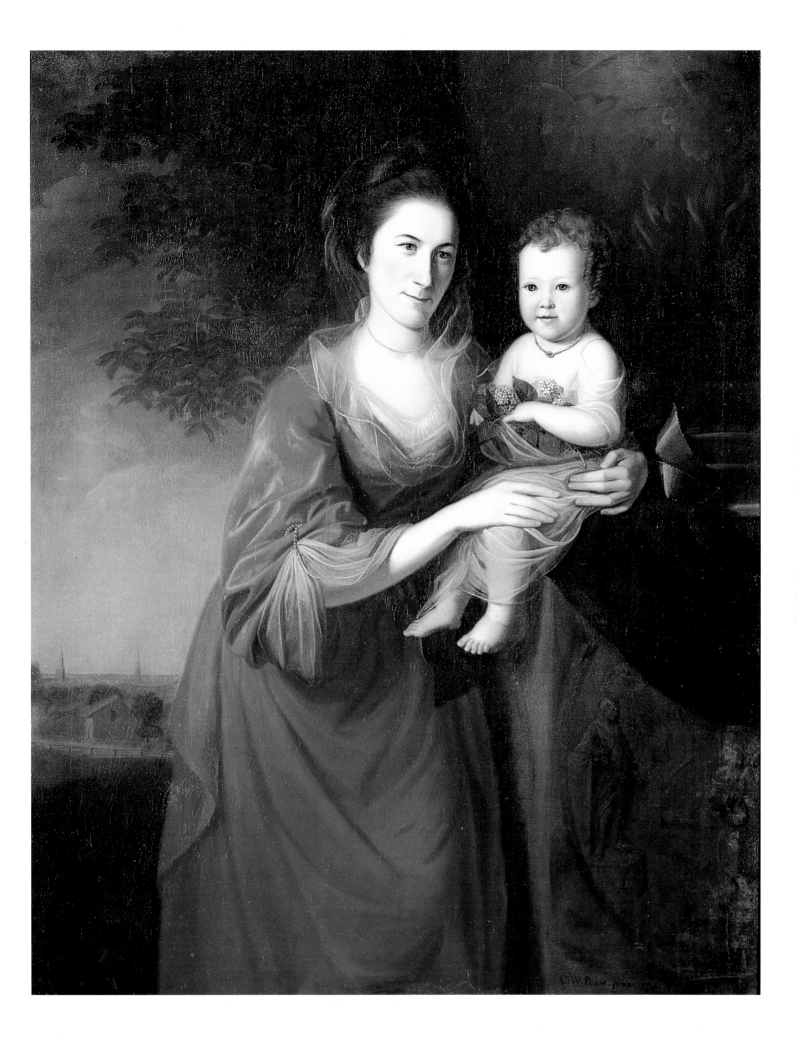

On July 8, 1816, Peale, who at seventy-five years old still had two teenagers in his household, would not allow his eighteen-year-old daughter Sybilla Miriam to visit her older sister Angelica in Baltimore. "She is young," Peale wrote, "and not acquainted with the habits and customs of the world—she has yet to learn that she must submit to the will & pleasure of others." In the same letter Peale somberly discussed his son Franklin's troubled marriage, and added a general comment on the subject: "I consider the marriage of our Children the most important act that we are concerned in & perhaps as difficult to govern as any we are concerned in. I believe we have no right to control but only to advise, and they are happy whose advice is good, and well received."

The quotation reveals the transitional nature of Peale's views of the family. While disclaiming any right "to control" these situations, he could not relinquish the father's role "to govern" and "to advise."[63] And Peale's ambivalence about his parental role in regard to his children's marriage arrangements is just, from the vantage point of the patriarch. His children, while usually willing to defer to his authority, feared his interference in these situations and in many instances kept their marriage plans a secret from him. What is startling in this incident with Sybilla is that Peale had not yet been told by other family members that Sybilla had secretly married Andrew Summers on November 9, 1815.[64] She was not his only child who secretly married. At least two—Franklin in 1815, and Linnaeus probably in 1816—married without previously informing their father.[65] In addition, an acrimonious conflict occurred when his twenty-one-year-old son Titian announced his intention to marry. Peale disapproved because he believed his son was in no financial position to marry, and because he despised the intended bride's family.[66]

The most serious of these episodes, and the most telling in regard to Peale's ambivalence, took place over Franklin's marriage to Eliza Greatrake. Franklin met Eliza in 1814, during his training at a textile machine manufactory in the Brandywine River Valley in Delaware.[67] According to Peale, the nineteen-year-old Franklin had told him that he had "no intention of taking a Wife in less than two or three years." On April 24, 1815, however, while Eliza was staying at the Peales' farm, "she went with Franklin without my knowledge or consent & got Married at Germantown."[68] The marriage brought grief to both families. On May 6, 1816, Eliza was placed by her mother in the Pennsylvania Hospital, admitted as a "lunatic" and kept there for almost four years, largely at Peale's expense. Peale later had Franklin's marriage annulled, claiming that Eliza had been insane before the union.[69]

The whole episode—certainly from the point of view of the Greatrakes—has not been fully researched, but testimony at arbitration hearings to determine who was responsible for Eliza's maintenance reveals interesting differences of perspective not only between father and son, but within Peale himself. A close friend of the Greatrake family testified that Eliza's father objected to the marriage because of Franklin's youth. Franklin responded by showing Greatrake a section of Peale's *Essay on Domestic Happiness* that strongly supported early marriage.[70] The spectacle of the son quoting his father's words in an argument with Eliza's father and at the same

time fearful of telling his own father of his marriage plans formed, as Peale characterized a different family "deception," "a melancholy picture in a farcical dress."[71]

Charles Willson Peale gave his first four children, who all died within a few years of birth, family names, a practice often utilized in the older family structure to emphasize kinship ties. He gave his fifth child the name of an artist. After Raphaelle, he named his eight boys and four of the five girls after artists and scientists, indicative perhaps of a break with the concept of the extended family.[72] But Peale's shift from the older extended family to the nuclear household did not mean a diminution of his patriarchal authority. As one historian has suggested, in the transition from the older extended family to the more private nuclear unit, there was often more leeway for a greater exercise of patriarchal authority. The names that Peale gave his children should not be viewed as the amusing fancy of a gentle and largely passive father, but as indication of the well-defined directions in which he would educate and govern his children.[73]

The shift in Peale's naming pattern from extended to nuclear household mirrors changes in the family during his lifetime. These changes—the transition to the modern family which Peale embraced in his paintings and writings— made for difficult situations and misunderstandings, particularly with his second cohort of children. Peale's desire to perpetuate the patriarchal family of his father and to control his children ran into conflict with the greater freedoms they expected as a result of his statements and beliefs in favor of less patriarchal authority. However, despite such contradictions and conflicts Peale, on his terms, was a successful parent; he governed his family and developed almost all of his children in ways he desired. His daughters all married and bore children.[74] He named his sons for artists and scientists, and all but one followed careers along those lines, contributing to the culture of the new nation and prompting one historian to refer to the Peales as "arguably the most talented family raised in Revolutionary America."[75]

Two

~

Charles Willson Peale Portrays the Body Politic

~

DAVID STEINBERG

CHARLES WILLSON PEALE explicitly pursued politics for only a few years following his move to Philadelphia in 1776, but his beliefs about the proper way to construct the social order affected his art over the course of some six decades of painting. Making portraits that emphasized expressive physical features, personal traits, and biographical facts, Peale shaped over a thousand likenesses to the curve of various ideals of citizenship. These paintings proposed to viewers what they ought to think about general categories of people as well as individual sitters.[1] Whether portraying highborn or lowborn, men or women, whites or blacks, each of Peale's pictures of the human body intervened in the ongoing debate over how to organize the body politic that dominated the era's public discourse.

Because this debate shifted its structure over the course of Peale's lifetime, it threw into relief different aspects of his rather stable system of values. Early on, his challenges to the standard connection between wealth and status represented what has come to be seen as progressive thinking for the 1760s and 1770s. In the nineteenth century, the hierarchical ideals that he endorsed put him at odds with new democratic ideals that rejected the traditional basis for organizing white society into ranks. Proceeding in chronological order through Peale's career, this essay aims to illuminate how his portraits aligned sitters with some contemporary categories of social order while distancing them from others.

At the outset of his career, seeking to please a wide variety of patrons and sitters who followed their own political convictions, Peale could not always depict his model citizenry. Indeed, in *Richard Bennett Lloyd*, made soon after he returned to his native Maryland from two years of study in London, he painted a portrait that promoted the very model of rank that he contested (see figure 2.1). The canvas embeds the features of one of the colony's wealthiest men within a sign system that claims how ease with vast property qualifies a white man for the highest of social positions. Looking off toward a landscape vista that suggests the enormous Lloyd holdings on Maryland's Eastern Shore, the image of the sitter denotes Lloyd's status as gentry. Its nonchalant relaxation signals a mastery of the body-management skills associated with high station.[2] With his arm leaning against a festooned plinth (a synecdoche for a grand domestic building), the painted figure acts out the

PLATE 67
Charles Willson Peale
Washington After the Battle of Princeton, January 3, 1777,
1779–1782
Oil on canvas, 96 ½ x 61 ½ in. (245.1 x 156.2 cm)
Princeton University Art Gallery, Princeton, New
Jersey; Bequest of Charles A. Munn

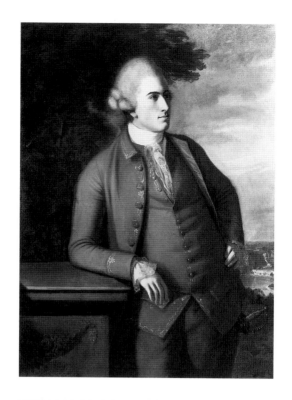

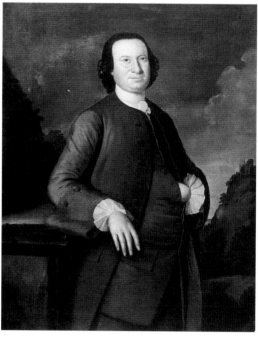

FIGURE 2.1
Charles Willson Peale
Richard Bennett Lloyd, 1771
Oil on canvas, 48 x 36 in. (116.8 x 91.4 cm)
The Henry Francis du Pont Winterthur Museum,
Delaware, Gift of H. F. du Pont

FIGURE 2.2
John Hesselius
Thomas Sprigg, 1764
Oil on canvas
North Carolina Museum of Art, Raleigh;
Gift of Mr. and Mrs. Charles V. Cheney

idea that property is a stable basis for rank. Moreover, by imitating the format, pose, and setting of *Thomas Sprigg,* a portrait by John Hesselius of another of Maryland's wealthiest men, the painting declares both a conservative social agenda for its sitter and his solidarity with other members of his class (figure 2.2).[3] Yet some fifty years later, Peale recalled with scorn Lloyd's reputation as a miser who saved rusty nails,[4] a piece of gossip that demonstrates the painter's distance from his act of accommodating sitter to social role when composing his portrait.

Peale's own ideal for white men found expression in another pictorial borrowing from the early 1770s. When depicting the gesture of a rule pen raised toward the head to signal creative inspiration in the portrait of the architect William Buckland (figure 2.3), Peale drew upon a portrait of himself with *porte-crayon* that Benjamin West had painted and presented to his occasional pupil in London (figure 2.4). The personal nature of this source shows Peale identifying with his sitter's capacity for ingenious design. Both men would also have recognized the similarity between their rise from low social origins to a respectable middling position in the local prestige order, a rise proclaimed if not propelled by their possessing portraits of themselves.[5]

The incommensurate models of social identity represented by *Lloyd* and *Buckland*—one that valued a man for what he inherited and one that emphasized what he did—generated a tension that fueled dramatic changes in the social structure of Annapolis and other cities during the late colonial period. The unquestioned attribution of the highest rank to men of wealth collapsed along with the traditional belief that such men always acted with disinterest on behalf of the common good. Simultaneously, men who lacked genteel social connections sought to fill the vacuum of credibility created by the withdrawal of faith from the old elite. They ran for political office and, in Philadelphia, organized extralegal committees and militia.[6]

As a former apprentice who possessed little property, Peale recognized the contribution of all ranks of society to the public welfare. But unlike many other men trained as artisans, he did not take his humble origins to mean that he could not participate in society at higher levels. His occupation as a painter of easel pictures, with its connection to the lofty tradition of the Fine Arts, provided him entrée to elevated circles such as the Homony Club of Annapolis. Entering into politics upon arriving in Philadelphia, he served on several committees representing middling and lower-labor-class interests. He also availed himself of newly created opportunities for men with little property to hold public office, and occupied a seat in the Pennsylvania legislature for the 1779–1780 session.[7] Not only in the realm of portrait painting, but in the political arena as well, Peale took on the estimable and challenging task of representing his contemporaries.

On the basis of his experiences as a painter in the social crucible of Annapolis during the 1760s and early 1770s, Peale came to prize the personal qualities that enabled him to advance his social rank above that of saddler, a trade already relatively high in the hierarchy of manual trades due to its complexity. What he learned during those years also informed his goals for his portraiture and spurred him on to master the formal means to fulfill them. It was not until 1818, however, that Peale finally jotted down a principle that

had guided much of his portrait production. On the occasion of his failure to get a meritorious but unattractive man to sit for him, he proclaimed his indifference to superficial appearances: "It is the mind I would wish to represent through the features of the man, and he that does not possess a good mind, I do not desire to Portray his features."[8] In its invocation of individual capacity, this statement complemented Peale's politics. This is not to say that he dismissed the values of a social hierarchy that accorded top rank to well-off, well-educated, well-bred, and well-connected white men. He simply added another criterion.

When considering what made a mind "good," Peale made no distinction between intellect and morality. Almost every element in his 1804 list of the highest mental faculties relates to the advancement of the public welfare:

> The Supreme Creator in his goodness has indowed man with a reflecting mind, he can compare the present with the past, he knows from the combination of certain things the results, he can calculate the revolution of the Planets, he can produce by labor of the hands various and wonderful works of art, and with knowledge of the various powers, of the lever, the screw & the wedge, he can make machines to lessen labour, and multiply the conveniences & comforts of Life, he can analize & know the componant parts of every kind of Substance by acutal [actual] experiments, so that nature are subjects of his researchs to acquire knowledge.[9]

Not surprisingly, these capacities gloss many of Peale's portraits. *William Buckland,* for example, fulfills the claim that man "can produce by labor of the hands various and wonderful works of art," although that painting emphasizes the mind that designs what the hands of others will build.

Peale's desire to represent good minds stemmed from a vision of the social functions of portraiture, according to which the genre could both honor minds that were worth commemorating and supply viewers with role models. By providing prescriptive images of ideal mental qualities, he in effect reconceived the contemporary history painter's ideal of an *exemplum virtutis* as an *exemplum ingenium.*[10] Classical republican thought posited a direct correlation between intellect and virtue, identifying the possession of the former as necessary to the exercise of the latter. As Thomas Jefferson wrote in 1779, only those few "whom nature has endowed with genius and virtue" could "be rendered by liberal education worthy to receive, and able to guard the sacred rights and liberties of their fellow citizens."[11] Not only would the possession of a good mind put a man in a class above other men, but in a successful republic it was an essential attribute of such a man's capacity for leadership.

Answering the question why Peale sought to portray good minds is less problematic than accounting for the way he attempted to portray them. Although he asserted that "It is the mind I would wish to represent through the features of the man," it is unclear what a man with a good mind would look like. At least some contemporary viewers had no difficulty determining when the appearance of a good mind was absent from a portrait head.[12] As the British painter Thomas Gainsborough lamented about a seventeenth-century portrait of Shakespeare, "Damn the original picture of him, *with your*

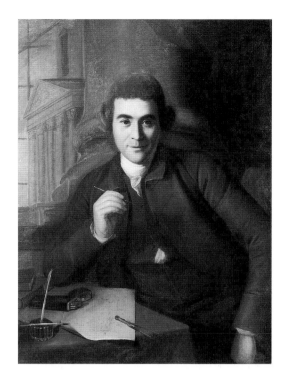

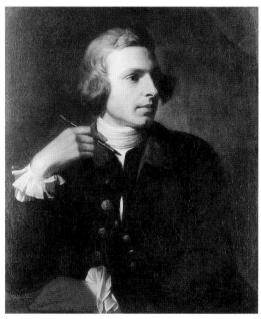

FIGURE 2.3
Charles Willson Peale
William Buckland, 1774 and 1787
Oil on canvas, 27 ½ x 36 ⁵⁄₁₆ in. (69.9 x 93 cm)
Yale University Art Gallery, New Haven,
Connecticut; Mabel Brady Garvan Collection

FIGURE 2.4
Benjamin West
Charles Willson Peale, c. 1768
Oil on canvas
Collection of The New-York Historical Society

FIGURE 2.5
Martin Droeshout
William Shakespeare, c. 1623
Engraving
By permission of the Folger Shakespeare Library,
Washington, D.C.

FIGURE 2.6
Charles Willson Peale
John Quincy Adams, 1818
Oil on canvas, 24 x 20 in. (61 x 50.8 cm)
Historical Society of Pennsylvania, Philadelphia

leave; for I think a stupider face I never beheld . . . it is impossible that such a mind and ray of heaven could shine with such a face and pair of eyes as that picture has" (figure 2.5).[13] When depicting Secretary of State John Quincy Adams with an enormous, illuminated pate similar to the one Martin Droeshout engraved almost two centuries earlier, Peale stumbled upon the same unappealing solution to the challenge of representing a powerful mind (figure 2.6). Perhaps the declaration of his "good-mind" agenda to his diary on the same day that he had the first of three sittings with Adams made him overly self-conscious about his goal. In this instance, the sitter himself registered irritation, declaring how Peale "has made a Caricature of my Portrait."[14]

Despite such occasional failures, from the outset of his career Peale had been captivated by the possibility of rendering intelligence. In 1763, during his first trip to Philadelphia to buy art supplies, he saw a self-portrait (unlocated) by the recent English émigré Christopher Steele. As Peale described the picture in his autobiography, it was "a half-length portrait of himself an entire front face, very like . . . good drawing and very expressive in a countenance of penetrating earnestness, with great force and relief." Unfortunately, apart from general references to good drawing and relief, Peale did not note the means by which this painting worked its spell. None of Steele's colonial work has been identified, but his English oeuvre includes faces whose penetrating earnestness compare with mature works by Peale.[15]

Peale's encounter with a representation of a good mind preceded his ability to paint one himself. Before his London trip, he produced faces with innocent, sweet expressions like those found in the contemporary work of his teacher John Hesselius.[16] Only after he went to London was he able to depict convincing signs of intelligent life, and probably first in the medium of watercolor on ivory (see plate 68).[17] The superb head of Matthias Bordley—turned in three-quarters view, inclined slightly, and gazing directly at the viewer from the center of the composition—is nearly spherical at the top. By providing the viewer with a stable point of mental contact in a busy composition, it not only represents an intelligence but functions as a locus of order radiating outward. Since the days that Peale first walked the streets of Annapolis as a boy he had been familiar with the use of geometric forms as organizing hubs (see plate 3); his double-portrait miniature is the earliest extant example of his employing this principle in portraiture.[18]

The head of Matthias Bordley, augmented at the right side of the painting by the sharply narrowing oval head of his brother Thomas—an unlikely seat of thought—employs a representational strategy similar to the one set forth in Robert Dodsley's popular *The Preceptor* (1748). This encyclo-pedic primer advised aspiring gentlemen-amateur draftsmen to "procure a Piece of Box, or other smooth even-coloured Wood, and get it turned in the Shape of an Egg, which is pretty nearly the shape of an human Head."[19] The accompanying plate illustrated how to articulate this shape with vertical and horizontal lines, rotate it left or right, and tilt it forward or back. The idea that the head can be defined in terms of geometric components was part of the broad contemporary concern with essential forms that affected fields of endeavor as diverse as architectural practice and mass production[20] (recall Peale's remark that man "can analize & know the componant parts of every

PLATE 68
Charles Willson Peale
Matthias and Thomas Bordley, 1767
Watercolor on ivory, 3 ⅝ x 4 ⅛ in. (9.2 x 10.5 cm)
National Museum of American Art, Smithsonian
Institution, Washington, D.C.; Museum purchase
and gift of Mr. and Mrs. Murray Lloyd
Goldsborough, Jr.

FIGURE 2.7
Charles Willson Peale
David Rittenhouse, 1772
Oil on canvas
American Philosophical Society, Philadelphia

kind of Substance by acutal experiments"). To identify the oval as the basic schema for a portrait institutes a systematic approach to the genre. As dramatized by the cut-off face in the lower left of Dodsley's plate (no. 11), geometry provided an armature onto which could be grafted whatever distinctive marks approximated the sitter's appearance.

The visual rhyme between face and drawing in *David Rittenhouse* makes that painting a key text for explaining how Peale understood the oval head's capacity to characterize a male sitter (figure 2.7). Cradling a geometer's stylus in hand, the astronomer gestures with outstretched index finger toward a drawing that shows a comet at his fingertip, the earth's orbit as a circle, and that orbit traversed at two points by the comet's orbit. The ostensible action is a lesson about scientific principles applied and information gained in 1770 when Rittenhouse discovered a comet and plotted its trajectory (recall Peale's remark that man "can calculate the revolution of the Planets").[21] Using a convention of astronomical drawing that represents a point of view beyond the limits of earth, the diagram attests to the regular, oval motions of a macrocosm whose rhythms Rittenhouse's mind—housed within a regular, oval microcosm—discovered through observation and extrapolation. The portrait as a whole not only invites viewers to understand the nature of rational movements of the universe, but advances rationality as an ideal for the motions of the mind.

The abstract sign of the oval head appears with some frequency in Peale's work; yet, whether he used it or more naturalistic contours in a given portrait, he also painted facial surfaces that, due to psychological processes still incompletely understood, invite viewers to project onto them vivacity and sensibility.[22] The telling phrase with which he first described the contents of his Revolutionary-War portrait series evidences his intent to depict bodily forms as if they naturally coincided with mental qualities. In 1779, he conceived a plan "to Etch a Set of Heads of the Principal Charactors Who has distinguished themselves during this Contest."[23] He did not make such a series of prints until 1787 (see plates 7,9), but he was well under way with a set of paintings on this theme by 1783 when he reflected "I have between 30 or 40 portraits of Principal Charactors, this Collection has cost me much time & labour."[24]

While "Principal Charactors" can be synonymous with "important people," the phrase denotes "leading personal characteristics" in a widely disseminated usage from the article "The principal Characters and Virtues of the Romans, with respect to War" in Charles Rollin's popular *The Method of Teaching and Studying the Belles Lettres.*[25] Under this rubric Rollin considered such traits as "Perseverance and Constancy in a Resolution once taken and decreed" and "The Habit of inuring themselves to painful Labours and military Exercises." His attention to qualities especially esteemed among military men fits neatly with Peale's concerns, given the exclusive attention to army personnel in his first idea for a portrait print series and the centrality of men of war in his earliest paintings for his museum. The passages quoted above, then, are simultaneously literal and figurative, announcing that he sought to etch heads—and had painted portraits—of characteristics. It is as if his depicted bodies of specific people were also allegories of personal traits.

At least one museum visitor responded to the paintings in such terms. Upon seeing *John Paul Jones* (figure 2.8), the British commodore Sir Edmund Affleck (d. 1788) declared, "I know not who this portrait is intended to represent; but, however great the merits of others may be, I see no expression of countenance in the collection, that gives to me so perfect an idea of bold and inflexible resolution"[26]. Peale may not have labeled his installation clearly, or Affleck may not have cared to read whatever texts were available. And it is probably no coincidence that he responded so strongly to the portrait of a man in the same line of military service as himself. Nevertheless, independent of any acquaintance with the sitter, Affleck understood a portrait to represent personal traits. Even the characteristic he singled out for praise —"bold and inflexible resolution"—closely resembled one that Rollin had noted in the Roman military—"Perseverance and Constancy in a Resolution." The visual signs for this in Jones may have been the uplifted eyes and the dramatic upward tilt of the entire head toward the sitter's proper left side, an angle emphasized by the lines of his hat.

While the representation of good minds might seem to offer a means to promote a meritocracy—a social hierarchy based solely on individual merit—its meaning was ambivalent, and shifted according to the sitter's class background, sex, and age. In *Timothy Matlack* (Private collection; on loan to Museum of Fine Arts, Boston), whose sitter lacked much property or high social standing but who served as secretary to the Pennsylvania Assembly's Supreme Executive Council from 1777 to 1782, individual talent as the primary basis for rank is affirmed.[27] In its almost singular attention to government service and its intelligent fulfillment, the portrait declares its sitter's qualification for office. In a complementary manner, it validates the assembly's founding principles.

Constituted in 1776, the Pennsylvania Assembly was a radical experiment in government that rejected the typical bicameral structure of a popularly elected lower house and elite upper house. Cast as a unicameral legislature, the assembly purported to provide a government in which the people's representation would not favor the special interests of the wealthy. It even limited the power of its body of overseers, the Supreme Executive Council of Pennsylvania.[28]

Affirming the rejection of social attributes that had given rise to the assembly, *Timothy Matlack* presents a figure set against an empty background while including a head-on-hand gesture and forehead-indicating finger that denotes a conspicuous capacity for cerebration oriented toward action. Significantly, the only other instance of Peale using this gesture in all of his portraits of living men appears in *Thomas Paine,* a portrait of another sitter without wealth or proper social connections (figure 2.9).[29] The abundance of published and written materials in Matlack's portrait indicates other credentials for office, such as a familiarity with the law (the legal volumes below the table), piety (the New Testament on the table), and industriousness (the neatly bound bundle of correspondence). The projecting seal-adorned scroll concludes prominently with an imitation of Matlack's signature, thereby announcing his service as keeper of the council seal.[30] Perhaps the most surprising evidence of the workings of Matlack's mind in the painting is

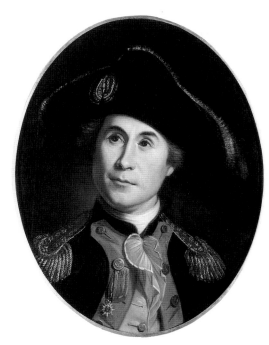

FIGURE 2.8
Charles Willson Peale
John Paul Jones, c. 1781
Oil on canvas
Independence National Historical Park Collection,
Philadelphia

FIGURE 2.9
James Watson (after lost Charles
Willson Peale painting)
Thomas Paine, published 1783
Engraving
National Portrait Gallery, Smithsonian Institution,
Washington D.C.

The London printmaker erred in lettering the
subject's name in this print, which he took from an
original painting (now lost) owned at the time by
South Carolinian Henry Laurens (1724–92).

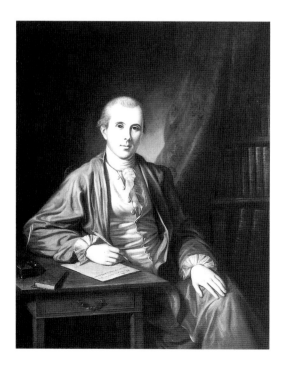

its careful delineation of worry lines and crow's feet. These traces of prior facial muscle movement set the portrait far apart from the idealization common in portraits of well-to-do sitters; by analogy, the wrinkles announce Matlack's distance from such sitters.

Alternatively, the portrayal of wealthy, established men such as Thomas Wharton (1777, private collection) and Samuel Mifflin (figure 2.10) with intelligent faces reinforced conservative ideals. These paintings of "good minds" evidenced their sitters' membership among the "natural aristocracy," a contemporary category devised by those whose hegemony the new politics threatened. Alarmed by the rejection of the stewardship of the highborn, Wharton and Mifflin nonetheless continued to occupy posts in the Pennsylvania Assembly. In their portraits, however, they affirmed their connection to other, more reputable social institutions. Both men had their wives painted along with themselves, so that each pair of paintings represents a couple bound in wedlock (figure 2.11).[31] (Matlack had been married since 1758, but his portrait apparently had no pendant.)[32] Depicting the council's president Thomas Wharton, Peale included law books below the table and a tabled sheet inscribed with council matters, as in the *Matlack,* but in the window vista of the Philadelphia coastline he recalled the source of Wharton's wealth in mercantile activity. The nearer view of sea and ship in *Samuel Mifflin* identifies the same basis of prosperity for its sitter. In all three cases, pictorial background is a visual metaphor for social background.

An even more extreme rejection of the assembly is represented by *Benjamin Rush,* in which the cerebral figure in the casual undress of a morning gown sits secluded in a study that lacks any window to the outside world (figure 2.12). Rush had initially criticized the assembly in restrained terms, and soon disowned the radical movement entirely. He wrote bitterly about the Pennsylvania constitution during these years, calling it "absurd in its principles," and lamenting how it "substituted a mob government to one of the happiest governments in the world." Elsewhere he scorned how "They call it a democracy—a mobocracy in my opinion would be more proper," and claimed that "my family and my business now engross all my time and attention. My country I have long ago left to the care of Timy. Matlack, Tom Paine, Charles Wilson Peale, & Co," mocking these men for claiming a capacity to govern.[33]

Showing Rush at a scene of writing similar, if not identical, to the place where he produced these letters, Peale offers a pictorial counterpart to Rush's rejection of the world of politics. A refined gentleman imagining himself addressing others of his station, he pauses to consider a work in progress. His paper reads, "Sec. 29. We come now gentlemen to investigate the cause of earthquakes." Because there is no record that Rush ever wrote or delivered a treatise on such disasters, however, this sentence needs to be considered an invention, contrived to serve the purposes of the canvas as a whole. The pose of preparing an oration showed the scholarly doctor contributing to the public good in a way other than political participation. Rush believed that every citizen of a republic should "be taught that he does not belong to himself, but that he is public property."[34] From this perspective, his portrait shows him fulfilling this ideal and providing viewers with an exemplum of civic activity.

The specific oration in the painting, however, represents Rush's uneasy relation to Philadelphia's public sphere in the 1780s, for it sublimates into the imagery of a natural phenomenon his belief that government by the assembly threatened society's foundations. To think of an earthquake in relation to the depicted scene is to undermine the sense of permanence and stability it otherwise constructs with such care. The sentence itself seeks to contain this potential violence: reason can discover the origins of geological disruption; a lecture on the topic can proceed in a measured manner from part to part. Including elements of both order and chaos, the painting depicts the sitter's models of society and citizenry constrained by the pressure of current events.

The similar setting in *Julia Stockton (Mrs. Benjamin) Rush,* the painting that Rush commissioned of his wife on the occasion of their marriage in 1776 and to which he later added his own portrait as a pendant, casts its sitter's contribution to public life in terms of what she could achieve within the domestic sphere (see plate 69). With a head as oval as any in Peale's portraiture, the image declared that its sitter had a good mind.

The distinctive iconography of oval-headed women helps to illuminate what this meant to some eighteenth-century men. As Hogarth commented in his *Analysis of Beauty* (1753): "this figure [of the oval] lessen'd at one end, like the egg, thereby being more varied [than the circle], is singled out by the author of all variety, to bound the features of a beautiful face."[35] Peale endorsed similar associations between ovals and beauty in 1790 when introducing an autobiographical fragment with a description of his recently deceased wife: "Her face a perfect oval . . . In short she would be called handsome amongst the most beautifull of an assembly of her Sex."[36] Calling the late Rachel Brewer Peale "Miss Rachel" at the beginning of this passage, Peale paired the ideal language of geometry with an invocation of a halcyon time prior to the intervention of childbearing and death. With portraits of Mrs. Rush, Mrs. Peale (see figure 1), and other female sitters, Peale negotiated between the representation of living, mutable sitters and timeless ideals. Favoring the imagery of archetypal purity over that of biology, his conceptually driven paintings seem to fulfill the prescription made by the London portrait painter and theorist Jonathan Richardson, who earlier in the century declared that "the painting-room must be like Eden before the fall, like Arcadia."[37]

Peale's thoughts on female beauty clarify how he intended pictures of women with oval heads to characterize sitters and to provide role models for female viewers:

> The temper of a man in a powerful degree fashions as I may say, the turns
> of the features. The constant exercise of any one passion the governing
> mucels being in constant action fixes the growing form—therefore as
> often as I find opportunity of giving instruction to young ladies, I tell
> them if they wish to be beautiful, they must be good natured and kind to
> all around them, but if they suffer ill natured Passions to govern them,
> their features will be moulded into extreme homelyness, and all their
> charms will vanish, and disgust be their Portion.[38]

Invoking the venerable belief that signs of personal qualities appear on surfaces of bodies, Peale's conversations with "young ladies" shifted the traditional

FIGURE 2.10
Charles Willson Peale
Samuel Mifflin, 1777–80
Oil on canvas, 49⅞ x 39¾ in. (126.7 x 100.1 cm)
The Metropolitan Museum of Art,
Eggleston Fund, 1922 (22.153.1)

FIGURE 2.11
Charles Willson Peale
Rebecca (Mrs. Samuel) Mifflin and Granddaughter,
1777–80
Oil on canvas, 50⅛ x 40¼ in. (127.3 x 102.2 cm).
The Metropolitan Museum of Art,
Eggleston Fund, 1922 (22.153.2)

FIGURE 2.12
Charles Willson Peale
Benjamin Rush, 1783 and 1786
Oil on canvas, 50¼ x 40 in. (127.6 x 101.6 cm)
The Henry Francis du Pont Winterthur Museum,
Delaware

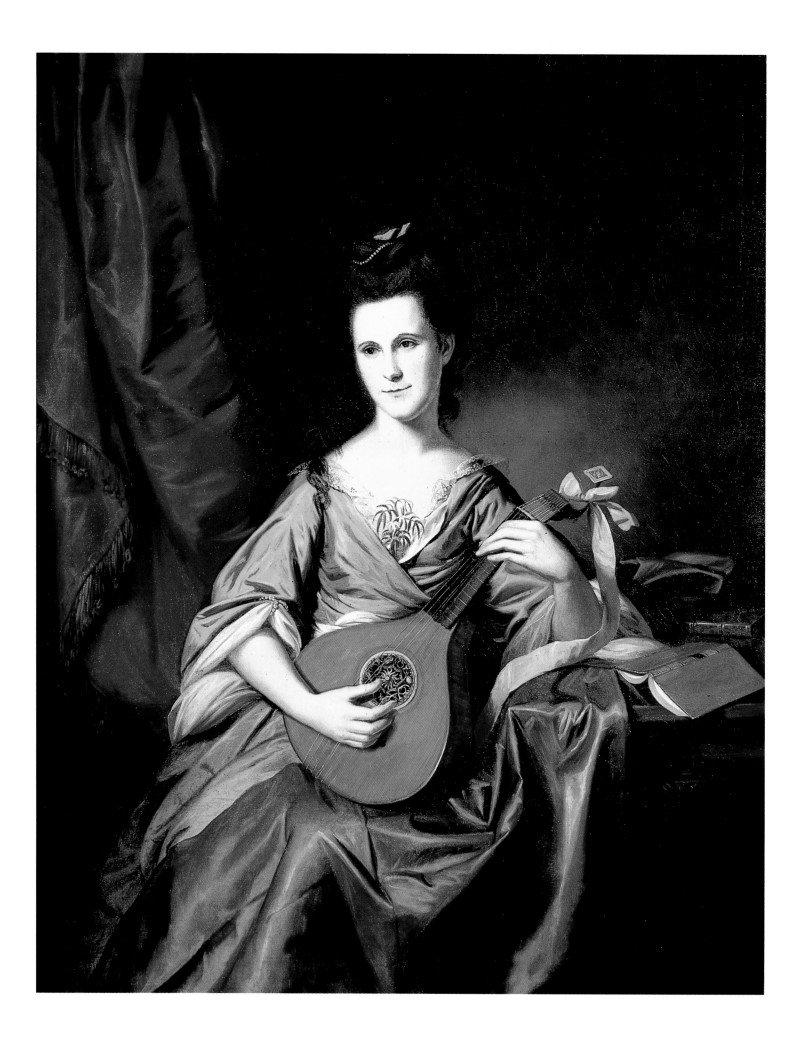

emphasis away from reading such signs toward controlling their formation. He cast himself as an adviser, cultivating listeners' mental self-government by manipulating whatever fears they might have had about their appearance as they grew older.[39]

In this passage, Peale's correlation of beauty with good nature and kindness marks the latter as qualities possessed by female sitters portrayed with oval—therefore beautiful—heads. In the portrait of Mrs. Rush, such characteristics complement the act of playing a cittern in the assertions it makes for the sitter. Just as music soothes the savage breast, Mrs. Rush, through the twin influence of her person and the beautiful sounds she created, had a refining effect on her new husband as well as on all that transpired in her new home. A beautiful object in itself, the painting might claim a similar function. Representing the sitter as an exemplum of beauty and kindness, the canvas presented female viewers with ideal physical and personal qualities toward which the painter believed they should strive. Given the contemporary belief in the connection of the domestic and political spheres, the effects of both sitter and painting on home life could have been understood to influence the world at large.[40]

Although men necessarily dominate any narrative about politics in eighteenth-century Philadelphia, republican ideology reserved for women an opportunity to serve the state by bestowing on them the role of educating boys who would grow up to lead the new nation.[41] As Benjamin Rush put it in his "Thoughts upon Female Education" (1787), "the equal share that every citizen has in the liberty and the possible share that he may have in the government of our country, make it necessary that our ladies should be qualified to a certain degree and suitable education, to concur in instructing their sons in the principles of liberty and government."[42] Rush's own wife could not play such a role in her wedding portrait, but by showing a woman educating a boy in *Mrs. James Smith (Mrs. Patrick Campbell) and Grandson,* Peale characterized his elderly sitter in terms of the most important role available to her for contributing to the public welfare (figure 2.13). It is telling that Peale never portrayed a man instructing a child in the art of reading.

The books with which he paired children demonstrate a concern to perpetuate this distinction between different kinds of republican action over the course of generations. While Smith oversees her grandson's training for public oratory with a lesson on "The Art of Speaking," Rebecca Mifflin teaches her granddaughter about familial ideals from a page crammed with figured medallions (see figure 2.11). The entire painting presents such a lesson, inasmuch as the grandmother's embrace of her granddaughter imitates the central picture of "Filial Love," with its large female figure resting her right hand on a short figure's shoulder. To the extent that these paintings provided the grandchildren with images of their appropriate roles, boys were to train for active participation in civic affairs, such as law and politics, while girls were to become grandmothers who, like their forebears, would prepare boys for adulthood in one way and girls in another.

In his model hierarchy, Peale reserved the highest rank for men who applied their good minds to leading others in advancing the public welfare. Although the brain belongs to the realm of biology and nature, the mind is

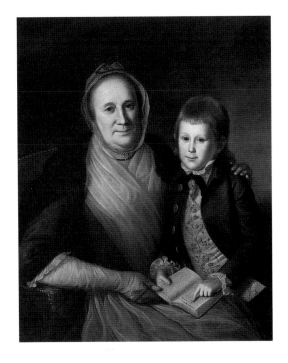

PLATE 69
Charles Willson Peale
Julia Stockton (Mrs. Benjamin) Rush, 1776
Oil on canvas, 49 ½ x 39 ¼ in. (125.7 x 99.7 cm)
The Henry Francis du Pont Winterthur Museum, Delaware

FIGURE 2.13
Charles Willson Peale
Mrs. James Smith (Mrs. Patrick Campbell) and Grandson, 1776
Oil on canvas
National Museum of American Art, Smithsonian Institution, Washington, D.C.; Gift of Mr. and Mrs. Wilson Levering Smith, Jr., and Museum Purchase

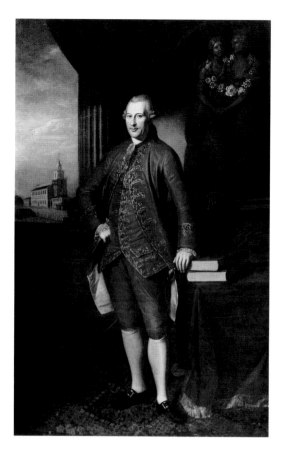

FIGURE 2.14
Charles Willson Peale
Conrad Alexander Gérard, 1779
Oil on canvas, 95 x 59⅛ in (241.3 x 150.2 cm)
Independence National Historical Park Collection,
Philadelphia

always subject to social forces that determine its development; similarly, society circumscribes the availability of opportunities to acquire leadership positions. While the 1770s saw the advent of a leveling institution like the Pennsylvania Assembly, its brief existence was marked by continuous efforts to wrest it from radical hands. More typically, traditional ideas about hierarchy informed the selection of leaders both military and civil. For this reason, when Peale fulfilled the commission from the Supreme Executive Council of Pennsylvania to portray the commander in chief of the Continental Army in 1779, he could simultaneously honor both his concern with individual talent and respect for an established elite.

Celebrating George Washington's early success at the Battle of Princeton (January 1777), Peale flanked the general at right with an anonymous groom and at left with triumphant soldiers leading British redcoats away from the recaptured Nassau Hall (see figure 31). The convention of perspective diminution offers a pretext for the use of a hieratic scale that distinguishes Washington from less auspicious countrymen. Peale derived this symbolic aspect of the composition, as well as the use of a cannon as a foreground prop, from West's *General Robert Monckton* (c. 1764, private collection). He made a decorous choice of source, for the Virginia planter and now full-time commander came as close as any American to the social rank of the English aristocrat and military leader celebrated by West in his full-length, grand-manner portrait.[43] As in a portrait such as *Richard Bennett Lloyd* (see figure 2.1), the casual ease conveyed by Washington's cross-legged stance denotes the "naturalness" of his aristocratic status (see plate 67).[44]

The striking ratio of head to figure length in the painting has sometimes been understood to represent an anomaly in the body of Washington, but it actually derives from an effort to make his image a vehicle for signifying greatness. Dodsley's *Preceptor* instructed readers to draw people so that "the Head is one-seventh Part of the Length of the Figureure," noting, however, that "the best-proportioned Figureures of the Ancients are 7 Heads ¾ in Height."[45] The standard proportion coincides with the contemporary full-length *Conrad Alexander Gérard* (figure 2.14), while the purportedly antique system describes the depicted Washington almost exactly: the ratio between his 9-inch head and 69⅝-inch total body height is 1 to 7.74.[46] Imitating what he thought was the ideal form from civilization's golden age, Peale exercised his neoclassical turn of mind.[47]

Despite the obscurity of some of its iconography, Peale's 1779 *Washington* unambiguously declared a lofty status for its sitter, a message antagonistic to the egalitarian spirit that had given rise to the Supreme Executive Council of Pennsylvania in the first place.[48] Slashed by "Sons of Lucifer" in 1781 as it hung in the Council chamber,[49] it was not reclaimed upon its repair; by 1783 it appeared in Peale's museum gallery. Given that almost every sitter in that collection also combined individual achievement with traditional qualifications for high social rank, the full-length portrait found a wholly suitable home in its maker's museum.[50]

Promoting hierarchies in general and heads in particular, the museum portraits coincided with Peale's social philosophy in ways that confirm the insight of anthropologist Mary Douglas about culturally specific correlations

between conceptions of the human body and social organization.[51] Filling the museum with paintings that either used the head as a module to determine a figure's length or isolated the head in a bust-length format, Peale followed conventional portrait practices attributing priority to the head over all other body parts (see, for example, plate 40). In an analogous manner, he believed that society should be a stratified structure with a clearly defined head.

Peale had supported the Pennsylvania Assembly during its radical phase, an organization that William Hooper described in 1776 as a "motley mixture of limited monarchy, and an execrable democracy—a Beast without a head."[52] Yet when Peale, the painter-cum-politician, refused to endorse the militia at the Fort Wilson riot of 1779, he supported the idea of absolute private property rights rather than a conception of the value of property for its service to the entire social body. He did not seek office again upon his defeat at the polls in 1780; after Fort Wilson, with the alliance between middle-class radicals and the laboring classes at an end, he no longer had a position at the head of a movement.[53] He also despaired of a politics of factionalism in which neither side ever clearly headed affairs. He recalled in 1784 that, "finding the party desputes of this State intolerably disagreable, four Years past I have laid politicks aside and persued the Brush."[54]

Established during a period of disquieting change, Peale's museum was intended to impart to visitors a sense that their new nation had a well-defined leadership. As James Madison declared in *The Federalist*, no. 62 (1788), "no government, any more than an individual, will long be respected without being truly respectable; nor be truly respectable, without possessing a certain portion of order and stability."[55] By displaying pictures of men who could be recognized as heads of state, the museum institutionalized order and stability from the top down. Furthermore, Peale avoided presenting sitters in ways that could call to mind the anti-Federalist rhetoric that accused Federalists of attempting to perpetuate the old hierarchy of wealth and traditional breeding with such obvious "qualifications of authority . . . as the dictatorial air, the magisterial voice, the imperious tone, the haughty countenance, the lofty look, the majestic mien."[56] Sporting uniform oval liners, the museum portraits presented their venerable sitters united in a common cause.[57]

The arrangement that Peale devised for the Long Room in Independence Hall introduced complementary structures of meaning (see figure 10.3). Looking at the array of paintings hung above the niches installed with stuffed fish and bird corpses, visitors could interpret the depicted male sitters as representatives of the human species situated atop the Great Chain of Being. While such a biological approach to the display allowed viewers to find themselves represented in it, a consideration of the installation in terms of the sitters' elevated social class would mean that the display did not represent visitors who lacked wealth, breeding, and the opportunity to lead.[58] Instead, the installation of the portraits high in the gallery offered such people a spatial and ocular metaphor of their limited social rank.

The only African-American that Peale depicted in the format of a museum portrait was "an Old Negro named Yarrow Mamout," who in 1818 claimed to be 133 years of age (figure 2.15).[59] Peale first used longevity as a criterion for gallery inclusion in 1809 to promote a correlation between

FIGURE 2.15
Charles Willson Peale
Yarrow Mamout, 1819
Oil on canvas
Historical Society of Pennsylvania, Philadelphia

the duration of one's life and the temperance with which one lived it.[60] While the portraits in this group are a colorful lot, *Yarrow Mamout* is the only one characterized in terms of the sitter's lack of control over his personal presentation. The left side of his inner coat collar creases properly in accordance with the cut of the garment, yet the right side flips up and sticks out. Portraying his sitter as genial and soulful but oblivious to his violation of sartorial decorum, Peale claimed Mamout as an exemplum of human longevity while marginalizing him relative to social conventions, and by extension, to full participation in the social order.[61] Accordingly, Peale never mentioned the painting in any of his gallery catalogues, and it is not clear if it ever hung among other museum portraits.

Commissioned almost three decades earlier by a son of its elderly sitters, *Mr. and Mrs. James Gittings and Granddaughter* includes black and white people in a single composition, but segregates them into discrete human communities through its representation of space, hieratic scale, detail, and action (see figure 15). In a distant field generalized figures of blacks toil, while on a foreground terrace individualized whites sit by a balustrade and draped column. As images of domesticated nature, the potted plants and chained ground squirrel mediating the transition between these spaces symbolize the Gittings' capacity to make transported African slaves and their descendants into a productive labor force, and (even though the Gittings do none of the work) to tame a fecund earth into a source of agricultural products. While painting this portrait, Peale noted that his elderly sitters' younger son "is a hearty, hard working boy. He constantly reaped the whole harvest."[62] But instead of an historically accurate image of black-white collaboration, the canvas shows no integration.[63] Its program offers a racially coded split between realms of property and owners, restricting signs of traffic between them to James Gittings' inexplicably attained handful of harvested wheat.

Peale used a similar left-right division in *The Exhumation of the Mastodon* to articulate a single workforce with one head and many hands (see plate 10). Pictorial space accords with numbers here, as the fully dressed Peale perches by the pit's bank, and the bare-chested and shirt-sleeved laborers who bring his conceptions into being dominate the composition's width (recall his remark that "with knowledge of the various powers, of the lever, the screw & the wedge, [man] can make machines to lessen labour, and multiply the conveniences & comforts of Life"). Mapping onto society a division between mental and manual labor that he had recognized since his days as an apprentice, Peale invented himself as a middle-class manager at a time of rapid transformations in production practices and working life.[64] Just as the head legislates the graphic order of the body in *George Washington,* the mind of Peale organizes the social body that appears in *Exhumation.* Analogously, on questions of public policy such as how to ensure morality or to achieve consensus, Peale distinguished a guiding head within the body politic and included himself among that head's membership.[65]

The painting's unifying, triumphant protagonist—the towering pyramid that supports both buckets and water sluice—demonstrates the necessary coordination of head and hands to achieve the public good, defined in this instance as developing land in Newburgh, New York, into a site that, by

yielding the remains of creatures that once walked United States' territory, produces national history. Nevertheless, the painting gives priority to the mind as it challenges viewers to reckon with its ingenious machine designs. This value system also extended to those whom Peale portrayed in the painting. While he included his own likeness, he apparently used anonymous Philadelphians to pose for the figures in the pit, since he did not return to Newburgh to record the features of the men whom he had paid to fetch bones for him. While those men had the franchise, they are represented in the *Exhumation* only through the portraits of other men.

In the nineteenth century, as the growth of democratic discourse made anathema all pretensions to rank, Peale's vision of the social order became increasingly unfashionable. William Dunlap, for example, criticized the structure of community support upon which Peale founded the Pennsylvania Academy of the Fine Arts as "an association of gentlemen of influence and fortune, (of course not artists)."[66] As John Lewis Krimmel envisioned the street outside Peale's museum, it was a space in which lowborn and highborn, blacks and whites mingled (figure 2.16).[67] Setting the dynamic public event of voting in a diagonally arrayed civic space populated by figures in a variety of unseemly poses, Krimmel gave form to his excitement about a thriving contemporary experiment in self-government. Such ideals clashed with those of the Long Room, where, as Peale depicted it, a graded order of things prompted quiet absorption and awe.[68]

The span of hands in *The Artist in His Museum* (see figure 10.2) measures Peale's recognition of the distance between his vision of how America should be and its changing actuality, a difference readily cast in temporal terms. From the perspective of his figure, the past is the space behind him showing the Long Room he installed between the early 1800s and the early 1820s. The future lies before him in undone works of taxidermy and paleontology, and, on the other side of the picture plane, in the bodies of future viewers like ourselves who inhabit a world shaped by the democratic forces that Krimmel depicted. Peale raises a curtain with his right hand as if to declare "this is the order that I composed." He gestures with his left hand toward the viewer as if to challenge "what kind of order do you make?" (recall his remark that man "can compare the present with the past"). Created from an awareness that the days were drawing to a close when he could picture—and thereby hope to shape—his ideal body politic, the depicted body Peale left behind interrogates the world and its ideals for perpetuity.

FIGURE 2.16
John Lewis Krimmel
Election Day in Philadelphia, 1816
Oil on canvas
The Henry Francis du Pont Winterthur Museum, Delaware

~

A Delicate Balance:

Raphaelle Peale's Still-Life Paintings

and the Ideal of Temperance

~

BRANDON BRAME FORTUNE

*R*APHAELLE PEALE'S STILL-LIFE PAINTINGS, such as his *Lemons and Sugar* of c. 1822 (plate 70), are carefully composed, expertly made pictures that display the elegance and restraint associated with neoclassicism in Western art. Peale's paintings often represent seasonal delights such as grapes, melons, or berries, or items found as part of the very last course of a good dinner—fruit, nuts, and wine. They depict dessert—an extra, unnecessary, pleasurable course, springing from the older word "desert" with its moral connotations of something deserved. We might expect that Raphaelle was simply painting decorative pictures to please an elite audience, and that his life was as ordered and regular as the objects in his paintings, but we would be wrong.

Instead, Raphaelle Peale (1774–1825) (see plate 71) struggled with the physical and emotional effects of intemperance for most of his adult life. Charles Willson Peale had encouraged him in a career as a painter of portraits and miniatures, a course that Charles was persuaded would bring Raphaelle sufficient income to support his family and an artistic reputation of which both could be proud. And yet, despite his family's exhortations and pleas, Raphaelle continued to live a seemingly haphazard life, and painted still-life pictures in preference to portraits.

In July 1820, Charles Willson Peale penned one more in a long line of letters to Raphaelle, expressing his frustration and longing for his son's return to health and a regularized life. Also embedded in the text are hints concerning the early nineteenth-century Philadelphia world in which he lived and the possible place of Raphaelle's still lifes in the matrix of his family relationships. This representative letter serves as a counterpoise to the visual balance and mastery displayed in Raphaelle Peale's still lifes, as we attempt to place those works in both a personal and cultural context.

Writing on the Fourth of July, Independence Day, Charles Willson Peale begins his letter by expressing concern for Raphaelle's recent "fit of the Gout"

PLATE 70
Raphaelle Peale
Lemons and Sugar, c. 1822
Oil on wood panel, 12 x 15 in. (30.5 x 38.1 cm)
Reading Public Museum, Reading, Pennsylvania

and offers advice on its treatment, including the hope that Raphaelle not take any unnecessary medicines. He then discourses further on the evils of excess:

> When we reflect that in order to injoy health we ought to eat and drink only such things as our best judgment on experience have proved as most condusive to that end, also, in *only* such proportion as shall be in exact proportion as to quantity as will nourish the body, for a single particle more becomes a clog and a burden to the digestive powers, therefore, produces disease more or less in due proportion to the excess. When we set down at the Table (perhaps loaded with a variety of unnecessary articles, for two or three things is realy all that is needful) then think on the end! & resolve that *taste* shall not be *superior to reason*. The government of all other passions as essential to promote health, is certainly of vast import. The mind has a vast influence on the health of the body. . . .
> Dear Raphaelle you must not think that what I have wrote is a charge on you of a breach of such rules, though like myself you may not always possess intire command of the appetite. and one motive I have for writing such, is a means of confirming my habits to like restrictions, they are rules which I daily endeavor to put into practice.

Peale goes on to recount his viewing of the recent exhibition at the Pennsylvania Academy of the Fine Arts, and concludes with another wish (repeated in other letters): "I hope on the next annuel Exhibition that you will shine as a Portrait Painter—for as I have always said, if you could have confidence in yourself, and paint portraits with the same exactness of finish as you have done in still life, that no Artist could be your superior in that line."[1]

Both Peale's exhortations and the imagery he uses to make his points are revealing. Charles Willson Peale was acutely concerned with regimen and health; by 1804 he seems to have stopped drinking wine, and was a staunch advocate of simple food and water as essential nutrients for a healthy constitution.[2] Was this concern, with its focus on absolute necessity (for a drop more would "clog" the alimentary system), exacerbated by his son's indulgences? Can we interpret the simplicity of Raphaelle Peale's quiet still lifes as having anything to do with his father's desire for just those "two or three" really needful things on the table, as opposed to the overabundance that conjures up images of seventeenth-century "pronk" still lifes?[3]

Although in his 1820 letter Charles Willson Peale seems primarily concerned for his son's health and self-governance, the intergenerational tension between them was artistic as well as personal, and formed the basis for Raphaelle's rivalry with his father, based on their respective abilities to make highly illusionistic, even trompe l'oeil paintings. This competition, and the relative valuation of still life and portraiture by father and son, form the basis for understanding, to some extent, why Raphaelle painted still life. The still-life pictures also indicate the delicate balance between temperance and overindulgence—a metaphor that binds the various strands of interpretation together and provides a key to understanding Raphaelle and his paintings.

Far from being just lovely, decorative pictures that serve only the senses (the "desserts" of painting), Raphaelle Peale's still lifes appear to be complex images that express a moral tension between necessity and indulgence, reason and passion. Raphaelle's still-life pictures are suffused with references, direct

PLATE 71
Charles Willson Peale
Portrait of Raphaelle Peale, 1822
Oil on canvas, 29 x 24 in. (73.7 x 61 cm)
Private collection

FIGURE 3.1
Raphaelle Peale
Still Life with Celery and Wine, 1816
Oil on canvas
Munson-Williams-Proctor Institute Museum of
Art, Utica, New York

FIGURE 3.2
Raphaelle Peale
Still Life with Dried Fish [A Herring], 1815
Oil on canvas
The Historical Society of Pennsylvania

and implied, to the ardent spirits that his father viewed as the cause of his son's unhappiness. The pictured decanters and glasses, and the elegant indulgence they represented, were also part of an elite, genteel lifestyle, to which Charles Willson Peale and his family aspired; these vessels provide the link between life and art in any attempt to realize the meaning of the objects portrayed in the still lifes. Paintings such as the *Still Life with Celery and Wine* of 1816 (figure 3.1) take on added resonance when considered as emblems of moral choice. At first we see almost overripe fruit in a dessert basket, accompanied by a decanter of wine, or perhaps a fruit-based cordial, and celery—much more fragile and rare than the ubiquitous vegetable stacked in twentieth-century supermarkets—imagery we now know to represent a dessert, an indulgence for the lucky few.[4] Add to this picture of a potential repast the related signification of apples as the fruit associated both biblically and mythologically to choice and its consequences, and we have a reading of one Raphaelle Peale still life that can stand for many others.

Raphaelle Peale grew up in a household in which still life was evidently encouraged, for it was a hallmark of the Peale family painting practice.[5] However, Charles Willson Peale, for all his interest in illusionism and trompe l'oeil, viewed still-life painting as a genre based on mechanical skill, involving little of the imagination and inventiveness that were required for higher forms of art. As he wrote in his autobiography of 1826: "The art of painting portraits cannot be attained without a vast deal of practice, the artist must love the art, or he will not succeed to perfection. It is not like the painting of still life; the painting of objects that have no motion, which any person of tolerable genius, with some application may acquire."[6] Given his own efforts to achieve fame as a gifted and learned painter of portraits, Peale disdained still life as an unsuitable pursuit for his talented eldest son.[7]

Peale was not alone in relegating still life to the bottom of the hierarchy of genres; most eighteenth-century writers shared his view that still life was an inferior form of art because of the mechanical aspects believed to be involved in depicting a dead bird or mimicking a piece of fruit. As Samuel van Hoogstraeten wrote in his late seventeenth-century treatise on Netherlandish art and artists, makers of still life were "only ordinary soldiers in art's army."[8] One of the few theorists to devote any critical attention to still life during the eighteenth century was Gerard de Lairesse, who also disparaged its lack of intellectual or symbolic content. He objected to the depiction of rotten or unripe fruit, or other "Deformities" of nature, and composed an entire list of unacceptable subjects (many painted by Raphaelle Peale), including "Cabbage, Carrots, and Turnips, . . . Codfish, Salmon, Herrings, Smelts, and such-like . . . he who is pleased with them may seek them in the Markets" (figure 3.2; see also plate 55).[9] Still life continued to be devalued, even though Dutch and Flemish examples of the genre commanded high prices on the Continent and in England for their decorative appeal. Still-life pictures were a source of visual, sensuous pleasure, but, as Jonathan Richardson wrote in the early eighteenth century, "they cannot Improve the Mind, they excite no Noble Sentiments."[10]

Portraiture, on the other hand, was variously praised as next to history painting in nobility or denigrated as a mechanical art, making claim to no more than a slavish imitation of likeness. As the eighteenth-century British

satirist William Hogarth remarked, a mere face painter "has no further views copying the person sitting before him who ought to sit as still as a statue and nobody will dispute a statues being as much still life [as] a fruit flower or a galipot broken erthen pan."[11] In other words, a portraitist might be no better than a painter of still life, but this was the sort of portraitist Charles Willson Peale did not wish to be. As the president of the British Royal Academy, Sir Joshua Reynolds, noted in his *Third Discourse* (1770), one should move beyond mere imitative study, for "if deceiving the eye were the only business of the art, there is no doubt, indeed, but the minute painter would be more apt to succeed: but it is not the eye, it is the mind, which the painter of genius desires to address; nor will he waste a moment upon those smaller objects, which only serve to catch the sense, to divide the attention, and to counteract his great design of speaking to the heart."[12]

Raphaelle Peale styled himself as a portrait painter in city directories and exhibition catalogues, but, particularly after 1811, he seems to have preferred still life. We have as evidence not only the exhibition records of the Pennsylvania Academy of the Fine Arts and a number of extant still-life paintings, but also his father's letters, which continually urged him to paint portraits instead of still life. These exhortations were often linked with requests for Raphaelle to exercise more self-control, perhaps implying that his failures at portraiture were due to his intemperance, and making him fit only for the mechanical art of still life. In his father's opinion, Raphaelle's inability to control his passions was causing his talents to atrophy. In 1817, Peale wrote to Raphaelle, who was then in Norfolk, Virginia: "Your pictures of Still-life are acknowledged to be, even by the Painters here, far exceeding all other works of that kind. And you have often heard me say that I thought with such talents of exact immatation, your portraits ought also to be more excellent—My dear Raph[aelle] than why will you neglect your self—? why not govern every unrully Passion?"[13] At one point, the elder Peale even seems to belittle the still-life work his son is doing. In 1818, he begs Raphaelle not to charge so much for his still life and not to value those pictures so highly, but to paint more and charge less: "with constant production you might paint 2 or 3 of them in a week. You can never want subjects to immitate, any common objects grouped together might form a picture, and instead of having only one picture for sale, you might soon have a Dozn."[14]

By insisting on the value of still life in the face of both cultural and familial pressure, it is possible that Raphaelle was introducing a subversive rivalry between himself and his father that harks back to an ancient tradition of artistic competition, based on Pliny's accounts of the Greek artists Zeuxis and Parrhasius. The story, commonly reproduced in many seventeenth and eighteenth-century books about artists, is also the original tale of artistic rivalry.[15] As Pliny tells it, Zeuxis painted grapes that were so naturalistic that birds flew to them. Parrhasius then painted a linen curtain that appeared to cover a painting; it was so like a real curtain that it fooled the artist Zeuxis. After this, Zeuxis painted a child carrying grapes, and again the birds flew down, but Zeuxis was further vexed, for had the *child* been a true deception, the birds would have been afraid. It is Parrhasius, with his trompe l'oeil curtain, who "wins" the competition.[16]

The story of Zeuxis and Parrhasius was so well known, even in the United States, that Margaret Bayard Smith used it in her novel *What is Gentility?* (1828) as a rhetorical structure for her account of a visit to an artist's studio in Washington, D.C. The prototype for her artist, Mr. K., was surely Charles Bird King, who was also known for portraits and still life.[17] Smith's heroine, Lydia, jokes with Mr. K. about the manner in which his painting of a cat and his still-life painting of a filled market basket fooled her little dog. At that point, they enter into a "genteel" and witty exchange concerning the artist's skill, comparing it to that of Zeuxis, and even to Parrhasius, for Smith has Lydia attempt to peep behind a painted curtain. Mr. K. then explains: "It was the anecdote of the picture of Parrhasius that induced me to paint that curtain over my picture; and to tell you the truth, that basket of fruit was suggested by the same story, and perhaps you will think my vanity justly punished, if I tell you, that when I exposed it in my garden, no birds deigned to pick at *my* grapes."[18]

By the early 1820s the rivalry between Raphaelle and Charles Willson Peale became explicit with the painting of the elder Peale's fascinating and well-documented *Staircase Self-Portrait* (1823; unlocated) and Raphaelle's complex and witty *Venus Rising from the Sea—A Deception* (see plate 56).[19]

The *Staircase Self-Portrait*, a full-length picture filled with references to Peale's earlier works, including the 1795 *Staircase Group* which featured portraits of Raphaelle and his brother Titian Ramsay (1) (see plate 23), was intended to be a trompe l'oeil illusion, or as Charles Willson Peale termed it, "a deception in toto."[20] Peale put himself in competition with the story of Zeuxis, which he attributed to Apelles: "The steps will certainly be a true illusion, and why not my figure? It is said that Apelles painted Grap[e]s so natural that the Birds came to pick them, that he then painted a Boy to protect them, but the Birds still came to take the Grapes."[21] If Charles Willson Peale wanted to paint as well or even better than Zeuxis, Raphaelle must have painted his *Venus Rising from the Sea—A Deception* at around the same time, for by painting the curtain, he announces a mastery of the medium that would outwit Zeuxis himself.

Another instance of the topos of artistic rivalry was the story recounted by Vasari of the young Giotto and his teacher Cimabue, in which Giotto painted a trompe l'oeil fly on the nose of one of Cimabue's figures, tricking his master into trying to brush it off. The anecdote is one of several examples given by Vasari of Giotto's witticisms.[22] It may be part of the reason why Raphaelle Peale, also known for his wit and love of illusion, included a fly prominently in his *Covered Peaches* of c. 1819 (plate 72), a picture filled with trompe l'oeil elements.[23]

Raphaelle Peale seems to have painted still lifes, in part, because his father did not want him to, and in part as a means of asserting his representational mastery in the face of his father's disapproval. Regardless of how much intemperance affected Raphaelle's quotidian existence, his overindulgences were also thorns in Charles Willson Peale's side. Temperance and the effects of intemperance were clearly at the forefront of Raphaelle Peale's familial relationships—with his father, his wife and children, and his siblings, and perhaps even his self-definition as an artist.[24]

PLATE 72
Raphaelle Peale
*Fruit Piece with Peaches Covered by a Handkerchief
(Covered Peaches)*, c. 1819
Oil on wood panel, 12 ½ x 18 in. (31.8 x 45.7 cm)
Private collection

The continuum between temperance and intemperance also informed the appearance and signification of Raphaelle's chosen genre. To understand the contents of his still-life paintings in terms of the artist's purpose in painting them, we must explore contemporary attitudes toward intemperance, especially as they affected the elite and aspiring classes, early nineteenth-century dining and drinking customs, and the culture of foodstuffs. Prevailing ideas concerning temperance, indulgence, and moral choice illuminate the meaning of each grouping of fruit, nuts, cakes, and wine. Raphaelle's still lifes were not painted solely as a form of rebellion against his father. Rather, the delicate balance between necessity and indulgence, reason and passion pictured in these little panels seems to indicate that the tension between pleasing his parent and asserting his personal independence also finds expression within the boundaries of Raphaelle Peale's paintings. When we examine this information in the light of the possible moral symbolism in earlier, Netherlandish still life, it becomes clear that the balance between temperance and intemperance, as an artistic metaphor and focus for familial admonition and control, informs both Raphaelle Peale's art and life.

Benjamin Rush's *An Inquiry into the Effects of Ardent Spirits upon the Human Body and Mind* (1784) was one of the best-known efforts to point out the deleterious effects of immoderate drinking and was certainly one of the earliest documents of the burgeoning nineteenth-century temperance movement. Rush, a contemporary and friend of Charles Willson Peale (see figure 2.12) discussed the chronic physical effects of drunkenness, including gout, as well as its effects on the mind and morals.[25] In the "Moral and Physical Thermometer" appended to the 1790 edition of his *Inquiry,* Rush clearly indicated the link between alcoholic beverages and disease and moral lassitude.[26] As the temperance movement grew stronger in the first three decades of the nineteenth century, intemperate drinking was increasingly considered to be the dominant sin of the day, outweighing all others. This may not have been due to an actual rise in consumption of alcohol, but to an increase in fear of its consequences. If the mind could not control physical desires—those passions which Charles Willson Peale longed to have his son master—the results of such moral failure were physical and mental decay, and early death. As Thomas Trotter pointed out, habitual drinking "is a gulph, from *whose bourne no traveller returns:* where fame, fortune, hope, health, and life perish."[27]

Charles Willson Peale's own interest in temperance, diet, and regimen was, therefore, not unusual in this period of growing concern with issues of self-regulation. Until his death in 1827, Peale continued to advocate the development of habits that would increase health and longevity.[28] His *An Epistle to a Friend on the Means of Preserving Health, Promoting Happiness; and Prolonging the Life of Man to Its Natural Period* (1803), expresses these interests fully. In this pamphlet he observed that if "a person takes the least portion [of alcohol], after he feels it in his stomach, head, or pulse; this is intoxication."[29] He also noted at the end of the essay that "most wines are rendered more or less unwholesome by the mixtures of the wine merchants as well as the retailers of it."[30] Peale commented further on the importance of moderation in all aspects of life, and the avoidance of "improper indulgence."

He described an ideal regimen consisting of water and simple foods, including soups, boiled or steamed meat and fish, vegetables, and "perfectly ripe" fruits, all to be enjoyed with only a sparing use of spices or flavoring, "as they do not afford the least *nourishment*." He continued: "Is it not just to suppose that everything which will not nourish the body, has a tendency to injure the stomach? Then how much do they degrade themselves who use things, merely to gratify a viciated appetite, knowing such are not nutritive."[31]

Peale's ideas were similar to those of his contemporaries, beginning with the theories of George Cheyne, who, as early as the 1730s, promoted temperance in diet, the exclusive use of water, and vigorous exercise for the prevention and cure of gout, from which Raphaelle Peale seems to have suffered with some regularity after 1812.[32] Gout was popularly viewed as an affliction resulting from too much rich food and wine, and was particularly linked with drinking among the well-to-do. Well into the nineteenth century, writers continued to ascribe to "*fermented* or *distilled* liquors . . . the whole Blame of all or most of the painful and *excruciating* Distempers that afflict Mankind: It is to it alone all our Gouts, Stones, Cancers, Fevers, high Hysterics, Lunacy and Madness, are principally owing."[33] While some treated gout by advocating a drastic change in habits, some sufferers thought that the only cure for "gouty fits" lay in drinking more wine, as is figured in James Gillray's 1799 print, *Punch Cures the Gout* (figure 3.3).

We do not know what Raphaelle Peale drank when he drank too much. In his 1784 essay, Benjamin Rush was more concerned with distilled liquors than with wine or beer, which he thought were "innocent" when taken in moderation and with food, "and often have a friendly influence upon health and life."[34] By the early nineteenth century, however, even wine was viewed as a spur to an intemperate life.[35] Also, wine was expensive, and therefore a rich man's drink. Although there is more evidence of overindulgence in "ardent spirits" by non-elite groups (because overindulgence by the privileged was necessarily protected), we know that gentlemen (not ladies) drank together as a form of genteel social ritual in which drinking punch or wine formed a means of group definition and a forum for the display of manners, deportment, and wit. Those able to afford them indulged in wines and brandy, but they did not necessarily drink less than their impecunious contemporaries. Overindulgence may not have been genteel, but it was not rare.[36]

Given his father's prescriptions against such indulgence, Raphaelle Peale's gout was not only a source of extreme misery, but a constant reminder of his lack of self-control. As Charles Willson Peale wrote to his son in 1818, "It gives me pain to think how wretchly you govern yourself. I am not uninformed of your associations you are possessed of superior talents to most men, and yet you will associate with beings that disgrace you—you have promised time after time to refrain from intemperance, and you have nea[r]ly destroyed, or thrown away your life; you have been on the brink of the Grave." A month later, Peale wrote, "I am certain that you do not want a monitor in your breast, then why not reflect on what you ought to do?"[37] Peale's rhetoric is that of the temperance tract; his son's behavior and illness seemed to him to be the result of self-destructive intemperance, indefensible in a son who ought to "act the Man."[38]

FIGURE 3.3
James Gillray
Punch Cures the Gout, the Cholie and the Tisick, 1799
Engraving, 10 x 13 ⅜ in. (25.5 x 34 cm)
Print Collection, Miriam and Ira D. Wallach Division of Art, Prints and Photographs. The New York Public Library, Astor, Lenox and Tilden Foundations

The tension between temperance and intemperance in Raphaelle Peale's life and artistic choices informs the very images in his paintings. Since still-life pictures sometimes adorned rooms used for dining, they may be read, perhaps subliminally, as comments on the possibility of overindulgence inherent in any upper-class meal in a household wealthy enough to afford such a separate space and paintings to decorate it.[39] Like his father, Raphaelle was fully cognizant of the language of images and their symbolic power. By examining a few of his "desserts" and the objects portrayed in them in both their early nineteenth-century American context and as participants in the continuing tradition of religious and moral imagery stretching back to the early Renaissance, the tensions residing within them become clear.

Raphaelle Peale painted many more still-life pictures than are now identified. From extant pictures and the titles of others found in the exhibition records of the Pennsylvania Academy of the Fine Arts, it is clear that the majority of his paintings were fruit pieces, pictures depicting cake and wine, or portrayals of other forms of dessert, including jellies.[40] These foodstuffs were often part of the dessert course of a meal, or part of a larger display of sweet confections, fruit and nuts, and ices, arranged around a decorative "plateau." Most of Peale's fruit pieces seem to represent the last course of a formal dinner that was served after all the cloths had been removed from the table, exposing the bare wood.[41] Then fruits, fresh and dried, nuts, and wine (possibly port, or madeira, for example) were served in a leisurely fashion, and were enjoyed well after the ladies had departed the room. Henry Sargent's well-known painting *The Dinner Party* (figure 3.4) documents this course at a gentlemen's dinner party. As an exhibition piece, it would have been seen by some who attended such functions, and by many for whom such a ritual and setting would have been only an aspiration, for dessert seems to have been a particular determinant of the success of a fine dinner.[42]

Desserts varied with the seasons. In *The Complete Confectioner,* published in 1800, fruits appropriate to the seasons are given, followed by an extensive listing of very elaborate dessert menus that always included small cakes, ices, or jellies, wet or dry sweetmeats, fresh and dried fruits, and nuts. Served in pearlware baskets or glass sweetmeat dishes, accompanied with stemware filled with wine or cordials, or combined with small, rich, iced and decorated cakes, Raphaelle's fruits and nuts take on the luxurious connotations of "dessert." He painted expensive drinks, sweets made of rich ingredients—double refined sugar and many eggs—and delicate, choice fruits.[43] And yet, there is never an abundance of items in Raphaelle's paintings; usually just two or three things or types of food. Is the wine, always just one glass, that perfectly calibrated amount that no physician would prohibit? Or does it, and the fruit and cake depicted in these pictures, allude to a fear of overindulgence? Raphaelle toys with the tension between temperance and indulgence; it is in that tension that the personal and the art historical meet. It may be possible that Raphaelle could assume control over the vehicles of his own intemperance only by means of these pictures and his mastery of their composition and medium.

Over and over again, mastery and control, or the loss thereof, figure in Raphaelle's personal life; this tension also informs almost all of his still-life pictures, taken individually or in groups. The ideals of temperance, moderation,

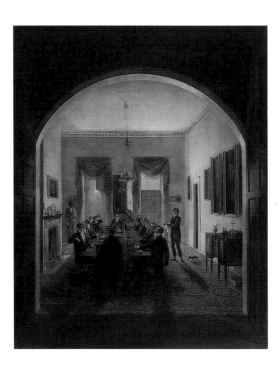

FIGURE 3.4
Henry Sargent
The Dinner Party, c. 1821
Oil on canvas, 61 ⅝ x 49 ¾ in. (156.5 x 126.4 cm)
Museum of Fine Arts, Boston; Gift of Mrs. Horatio A. Lamb in memory of Mr. and Mrs. Winthrop Sargent

and rational choice figure largely in the symbolism we can discover in these pictures. Interestingly, when scholars of Dutch and Flemish still-life painting examine the possibility of meaning in such works, their focus has also been on the moral ambiguity inherent in a genre that combines intense scrutiny of worldly objects with meditations on larger issues of moral choice, moderation in behavior, and the transience of life.[44] Thus, in reading Raphaelle Peale's work, we find that meaning emerges not only from the life and culture of the artist, but from the visual tradition as well, giving even more force to his pictures.

A few of the most visually arresting pieces in Peale's oeuvre are those which depict citrus fruits. Both the *Still Life with Oranges* of c. 1818 (figure 3.5) and his *A Dessert [Still Life with Lemons and Oranges]* of 1814 (private collection) are representative "desserts" and serve as examples of a subject that Raphaelle often painted. In both, the fruit is displayed with leaves, as though recently picked, and is offered in a bowl with nuts, dried fruit (raisins), and, in the Toledo picture, grapes. A decanter and/or a glass of wine complete the image of a luxurious dessert. Oranges and lemons were still rather rare in the early nineteenth century, but were available commercially in Philadelphia.[45] They were also grown by those privileged few who owned hothouses. Charles Willson Peale grew fruit at his farm, Belfield, after 1810; we also know that he had a greenhouse, for it is visible in his painted view of Belfield's grounds (see plate 11). He may well have supplied Raphaelle with some of his subject matter, perhaps even oranges and lemons.[46] Lemons and oranges were used for many dessert dishes and treats. Sweet oranges were peeled and consumed at table, and lemons were sometimes used for lemonade, which was quite fashionable in the early decades of the nineteenth century. Raphaelle's *Lemons and Sugar* of c. 1822 (see plate 70) may refer to the pleasures of lemonade, with its decanter of water, Chinese export sugar bowl, pearlware basket with lemons, spoon, and pearl-handled knife—all the ingredients, along with a book of poetry to be enjoyed while sipping (see also plate 73). As with the dessert pieces, the ritual signified by the objects was one experienced not only by Philadelphia's elite, but more importantly, by those aspiring to gentility.[47]

If we admit the possibility of deeper meaning in such pictures, oranges and lemons as relatively rare, perishable fruits not easily cultivated in northern climes may also be understood as *vanitas* symbols.[48] The peeled orange, so evident in Raphaelle's works, has been read as a play on the Peale surname. By linking the fruit with the family name, Raphaelle may also have been (once again) alluding to his own rare mastery, for oranges, particularly when combined with their leaves and blossoms, were viewed even in Peale's time as signs of genius.[49]

Raphaelle's paintings of cake and wine continue the idea of a small, elegant dessert, but they also may be interpreted symbolically. Examples of these pictures include his *Still Life with Cake* (figure 3.6), *Still Life: Wine, Cakes, and Nuts* (1819, Huntington Library and Art Gallery, San Marino, California), and *Cake and Wine* (1813; private collection). Small cakes were associated with special occasions; the tiny ones were probably "queen cakes," which were about the size of modern cupcakes, and like the larger "plumb cakes" (meant to be cut and shared), were often coated with a hard sugar icing and decorated with colored sugar. Cake and wine were served at

FIGURE 3.5
Raphaelle Peale
Still Life with Oranges, c. 1818
Oil on wood panel, 18 ⅝ x 22 ⁵/₁₆ in.
(47.3 x 58.4 cm)
Toledo Museum of Art; Gift of Florence
Scott Libbey

FIGURE 3.6
Raphaelle Peale
Still Life with Cake, 1818
Oil on canvas, 10 ¾ x 15 ¼ in. (27.3 x 38.7 cm)
The Metropolitan Museum of Art, New York;
Maria DeWitt Jesup Fund, 1959 (59.166)

PLATE 73
Raphaelle Peale
Still Life with Orange and Book, n.d.
Oil on canvas, 9 x 11 ⅝ in. (22.9 x 29.5 cm)
Private collection

weddings, and even at funerals, but could also be consumed as part of a dessert or evening's entertainment.[50] Raphaelle gave *Cake and Wine* to his brother Rubens and Eliza Burd Patterson on the occasion of their marriage in 1820—a visual reminder of the celebratory ritual (see plate 85 for Rubens's copy of this work).[51] Cake and wine also carry unmistakable Eucharistic connotations, especially when combined with grapes and a thorny branch.

Grapes may be interpreted in Raphaelle Peale's pictures on many levels. Not only are they emblems of his mastery of representational art, but they serve as the source of wine—the vehicle for holy communion as well as bacchic rites—and therefore as emblems urging temperance, or perhaps indulgence, in the wine produced from them (figure 3.7). Other fruits may also be references to the ideal of temperance: apples (as well as peaches and sometimes oranges) were identified with the fruit of the Tree of Knowledge of Good and Evil as well as the mythological "golden apples" of Paris, and therefore suggest the idea of choice. Apples were also attributes of both Mary and Venus, of both sacred and profane love.[52]

In his pictures of peaches, melons, and berries, Raphaelle repeats this imagery, like variations on a musical theme. Peaches, which were grown in great abundance in the middle Atlantic states, and flourished particularly well in this region, were, like apples and grapes, also the basis for alcoholic drinks—cider and brandies. Peaches were even considered to be of great assistance in clearing the palate of a wine connoisseur.[53] In Peale's *Peaches* of c. 1817 (figure 3.8), the fruit is depicted with all its connotations of voluptuousness, both intact and peeled, with the small pearl-handled fruit knife shown plunged into the fruit. The peel, once again, may be a Peale signature. A sweetmeat container, or pokal, is pictured behind the peaches. Its function is uncertain; with its residual liquid, it may be intended to receive the sliced peaches for preservation in syrup, or it may be a drinking vessel, used on festive occasions.[54]

In his paintings, Raphaelle Peale expressed the specificity of the seasons and their harvest. Although fruits from various seasons may be combined in a few of his works (as in Netherlandish flower pieces which incorporated blossoms that never bloomed at the same time), his subjects are usually taken from that season's bounty; some of the paintings are inscribed with specific months, and even days. Most of these were painted in the late summer or early autumn. Only a few—paintings featuring berries—seem to have been done in early summer. And, from the only extant letter of Raphaelle to a patron, we know that he considered the late summertime to be his productive "season" for painting, falling just before (and thus linked to) his miserable "season" for Gout: "My old and inverterate enemy, the Gout, has Commenced a most violent attack on me, two months previous to its regular time—and most unfortunately on the day that I was to Commence still life, in the most beautiful productions of Fruit, I therefore fear that the Season will pass without producing a single Picture, I meant to have devoted all my time, Principally, to Painting of fine Peaches & instead of whole water Mellons, merely single Slices on which I could bestow a finish that would have made them valuable—"[55]

In Raphaelle's paintings of berries, the freshness and ephemeral quality of this early summer treat is again emphasized. Pictured alone, as in his

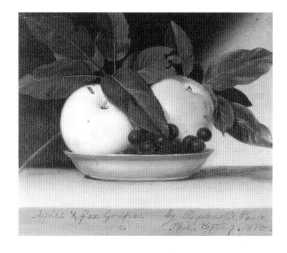

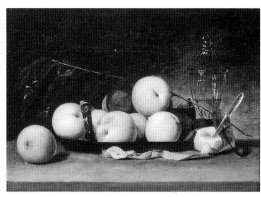

FIGURE 3.7
Raphaelle Peale
Apples and Fox Grapes, 1815
Oil on canvas, 9 11/16 x 11 7/16 in. (25.2 x 30.3 cm)
Courtesy of the Museum of American Art of
The Pennsylvania Academy of the Fine Arts,
Philadelphia. Source unknown (probably
Pennsylvania Academy purchase, 1817)

FIGURE 3.8
Raphaelle Peale
Peaches, c. 1817
Oil on canvas, 13 1/8 x 19 3/4 in (33.1 x 50.2 cm)
Richard York Gallery, New York

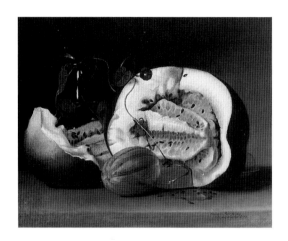

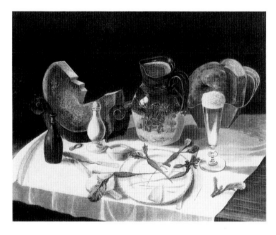

FIGURE 3.9
Raphaelle Peale
Melons and Morning Glories, 1813
Oil on canvas, 20¾ x 25¾ in. (52.7 x 65.4 cm)
National Museum of American Art, Smithsonian
Institution, Washington, D.C.; Gift of Paul Mellon

FIGURE 3.10
Peter Pasquin (after J. M. DeLattre)
Frugality, 1796
Mezzotint, 8¾ x 10¾ in. (22.2 x 27.3 cm)
Colonial Williamsburg Foundation

Blackberries of c. 1813 (Fine Arts Museums of San Francisco; Rockefeller Collection), they appear weighty and ready to be pulled from their thorny stem; one cannot dismiss categorically the traditional linkage of their red juice with Christ's Passion. Proferred with cream, in the *Strawberries and Cream* of 1818 (Mr. and Mrs. Paul Mellon) or the *Still Life with Strawberries and Ostrich Egg Cup* of 1814 (private collection), they suggest transience and simplicity, particularly when contrasted with the strange, exotic beauty of the ostrich egg cup, the only truly rare object in any of Raphaelle's extant still lifes.[56] These pictures, as well as his paintings of sliced and broken melons, reiterate the theme of abundance—and the potential for a sweet and juice-laden indulgence—in terms that are frankly sensuous and yet couched in a controlled visual language that contains the possibility of overindulgence and intemperate enjoyment (figure 3.9).

It is difficult to find other examples of a direct link between overt moral signification and still-life imagery in visual art works contemporary with Raphaelle Peale, but they do exist. For example, there is an unusual mezzotint by Peter Pasquin entitled *Frugality* (figure 3.10), that relies on the depiction of a meager meal for its imagery, much as some Netherlandish painted still lifes of similar subjects were paired with images of opulent, overabundant meals as examples of the poor and rich man's repast, expressing a warning against luxury and indulgence.[57] In the second print from Amos Doolittle's series on the Prodigal Son (1814), an even stronger connection is made between the son's riotous life and the fruit and wine set before him for his revelries (figure 3.11).

There is even a hint of the moral significance of fruits and vegetables in the popular city "Cries" published with great frequency in the later eighteenth and early nineteenth centuries in England and America. "Cries" were usually a bound series of engraved, sometimes colored, images of street criers hawking seasonal fruits, vegetables, fish, flowers, or even love poems, accompanied by short verses. The verses clarify the moral, educative tone of these little books, for they give examples of industriousness, sobriety, frugality, self-sufficiency, and their opposites—the glutton who eats too many apples or pears, the drunkard, or the foolish woman who sings nonsense songs.[58] Even Charles Willson Peale's 1787 etching, *The Accident in Lombard Street,* resembles the "Cries" in appearance and, with its accompanying verse, in moral purpose; it also makes use of a lost or wasted dessert as the focus for its morality—bringing us back to Raphaelle's imagery and possible readings of it (figure 3.12).[59]

Raphaelle Peale's still-life desserts confirm that an artist's life may have a great impact on his art. It is clear that the intergenerational conflict between father and son had as much to do with arguments about art as with attitudes toward self-regulation. We can also read into the extant verbal evidence a powerful tension between Charles Willson Peale's concerns for the power of reason over self-indulgence and passion and Raphaelle's assertion of his artistic mastery in the face of seemingly dissolute behavior and physical illness.

Raphaelle's pictures offer us a choice, but no real resolution. In life, he seems to have wanted to please his father, but he rebelled against him, as well. The still-life paintings, particularly the desserts, also contain this tension

between temperance and indulgence. They represent the extra, unnecessary, delicious part of a meal, the course that was the subject of a spate of prescriptive literature, and also a mark of gentility. The possibility for overindulgence is present in both a straightforward reading of the objects and foodstuffs, and through a more symbolic reading of the same imagery. And yet, the objects, foods, and drinks are few, and they are carefully and rationally arranged. By governing their numbers, and picturing them with restraint, Raphaelle controls the signification of intemperance, and injects the possibility of restraint into each small picture. He paints the delicate balance between genteel temperance and its dark underside in terms that would resonate for his educated and basically elite audience, but would also speak to his worried family, particularly his father.

This intermingling of the familial and the aesthetic, as well as an overriding concern with issues of artistic mastery, control, and choice are at the crux of Raphaelle's still lifes. If we read the pictures in tandem with Charles Willson's letters and other writings, their message is further clarified. Ultimately, one comes back to that piercing verbal image with which this essay begins, taken in its full context. In the middle of a sermon against intemperance, a plea for control of passion, and an insistence on changing the subject of Raphaelle's own painting, there emerges an image of a "Table (perhaps loaded with a variety of unnecessary articles, for two or three things is realy all that is needful)."

FIGURE 3.11
Amos Doolittle
The Prodigal Son Revelling with Harlots, 1814
Line etching, 15 x 11 in. (38.1 x 27.9 cm)
The Henry Francis du Pont Winterthur Museum,
Delaware

FIGURE 3.12
Charles Willson Peale
The Accident in Lombard Street, 1787
Etching
The Henry Francis du Pont Winterthur Museum,
Delaware

The Rewards of Virtue:

Rembrandt Peale and Social Reform

~

W I L L I A M T . O E D E L

OR REMBRANDT PEALE, in an accounting at the end of a long life, the heroic age was the time just before his own (plate 74). It was not the age he had helped create, but was, instead, his father's age: the Enlightenment, the Revolution, the establishment of the Republic. Notices upon Rembrandt's death in 1860 were dutiful to the "venerable patriarch among American artists," expressing vague gratitude for the "unwearying dedication of his talents, to the cause of art in this country." While Rembrandt was remembered as an amiable gentleman, most commentators agreed with the limp assessment that "Mr. Peale was neither a great artist nor the founder of a school, but he was the last of our painters whose name is connected with our Revolutionary period."[1] After a productive, thoughtful, feisty career devoted to an ideal of betterment, was there no more to be said of this determined contributor to American culture? If Rembrandt Peale lived anxiously and deferentially, mindful of the forever exemplary achievements of his father and his father's generation, and of inadequacy in his own generation's claim upon history, that same anxiety generated in him an edgy commitment to originality, to going one better.

The paintings map such intensity and tension. Part of what Rembrandt Peale imaged in his art was the invisible construct of his age, the uncertainty that obscured boundaries between faith and reason, the individual and community. To Peale nearly all aspects of life—religion, science, economics, politics—depended on the individual and the individual's understanding of what constituted the virtuous life in relation to the common good. His art is laden with the moral sense and the moral imperative, as he relentlessly instructs. If by mid-career his instruction stoutly glanced backward to the Jeffersonian ideal of a cultural elite, Peale still worked to devise modes of address to the emergent realities of urbanization, industrialization, immigration, and democratic politics. His art became a forum for both celebration and caution; as it was reformist, it acknowledged the instabilities and threats of its time.

There were family tensions, too, evinced in Rembrandt's restlessness, both professional and personal. Problems of self-definition plagued him:

PLATE 74
Rembrandt Peale
Self-Portrait, 1856
Oil on canvas, 21 x 17 in. (53.3 x 43.2 cm)
Mead Art Museum, Amherst College, Amherst,
Massachusettes; Gift of Edward S. Whitney,
Class of 1890

"if he meets with great difficulties he is apt to dispond," his father admitted.[2] While Charles Willson Peale was alive, Rembrandt moved frequently, claiming lengthy residences in Philadelphia, Charleston, Baltimore, New York, Boston, London, and Paris. During periods of acute self-doubt, he sought employment as bank officer, diplomat, and teacher. Often he confronted his father's authority directly. In 1812, for example, he planned his move from Philadelphia to Baltimore over his father's unequivocal protests, and his impulsive marriage at age twenty to Eleanor May Short (see figure 22)—the uneducated, undowried Catholic daughter of the family housekeeper—almost certainly challenged his father's prescription for the courtier-artist. Charles Willson Peale obliquely described the liaison as "a great pity," masking his displeasure behind the pretext that Rembrandt should have studied in Europe before marrying.[3]

Family tensions came into focus on issues of painting themes and style. When, at every turn in his early career, Rembrandt was identified as the son of Charles, nephew of James, or brother of Raphaelle, he responded by resolving publicly that "whereas few persons discriminate between the peculiar names of my father, uncle, brother or myself, which creates confusion disadvantageous to the distinct merits of each as an artist; I am induced to obviate this inconvenience on my part, in being known only by my first name Rembrandt; the adjunct Peale serving only to show from whom descended."[4] Now there is an odd statement, one that attests to a despairing perception of being understood in relation to forces more commanding than oneself. And what were the "distinct merits" of Rembrandt as artist that became concrete over the years? They included a daring inconstancy in both style and theme, a bookish fascination with the chemical properties of picture-making and the techniques of the masters (which resulted in the "Notes from the Painting Room" in the 1850s), a commitment to reformist French theory (which resulted in the professedly democratizing *Graphics,* a drawing manual first published in 1835), and an obsession with what was called "finish," implying the meticulous recording of selected visual facts and the suppression of the painter's physical interest (as evidenced by brush stroke, in particular).[5]

Such "distinct merits" drove Charles Willson Peale to complaint, although he was to some degree the engine of them all. He worked to master Rembrandt's researches in color and glazing techniques, but he did not shy away from criticizing Rembrandt's insistence on finish and fascination with unconventional subject matter. "Truth is better than a high finish," he advised in a memorably goading diatribe; " . . . the portrait painter must dispatch his work as quick as possible, by aiming at good character, truth in drawing & colouring—effect at a proper distance if not so highly finished may be acceptable with the multitude."[6] In response to such outré productions as *The Roman Daughter* (plate 75) and *The Dream of Love* (1812–15; destroyed by fire), Peale boiled over: "keep clear of every offence to religious societies," he warned. "I have been much mortified by the Exhibition of . . . [nudities] at Ruben's when I heard it said that it ought to be presented as a public nuisance."[7] "I love the Art of Painting," Peale later wrote to President Jefferson, "but the greatest merit of execution on subjects that have not a virtuous tendency, lose all their value."[8] Rembrandt, as his paintings document, resisted his father's formula for success.

Nonetheless, in the two definitive enterprises of his career, Rembrandt Peale was the consummate straddler, re-envisioning the past to construct the future, honoring the family legacy while redefining it for an age with which he was in nervous, imperfect synchrony. Rembrandt's moment of balance—when his purposes became largely indistinguishable from his society's—came in the 1820s in the form of two paintings, the *Court of Death* and the "national likeness" of George Washington. Significantly, he undertook these projects as his father, uncle, and older brother were concluding their careers.

To glimpse the seasoned intentions of Rembrandt Peale, then, we must look to his work during the decade when American art and culture experienced their first generational realignment since the revolutions of the late eighteenth century. In art parlance, the much-relieving Era of Good Feelings was souring well before 1825. The Erie Canal opened as Thomas Cole began to exhibit reactionary landscapes. Federalism imploded before Gilbert Stuart received the first retrospective show accorded an American artist and Democrats leveled invectives of elitism at John Quincy Adams. Factories were multiplying and capitalism turning impersonal as cities began to mass-produce and farm culture wither. Intemperance, opportunism, and lawlessness appeared ascendant; the middle-class family and women were asserting their causes in recognition of their jeopardized status, while the Second Great Awakening was in mid-realization, again in response to perceived threat. The live heroes of independence received their last hurrah in trumped-up support of nationalism; slavery was abolished in the North, signaling the march of sectionalism. Many cultural workers found linkage among such drifts, and that long before Andrew Jackson cast them in high relief at the end of the decade and through the 1830s. At the onset of the Age of Reform, Rembrandt Peale, glancing back, was alarmed at what he saw as the erosion of denominators of virtue laid down during the Age of Reason. He published his ideology in paint, notably in the *Court of Death* and the Washington portraits.

Rembrandt suffered in the Panic of 1819 and the severe depression that ensued. At Baltimore, he had so overextended himself financially that he lost grip on his principal investments—the museum and the illuminating gas company; both were out of his control within three years. To recover financial stability as portrait commissions evaporated, Rembrandt invested nine months in 1819–1820 to create his enormous painting, the *Court of Death* (figure 4.1). He intended to send it on tour and profit through admission fees. He had painted on speculation before—in assembling the Apollodorian Gallery in Philadelphia in 1811–1815, for example—but the production of a large-scale painting exclusively for traveling show and public display was a risky new enterprise. He secured the approval of his father, who admired (and copied) a preliminary sketch (plate 76), and then remodeled the Baltimore Museum to accommodate the nearly 12-by-24-foot canvas. He was nervous; Thomas Sully visited the studio and dared friendly comments about color, but Charles Bird King found "many faults in my Picture," Rembrandt reported. "As far as he went, it did me good—but *perhaps* if he had staid longer he would have made me too discontented with it."[9]

In undertaking a project of such magnitude, Rembrandt joined the most ambitious artists in the United States. A few painters, all of whom had

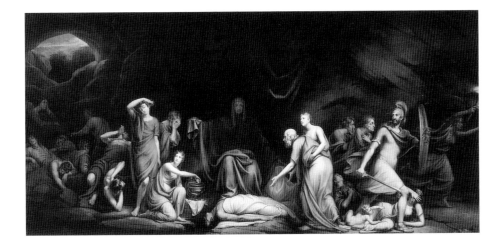

FIGURE 4.1
Rembrandt Peale
Court of Death, 1819–20
Oil on canvas, 11 ft. 6 in. x 23 ft. 5 in.
(3.50 x 7.13 m)
Detroit Institute of Arts; Gift of George H. Scripps

studied in European academies, were developing innovative exhibition techniques and professedly democratic modes of address. Their ostensible goal was to empower the artist as an aesthetic, moral, and ideological voice within a society that placed a narrow value on art. The big winner in the new arena of sensational paintings and profit-generating exhibitions was John Trumbull, who received the prize of the season when the federal government commissioned him in 1817 to paint four large canvases treating events of the Revolution for the Capitol Rotunda. By all accounts, the prize—thirty-two thousand dollars—was vastly more breathtaking than the paintings, especially when Trumbull was able to enhance his income through a series of exhibitions before surrendering the canvases to the public domain.[10]

Other artists followed suit, hoping that their large-scale efforts and promotional campaigns would lure the next big government commission. In New York John Vanderlyn, having returned from Paris in 1815, established

PLATE 76
Charles Willson Peale after Rembrandt Peale
"Court of Death," 1819
Drawing, graphite on paper
Private collection

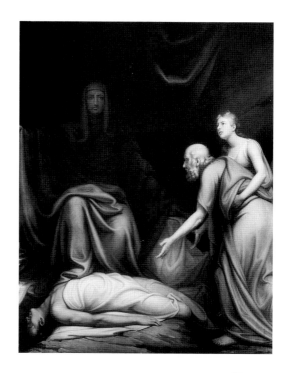

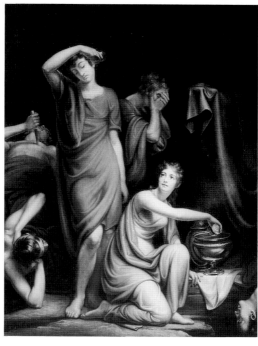

FIGURE 4.2
Rembrandt Peale
Detail (Death and corpse) from *Court of Death*,
1819–20
Oil on canvas, 11 ft. 6 in. x 23 ft. 5 in.
(3.50 x 7.13 m)
Detroit Institute of Arts; Gift of George H. Scripps

FIGURE 4.3
Rembrandt Peale
Detail (Pleasure serving drink to youth) from
Court of Death, 1819–20
Oil on canvas, 11 ft. 6 in. x 23 ft. 5 in.
(3.50 x 7.13 m)
Detroit Institute of Arts; Gift of George H. Scripps

the Rotunda, his own mini-Capitol, at Park Square behind City Hall. He designed the facility to allow for the exhibition of panoramas, gigantic circumferential paintings, which, as modern inventions, set new limits for illusionism and sensationalism. Vanderlyn characterized the panorama as a democratic art form, requiring no specialized knowledge from the viewer and for that reason amenable to the middle-class American audience. Painting his own panorama (1819; Metropolitan Museum of Art, New York) and renting others, he unfortunately made his capital-intensive ventures on the eve of the 1819 panic and went bankrupt. Many such efforts proved financial, if not aesthetic, disappointments: Sully's huge *Washington's Passage of the Delaware* (1820; Museum of Fine Arts, Boston), Allston's huge *Belshazzar's Feast* (1817–1843; Detroit Institute of Arts), and Samuel F. B. Morse's not-huge-enough *The House of Representatives* (1822; Corcoran Gallery of Art, Washington, D.C.).[11]

In contrast to these failures stood the success of Rembrandt Peale's *Court of Death*. When on tour in eastern cities between 1820 and 1823, it attracted audiences whose numbers and evident acceptance of the power of the visual arts were unprecedented in the United States. Peale cleared a profit of four thousand dollars in the first year alone, as over thirty-two thousand people paid twenty-five cents each to see it. It was something to see, often illuminated by gaslight, orchestrating twenty-two larger-than-life figures in tightly staged interaction. Peale grouped the figures as a shallow, panoramic frieze within a theatrical context rendered horrific and sublime by obscure lighting, sudden contrasts, and rough, irregular forms and linear rhythms. As a visual sermon on the rewards of a virtuous life based on temperance, pacifism, reason, and faith, the painting is a readily legible, reformist treatise.[12]

Peale drew inspiration from the well-known poem "Death" by Beilby Porteus (1723–1809), late Anglican bishop of London. "Deep in a murky cave's recess," Death sits enthroned "in unsubstantial majesty" at the source of the waters of oblivion, holding court over his "dread Ministers." Like a conquering emperor, he rests his foot on the body of a man laid low in his prime by some irrational agent (figure 4.2). On the left are likely suspects, the kneeling, alluring figure of Pleasure and her retinue: Remorse, Intemperance, Frenzy, and Suicide (figure 4.3). Beyond, as Peale wrote, is "a darkened group of disease and misery, the victims of luxury and intemperate pleasure": Gout, Dropsy, Apoplexy, Hypochrondia, Fever, and Consumption (figure 4.4). On the right are the consequences of war: a warrior "with a countenance agitated by ambition and revenge," looks furtively over his shoulder, his sword dripping blood, as he rushes offstage, past his murdered enemy and over an infant and its widowed mother (figure 4.5); harpy-like personifications of Want, Dread, and Desolation exit in his wake. In contrast to these younger victims of the passions gone out of control, "venerable Old Age, supported by Virtue," which Peale cast also as hope and religion (see figure 4.2), advances in the foreground. These figures provide the moral punch line: "Old Age, bending at the close of Life—the faded purple of his worldly power falling from his shoulders—his foot on the verge of oblivion —beholds the prospect without alarm, and submits with cheerfulness to the divine law. Virtue still supports him, and *looks* the sentiments he *feels*."

The point is disarmingly straightforward: "Death has no terror in the eyes of Virtuous Old Age, and of Innocence, Faith, and Hope."[13]

Peale dedicated his career to the celebration of virtue, which circumspect American society regarded as the rationale for the fine arts in the new Republic. Even in his controversial *The Roman Daughter,* he extolled patriotism and filial piety. In the portrait gallery of eminent men that he created for the Baltimore Museum, in his New York portraits (see plate 77), and later, in his "Porthole" portraits of Washington, he sounded the same theme: exemplary virtue and patriotism bring everlasting fame and the homage of posterity, the secular equivalent of eternal life.

Although *Court of Death* is a vision from the afterlife, Peale understood death as involving no unfathomable mystery. Death, he argued, is simply "a fact, an incident, the natural and ordained termination of life."[14] Death cannot be denied, but on a rational plane the individual can influence and stave off its claim through virtue. The theme is grounded in middle-class humanism and materialism, as Peale assigns greater weight to reason, merit, accountability, and free will than to faith, spiritual revelation, authority, or a psychology of predestination. He envisions the capacity for upward social mobility through self-help and moral reform. If the individual adheres to temperate, virtuous conduct, renouncing vice and excess, he will neutralize death's fearsome potential for agony, violence, and untimeliness. Virtuous behavior is the manifestation of inherent spiritual character, and virtue itself is a democratizing agent, extending to all an access to divinity.

Court of Death images the moralistic, rationalistic alternatives to traditional doctrine that liberal Christians, especially Unitarians, advanced at the time. Rembrandt Peale was a founding member of the Unitarian Church in Baltimore in 1817 (and later, a member of the Philadelphia church). His was the first Unitarian congregation in the city, as, indeed, Unitarianism was relatively foreign to Americans outside of Boston. Peale likely played a role in selecting the architect of the new church, Maximilian Godefroy, whose portrait he painted about the same time (see figure 4.6). The ordination of Jared Sparks in May 1819 was momentous, for it was then that William Ellery Channing, the guiding figure in Unitarianism and, like Sparks, a Harvard graduate and Bostonian, delivered the manifesto Baltimore Sermon (see figure 4.7). Subsequent publication of Channing's address had the largest circulation of any American pamphlet up to that time, except, perhaps, Thomas Paine's *Common Sense.* In its formative context, Unitarianism was radical opposition, especially because of its rejection of Trinitarian dogma and the miraculous (that is, irrational) works of Jesus. Channing reasoned that the quality of divinity resides within every individual and that the individual properly approaches salvation through devotion to virtue and temperance. "We want that truth," he wrote, "which can carry us forward against the strength of passion, temptation, and evil." In *Court of Death,* Peale made visible a measure of that truth, and at the very moment when Baltimore was at the hub of newsmaking events in liberal Christian theology.[15]

Salvation through virtue was heartening news for the ever-increasing middle class. Rembrandt painted his counterpart to Channing's sermon during a period of religious fervor, when the Second Great Awakening, in

FIGURE 4.4
Rembrandt Peale
Detail (Disease and misery) from *Court of Death,* 1819–20
Oil on canvas, 11 ft. 6 in. x 23 ft. 5 in. (3.50 x 7.13 m)
Detroit Institute of Arts; Gift of George H. Scripps

FIGURE 4.5
Rembrandt Peale
Detail (War trampling widow and orphan) from *Court of Death,* 1819–20
Oil on canvas, 11 ft. 6 in. x 23 ft. 5 in. (3.50 x 7.13 m)
Detroit Institute of Arts; Gift of George H. Scripps

PLATE 77
Rembrandt Peale
Chancellor James Kent, 1834–35
Oil on canvas, 30 x 25 in. (76.2 x 63.5 cm)
National Portrait Gallery, Smithsonian Institution,
Washington, D.C.

gear since the turn of the century, powered a resurgence of evangelistic moralism and social reformism. Despite its Unitarian bias and monotheistic underpinnings grounded in Enlightenment Deism, the universal import of the *Court of Death* could motivate all socioeconomic and religious constituencies toward a common morality and ideology. In a liberal culture, who would not conclude that war was abhorrent? In a capitalist society, who would not argue that intemperance and tyranny of the passions were unproductive and immoral?

Rembrandt painted from moral urgency with clear intentions. He apportioned a third of the canvas to an indictment of war because he was a pacifist. He respected heroes of the Revolution and the War of 1812, but he had risked arrest in 1814 by refusing to be drafted in the defense of Baltimore, because, as he confessed at the time, he was "conscientiously Scrupulous" and "found it impossible to shoot at a human being." The conflict is generational —it also speaks to Charles Willson Peale's own refusal to remain in a military service that involved mortal combat.[16]

Militarism and talk of war were very much in the air when Rembrandt worked on *Court of Death,* as General Andrew Jackson's campaigns against the Seminoles were but a smokescreen for driving Spain out of Florida. Sully, although an active Unitarian himself, glorified the martial spirit in *Washington's Passage of the Delaware,* and Vanderlyn did the same in his portrait of James Monroe in 1821 (Art Commission, City Hall, New York), where the map of Florida and the sword made clear the President's role in wresting territory and mandating American hegemony in the hemisphere. While these images celebrated a kind of defensive imperialism, Peale's statement was cautionary. At the same time, his father was finishing a composition, now lost, of a "night scene" depicting "the retreat of the American Army crossing the Delaware at Lamberton in 1776"; it was, the Revolutionary veteran admitted, "the most like *Hell* of any thing I ever beheld. And, as I hate *Wars,* I take this occasion to represent some of the Horrours of it."[17] If Charles Willson Peale considered his anti-heroic night scene as an antidote to Sully's heroic night scene, in the *Court of Death* Rembrandt expressed similar views, and, inextricably in concert with his father, proffered the first clear assertion of pacifism in American art.

Peale was also among the first artists to raise intemperance as a public concern by inveighing against its evils in the left third of his canvas. He had a personal stake in the issue, since he was an avowed water-drinker. As medical books of the time confirm, the afflictions that Rembrandt catalogued in the painting were believed to result from what might be termed an immoral diet: alcohol, the wrong foods, and excessive eating were all associated with gout, dropsy, apoplexy, hypochrondria, and consumption. Chronic psychoses, such as remorse and frenzy, also accompanied overindulgence, and any of these disorders could either lead to suicide or be interpreted as resulting from self-destructive behavior.[18]

Philadelphia genre artist John Lewis Krimmel already had sounded the temperance alarm in a number of paintings, including the *View of Centre Square on the Fourth of July* (see figure 4.8). With the *Court of Death,* Rembrandt Peale not only fueled the temperance movement that became established in the 1830s, but he also affirmed that moral discourse was a public imperative

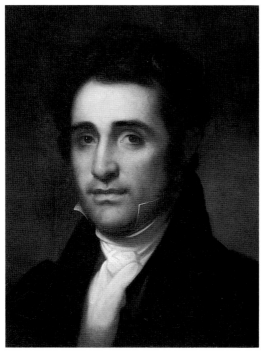

FIGURE 4.6
Rembrandt Peale
Maximilian Godefroy, c. 1815
Oil on canvas, 23 3/16 x 19 1/16 in. (58.7 x 48.3 cm)
Peabody Institute of The Johns Hopkins University, on indefinite loan to the Maryland Historical Society, Baltimore

FIGURE 4.7
Rembrandt Peale
Jared Sparks, c. 1819
Oil on canvas, 20 1/8 x 15 3/16 in. (51.1 x 38.6 cm)
Harvard University Portrait Collection, Cambridge, Massachusetts. Bequest of Lizzie Sparks Pickering

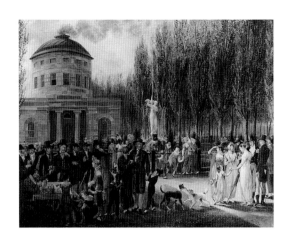

FIGURE 4.8
John Lewis Krimmel
Fourth of July in Centre Square, 1812
Oil on canvas, 22 ¾ x 29 in. (57.8 x 73.7 cm).
Courtesy of The Pennsylvania Academy of the Fine
Arts, Philadelphia. Pennsylvania Academy Purchase
(From the Estate of Paul Beck, Jr.)

in the new Republic, in which each individual was to be regarded as representative of the nation as a whole.[19] Women, he emphasized, exerted a determining influence on that discourse. As he characterized the male, only the old man, guided by Virtue (a restaging in many ways of *The Roman Daughter*) survived in the culture of violence that infected all others; in underscoring the paternal dependence on female nurturing, Rembrandt paid tribute to his father's longevity and deliberate strategy in conducting his life. Rembrandt's (and Krimmel's) characterization of the female, however, was multidimensional: women were "ministers" of intemperate behavior and preventable degeneracy, both victims and attendants of violence, yet, in the guise of Virtue, the redeemers of mankind.

Peale's moral sense corresponds to the essays on health written by his father, by Benjamin Franklin, and by Benjamin Rush, all of whom advised the responsible citizen of the enlightened community to "bring thy Appetite into Subjection to Reason." Charles Willson Peale's *Epistle to a Friend on the Means of Preserving Health* is a blueprint for Rembrandt's painting in its emphasis on reason, temperance, and proper diet. The "*strengthened constitution will resist disease,*" evil, and vice, the elder Peale wrote, yielding the reward of "*health* and *long life*" as opposed to "misery and premature death!" Virtuous conduct would even ward off yellow fever, the dreaded "minister" of death that afflicted Baltimore and Philadelphia in the summers of 1819 and 1820, precisely as Rembrandt began and completed the painting. Charles Willson Peale wished his prescription to result in the "sweet benevolence" and "love of order" that are themselves "springs of health." "What is the cause of those violent struggles in death," he asked, presaging the central theme of the *Court of Death,* "but a premature exit, hastened by an *improper* mode of living? Whereas by a prudent conduct, they might have lived so long, as insensibly to wear out the machine, and then depart quietly, without a pang. . . . Was one to live as he should do, *enjoying* every good gift and *abusing none,* he would, bar[r]ing accidents, live to extreme old age, without disease."[20]

If *Court of Death* was charged with personal references—to the Peale family as the representative family of modernized Enlightenment values and conflicts—it was the particular case of Raphaelle Peale that lent prophetic urgency to the picture. In his still-life art, Raphaelle waffled between statements about luxurious indulgence (burgeoning, irrational capitalist consumption) and reasoned frugality (enlightened republican morality), perhaps thus signaling his own ambivalence toward family strictures. For years, however, the family had been concerned by Raphaelle's drinking, and lately his conduct had raised more strident alarm. His father pleaded with him to renounce "destructive habits," to "act the Man and respect yourself." "When the laws of Creation is broken," Charles Willson Peale advised, "then disease, destruction and Misery follow. Thus man can have no right to complain, as having a free will to act . . . can we do what we know is a breach of laws enacted for our happiness . . . without feeling remorse for our conduct?" When Raphaelle mentioned suicide, his father raised his voice: "we do not live for our selves alone. Is it not one of our first duties, to endeavor to make all other beings happy? . . . is it not criminal in us to neglect our duties to those who ought to be dear to us?"[21] These words seem terribly harsh,

despairing of Raphaelle as a deviant who broke the laws of nature, rejected Enlightenment thought, and dishonored the family. If Raphaelle was the wayward soul, however, Rembrandt was the dutiful son who had assimilated his father's moral code and then published it in *Court of Death*.

Although Rembrandt loaded the painting ideologically, he worked to make it accessible both physically and intellectually. Building on the example of his father, Rembrandt was part showman and promoter, who made sure that the public took note of his grand productions. After opening in Baltimore, the painting went on national tour in 1820 until 1823, traveling to Philadelphia, New York, Boston, Albany, Charleston, and Savannah. Rembrandt published a pamphlet explaining the picture, while his agent, John Pendleton, released the itinerary to the press and arranged showings in churches, town halls, and specially built facilities. Ministers praised the picture's virtues and urged their congregations to see it; even politicians made a point of being seen in its company.[22]

Rembrandt attached special significance to the painting's popularity because he had produced it for the general public not educated in the grand tradition of art, just as, at the same time, Vanderlyn had advanced the panorama as a democratic art form, requiring no specialized knowledge on the part of the audience. Aunt Hannah, the Peales' "old black cook," understood the theme and, Rembrandt noted, "went through the entire picture, translating it into her own language, entirely to my satisfaction." Thomas Jefferson also seized on the painting's effect: "It presents to the eye more morality than many written volumes and with impressions much more durable and indelible." Rembrandt had his own criteria for gauging the painting's impact. "It was not," he maintained, "an Allegorical Picture, composed after the examples of Lebrun or of any school," but "an attempt by *personification* to show the reality and necessity of death, and the charms of virtue, contrasted with vice and intemperance, and the horrors of war."[23]

Rembrandt believed that he had rediscovered a classical Greek type of painting—"metaphorical painting"—which he characterized as uniquely appropriate to the American democratic Republic. Indeed, he touted the *Court of Death* as "the first attempt, in modern times, to produce moral impressions on the ancient Greek plan, without the aid of mythology, or conventional allegory, being as readily understood by the ignorant as the learned." His reference to the "ancient Greek plan" was specific, for he had read about the artists Zeuxis (mistakenly called Apelles) and Parrhasius, who had treated moral themes in public murals by typifying figures through expressions, gestures, and physical attributes; the public recognized each figure as representing a specific character trait, such as compassion or humility, without having to decipher arcane symbols or allegories. Thus, for example, Rembrandt depicted death as a graspable human form, rather than, as one Philadelphia philosopher had put it, the stereotypical "skeleton with a sithe in one hand, and an hour glass in the other," which was "difficult" and "unappropriate" for the mind of man to conceive. Rembrandt described himself as the first modern painter "to employ the language of painting, in this maner, for the purpose of affecting the heart without doing violence to the understanding." Charles Willson Peale announced the innovation to

Jefferson: "Rembrandt has endeavored to produce a speaking Picture, and to avoid all emblematical signs."[24]

Rembrandt's efforts at democratizing painting did not compromise his commitment to the grand manner or his publication of a lengthy explanatory text. Even as he employed friends, family, and a corpse from the Baltimore Medical College as models, he based many of his figural types on guidebook standards from the grand tradition. The features of Old Age came from the bust of Homer at the Louvre, and Pleasure and Intemperance were based on Hellenistic Venuses. Rembrandt adapted figures from a number of familiar Baroque images, such as lamentation scenes and representations of the "Massacre of the Innocents," and he was extensively indebted in his visual thinking to the large canvases by Peter Paul Rubens that he had studied in Paris, particularly the Government of the Queen allegory in the Marie de' Medici cycle (1624; the Luxembourg Palace, Paris).[25]

Rembrandt drew parallels with contemporary painting as well. As he began *Court of Death,* he had in mind Benjamin West's *Death on the Pale Horse* (figure 4.9), which he had seen in London. West's drawing *Moses Striking the Rock* (1788; retouched 1803; Royal Academy of Arts, London) could have provided prototypes for Rembrandt's figures of Old Age and Virtue. In contrast to West, however, Rembrandt composed not a scene of divine wrath or miraculous salvation in the context of revealed religion, but a tableau of revealed morality. He may also have quoted from paintings that he had seen in Paris by Jacques-Louis David, Robert Lefebre, and François Gérard, the French artists whose work he most admired and whom he had met in 1809. He owed more to French neoclassicism than to West in terms of style, sculptural forms, clarity of line, and surface finish.[26]

Why did Rembrandt's sensational venture succeed while other such enterprises failed? In his Versailles panorama, Vanderlyn asked Americans to consider a difficult abstraction: the relationship between art and national culture. In *The House of Representatives,* Morse asked his audience either to equate a magnificent architectural space with a magnificent political institution or to marvel that midget lawmakers could function after dark, provided the chandelier was lit; in either case, Morse asked too much, for the public stayed home. Both Vanderlyn and Morse were puzzled because they had thought that their essentially scenic, civic paintings were democratic, readily accessible to an audience unlearned in art.

FIGURE 4.9
Benjamin West
Death on a Pale Horse, 1796
Oil on canvas, 23 ⅜ x 50 ⅝ in. (59.5 x 128.5 cm)
Detroit Institute of Arts, Founder Society Purchase, Robert H. Tannahill Foundation

Meanwhile, the public happily paid to witness the devotional scene or religious event, whether historical or miraculous. The public opened its purse in the 1820s to view, for example, Henry Sargent's *Christ's Entry into Jerusalem* (unlocated), François Marius Granet's *The Choir of the Capuchin Church in Rome* (1815; The Metropolitan Museum of Art, New York), and Sully's copy after it (unlocated), Francis Danby's *An Attempt to Illustrate the Sixth Seal* (unlocated), and William Dunlap's *Christ Rejected* (1822; The Art Museum, Princeton, New Jersey). Dunlap, for one, waxed very religious and very theatrical, painting large exhibition pictures—cloned, as was *Christ Rejected*, from the late work of West—of *The Bearing of the Cross, Calvary,* and *Death on the Pale Horse* (all unlocated), and rolling them out for successful tours at least to 1828. Rembrandt himself began another enormous canvas in 1821 as a follow-up to the *Court*—"of equal dimensions," he said, "but of more extensive design"—depicting "Christ's Sermon on the Mount"; it was another basically rationalist subject, offering a moral code that clarified the rewards of virtue. He abandoned the project, however, complaining that "the difficulties attending the exhibition of such large Paintings is at present too great" and hoping to devote his studio time to "smaller subjects of History & Poetry." Still, Rembrandt's example inspired Charles Willson Peale in 1821 to paint a large composition, 4½ by 8 feet, based on an engraving of "Christ at the Pool of Bethesda" (not a rationalist subject), now lost.[27]

Such paintings met a ready public demand for envisioning religious and moralizing subjects. They objectified the ideological order as formulated especially by the emerging constituency of the middle class, and they proved that the visual rhetoric of the grand manner in art, far from exhausted and irrelevant, had broad appeal when applied to the religious rather than mythological or classical history context. In their sublime language, millennial intensity, and moral assertiveness, the "big pictures" of the 1820s did have effect, coursing seamlessly, in particular, through the evangelical and moralizing landscapes of Thomas Cole. For its part, *Court of Death* remained sufficiently potent as an embodiment of middle-class reformist energy that it was broadcast as a lithograph in 1859. As Rembrandt defined the rewards of the virtuous life, as he identified the possibility of moral perfection in the Second Great Awakening, and as he invented a Greek revival in painting, he assured for his sensational large-scale project a relevance and authority that eluded most artists of his generation.

Rembrandt Peale carried his moral crusade into his second ambitious undertaking of the 1820s: the creation of the "national portrait and standard likeness" of George Washington (see figure 4.10). It was, he puffed in 1823, "my great work . . . an undertaking which no one else could or would attempt." Only five artists then alive had painted Washington from life: Trumbull, Stuart, and the Peales—Charles Willson, James, and Rembrandt. Rembrandt believed that "to combine the excellencies of the originals" would produce a stirring composite encoding in Washington's features exemplary characteristics of the virtuous life: "it has a grand & imposing aspect & is calculated for public buildings." His plan was to sell the portrait to a grateful and munificent United States government, thereby eclipsing Stuart and Trumbull as national historians in portraiture and asserting the Peale name in their stead. The first

order of business was to discredit Stuart—"to correct the popular misrepresentations spread over the whole country"—but no less urgent was to supplant Charles Willson Peale—"My father . . . is already satisfied that mine will be the standard likeness."[28]

Rembrandt's prototype "Porthole" portrait shows Washington as the statesman in civilian dress, the figure set within a trompe l'oeil oval frame simulating stone. The frame expands in the form of a large masonry monument encircled by an oval oak wreath and surmounted by a keystone with the head of Zeus-Jupiter. A plaque below is inscribed "Patriae Pater." This was a strange painting with perhaps no recent formal precedent beyond the French Rococo memorial portrait type. The oval format relates to the mat spandrels of Charles Willson Peale's museum portraits, but, in the context of Rembrandt's forays into a Greek revival, it derives from the ancient *clupeus* or "portrait-shield." Pliny, the Peales' habitual source of legitimacy for their novel ideas, recounted that Greeks decorated their shields with portraits of ancestors during the Trojan wars and by the fifth century B.C. established the custom of reading publicly "the inscriptions stating their honours" and "dedicating the shields with portraits in a temple or public place."[29] Rembrandt had in mind the Capitol.

Rembrandt devised a composite of Charles Willson Peale's 1795 life portrait (figure 4.11), Jean-Antoine Houdon's 1785 life sculpture (figure 4.12), and his own 1795 life study (figure 4.13), "aided by my recollection of the original himself and the Criticisms of his friends." He conducted extensive research, not only studying portraits of Washington, but also interviewing associates, checking the portrait against their recollections, and soliciting statements of authentication.[30]

Peale's approach was similar to that of Jared Sparks. While minister of the Baltimore Unitarian Church, Sparks also served as Chaplain of the House of Representatives from 1821 to 1823. He developed a passion for Revolutionary history, gathering information from those who had known Washington and his circle. Later, just as Peale tapped the growing market for Washington portraits following the centennial of the hero's birth in 1832, Sparks converted his research into the publication of the twelve-volume *Letters of George Washington* (1834–1837) and the *Life of Washington* (1839), as well as a renowned series of lectures at Harvard University.[31]

Jared Sparks, Rembrandt Peale, and like-minded arbiters of the national memory both aggrandized and responded to the growing cult of the founding fathers. Nostalgia for the golden age of American history increased as the number of living veterans and statesmen of the Revolutionary era decreased. In 1823, as the fifty-year anniversary approached, only three signers of the Declaration of Independence were alive—Jefferson, John Adams, and Charles Carroll. The Marquis de Lafayette endured a year-long tour of the nation in 1824–1825, igniting an extensive memorabilia industry. Rembrandt painted his portrait, using the porthole device (1824; Metropolitan Museum of Art, New York).[32]

The intense nostalgia testifies to intense anxiety. The very durability of Rembrandt's "national portrait" until the onset of the Civil War (and the artist's death) suggests that even in 1824 it embodied layers of meaning beyond

blanket patriotism: an iconic understanding that mollified ideological difference at the national level and sought literally to standardize the American "type." It is well known that Rembrandt returned profitably to the Washington image in the 1830s, 1840s, and 1850s (see plate 78) in equivocal response to sectionalism, since Washington was common ground for interests north and south; but it is also likely that the portrait indicated his perception of national divisions within its original context in the early 1820s, just after slavery was abolished in the North. Beginning in the twenties, too, unfamiliar constituencies challenged the definition of the American character and experience, necessitating a comforting reaffirmation of founding principles in mythic terms. The issue, rationally apprehended, was assimilation into mainstream American culture—white, male, Protestant, entrepreneurial, definable—of those perplexing "others" who were pressing claims as early as the twenties: native Americans, free and freed African-Americans, women, Catholics, factory workers, expansionists, even veterans of '76 demanding pensions. Washington offered the ideal foil to volatile factors: he was the national exemplar and conciliator, his biography and his image were both reassuring to those who felt threatened and instructive to those who felt adrift adapting to a new culture. The insistence on the paradigm of virtue implied that it was under siege. The shaping of history was at issue: as Charles Willson Peale stated the case, paraphrasing René de Chateaubriand, "I wish never to paint the Portrait of a bad man, as none but the virtuous dese[r]ve to be remembered."[33]

Again, Rembrandt Peale was conflicted, wanting to pay tribute to the experience of his father (who, like the surviving signers, was about to pass from the stage), leery of a world without long-standing moorings, yet committed to reshaping history and defining the terms of moral discourse for his own time. If the very look of Washington cut across barriers in an age of fragmentation, it affirmed an ideology that wished to avert the inevitable reversal of an outmoded order. In reconfiguring Washington's likeness, Rembrandt phrased the mission in urgent terms, as a "rescue from oblivion," yanking back into consciousness not so vitally how the hero appeared as what his appearance could substantiate.[34] The painting is a moral metaphor like the *Court of Death,* and like the momentous visual treatise that Charles Willson Peale completed the year before, in 1822, *The Artist in His Museum* (see figure 10.2).

As he fabricated Washington's fixedly delineated, standardized physiognomy, Rembrandt Peale drew on his knowledge of the pseudo-science of physiognomics, which offered formulas for comprehending character through close reading of physical attributes. Like its later offshoot phrenology, physiognomics held social reform as a central principle, identifying ideal standards and, by contrast, character faults that warranted remedy; contemplation of the ideal encouraged virtuous conduct ("even the fashion of our faces are determined by our passions," as Charles Willson Peale put it). In the "Porthole" portrait, Rembrandt framed the important equation between Washington and Zeus-Jupiter in terms of not only Olympian qualities but also Olympian physiognomy, constructing an ideal leonine type with square face, broad forehead, lowering brow, deep-set eyes spaced far apart, wide aquiline nose, and square jaw. Still, within the generic type that reveals the god-like and paternal ruler virtues of Washington—as well as the more

FIGURE 4.10
Rembrandt Peale
Patriae Pater, 1824
Oil on canvas, 69½ x 52½ in. (179.5 x 133.4 cm)
United States Senate Collection, Washington, D.C.

FIGURE 4.11
Charles Willson Peale
George Washington, 1795
Oil on canvas, 29 x 23¼ in. (73.7 x 60.3 cm)
Collection of The New-York Historical Society

FIGURE 4.12
Jean-Antoine Houdon
George Washington, 1785
Plaster, 21 in. (53.3 cm)
National Portrait Gallery, Smithsonian Institution;
Gift of Joe L. and Barbara B. Albritton, Robert and Clarice Smith, and Gallery purchase

FIGURE 4.13
Rembrandt Peale
George Washington, 1795
Oil on canvas, 15¼ x 11⅜ in. (38.7 x 28.9 cm)
Historical Society of Pennsylvania, Philadelphia;
Bequest of Mrs. John J. Henry, 1935

PLATE 78
Rembrandt Peale
George Washington as Patriae Pater, 1859.
Oil on canvas, 37 x 30 in. (94 x 76.2 cm)
The Hendershott Collection

particular attributes of intelligence, dignity, strength, resolve, and magnanimity—Rembrandt injected through peculiar lines, lumps, florid highlights, and other marks of idiosyncrasy the belief that individualism was integral to the Washington ideal and, thereby, national character.[35]

Washington's eternal role of *exemplum virtutis,* or arbiter of national values, found similar urgency in the genre paintings of John Lewis Krimmel. Working in the teens, within the close orbit of the Peales, Krimmel actually included Stuart's iconic portrait of Washington (see figure 29) in a series of paintings that dealt with virtue compromised: a quilting frolic gone amiss, a Fourth of July celebration gone awry, and a country frolic gone to the devil (see figure 2.16). The portraits hang over a mantle and atop the tent post. Throughout the series, Krimmel equates Washington's moral image with triumphant nationalism, as he pairs the portrait with framed pictures of American naval victories in the War of 1812. In each case, Washington's exalted presence *via* his portrait acts as a foil to the base activities catalogued below it: drunkenness, theft, infidelity, wantonness, and the miseduction of children. Krimmel's images clarify the connection in the public imagination between the themes of Rembrandt's two landmark paintings—intemperate behavior stressed in *Court of Death* and heroic individualism epitomized in the Porthole portrait.[36]

Did Rembrandt Peale succeed in his career dedicated to what he interpreted as the common good? Was there a shred of real understanding or contextual awareness in the critical judgment that he was "neither a great artist nor the founder of a school"? Rembrandt Peale did at least this: he made available in historically informed images what many men and women of his generation considered to be the central concerns of their lives, and he enlightened a path by which they could realize the rewards of virtue.

F I V E

~

Fruits of Perseverance:

The Art of Rubens Peale, 1855–1865

~

P A U L D. S C H W E I Z E R

*L*ATE IN LIFE, RUBENS PEALE (1784–1865) (plate 79) recounted in his memoirs an incident that took place when he was a child at his father's home in Philadelphia. Benjamin Franklin was there and, seeing the young lad laboring over a drawing he was making, said to Rubens, "Persevere my boy you will make a painter yet." Franklin took a card from his pocket, wrote the Spanish word, *"Perseverancia"* on it, and handed it to the young boy, saying, "keep this and remember it."[1] Decades later, after years of public service at museums in Philadelphia, Baltimore, and New York, Rubens moved to a farm on the banks of the upper Schuylkill River in an area of gently rolling hills less than two miles south of the small village of Schuylkill Haven. Retiring from active management of his farm around 1855, and with ample time at his disposal, together with the encouragement of family and friends, the seventy-one-year-old Rubens began fulfilling Franklin's prophesy by taking up painting. It was at this time that the seeds of his lifelong exposure to the artistic accomplishments of his family began bearing familiar-looking fruit.

That fall Rubens began a diary, which he called the "Journal of Woodland Farm."[2] During the next ten years, he made virtually daily entries about his life at the farm and in Philadelphia and nearby Holmesburg during the months just before he died. Although Rubens never explained why he began it, a comment he wrote in the top margin of the first page—"My journals have been in old account books and not taken any care of by me"—suggests, possibly, that he regretted the destruction of some earlier papers, and that the journal was an attempt to compensate for their loss.[3] He may have had before him the example of his father's extensive diaries and letters as a record of a full life; and the series of "Reminiscences" his brother Rembrandt began publishing around this time in the art journal, *The Crayon,* may also have influenced his decision to begin a systematic record of his own life as a contribution to the continuing story of his illustrious family.[4] His sense of the Peale family's historical importance, and the concern he had for the preservation of its legacy, is apparent in a letter he wrote to his only daughter, Mary Jane:

PLATE 79
Rembrandt Peale
Rubens Peale, 1807
Oil on canvas, 26 ⅛ x 21 ⅜ in. (66.4 x 54.3 cm)
National Portrait Gallery, Smithsonian Institution, Washington, D.C.; Museum purchase and gift of Mrs. James Burd Peale Green

"I want Rembrandt to tell you who Grandfather and Mother was and where they lived before coming to this country and anything he knows about them as well as my fathers brothers and sisters . . . and anything about my fathers history of early life and where is his first attempt in painting etc. . . . Rembrandt is the only one now living that can say anything about these matters."[5]

In his journal, Rubens gave a considerable amount of attention to the topic of local agriculture and mid-nineteenth-century Schuylkill County farming practices; he wrote a great deal about his family, and faithfully chronicled the comings and goings of the stream of relatives and friends who regularly visited from the nearby towns of Schuylkill Haven, Orwigsburg, Pottsville, and Shamokin, as well as the more distant cities of Reading and Philadelphia. Most importantly, the journal documents Rubens's artistic career. Although his remarks on this subject are not entirely reliable, comprehensive, or consistent, they provide insights into his working methods and daily progress on the more than one hundred and thirty paintings he created during the last ten years of his life. Rubens's comments and entries also tell us something about the various family influences that guided him as he went about the task of learning to become an artist.

In the 1880s, Mary Jane recalled that her father's first picture was a floral subject.[6] If this is true, Rubens must have painted this work sometime before December 19, 1855, for it was then that he made the first reference to art in his journal. Noting that he was beginning to paint a landscape, he wrote: "I was occupied with various matters about the house and in the afternoon commenced painting my sketch, a view of this house from beyond the mulberry tree."[7] Although this comment suggests that Rubens already had a working knowledge of the rudiments of painting, Mary Jane's arrival at the farm that day may have prompted him to start this work, for at the time she was studying art at the Pennsylvania Academy of the Fine Arts.[8] "Mary came from Pottsville by the morning train," he noted, "and painted at her coppey of Rembrandt's Pearl of love."[9] It is easy to imagine father and daughter working shoulder to shoulder on their respective pictures in a Victorian reenactment of the convivial scene her grandfather had depicted in *The Peale Family* (see plate 1).[10] Mary Jane's filial devotion, which may have played an important part in encouraging her father to take up painting, is apparent in the New Year's Day passage she wrote around this time in her diary: "May I be more devoted to his service—live more for others than for myself, and may I prepare for my death—while I live I shall devote myself to making my parents happy."[11]

Several years before Rubens started painting, his younger brother, Titian Ramsay Peale, had also taken up the brush.[12] This may have encouraged Rubens to consider doing the same. However, his rapid progress in learning the craft of painting was facilitated by his lifelong exposure to the painting traditions of his family and the knowledge he had gleaned from the art exhibitions he personally had organized at his Baltimore and New York museums and those he attended from time to time in Philadelphia and elsewhere.[13] Instructional art books may have played a part as well, such as Rembrandt Peale's *Graphics: a Manual of Drawing and Writing, for the Use of Schools and Families* (1835). Printed in large letters on the title page was the word "TRY,"

which would have been especially meaningful to Rubens if he had consulted Rembrandt's slim volume while he was learning to paint.[14]

Rubens built much of his own painting equipment. In his journal he mentioned making an "ezel," a maulstick, and boxes to hold brushes and paints. He built stretchers and stretched canvas on them. He also prepared the tin for the few pictures he painted on that type of support. It was not unusual for Rubens to make the frames for his paintings as well. Most of these appear to have been simple wood moldings that he shaped, painted, ornamented, and varnished, sometimes with the help of Mary Jane. Rubens purchased canvas and paints during his infrequent visits to Philadelphia, or they were mailed or carried to the farm by relatives and friends.

Typically, Rubens worked during the winter months when the weather kept him indoors. January was his favorite month to "commence" a picture, followed by February and December. Usually, he painted all days of the week except Sunday, but only during the daylight hours, never by the artificial light his father depicted in his lamplight portrait of James Peale (1822; The Detroit Institute of Arts). On short winter days or in bad weather, Rubens would complain in his journal that there was insufficient light for him to work.[15]

Rubens took an average of about six months to execute a picture, although he painted many in much shorter time. His compositions derived from two sources. About two-thirds were original designs "from nature." Since he painted so many of these still lifes during the winter season, he probably based the fruits and vegetables in these works on his recollection of their appearance, or on drawings or oil sketches made during the growing season. Rubens also copied paintings by members of his family or by other artists. He made these either by tracing the original composition, by free-hand, or sometimes from memory. There is no evidence in his journal or in his only extant sketchbook, that he ever used the traditional grid technique to copy a picture, or any other type of reproductive process or technique.[16]

After "sketching" his subject on a canvas, Rubens used what were probably thin washes of neutral gray or brown paint to "dead color" the design. Then, typically, in a burst of enthusiasm, he would work on the picture for several successive days. Sometimes, when there were no interruptions and he had the energy, Rubens worked all day on several pictures. After he brought the subject of a still life to a certain point, he painted in the tabletop and the background. Often, he set a work aside for several months or longer before taking it up again. He usually recorded the date he finished a picture but, in many instances, he reworked it later, making small or major changes, or adding small improvements before varnishing. In early February 1856, Rubens began referring to the pictures he was painting by number. Given his experience with taxonomic systems in his museums, it is not surprising that he adopted this expediency.

Although he occasionally exhibited his paintings locally as well as in Philadelphia, Rubens apparently painted because of the pleasure it gave him, rather than because he hoped for sales.[17] Of the nearly seventy paintings whose disposition Rubens recorded in his journal, only a few were sold to a small circle of acquaintances. He presented others as gifts to his friends or family. "I got a letter this evening from Anna Sellers," Rubens noted early in

1861, "thanking me for the christmas present of the fruit piece which I painted for her, her brothers are all pleased with it. They are surprised that I could paint so good a picture at my time of life."[18]

Many of Rubens's pictures resonate the influence of his family. Because of his limited powers of pictorial invention, Rubens looked to his brother Raphaelle and his uncle James for lessons in composition. His copies, as well as the subjects of his original compositions, reveal a great deal about the Peale family's values, the strong ties of kinship that existed among various family members, the types of subject matter the family favored, and the regard shown by members of the clan toward works by other family members.

If the number of copies he painted is a reliable indication, the Peale family artist whom Rubens admired the most was his uncle James. Rubens copied—and sometimes recopied several times—at least six different still-life compositions by James, as well as an oil sketch he believed James had painted of his father's house in Philadelphia (1781; American Philosophical Society, Philadelphia).[19] For example, he borrowed one of the versions of James Peale's *Porcelain Bowl with Fruit* (figure 5.1) from his friend George M. Tatham in order to copy it, noting that James had painted the canvas "in his 82d year."[20] Proud of his uncle's late-life achievements, Rubens may also have been cheered by the hope the painting offered that he, too, would be able to paint at the same high level when he reached that age. Late in 1857 and during 1858 he made four copies of this work (figure 5.2).[21]

Rubens copied more of his uncle's pictures than of Raphaelle's.[22] Assuming that this was a deliberate choice, it is possible he found his brother's more austere compositions less interesting pictorially. One notable exception, however, was Raphaelle's *Cake and Wine* (1813; private collection), which had special significance for him.[23] In 1865 he made at least five copies of the work, which he gave to his children and to one of his wife's relatives (plate 80).[24] Raphaelle had presented *Cake and Wine* to Rubens and his wife on their wedding. Rubens may have painted the copies because of loneliness following his wife's death late in 1864 and a desire to memorialize the happy years they had spent together.

Five years earlier, in the summer of 1860, Rubens began painting *The Garden at Belfield* (private collection), a copy of his father's *View of the Garden at Belfield* (see plate 11) and one of his most ambitious landscapes.[25] Rubens and his father were both about seventy-five years old at the time they painted their respective versions of this scene. Although this may be the only work by Charles Willson that Rubens ever copied, it would be a mistake to regard this as a measure of Charles Willson's influence on his son. Rubens was not taught the art of painting by Charles Willson Peale as were Raphaelle and James, nor did he emulate his father's effort to paint lofty subject matter. Rather, the most important lesson Rubens received from Charles Willson Peale was the example of industry and ambition in old age. Charles Willson believed that happiness in life depended on the cultivation of the mind, and Rubens's decision to take up painting late in life indicates his belief in that principle. "I am now eighty years and seven months of age," Rubens remarked in a letter to the historian, Benson Lossing, "and hope to make improvement in the art."[26] In doing so, he became the only member of his family who

FIGURE 5.1
James Peale
Porcelain Bowl with Fruit, 1830
Oil on canvas, 16 ⅜ x 22 ¾ in. (41.6 x 57.8 cm)
Gift of Jo Ann and Julian Ganz, Jr., Gift of Mrs.
Samuel Parkman Oliver, and Emily L. Ainsley
Fund. Courtesy, Museum Fine Arts, Boston

FIGURE 5.2
Rubens Peale
Fruit Piece, 1858
Munson-Williams-Proctor Institute Museum
of Art, Utica, New York

PLATE 80
Rubens Peale
Cake and Wine Glass, 1865
Oil on canvas, 8 x 12 in. (20.3 x 30.5 cm)
Schwarz Gallery, Philadelphia

pursued four of his father's occupations: agriculturalist, naturalist, museum manager, and artist.

It is significant that the only work by Charles Willson that Rubens copied was a landscape that his father had painted more for amusement than anything else. Peale's *View of the Garden at Belfield* depicted the garden Rubens had planted at the Germantown farm as a young man.[27] The painting, therefore, had special significance for him. Rubens also had a keen interest in the fate of the garden itself. When he and Mrs. Peale visited Belfield on July 7, 1857, he remarked proudly in his journal that the farm's owners "keep up the garden as I left it, the trees that I planted are now grown to an immense size, scarcely to be recognized by me."[28] The opportunity to copy the painting occurred three years later, when his daughter Mary Jane, in response to her mother's plea that she should "try and bring something new for . . . [Rubens] to coppy" when she returned to the farm from Washington, D.C., arranged to have Charles Willson's painting sent to him.[29] Rubens's enthusiasm about copying the picture may also have been sparked by the recollection that his father had originally called the place Farm Persevere, a name that would have reminded Rubens of the encouragement he had received as a boy from Benjamin Franklin.

The German-born artist, Paul Weber (1823–1916), whose European and American scenes were a common sight at the Pennsylvania Academy's exhibitions between 1849 and 1869, painted a landscape that also held special meaning for Rubens.[30] One of the first canvases Rubens painted was a copy of Weber's view of the Juniata River in Pennsylvania. During the next eight or nine years, he made at least four more works based wholly, or in part, on this view. Rubens made more copies of this painting than he did the work of any other artist not a family member.[31] He gave or sold all but one of these copies to members of his family; the first he presented to his son James Burd, and, in 1859, he presented another version as a wedding present to his son Edward Burd. Both sons would have responded to its familial allusions.[32]

The Juniata River landscape depicts the region near the village of Mexico, Pennsylvania, which was the site of Mrs. Peale's ancestral homestead and nativity.[33] In drawing personal meanings from this landscape subject, Rubens followed the associationist strategy his father used when he painted the rays of sunlight as an emblem of hope in the background of his 1818 portrait of Rembrandt Peale (see figure 18).[34] However, because the familial memories that are contained in Rubens's copies of Weber's picture would only be evident to members of his family, the work does not comply with Rembrandt Peale's belief that the meaning of a picture should be universally apparent.[35]

Copying was an expediency for Rubens because of his limited powers of pictorial invention as a result of his lack of formal artistic training. Besides Paul Weber, Rubens copied the work of two other contemporary Philadelphia-area artists, William E. Winner (c. 1815–1883), and one of the Moran brothers, probably Edward (1829–1901) (plate 81). Newspaper illustrations and prints also provided the basis for a small number of paintings. These works, and the copies he made of paintings by members of his family, total about one-third of Rubens's output. Despite the relative frequency with which Rubens painted copies, it is wrong to assume he indiscriminately used whatever pictures were

PLATE 81
Rubens Peale
*Landscape after Second Lesson with
Edward Moran*, n.d.
Oil on canvas
Private collection; Courtesy of
Berry-Hill Galleries, Inc., New York

readily at hand. There were some portraits by Mary Jane and other members of Rubens's family at the Schuylkill Haven farm, but he was not interested in copying such works. On the other hand, the special arrangements he sometimes made to borrow works by James, Raphaelle, or his father suggest that they held special appeal for him. Though Rubens's versions were generally more thinly painted and the forms somewhat flatter, copying enabled him to assimilate many of the pictorial conventions members of his family had developed. The influence of his family may be seen in his choice of subject matter and in the way he arranged the elements of his compositions.

Many of Rubens's original pictures were the type of fruit or vegetable compositions that occupied a low rank in the traditional hierarchy of genres. More than half of what Rubens typically called a "fruit piece" (instead of "still life") featured artfully arranged combinations of four types of fruit—grapes, peaches, apples, and watermelons (see figure 5.2). The elaborateness of the composition in Rubens's original works, and the number and variety of fruit or vegetables in their design, suggest whether Rubens was painting in the manner of his uncle or his brother. For example, *Still Life with Grapes, Watermelon, and Peaches* (plate 82) is close in spirit to James's bountiful

designs.[36] The knife in the lower left corner of the composition links this work more closely to the tradition of mid-century dessert still lifes than other pictures Rubens painted that do not include an eating utensil.[37]

The original still lifes by Rubens that display a more restrained compositional arrangement are indebted to Raphaelle. For example, on February 5, 1856, Rubens "dead colloured the Ostrich Egg, Cream Jug and basket" for the painting, *Basket of Peaches with Ostrich Egg and Cream Pitcher* (plate 83).[38] Although he regularly used tableware, such as bowls, dishes, plates, and baskets in his still-life compositions, they rarely assume the prominence of the silver objects in this picture, which appear close to the picture plane on a curved tabletop.[39] Rubens appears to have begun this work as a copy of his uncle's painting, *Fruit and Grapes* (date and location unknown), which was owned by Rubens's eldest son, Charles Willson.[40] Besides the silver basket, the design and placement of the sprig of leaves are similar in both works, as is the location of the dimples on at least four of the peaches. As the work progressed, Rubens decided to omit the pieces of fruit his uncle had painted on the tabletop around the silver basket and, instead, flanked the basket with the bowl and pitcher. By eliminating about half the fruit

PLATE 83
Rubens Peale
Basket of Peaches with Ostrich Egg and Cream Pitcher, 1856–59
Oil on tin, 14 x 20 in. (35.6 x 50.8 cm)
Private collection

FIGURE 5.3
Rubens Peale
Still Life Number 26: Silver Basket of Fruit,
1857–58
Memorial Art Gallery of the University of
Rochester; Gift of Helen C. Ellwanger

FIGURE 5.4
Rubens Peale
Basket of Fruit, 1860
Oil on canvas, 14 x 22 in. (35.6 x 55.9 cm)
Museum of Fine Arts, Boston; M. and M. Karolik
Collection

included in James's picture, and by using a close-up point of view, Rubens's work begins to assume some of the hermetic, austere intensity of Raphaelle's still-life compositions.

Raphaelle's influence may be seen in another painting, now called *Still Life Number 26: Silver Basket of Fruit* (figure 5.3), which Rubens began early in 1857.[41] In this work he depicted an assortment of fruits with the low, close-up point of view that Raphaelle favored. The small bunch of cherries in Rubens's design recalls the sprigs and leafy branches that regularly appear in Raphaelle's still lifes, as well as James's. Like his brother and uncle, Rubens made this detail a discreet part of the general design. In his works, such twigs never became as prominent as, for example, Martin Johnson Heade's (1819–1904) apple-blossom branches, or the fruit boughs of Joseph Decker (1853–1924) or Worthington Whittredge (1820–1910).[42]

Raphaelle's influence may also be found in a picture of apples and grapes titled *Basket of Fruit* (figure 5.4).[43] The work is a straightforward presentation chiefly of several large apples, the most popular fruit grown in the United States in the middle of the nineteenth century.[44] Although Rubens periodically attended church, there is no reason to think he intended the apples or grapes in this painting to convey Christian allusions to the Fall of Man or the Eucharist, as still-life compositions with such fruits sometimes suggest.

This picture is noticeably different from the flamboyant single- or two-shelf flower and fruit arrangements that Severin Roesen (c. 1816–c. 1872) painted at mid-century. Instead, its restrained composition is indebted to the type of still-life compositions Raphaelle had created earlier in the century, and may be regarded as an example of the "intermediary link" between Raphaelle's work and the early still lifes of William Michael Harnett (1848–1892).[45]

In his dedication to still-life painting, which can be one of the most optically demanding painting genres, Rubens shared his family's delight in vision—in the careful delineation of the materiality of nature, its textures, colors, and surfaces. He aspired to paint illusionistic pictures, but his limited painting skills prevented him from achieving the exquisite optical nuances that make the still lifes of James, and especially of Raphaelle, so impressive. Thus, in pictures, such as the *Basket of Fruit,* Rubens reveals his scientific inclination to report rather than interpret the phenomena of nature, a tendency that has affinities to the way his father portrayed sitters in his portraits.[46]

As a rule, Rubens's still lifes are illuminated by a soft, diffused light that defines, in a pictorially consistent way, the textures and shapes of his subjects. Following the example of his brother and uncle, Rubens employed a compositional formula that focused attention on the objects in the foreground which, because of their perishability, impart an aura of transience to the picture. Living during Pennsylvania's "golden era" of fruit culture, Rubens paid close attention to the species and variety of the objects he depicted. In paintings such as his *Fruit Piece* (1858; Munson-Williams-Proctor Institute, Utica, N.Y.), he used color to differentiate the several varieties of grapes and apples in the work. Rubens's attention to such pomological issues was not unlike the way he displayed specimens in the Peale museums he managed. Additionally, the restrained use of color in *Fruit Piece* is closer to his father's conservative palette than to Rembrandt's richer, more skillful use of color.

Rubens also devoted a significant amount of time to landscape painting, which next to still life became the most frequently painted subject in his oeuvre. The thirty or so landscapes he painted over a ten-year period can be divided equally between copies and original designs.

In the fall of 1864, just before Rubens left Schuylkill Haven to live in Philadelphia, he received a fifty-dollar commission to paint a nearby scene of the Schuylkill River "above Mr. Warner's grand Lock." The work Rubens produced for this commission is more than likely the painting now called *Pennsylvania Landscape* (figure 5.5). The canvas depicts the road and river between Schuylkill Haven and Pottsville, with the towpath of the Schuylkill Navigation Company on the far side of the waterway and a railroad train in the distance.[48] The plunging perspective of the road and the blocky, exaggerated diminution of the buildings that line it recall similar details in views of Belfield that Rubens's father created with the aid of his "painter's quadrant."[49] There is no indication, however, that Rubens composed his landscapes with the aid of mechanical, perspectival, or optical devices, such as the "painter's quadrant," the drawing machine James Peale used for his landscape views, or even the camera lucida, which Titian Ramsay used during the Wilkes Expedition of 1838–1842.[50] What few comments Rubens made about the way he created his landscapes suggests that he followed traditional practice. For example, for landscapes in Ashland and Shamokin, Pennsylvania, Rubens worked from pencil sketches he drew at the site; and for his unlocated view of Emmanuel Episcopal Church in Holmesburg, he painted the work both out-of-doors and in his studio.[51]

The *Pennsylvania Landscape* is stylistically similar to a work bearing the same name (figure 5.6) that several authorities have attributed to Rubens.[52] Both landscapes have similarly high vantage points and lack foregrounds. The tree leaves are rendered in the same generalized manner, and the buildings have the same blocky character. Also, the canal and road in the one painting, and the lake in the other, tilt toward the picture plane and appear as large, flat shapes.

The second landscape conveys the feeling of a topographical view rather than an imaginary scene. It is a still, peaceful picture, rendered in warm, autumnal tones, with a pellucid sky, and the long shadows of late afternoon visible on the distant hill. Only the rapidly painted clouds provide a slight hint of emotional fervor. The two small figures shown on the shore of the lake at the lower right are sized appropriately for someone like Rubens, who was not proficient at this type of detail.

Sometime between March 22, 1861 and November 11, 1864, Rubens began painting *Bobwhite Quail in a Landscape*, one of a series of fourteen bird pictures he had started during the summer of 1860.[53] Rubens painted the most characteristic type in this series in 1861, when he completed the first of what he called "Mrs. Peale's Happy Family of Partridges" (see plate 53).[54] He completed the last picture in the series in early June 1865, about five weeks before he died. This group of works is the third most frequently painted subject in his oeuvre.[55] Neither his father, uncle, nor older brothers painted game pictures, although his younger brother Titian Ramsay did, late in his painting career. Rubens's exploration of this type of subject matter reveals his growing confidence as a painter during the 1860s.

FIGURE 5.5
Rubens Peale
Pennsylvania Landscape, 1864–65
Oil on canvas, 20 x 27 in. (50.8 x 68.6 cm)
Private collection

FIGURE 5.6
Rubens Peale, attr.
Pennsylvania Landscape, c. 1859
Munson-Williams-Proctor Institute Museum of Art, Utica, New York; Mrs. Elizabeth Dressler Bequest

PLATE 84
Rubens Peale
Magpie Eating Cake, 1865
Oil on canvas, 19 x 27 in. (48.3 x 68.6 cm)
Private collection

All the works in the series depict live game birds in naturalistic settings which, in at least two instances, include representations of moss, ferns, laurel, and rhododendron branches, and a variety of other small plants that Mrs. Peale had gathered in the woods and brought to her husband's studio.[56] Rubens's interest in subject matter appropriate to an out-of-door setting parallels the general tendency that emerged in the 1860s for displaying still-life subjects in natural surroundings.[57] In another respect, the game pictures replicate the pictorial formula of his still-life paintings in their depictions of the subjects on a flat surface near the picture plane, in front of a shallow background. Apparently, the Pre-Raphaelite style of bird picture, exemplified by John William Hill's (1812–1879) watercolor, *Dead Blue Jay* (c. 1865; The New-York Historical Society, New York), which shows a dead bird on a table with its eyes closed and its legs awkwardly pressed together, held no interest for Rubens, nor did the game picture, with its associations of hunting and dining, even though this type of still life was conceptually closer to his fruit pictures than to his paintings of live birds (plate 84).

Early in life, Rubens had stuffed birds and arranged them in naturalistic settings in his father's museum. He had continued to practice taxidermy at the museums in Baltimore and New York and during the years he lived at the farm. Although Rubens based some of his bird pictures on stuffed specimens, his work in this genre may have been influenced by the pictures of chickens, grouse, quail, and other game birds shown in their natural settings that the artist Arthur F. Tait painted in the 1850s, some of which Currier & Ives subsequently published as lithographs.[58] In at least three of his game pictures, Rubens included Paul Weber's view of the Juniata River as the background.[59] One wonders, given the special meaning this view had for members of his family, whether Rubens and Mrs. Peale regarded these paintings of birds nurturing their young in rural settings as nostalgic evocations of their "happy family" which, by the 1860s, had been largely dispersed by marriage and death.

In his journal, Rubens often remarked about the gardening he did at his farm. He dug the beds, sowed seeds, recorded their germination, transplanted flowers and bushes, trimmed rosebushes, hoed, pulled weeds, spread gravel on the walks, and lifted and labeled bulbs in the fall. During the winter months, he tended the house plants, perused horticultural magazines, and made long lists of the flower seeds he acquired by purchase, gift, or trade. Mary Jane had a "green room" (greenhouse) at the farm and when she was away, Rubens would care for the plants. On one occasion, he sent great quantities of flowers from his garden to a local church festival, and in another instance, he proudly noted in a letter to Mary Jane: "all say we have the greatest display of flowers of any body else."[60]

Despite Rubens's keen interest in floriculture, he painted only about seven flower subjects, and these mostly during his first three years as an artist.[61] Neither James nor Raphaelle painted flowers, a subject that was not popular until midcentury. *From Nature in the Garden* (figure 5.7) shows cut flowers in an interior setting rather than growing outdoors, as Pre-Raphaelite artists usually showed them.[62] Rubens's elaborate composition is closer in spirit to the midcentury floral displays produced by Currier & Ives. It also calls to mind similar works by George Harvey (c. 1800–1878) and Severin Roesen, whose paintings Rubens may have known, even though neither artist exhibited flower paintings at the Pennsylvania Academy of the Fine Arts.[63] Rubens's journal indicates that he worked on *From Nature in the Garden* from June 1856 until the end of the year.[64] He would, therefore, have had sufficient time during those six months to paint from nature the roses, peonies, pansies, daisies, lilies, cactus blossoms, gaillardia, and other spring, summer, and fall flowers that comprise this bouquet.[65]

In *From Nature in the Garden,* Rubens emphasized the characteristic outline of the flowers in a way similar to the rendering of botanical specimens by the naturalist William Bartram, the Peale family's friend, and Rembrandt's lessons in *Graphics,* in which he maintained that line was the essence of form.[66] Rubens intended this painting for his son Charles Willson who, at the time, was a partner in a colliery in the village of Shamokin, near Schuylkill Haven.[67] He inscribed the work to "C.W. P./1856" as a sign of parental affection, expressing his sentiments through what was called in the nineteenth century the "language of flowers."[68]

FIGURE 5.7
Rubens Peale
From Nature in the Garden, 1856
Oil on canvas, 20 x 24 in. (50.8 x 61 cm)
Kennedy Galleries, Inc., New York

PLATE 85
Rubens Peale
Wedding Cake, Wine, Almonds, and Raisins, 1860
Oil on canvas, 17 x 29 in. (43.2 x 73.7 cm)
Munson-Williams-Proctor Institute Museum of
Art, Utica, New York

Several years later, Rubens painted *Wedding Cake, Wine, Almonds, and Raisins* (plate 85), a picture he intended as a gift to his son, James Burd, who had married several months earlier.[69] Rubens was perhaps reminded of the similar painting his brother Raphaelle had presented to him and his wife on their wedding. The painting involved considerable preparation—first assembling the materials to be depicted, drawing the composition and coloring the background, and then working out the details. Rubens made substantial progress on the picture in early March 1860, and Mary Jane even worked on the picture one day that month. The paint surface of the work suggests that the stem and base of the sherry glass at the left of the decanter were moved closer to the front edge of the shelf, while the icing on the cake and the highlights on the decanter and glasses were painted with a degree of control that is not always present in Rubens's paintings.[70] If it could be shown that Rubens actually painted these details, we would have to revise the generally held notion that the primitive style of many of his paintings was due to poor eyesight. As Rubens's and Mary Jane's painting styles become better understood, there may be good reason to consider this work a collaborative effort by father and daughter. Arriving at a sound definition of Rubens's painting style will not be easy, however, especially if it can be shown that Mary Jane or someone else completed the works in Rubens's studio when he died.[71]

The nuptial allusions in *Wedding Cake, Wine, Almonds, and Raisins* are similar to the familial sentiments Rubens embodied in his Juniata River landscapes after Weber, and in the floral still life *From Nature in the Garden*. His view of Emmanuel Episcopal Church in Holmesburg, near Philadelphia, also contains familial associations, for it was in the graveyard of this church that Mary Clarissa McBurney Peale, his son James Burd's first wife, was buried.[72]

On December 17, 1860, Rubens noted in his journal that he began a painting of himself in his "painting room" (figure 5.8).[73] This may have been his first attempt at an interior view. The subject takes on a special significance when considered with two other works: the copy Rubens made of his father's house in Philadelphia and the copy of his father's picture of the garden at Belfield. Collectively, the three paintings commemorate three stages of Rubens's life: his childhood in Philadelphia, the years of early manhood at his father's farm, and the decade he worked as a painter in old age.

Rubens began his self-portrait by having Mary Jane sketch him sitting at his easel. He noted in his journal on February 23, 1861: "Soon after breakfast I sat to Mary, her to paint me in the attitude of painting a picture in my *interior of my studio* she also sketched Anna Frances [Peale, daughter of Rubens's youngest son] sitting in the middle of the room on the carpet." For the next ten months he made little progress on the work, but during the first weeks of 1862, he worked on it in tandem with another interior view of his parlor as it appeared from the door of his studio.[74] Although *Rubens Peale in His Studio* is a departure from the type of self-portraits Charles Willson Peale painted in the guise of an artist, the emphatic orthogonals in Rubens's composition and the pictorial references it contains recall similar aspects of his father's masterpiece, *The Artist in His Museum* (see figure 10.2).

In the center of the composition is a bookcase with one door open, revealing three shelves of books. Conspicuously displayed on the shelf below

FIGURE 5.8
Rubens Peale, with Mary Jane Peale
Rubens Peale in His Studio, 1860–62
Oil on canvas, 14 x 20 in. (35.6 x 50.8 cm)
Private collection

the books is the exotic sugar bowl Rubens depicted three years earlier in his *Basket of Peaches with Ostrich Egg and Cream Pitcher*. The picture hanging to the right of the bookcase may be Rubens's copy of his father's view of Belfield Farm, which he had finished several months earlier. At the left, over Rubens's head, the picture of several sections of a watermelon resembles the work of James Peale's youngest daughter, Sarah Miriam Peale (1820, Maryland Historical Society). To the right of this, in the adjoining room, there is a pair of portraits hanging above a stove. The one on the left is difficult to identify, but the right-hand one is probably Sarah Miriam's portrait of Mrs. Rubens Peale with her first-born son, Charles Willson, when he was a small child (c. 1822; Municipal Museums of Baltimore, The Peale Museum).[75] Other family paintings that Rubens had at the farm included not only an assortment of pictures by his daughter Mary Jane, but also portraits by Charles Willson Peale, James and Raphaelle Peale's still lifes, Raphaelle's early portrait of *Rubens Peale as Mascot* (see plate 27), paintings by the younger generation of Peale artists, and probably miniatures as well—family mementos that tied Rubens physically as well as emotionally to the large family of artists whose work he emulated.[76]

Even though Rubens's skills as a painter fall short of the abilities of several other family members, this does not indicate that the Peale legacy was exhausted at midcentury. Rubens's art was separated by twenty-five or more years from some of its sources, but he perpetuated the most orthodox aspects of the still-life tradition established by Raphaelle and James earlier in the century. Because Rubens's compositions of fruits and vegetables imitated rather than generalized natural forms, they do not reflect that earlier age's taste for idealization.[77] And it was only when Rubens embedded personal associations into what were nominally straightforward still-life paintings or landscapes that he came closer to emulating his father's efforts to instill into his portraits and landscapes the ideals of history painting.[78]

At his farm near the headwaters of the Schuylkill River, Rubens painted in almost complete geographic and ideological isolation from the aesthetic concerns of the mid-nineteenth century. His paintings reveal his retrospective orientation, fashioned by equal measures of personal conservatism and the momentum of his family's influence. Despite Rubens's relative proximity to other important still-life painters in Pennsylvania, he was not influenced by them. He most likely had seen examples of contemporary still-life painting when he visited Philadelphia, but the flamboyant compositions of Severin Roesen and John F. Francis (1808–1886), and the new range of still-life subjects—birds' nests, leaves, clumps of grass, or studies of single flowers—painted by Pre-Raphaelite artists such as John William Hill, Thomas C. Farrer (1839–1891), and John Henry Hill (1839–1922) exerted almost no influence on his work.

The pictorial effects that could be achieved by applying paint thickly on a canvas were also a revelation to Rubens when one of the Moran brothers, probably Edward, showed him how to paint in this manner.[79] The only aspects of Rubens's work that can be considered a departure from the Peale tradition were his flower and game pictures, which mirror the mid-nineteenth century's emerging interest in such subjects and were popularized at the time by artists such as George Harvey and Arthur F. Tait.

It would be misleading to describe the works Rubens painted during the last ten years of his life as examples of an *Altersstil*. Traditionally, an old-age style includes a certain reductiveness in manner, a freedom of expression, and a complete mastery of materials and techniques.[80] None of these qualities appears in Rubens's art. In terms of subject matter, he had no interest in portrait painting and, perhaps because of his lack of formal art training, Rembrandt's "fancy pieces" also did not appeal to him. Possibly because of poor eyesight, Rubens did not paint miniatures. Unlike Charles Willson and Rembrandt, Rubens neither envisioned nor intended his art to address larger social themes, to have broad mass appeal, or to contribute to the nation's growing artistic identity. Finally, apart from two lost landscapes that may have contained depictions of the Union Army, Rubens's paintings do not have overt or veiled references to the Civil War, although he frequently wrote about this subject in his journal.[81]

The persistence of tradition is deeply embedded in Rubens's art along with the emotional ties and tensions of his large and talented family. His paintings have a recognizable identity that reveals how robust a tradition Charles Willson Peale had established. The closely-knit relationships that existed in the extended Peale family played an important role in perpetuating in Rubens's art the Peale style of painting. The gap between Rubens's pictures and the aesthetics of midcentury still-life practice demonstrates how deeply indebted his pictures are to the painting traditions established by his family. On the day he died, Rubens was preparing to paint another copy of James Peale's "white watermelon." Like his uncle, Rubens had continued to paint into his early eighties, inspired by the perseverance Benjamin Franklin had urged him to adopt when he was a child.

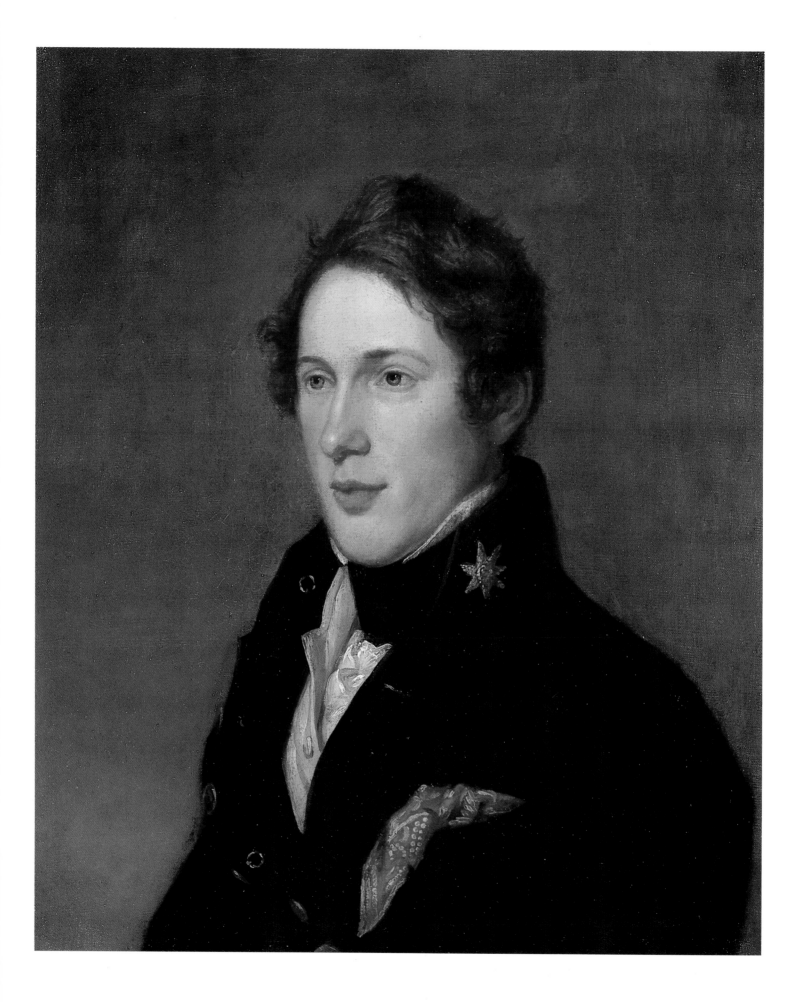

Six

~

Titian Ramsay Peale's Specimen Portraiture; or, Natural History as Family History

~

KENNETH HALTMAN

TITIAN RAMSAY PEALE (plate 86), the last born of Charles Willson Peale's many sons, resisted perhaps more than any of his siblings the burden of the family legacy. And yet it was Titian, ultimately, who embraced that legacy most completely. Even as a young man, motivated as much by desire for paternal approval as by desire to be independent of paternal expectation and control, Titian structured his art of natural history in response to this deep-seated ambivalence. His early efforts to stake out a scientific and artistic territory of his own were effectively circumscribed in institutional as well as in more personal terms by the ambitions of his father, in the context of whose life work—the museum—Titian's own career took form. His earliest artistic achievements were infused with a pattern of resistance to authority, but as these tensions began to resolve toward the end of his father's life, he became increasingly self-conscious in his emulation of the man against whom he had formerly rebelled. This acceptance of the family legacy culminated decades later in his compilation of an adulatory biography of the *pater familias,* whom he had come in many respects to resemble.[1]

Titian was born in Independence Hall in 1799, little more than a year following the death of his namesake, his half-brother Titian Ramsay Peale, whose great promise as an artist-naturalist he found himself expected to fulfill (see plate 17). The earlier Titian, by all accounts his father's favorite son, had been Peale's tireless companion and co-worker, both in the field on specimen-gathering expeditions and back home in the museum. The boy's accomplishments had been considerable. At age 16, two years before his death, he had begun work on illustrations for an American entomology (figure 6.1). Titian's father certainly never tired of singing his praises nor ever fully ceased to lament his loss, and in 1817 commemorated the anniversary of his son's death by a visit to the room in which the boy had died. Charles described him on that occasion in his daybook as "a lovely promising youth . . . possessing an ardour in acquiring a knowledge of natural history—with industry unbounded. . . . I cannot enumerate all his rare, good and amiable qualities."[2] Upon his death, the older Titian came to represent a standard

PLATE 86
Charles Willson Peale
Titian Ramsay Peale, 1819
Oil on canvas, 24 ¼ x 20 ¼ in. (61.5 x 51.4 cm)
Private collection

FIGURE 6.1
Titian Ramsay Peale (1)
Papelio, 1796
Watercolor over ink on paper, 9 ½ x 7 ½ in.
(24.1 x 19 cm)
In "Drawings of American Insects," National
Agricultural Library, Greenbelt, Maryland

of filial virtue which his siblings, and the younger Titian most particularly, were unlikely ever to attain.

The only extant childhood portrait of the second Titian by his father appears in the distant midground beyond the excavations in *The Exhumation of the Mastodon* (see plate 10), being scolded by his then but recently deceased mother, Elizabeth DePeyster Peale. She grasps the five-year-old firmly by the hand, warning him to behave. As represented by his father, little Titian, preferring the promise of adventure to submission to authority, gestures downward with *his* left hand toward the vortex of darkened waters swirling in the pit below.

In letters to family members, Charles repeatedly articulated his concern that Titian's disobedience and lack of discipline would lead to no good—this despite the boy's marked, precocious interest in natural history and art.[3] On at least one occasion Titian ran away from home, received by an uncle, to whom the boy's father wrote in soliciting his return, "you would have done me a favor if you had given him the Birch"—a practice he elsewhere proscribed but could envisage in this case both "for [Titian's] benefit, and to save me future trouble."[4]

Shortly following the boy's thirteenth birthday, Titian's father took the more drastic step of binding him out until his majority to George and Isaac Hodgson, English-born brothers who operated a spinning machine manufactory along the Brandywine.[5] Charles considered this exercise of paternal authority as providing an opportunity for his son to acquire discipline, explaining that Titian "would [have] been Idle and dissipated, if keept at home."[6] The apprenticeship would also provide a useful introduction to an industrial trade. Titian, however, did not like making machinery and by early autumn 1814 was back home in Germantown, having served barely twelve months of what was to have been a six- or seven-year apprenticeship.[7]

Charles, it is worth remembering, had himself been bound out in his early youth, to a saddler in Annapolis, and knew from experience how a lowly condition might lend urgency to personal ambition.[8] Resistance to subservience, in itself, seems not to have been perceived as a sign of questionable character; idleness, however, was, as an angry letter to Rubens written more than a year following Titian's return from the Brandywine made clear: "It is high time," he wrote, "that [Titian] should apply himself to some business by which he may in future be able to support himself. . . . He must not be Idle any longer, I will not support him in Idleness. . . . His conduct has very much unhinged me—I am really fearful that he will become dissipated and a disgrace to the family."[9]

In the same letter, Charles complained that Titian had "*usurpt* too often authority by saying and doing such things as a Master of my House I cannot submit to."[10] An earlier phase of struggle between them had ended only in an uneasy compromise, with Titian's withdrawal from school and his departure for the Brandywine. Following his return, open rebellion was replaced by a pattern of accommodation formalized in what amounted to a family apprenticeship at the museum, specializing in natural history. This combination of science with art for the purposes of public display meant that Titian's chosen area of expertise lay wholly within the bounds of a professional arena his

father had essentially designed. While he may have appeared "idle" at first, he soon immersed himself in the collection, preservation, and representation of specimens.[11]

Titian's first professional commission, preparing colored plates for the prospectus volume for Thomas Say's *American Entomology* (figure 6.2), was reminiscent of his namesake's pioneering work in the same field. With its publication in November 1817, Titian was elected to full membership in the Academy of Natural Sciences of Philadelphia at age seventeen. The following month he was invited to accompany Say, the noted ornithologist George Ord, and geologist William Maclure on an exploratory mission into the wilderness of Georgia and Florida.[12] The voyage provided Titian occasion to demonstrate his scientific competence far from the eyes of paternal judgment, although of course he owed the opportunity directly to his father's influence.[13] Titian's prowess as a hunter, a skill necessary to the investigation of natural history, afforded him status in the eyes of his companions and constituted an expression of selfhood, masculine power, and authority.

In 1819 he was named, again thanks to his father's intercession, assistant naturalist on the Stephen H. Long Expedition (see plate 86), the first federal survey of the far West following the return of Meriwether Lewis (1774–1809) and William Clark (1770–1838).[14] In arranging for his son's participation, Charles was motivated, at least in part, by the prospect of satisfying a long-standing desire to acquire additional western artifacts and specimens for the museum to augment its small but important holding in objects collected by that earlier expedition into the northern Rockies.[15] Lewis and Clark had lacked not only a certain proficiency in the natural sciences, but also the necessary artistic training to produce detailed and accurate sketches as illustrations of their observations in the field. The Long Expedition's organizers in the War Department were aware of the value such documentary images might have in encouraging public support of present and future exploration.

Titian passed nearly two years away from home, during which time he traveled thousands of miles in the company of soldiers and scientists, became one of the first white artists to represent many of the region's indigenous peoples, and sketched and preserved hundreds of previously unrecorded botanical, entomological, zoological and ornithological specimens (see plates 87, 88).[16]

As a result of a prior arrangement with the War Department, these materials made their way back to the museum, where Charles understood his son's work as contributing to his own. He reassured Secretary of War John C. Calhoun that he would be personally responsible for any drawings of Titian's specimens required for the purposes of publication. "I will execute them in the most advantageous manner I am able to do," he wrote, adding that as a result of Titian's careful field work, "my son . . . will be able to fill up the deficiencies."[17] We might note the easy use of the first-person singular "I will," suggestive in its very unconsciousness of a pervasive pattern of expropriation and paternal presumption, which Charles considered his due.

Moreover, upon his return to Philadelphia, Titian discovered that what he had considered his rightful place in the affairs of the museum had been given to his brother Franklin.[18] More galling still, Charles refused his assent

FIGURE 6.2
Cornelius Tiebout, after Titian Ramsay Peale
Papilio philenor, 1816
Hand-colored engraving, 9⅜ x 5⅜ in.
(23.8 x 13.7cm)
In Thomas Say, "Prospectus," *American Entomology*
(Philadelphia, 1817), pl. 1. American Philosophical
Society, Philadelphia

PLATE 87
Titian Ramsay Peale
White Squirrel, 1819–21
Oil on canvas, 8 x 10 in. (20.3 x 25.4 cm)
Private collection

PLATE 88
Titian Ramsay Peale
Prairie Dog, 1819–21
Watercolor on paper, 9 ½ x 12 in.
(24.1 x 30.5 cm)
Private collection

to Titian's desire to marry, finding Eliza Cecilia Laforgue, whom Titian had long been courting, unsuitable.[19] He had first rejected the match years earlier as yet another indication of his son's immaturity[20]—this despite his own marriage in 1762 to seventeen-year-old Rachel Brewer when he was himself but an impoverished twenty-year-old apprentice,[21] not to mention his more recent pronouncement in "An Essay, to Promote Domestic Happiness" (1812): "I am a strong advocate not merely for matrimony, but for early marriage."[22] Having just recently had another son's marriage annulled at great cost and effort, Charles was concerned that his troubled finances not be strained by any new dependents.[23]

Titian responded to the combination of professional and personal injury with indignation: "You expressed a fear that I would become involved with a woman," he declared to his father; "I am already and have for some time been so. I see nothing unnatural in it, but never suppose sir that I am going to become a dependent on you."[24] Titian was to remain a dependent for some time, however—professionally as well as financially—as evidenced most eloquently in his artistic production in this period.

A collaborative painting of the interior of the museum (see figure 10.3), for example, was produced under the same division of labor Charles had envisioned for the preparation of the Long Expedition specimen drawings. He laid down the drawing with his "painter's quadrant" and had Titian "fill it up with his watercolors."[25] The watercolor was then subsumed in an edited form into the background of Charles's magisterial self-portrait, *The Artist in His Museum* (see figure 10.2).[26]

A long unnoticed doodle lightly penciled on the last leaf of Titian's 1822 sketchbook recasts his father's famous full-length self-portrait as his own (figure 6.3). To the right of this figure Titian inscribed "I would have drawn this if I could" over the signature "Nemo," Latin for "No One." Yet the son's displacement of his father here remains a fearful act, visually ambiguous, buried in the back pages of the sketchbook and "signed" with a disclaimer. The same sketchbook contains a second example of Oedipal projection, a watercolor fantasy of Charles's decapitated head (figure 6.4),[27] conceptually as well as formally related to the specimen studies that Titian was producing in this same period based on Long Expedition field sketches.

In *Dusky Wolf Devouring A Mule Deer Head* (see plate 89), a composite based on field sketches of a female wolf, black-tail deer, and magpie,[28] the head of the deer lies lifeless at the same angle as that of his father—each with a gaping wound at the neck splashed with an identical shade of red as if applied with the same brush. *Dusky Wolf,* furthermore, appears to have doubled as the design for a museum display that rescripted a popular exhibit produced around 1796 by Titian (1). That earlier mount, known today only in description, depicted a wolf devouring a lamb and featured a bravura display of papier mâché entrails and blood.[29] By here replacing lamb with black-tail deer and eastern with western wolf, Titian displaced his brother's borrowed pastoral conceit with one set in the wilderness as he himself had known it.[30]

Titian's desire to establish and assert a personal authority based on knowledge gained in his western travels, in other words, found expression in his important series of watercolor specimen portraits and exhibition

FIGURE 6.3
Titian Ramsay Peale
"I Would Have Drawn This If I Could," c. 1822
Ink over graphite on paper, 9 5/8 x 7 1/4 in.
(24.4 x 18.3 cm)
Sketchbook 15c, 48v, American Philosophical
Society, Philadelphia

FIGURE 6.4
Titian Ramsay Peale
Decapitation, c. 1822
Watercolor over graphite on paper, 7 1/4 x 9 5/8 in.
(18.3 x 24.4 cm)
Sketchbook 15c, 29r, American Philosophical
Society, Philadelphia

Dusky Wolf. E Nubilus Say
Type & pair killed & drawn at
Engineer cantonment by T R Peale
1820

PLATE 89
Titian Ramsay Peale
Dusky Wolf [Lupus Nubilus] Devouring A Mule-Deer
Head, c. 1820
Watercolor and ink over graphite on paper,
7 ½ x 9 ¼ in. (19.1 x 23.5 cm)
American Philosophical Society, Philadelphia

mounts executed between 1821 and 1824 for display within a museum space still dominated by his father.[31] A related watercolor in a post-expedition sketchbook depicts an armed man superimposed against a midground plateau (figure 6.5). The solitary figure in this surrogate self-portrait looks out over a western landscape available to the viewer only thus, as mediated by Titian's own experience.[32]

The same midground plateau appears as the backdrop for his *Black-Tail Deer* (figure 6.6), represented here as inaccessible to viewers, obstructed by the handsome two-year-old male of the species *Cervus macrotis* posed before it, the man with a gun replaced by the now manifest object of his hunt. Indeed, the stances of man and deer are remarkably alike, their prepossessing presence supplanting as well as organizing our own—a compositional device serving to disrupt imaginary entry into picture space even as it thematizes viewer control.[33] In these compositions, structural discontinuity between foreground and distance interrupts viewer access to deep picture space and so constitutes a neat structural assertion of Titian's own prior presence and prerogative.

The sense of visual blockage in *Black-Tail Deer* is given a psychological dimension by its resemblance to the gesture of ambivalent welcome in *The Artist in His Museum*. The deer, a hunting trophy and a tour de force of taxidermic reconstruction as well as surrogate self-portrait, similarly frames a realm of power and control, its stance in the western landscape functionally analogous and morphologically identical to that of Charles in his museum. Titian here emulates his father even while contesting his authority. Each organizes viewer access to the world he represents in a highly qualified fashion, laying what is in effect preemptive claim to cognitive territory.

Just as Titian's specimen studies can be read as portraits, his more complex arrangements of specimens in groups can be read as family portraits. His 1822 watercolor *American Antelope* (see figure 6.7), for instance, organizes its members into recognizable hierarchies, with a large adult male nearest the picture plane facing a smaller adult female slightly further into picture space, with their two young between them nestled in the grass. Despite its careful symmetry and comfortable pairings, this vision of domestic happiness (as Titian's father might have termed it) visually deconstructs into a composite

FIGURE 6.5
Titian Ramsay Peale
Gray Sand Stone With Reddish Horizontal Lines,
c. 1820—22
Watercolor and ink over graphite on paper,
5 ⅛ x 8 in. (13 x 20.3 cm).
Sketchbook Ib, 13r, Yale University Art Gallery,
New Haven, Connecticut; Gift of Ramsay
MacMullen, M.A.H. 1967

FIGURE 6.6
Titian Ramsay Peale
Black-Tail Deer, 1821—22
Watercolor over graphite on paper,
10 ⅞ x 13 ¼ in. (27.7 x 33.8 cm)
American Philosophical Society, Philadelphia

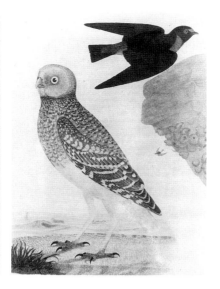

FIGURE 6.7
Titian Ramsay Peale
American Antelope, c. 1821–22
Watercolor over graphite on paper, 11 ¹/₁₆ x 13 ⁷/₁₆ in.
(28 x 34.1 cm)
American Philosophical Society, Philadelphia

FIGURE 6.8
Cornelius Tiebout, after Titian Ramsay Peale
Hipparchia semidea, 1828
Hand-colored engraving, 9 ¾ x 6 in.
(24.6 x 15 cm)
In Thomas Say, *American Entomology*, vol. 3
(Philadelphia, 1824–28), pl. 50, American
Philosophical Society, Philadelphia

FIGURE 6.9
Alexander Lawson, after Titian Ramsay Peale
*Fulvous or Cliff Swallow (Hirundo Fulva) and
Burrowing Owl (Strix Cunicularia)*, 1824
Engraving, 13 ½ x 10 ½ in. (34.3 x 27 cm)
In Charles Lucien Bonaparte, *American
Ornithology*, vol. 1 (Philadelphia, 1825), pl. 7,
American Philosophical Society, Philadelphia

of individual elements. The male and female of the species stand on different planes, each stiffly oblivious to the other's presence, a static image of incommunicativeness and disconnection. The two adult antelope, moreover, lifted from separate field sketches (1820; American Philosophical Society, Philadelphia), have been joined here face to face, without effort on the artist's part to create an illusion of psychological or affective attachment between them other than the presence of "their" young visible behind and between them—a family portrait indeed!

This museum group functions as a fictive family,[34] at some level an embodiment of family relationships as Titian himself experienced them, marked by clearly defined roles and centered around a patriarch abetted by a strong but diminutive wife and attended by docile and obedient children. This public display of order and calm, however, reveals on closer scrutiny a subtextual narrative of controlled violence and presumptive power, of isolation and division, out of which its surface harmonies have been fashioned.

Here a comparison with the father's early masterpiece, *The Peale Family* (see plate 1), only completed when Titian was nine and ever-present on the walls of the museum, may be apposite. This painting, as David Steinberg has shown, creates its fiction of family unity by combining in one space figures who would not or could not have been present all at once, each "accommodated to the conventional ideal of a happy family."[35] Here, as in *American Antelope*, the artist emerges as enabling genius, having known how to orchestrate a celebration of family out of family fragments—in Titian's case, literally how to bring back to life an array of unrelated specimens put to death for this purpose.

The tension between Titian and his father evolved as both men aged. In October 1822, Charles relented and accepted Titian's marriage to Eliza Laforgue.[36] In a related change, Charles signed nominal control over the museum to his sons, formalizing a professional retirement that had been proceeding incrementally for a number of years. With this, the son's decade-long process of accommodation to his father was complete, his stake in, and some measure of control over, the museum at last publicly acknowledged.

Titian now turned his attention to the scientific illustrations for which he is best known. Over the course of the next decade, in the margins of his work as museum conservator, curator, and foreign correspondent, Titian

produced drawings and paintings for thirty-four color plates in Say's *American Entomology, or Descriptions of the Insects of North America,* issued in three volumes between 1824 and 1828 (figure 6.8), and for ten plates in Charles Lucien Bonaparte's *American Ornithology; or, the Natural History of Birds Inhabiting the United States,* issued between 1825 and 1833 (figure 6.9). Many of the museum mounts which he designed in this period are preserved in John Davidson Godman's *American Natural History* (1826–1828), in illustrations which in many cases correspond exactly to surviving watercolors (figure 6.10).

Carrying on the work of public education outside the museum proper, Titian contributed to such journals as the short-lived *Cabinet of Natural History and American Rural Sports,* published by fellow-artist Thomas Doughty between 1830 and 1833. His name is cited in this publication frequently as an authority in natural history as well as hunting.[37] His engaging, now quite rare, *American Buffalo* (see figure 6.11) was produced by Childs and Inman for the American Sunday School Union as an educational aid. The accompanying text made explicit the source of the image's dual appeal based in frontier adventure on the one hand and history and science on the other: "The person who made this picture, was very near him, as he stood feeding on the bank of a river. He was then killed, and his body is in Peale's Museum, at Philadelphia."

After the death of his father in 1827, Titian assumed the title "Professor of Zoology in and Curator of the Museum," and the responsibility for augmenting its collections. His travels in the northern extremity of South America between the fall of 1830 and the spring of 1832, though poorly documented, are known to have produced hundreds of new specimens and a number of careful topographic drawings.[38] The confident spirit of post-Enlightenment imperialism expressed in this foray into the wilds of Surinam, Colombia, and Brazil, similar to that which underlay the earlier expeditions in which he had participated, was given narrative form in the frontispiece to Titian's 1831 *Circular of the Philadelphia Museum.*[39] He adopted and personalized this image—not without humor—from François le Vaillant's *Travels into the Interior Parts of Africa* (see figure 6.12), a work which had been in the museum's library since shortly after its first publication in 1790.[40]

Titian's major effort in these years, however, involved the preparation of plates for his *Lepidoptera Americana,* subtitled *Original Figures of the Moths and Butterflies of North America.* Although he intended this work eventually to include one hundred colored plates accompanied by descriptions, only the 1833 "Prospectus" was ever issued (see figure 6.13).[41] That year Titian succeeded Franklin as manager of the museum and was elected a member of the American Philosophical Society. Over the next few years, he witnessed a slow decline in the museum's popularity and attempted to renew public interest with novel collections and exhibits.

Between August 1838 and June 1842, Titian served on the United States South Seas Surveying and Exploring Expedition (the Wilkes Expedition) which traveled to distant ports: Madeira, Valparaiso, Sydney, Honolulu, Shanghai, and Cape Town. As zoologist for the expedition he contributed to its collections of birds, mammals, and insects, and gathered ethnological artifacts as he had on the Long Expedition decades earlier. Titian also made use of a camera lucida to record careful topographic views.[42]

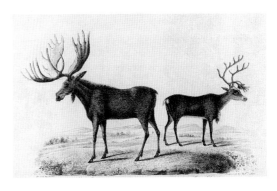

FIGURE 6.10
W. E. Tudor, after Alexander Rider, after Titian Ramsay Peale
Moose Deer and Rein Deer, 1826
Engraving, 5 ¼ x 8 ¾ in. (13.3 x 22.2 cm)
In John D. Godman, *American Natural History* (Philadelphia, 1826), 2, facing p.283, American Philosophical Society, Philadelphia

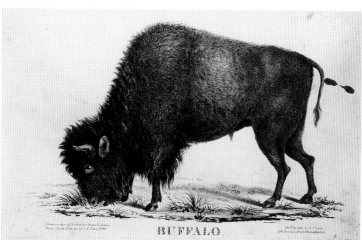

BUFFALO.

The Buffalo (or Bison, as he is sometimes called) is found west of the river Mississippi. They pass over the wide praries or plains in herds. Their flesh is eaten by the Indians; their tongues make very delicious food, and their hides are dressed for robes, called Buffalo skins, and are sent into all parts of the world.

The Buffalo, of which the above is a picture, was about two years old when the picture was made, and had on his winter coat of hair: the older Buffalos are higher and more shaggy. The person who made this picture, was very near him, as he stood feeding on the bank of a river. He was then killed, and his body is in Peale's Museum, at Philadelphia.

FIGURE 6.11
Childs and Inman, after Titian Ramsay Peale
American Buffalo, c. 1830–33
Engraving for the American Sunday School Union, 16 x 18¾ in.
(40.5 x 47.6 cm)
American Antiquarian Society

FIGURE 6.12
Anonymous
Campement dans le Pays des Grands Namaquois, c. 1790
Engraving, 7 x 4½ in. (17.7 x 11.4 cm)
In François le Vaillant, *Voyage de F. le Vaillant, dans l'intérieur de l'Afrique, par le Cape de Bonne-Espérance,* vol. 1 (Paris, n.d.), frontispiece

FIGURE 6.13
After Titian Ramsay Peale
Danaus plexippus, 1833
Hand-colored engraving, 11¾ x 9 in. (29.6 x 24 cm)
From the Prospectus for *Lepidoptera Americana,* vol. 1 (Philadelphia, 1833), pl. 7, Library, The Academy of Natural Sciences of Philadelphia

Perhaps his most colorful expedition works are a series of drawings and oil sketches from Antarctica and the South Seas.[43]

As always, the focus of Titian's labors lay in the production of plates, this time for the illustrated Atlas that was to accompany his official published report of the expedition's findings. Yet the appearance of that account, *Mammalia and Ornithology,* in 1848, proved a serious disappointment. None of Titian's plates were included and, after only one hundred copies were printed, the text itself was suppressed and its scientific rigor called into question.[44] The volume of scientific description was thoroughly revised by university-trained, "closet" naturalist John Cassin, and reissued in 1853 under his authorship. The long-awaited *Atlas,* when it finally saw the light in 1858, did include thirty-two plates after Titian's drawings, but in almost every instance his original backgrounds had been simplified, left uncolored, or eliminated altogether.[45]

By the middle decades of the nineteenth century, Titian had essentially outlived his age. The Enlightenment ideal of the artist-naturalist, at home both in the cabinet and in the field, had survived quite well in the Romantic age of idiosyncratic and entrepreneurial ambition which the museum had, in many respects, typified. Titian's art, like his science, bore the mark of habits of mind carried over from the eighteenth century and inherited from his father. His interests were broad in an age of increasing specialization. A certain casualness regarding nomenclature and the originality of specimen types, perhaps the major shortcoming for which Cassin had reproached him, was the survival of a style of public presentation with emphasis on the experiential value in data aesthetically reworked. In this, Titian, like his father, permitted himself a degree of rhetorical leeway in illustrations that modern science would no longer allow. Seen as extraneous in these specimen portraits were their backgrounds, the very elements that made his compositions portrait-like: warm and not cold, implicitly narrative rather than static, quietly personal rather than calculatedly impersonal. Both taste and sensibilities had changed.[46]

Ironically, the very reliance on fieldwork that ill-disposed Titian to the postures of academic detachment following the Wilkes Expedition, in at least one notable case proved him more qualified than some of his critics when it came to accurately delineating and identifying specimens. The engraving in figure 6.14 is a case in point. Based on his observations in Hawaii, Titian had executed a drawing of a bird, which he identified as a hawk, clutching a smaller bird, the Hawaiian honeycreeper, in its talons. When Cassin returned to this image a decade later, he concluded erroneously from superficial similarities that the bird must be an osprey, reidentified it accordingly, and had his engraver replace the honeycreeper with the fish it can still be seen eating.[47]

The Wilkes Expedition marked a turning point in Titian's life in other respects. He returned in 1843 to manage a museum facing fiscal collapse. His differences with Wilkes led to his removal from the expedition payroll in spring 1848. These professional frustrations exacerbated by financial difficulties and personal tragedy—the recent death of his wife Eliza, preceded by the death of one child and followed by the death of another[48]—caused him later that year to seek an appointment as assistant examiner with the United States Patent Office in Washington.

FIGURE 6.14
William H. Dougal, after Titian Ramsay Peale
Pandion solitarius, 1858
Engraving, 16 7/8 x 10 7/8 in. (43 x 27.8 cm)
In John Cassin, *Mammalogy and Ornithology,* vol. 2
(Philadelphia, 1858), pl. 3, American Philosophical
Society, Philadelphia

PLATE 90
Titian Ramsay Peale, possibly with the help of
Rembrandt Peale
Sketch for a Self-Portrait, c. 1850
Graphite on paper
National Portrait Gallery, Smithsonian Institution,
Washington, D.C.; Gift of Edgar L. Smith, Jr.

A self-portrait dating from this period, produced "with a little help" from his brother Rembrandt (see plate 90), portrays a man in his fiftieth year, somewhat wearied yet still warm and personable. Titian, however, apart from this effort, produced little in the way of art during his first decade in Washington. In 1850 he remarried—thirty-six-year-old Lucinda MacMullen —and dedicated himself to achieving a measure of security and seniority in the Patent Office, eventually rising to the rank of chief examiner. Through this work Titian maintained a professional involvement in the graphic arts with special interest in reproductive technologies, at one time heading up the Division of Fine Arts and Photography.

Enthralled with the new medium of photography, Titian became a devoted enthusiast and founding member of Washington's Amateur Photographic Exchange Club. His photography spanned the range of genres from pastoral to urban landscape and included work in a more documentary mode, most notably his record of Lincoln's first inauguration.[49] A series of family portraits set in the garden behind his and Lucy's house at 1321 K Street constitute a

late-Victorian response, both to his own *American Antelope* (see figure 6.7) and to his father's *The Peale Family,* a work painted a full century before.

In one of these, taken on the Fourth of July, 1870, we see the artist, not acknowledging the viewer, seated at a table along with his wife, his brother Franklin's daughter Anna, and his only grandchild, Louis Titian Peale, the son of his and Eliza's fourth son Francis Titian Peale who had died a few years earlier.[50] This small extended family, composed of a second wife, a niece, and a grandson, echoes, albeit in miniature, the fragmented unity of his father's group portrait, organized as it had been around a gesture of apparent modesty, the artist-maker turned away, with its own quiet symbol of plenitude: on the table a full glass of water. This Peale family, like that earlier one, and unlike Titian's adolescent family portrait *American Antelope,* has a visual coherence, an affective as well as a compositional center of gravity (figure 6.15).

Jessie Poesch has aptly observed that, to judge from Titian's photographs, the interior of this home (see figure 13), "with its photographic paraphernalia, easels and painting equipment, rows upon rows of neatly arranged specimens of butterflies, and guns," must have strongly resembled the painting rooms in the museum where he spent his youth.[51] Titian at seventy, seated at a table in the garden of this house, his hair now white, approaching retirement, has something of the aspect of his father in his later years. The coincidence was a conscious one. When Franklin died at just about this time, Titian became the oldest living member of his family. As such, with Lucy's help, he undertook to write—or, actually, to compile—a Charles Willson Peale biography, making use of his father's letterbooks, papers, and manuscript autobiography, materials he had inherited from his brother, whose idea the project seems originally to have been. This labor was patently an act of filial devotion, as evidenced by its dedication:

> To our Father
> A tribute of Affection
> An offering of Gratitude, for his noble example
> and Honor, for his fine elevated character.[52]

Titian's return later in life to images and ideas as well as to places and events associated with his youth was frequently pious or nostalgic in this manner. Following his retirement in 1873, after returning to Philadelphia, for instance, he painstakingly reworked old motifs—scenes of bison hunts, or of grazing elk—into large oils. Such scenes, although often copied directly from his own sketchbooks, generally lacked conviction and vitality. On occasion, however, in less formal compositions executed in the old familiar medium, watercolor on paper, Titian's reprise of earlier concepts took on a spiritual dimension lacking in even his most accomplished compositions from before midcentury. His *View on Cooper Creek, New Jersey* (see figure 6.16), an ornithological landscape in which one marsh bird can be seen wading in the rushes while another takes flight, its whiteness silhouetted against darker foliage on shore, distantly echoes his lovely Long Expedition watercolor *Sand Hill Cranes* (see plate 91), a work painted more than five decades before.

In that earlier image, opposition between static portraiture and active flight emerges directly from Titian's professional concerns as a natural history

FIGURE 6.15
Titian Ramsay Peale
*Back door, 1321 K Street, Washington,
Fourth of July, 1870*
Photograph, 9½ x 7 in. (24.1 x 17.8 cm)
American Museum of Natural History,
New York; Scrapbook

illustrator, careful to establish a continuum between the ideal and the real; the generalized portrait of a species (*Ardea canadensis*) is in the center foreground of his image, while "field notes," more suggestive of a moment of actual observation, are relegated to a slightly further distance. In *View on Cooper Creek,* on the other hand, similar opposition between bird at rest and bird in flight reads rather as an allegory of emancipation from physical reality. Though based perhaps in similar habits of observation, the two images could hardly be more different in impact and appeal. As Titian's *Sand Hill Cranes* engages the intellect, so his *View on Cooper Creek* engages the emotions.

One receives a similar impression from the great work of his final years, *The Butterflies of North America.* This was a return to the study of lepidoptera that decades before his own birth was begun, after a fashion, by the first Titian. The younger Titian had pursued it first in his boyhood and then again in the 1830s, but had been forced in each instance to abandon it. Now taken up by him in his old age, the project, though no less serious than it had been,[53] seems to have been as much a labor born of love as of ambition. The hundreds of small illustrations for it that he painted in oils are richly colored, elaborate, and painstakingly detailed (plate 92).[54] Titian had given his earliest surviving lepidoptera sketchbook, dated 1817, the poetic subtitle "Seas of Appearance," alluding one would imagine to the style of metamorphosis his subjects underwent in their transformations from caterpillar to moth.[55] His late lepidoptera studies evidence a strikingly similar sensibility. Titian's perception—his celebration—of the mutability of matter, now discernible not just at the level of concepts but in the textures of the images themselves, signify here the symbolic culmination of his long career, a quasi-religious epiphany. Self-portraits and specimen portraits at one and the same time, these tiny works—a "world in miniature" unlikely to be recognized in his lifetime—reveal an artist who has come full circle, as attuned to the nature within as to Nature without.

PLATE 91
Titian Ramsay Peale
Sandhill Cranes, c. 1822
Watercolor over graphite on paper
American Philosophical Society, Philadelphia

PLATE 92
Titian Ramsay Peale
Caligo Martia (Butterflies), n.d.
Gouache on paper, 12½ x 10½ in. (31.8 x 26.7 cm)
Private collection

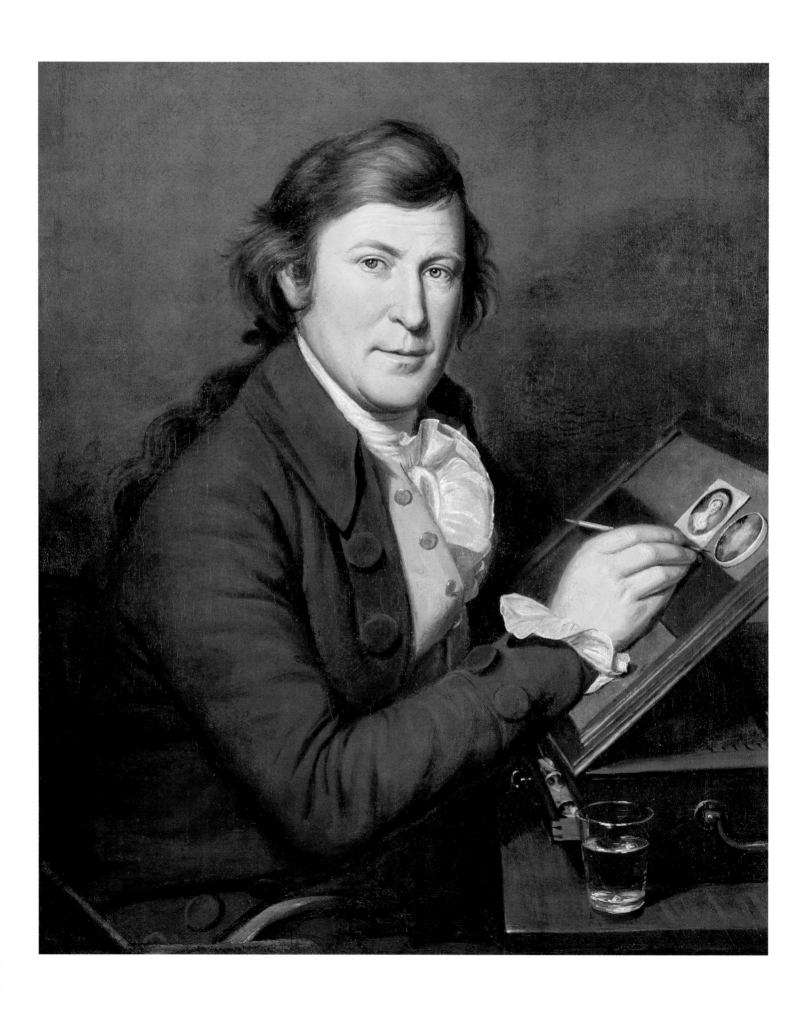

~

James Peale:

Out of the Shadows

~

L I N D A C R O C K E R S I M M O N S

F OR OVER ONE HUNDRED SIXTY YEARS James Peale (plate 93) has been recognized, when acknowledged, as an artist who lived, was trained, worked, and died in the glorious aura of his brother—Charles Willson Peale, the important Philadelphia painter, museum founder, and progenitor of a family of artists. When credited with an existence separate from the overshadowing Charles, James has been identified by only one aspect at a time of his multifaceted self: a painter of exquisite miniature portraits or of still-life subjects, a patriot, and the father of three interesting and gifted women artists. Evidence, however, indicates that James was an artist of greater variety and depth, and more diverse abilities, than any one facet now known about him would suggest. His many accomplishments as a painter of oil portraits, miniatures, landscape, history, genre, and still-life subjects have never been fully acknowledged or presented together in an exhibition or scholarly publication.

This essay reconsiders some of the limited views of the past, looks beyond the strong pull from a family of artistic overachievers, and, hopefully, illuminates the shadow of obscuring darkness resulting from the passage of time and paucity of written records, to begin to reveal a broader view of James Peale, his life, and his artistic career.

James, or "Jemmie"—as he was known within the Peale family—was the fifth and youngest child born to Charles and Margaret Triggs Peale. The family was then residing at Chestertown, Maryland, where Charles taught at Kent County School. With his death in 1750, the family moved to Annapolis, and here, at age 13, James was apprenticed as a saddle maker to his brother Charles Willson.[1] His interest in such an occupation did not last, and in 1765 he was apprenticed to a cabinetmaker-carpenter in Charlestown, Maryland.[2] His brother Charles Willson went through a similar series of career changes before determining on a final course. Therefore, given the lifelong ties of affection between the brothers, it is not surprising that they would each eventually follow a similar course into the arts.

PLATE 93
Charles Willson Peale
James Peale Painting a Miniature, c. 1795
Oil on canvas, 30 x 25 in. (76.2 x 63.5 cm)
Mead Art Museum, Amherst College, Amherst, Massachusetts; Bequest of Herbert L. Pratt, Class of 1895

When Charles Willson Peale returned from England to America in 1769, James came back to Annapolis from Charlestown and began training in his brother's studio. The exact course of studies prescribed is not known. Early references from Charles indicate that James was learning technical skills such as producing battens for picture frames, and working generally as studio assistant.[3] Drawing would certainly have been a necessary skill before the instruction would have progressed to painting from copies and still life and then from life. Charles was proud of the progress James made as a pupil and of himself as instructor. He wrote to his own teacher, Benjamin West, in April 1771: "My two brothers have lately made some essays in the Art the Youngest [James] will be a painter, he coppys very well, and has painted a little from life."[4]

Few references to Charles's teaching methods have been found, and paintings from this period in James's career are rare. A later sketchbook, however, dating from the 1780s to the 1830s, provides evidence of his initial training, which became the foundation of career-long practices.[5] Clearly James had been instructed by his brother to use drawing as part of the preparatory process for painting, and the keeping of a sketchbook must have been encouraged as James emerged from student-assistant to independent professional painter.

Sketchbooks are pads or bound volumes of blank paper used for making hasty or undetailed drawings as preliminary studies to be utilized in the completion of a more finished composition, often in another medium. The word sketch is usually applied to an early stage in the development of an idea prior to its execution in the final work. A sketch may be roughly and sometimes rapidly executed to present the characteristic lines and express the feeling of the thing drawn. Details of many parts are necessarily neglected to capture the interesting element of the moment.

These small volumes were carried by artists and used within the studio, around the home, out in the street, and in the country. The recorded images formed an archive of ideas and details to serve as a resource for studio work. Until later in the nineteenth century, few artists did little more than sketch outside the studio. Sketchbook drawings were rarely regarded as finished works of art or even developed as finished compositions, thus explaining in part their poor survival rate. The physical condition of sketchbooks—dirty edges, frequent tears, soft corners—is silent witness to their hard use and methods of transportation via pockets and artists' supply kits or sacks. A few elements are usually shared by most sketchbooks: a size to be handled and transported easily, rigid covers to provide horizontal support for the full width and breadth of each sheet, and a binding flexible enough to allow the full expanse of the sheet to be available. The paper surface is frequently unsized to provide texture receptive to varied media.

James Peale's only known sketchbook meets all these requirements.[6] The subjects depicted that relate to dated or dateable paintings cover the late 1780s to the mid-1820s, a range of four decades. This is a considerably long period for an artist to have used one volume, suggesting that this book was one of many employed at various times by James Peale. The nature of the drawings further indicates that the book was a working tool for an active painter who, of necessity, kept and continued to use a number of sketchbooks.

Subject matter varies throughout the volume, in which nearly every page bears diverse images, beginning with dogs, cows, human figures, ships, and furniture, followed by composition studies and more than eighteen full-page landscape scenes. This last group of drawings is the great glory of the sketchbook; it is especially notable for containing early examples of what was soon to be a subject of dominant concern for successive generations of American painters, popularly identified as the Hudson River School of landscape painting.

It would not be entirely fair to judge an artist's abilities as a draftsman on the basis of one sketchbook, since evidence of his full development and abilities may not be found in one location. A number of observations, however, can be made. James used the customary medium of graphite as well as pen and ink to produce lines of varying width, lightness, and darkness. He was a linear, direct draftsman, working in a literal style. He first developed forms in outline, then filled the interior with massed parallel lines to indicate areas of light and dark. By so doing, he achieved an effect of three-dimensional volume. Some of his drawings are fragmentary and the objects are not completely formed. Very rarely did James make corrections or distinct changes to any drawings, nor did he overlap images.

None of his drawings, except the group of landscape scenes, attempts to record atmospheric effects. Figures and objects exist as independent entities without a contextual setting or defined space: dogs leap from a nonexistent ground, ships float without waves, chairs sit on empty air. The effect is not disconcerting when one keeps firmly in mind that these little images are visual building blocks for the artist and should be examined in relation to the finished works that necessitated their creation.

James Peale's emerging artistic career was interrupted by the Revolutionary War, in which not only two of the Peale brothers served but also their two brothers-in-law. James was commissioned an ensign in Smallwood's regiment of the Maryland Line on January 14, 1776. Within three months, he was promoted to captain.[7] He served two more years, taking part in the battles of Long Island, White Plains, Trenton, Brandywine, Germantown, Princeton, and Monmouth before resigning.[8] The reason for his resignation is not recorded; however, George Washington noted his impending departure and, on June 2, 1779, wrote to James asking him to "consider . . . the propriety of leaving the service at a juncture, when perhaps we shall want abilities of every good and brave officer."[9] James replied regretfully that he would not reverse his decision: "[I] wish it Possible for me to continue in the Service with t[he] kind of satisfaction which an officier ought to be P[roud] of—my Baggage (Except one spare shirt and P[air] of Stockings [)], was sent off to Philadelphia ten d[ays] ago and my determination of Resigning was ful[ly] made some days before that. . . ."[10] He remained with the army for only a brief period and by September 1779 was back in Philadelphia.[11]

Charles Willson welcomed James into his studio and home as he had earlier in Annapolis. James would not move to his own place until his marriage to Mary Claypoole, sister of the artist James Claypoole, on November 14, 1782.[12]

After the war, Charles and James resumed their artistic careers, but times were hard and commissions scarce. Charles's solution was to divide the

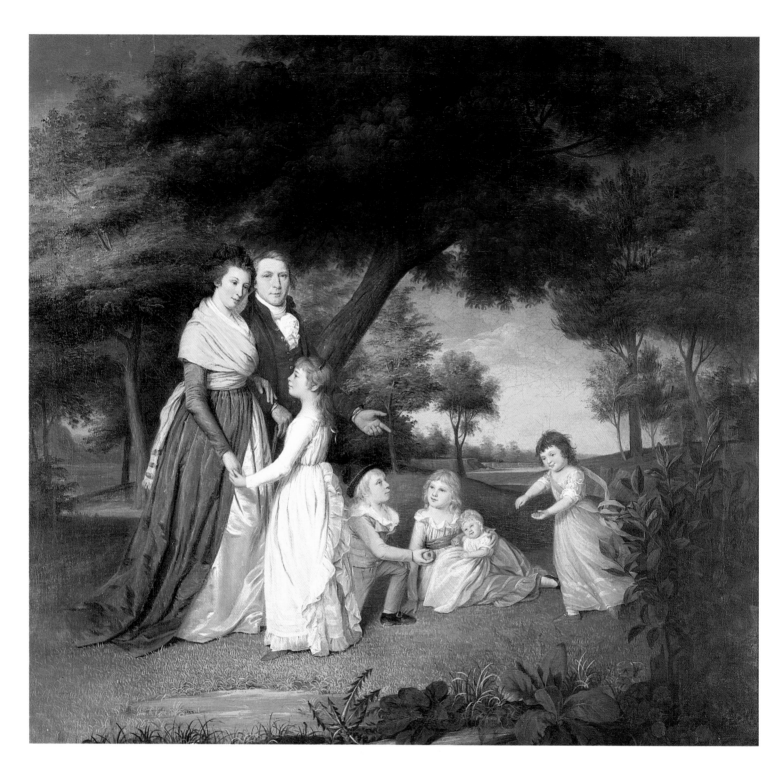

PLATE 94
James Peale
The Artist and His Family, 1795
Oil on canvas, 31 ¼ x 32 ¾ in. (79.4 x 83.2 cm)
Pennsylvania Academy of the Fine Arts,
Philadelphia; Gift of John Frederick Lewis

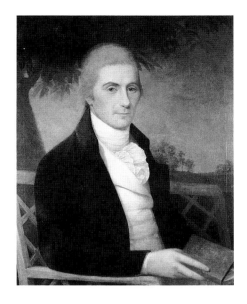 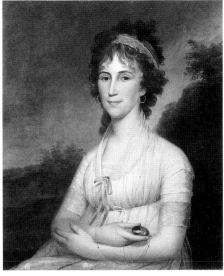

FIGURE 7.1
James Peale
Edmond Rouvert, c. 1803
Oil on canvas, 30 x 25 in. (76.2 x 63.5 cm)
Santa Barbara Museum of Art; Gift of Mrs. Sterling
Morton for the Preston-Morton Collection

FIGURE 7.2
James Peale
Jane (Mrs. Edmond) Rouvert, 1803
Oil on canvas, 30 x 25 in. (76.2 x 63.5 cm)
Santa Barbara Museum of Art; Gift of Mrs. Sterling
Morton for the Preston-Morton Collection

production of portraits in different mediums between them and hopefully stimulate the market for each. Charles Willson was to produce oil portraits at lowered prices, while James was to charge three guineas each for miniature portraits. The results were not spectacular. Although Charles did paint oil portraits, he also continued to produce miniatures in Maryland at his former price of eight guineas.[13]

For the next four decades, the brothers worked and lived in or near Philadelphia, raising families, sharing some projects, diverging as desired, and sometimes following interrelated careers as painters. Charles pursued a variety of lifelong projects in the arts and sciences, while James, by contrast, focused his energies on earning a living as a painter.[14]

The Artist and His Family (plate 94) presents the artist and his wife with their five children: Jane Ramsay (1785 or 1786–1834); Maria (1787–1866); James, Jr. (1789–1876); Anna Claypoole (1791–1878); and Margaretta Angelica (1795–1882).[15] The family stands in a forest glade with a distant view of a stream, framed by overhanging trees and foreground plants. The artist and father looks out at the viewer and gestures with a sweep of his hand to his surrounding family. Mary Claypoole Peale, wife and mother, places one hand in the bend of his arm and with the other hand, gently grasps their eldest child. By glance and gesture, the various members of the family are lovingly bound together, further unified by a harmonious repetition of varied hues of silver, white, pink, and other pastel tonalities.[16] The physical closeness of the setting, the diminutive scale of the figures, the relatively modest size of the canvas—31¼-by-31¾ inches—and the emotional interrelationship of the figures implied by the poses, all combine to create a conversation piece more than a group portrait. This work is unique in James's oeuvre. He painted other portraits, some in landscape settings, such as the companion portraits of Mr. and Mrs. Rouvert (figures 7.1, 7.2) and Mr. and Mrs. Young (1812; both, private collection), but none with the emotional power, personal involvement, and aesthetic quality manifested in the family portrait.

During the early 1790s, James Peale painted his earliest known significant landscape, *Pleasure Party by a Mill* (see plate 95). Only slightly larger than the family group, the canvas does not focus on the human form or human relations.

PLATE 95
James Peale
Pleasure Party by a Mill, c. 1790
Oil on canvas, 26 3/16 x 40 in. (66.4 x 101.6 cm)
Museum of Fine Arts, Houston; Bayou Bend
Collection; Gift of Miss Ima Hogg

Its composition and other elements do, however, derive from a number of preparatory drawings in the sketchbook of a site identified as Bloomsbury, a mill town in northern New Jersey.[17]

The most clearly related drawings (figures 7.3, 7.4, 7.5) present segments of the scene depicted in the painting. James experimented with various vantage points: the middle distance, with wooden-covered sluice directing water to the mill, shown in detail in figure 7.3; the little footbridge over the stream and the buildings to the left and right of it in figure 7.4; and the final vantage point and location of the painting in figure 7.5.[18] The arrangement of buildings and the general shape of the hills are depicted similarly in the painting, but other elements were added by the artist when he returned to the studio. His sketches do not include the group of people—the pleasure party—on the right in the painting, nor do they capture the effect of the light of an almost clear sky, or the atmosphere of the late afternoon sun across a sylvan setting, seen in the final work.[19] The framing tree and bushes on the left do not appear in the sketches, nor does the clump of plants on the right. The use of such elements in this composition suggests additions that were not in the actual scene but were derived from English landscape conventions designed to define the foreground and then lead the eye into depth.

Charles Willson noted James's early work in landscape and helped him dispose of paintings at a "raffle" in Annapolis in 1788.[20] In later life the two brothers shared an interest in sketching landscape; "My Brother James is with me," Charles wrote in 1820, "and I propose to visit Schulkill in the neighborhood of Canal, for the purpose of taking several interresting views."[21]

Changes in the style of James's landscapes between the 1790s and the 1820s are not easily discerned from an examination of the drawings in the sketchbook. It has been speculated that James painted very few landscapes except as settings for portraits until later in his life, when he returned to landscape painting about the same time as he resumed still-life subjects.[22] It is likely that the artist chose both genres to fill the time between portrait commissions and that these works were painted for his own pleasure. There are drawings in the sketchbook which have not been identified by their relationship to his paintings, but all are in the detailed linear style seen in his early landscape subjects. His later paintings eliminate unnecessary details to concentrate on the romantic qualities perceived in the swirling forces of weather and the massing of forms in highly contrasting areas of light and dark, such as appear in *Romantic Landscape* (see figure 7.6).

Beginning in the 1780s, James produced a number of modestly sized canvases depicting historical scenes based on individuals and events. These appear to have been motivated partly by the close working relationship the brothers enjoyed. Occasionally, while Charles painted a portrait, James would paint a historical subject related to the sitter. Over eight different subjects painted between 1782 and 1811 have been identified. They include: *The Generals at Yorktown* (see plate 96), *Sir Peter Parker's Attack Against Fort Moultrie* (see plate 97), *The Battle of Princeton* (c. 1782; The Art Museum, Princeton University, Princeton, New Jersey), *General Joseph Reed Represented after His Horse was Shot Under Him at the Battle of Whitemarsh* (c. 1785; fragment of the head in the Historical Society of Pennsylvania, Philadelphia);

FIGURE 7.3
James Peale
Watermill and Buildings, n.d.
Watercolor over graphite on paper, 4⅜ x 7½ in.
(11.1 x 19.1 cm)
James Peale Sketchbook, American Philosophical Society, Philadelphia

FIGURE 7.4
James Peale
Farm Buildings, n.d.
Watercolor over graphite on paper, 4⅜ x 7½ in.
(11.1 x 19.1 cm)
James Peale Sketchbook, American Philosophical Society, Philadelphia

FIGURE 7.5
James Peale
Scene with buildings, n.d.
Watercolor over graphite on paper, 4⅜ x 7½ in.
(11.1 x 19.1 cm)
James Peale Sketchbook, American Philosophical Society, Philadelphia

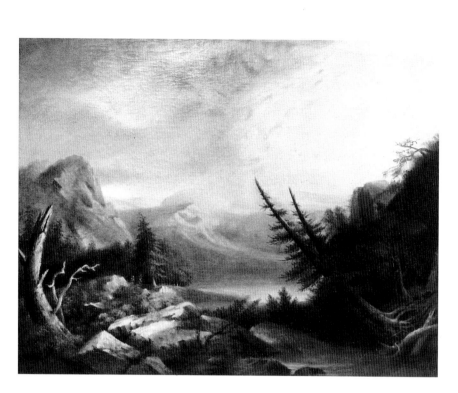

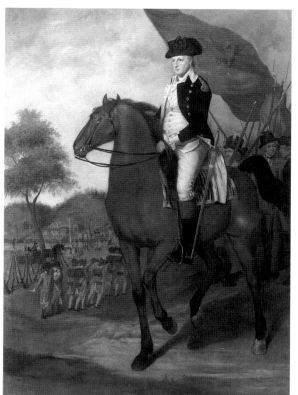

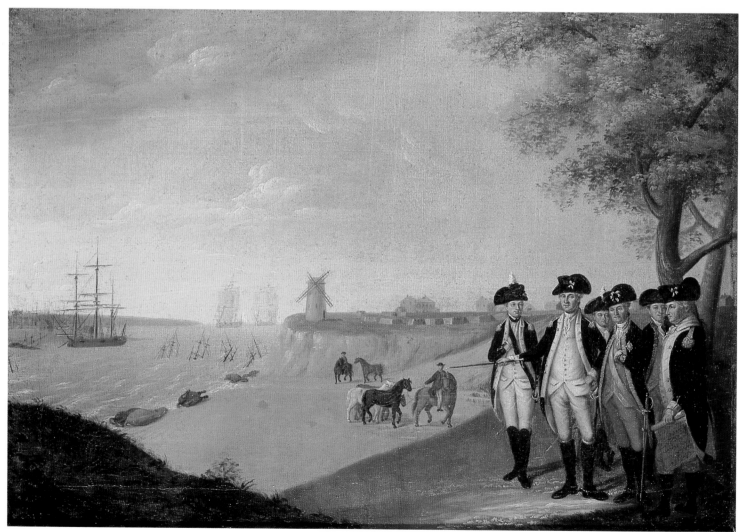

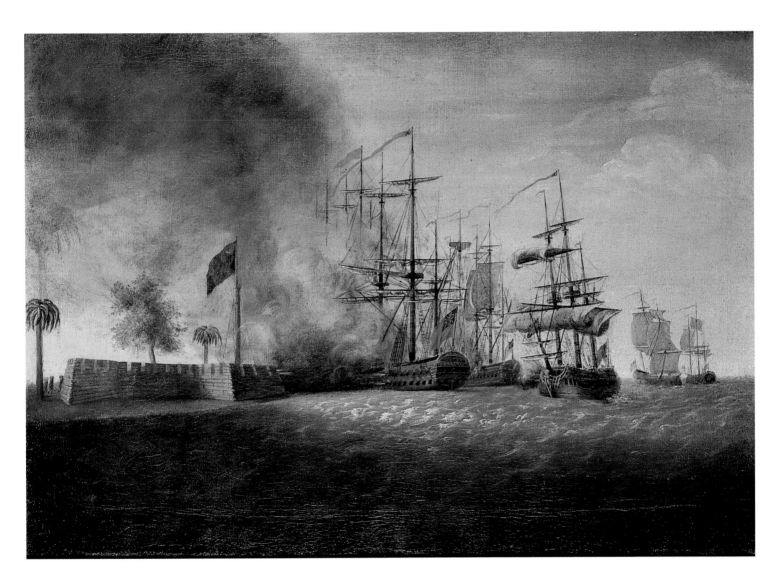

FIGURE 7.6
James Peale
Romantic Landscape, 1828
Oil on canvas, 20 x 25 ½ in. (50.8 x 64.8 cm)
Washington County Museum of Fine Arts,
Hagerstown, Maryland

FIGURE 7.7
James Peale
General Horatio Gates at Saratoga
Oil on canvas, 36 ¹/₁₆ x 27 ⅜ in. (91.6 x 69.9 cm)
Maryland Historical Society, Baltimore

PLATE 96
James Peale
The Generals at Yorktown, n.d.
Oil on canvas, 20 x 29 in. (50.8 x 73.7 cm)
The Colonial Williamsburg Foundation, Virginia

PLATE 97
James Peale
Sir Peter Parker's Attack Against Fort Moultrie, n.d.
Oil on canvas, 20 x 30 in. (50.8 x 76.2 cm)
The Colonial Williamsburg Foundation, Virginia

FIGURE 7.8
James Peale
Horserace, n.d.
Watercolor over graphite on paper, 4⅜ x 7½ in.
(11.1 x 19.1 cm)
James Peale Sketchbook, American Philosophical
Society, Philadelphia

FIGURE 7.9
James Peale
Man with a gun, n.d.
Watercolor over graphite on paper, 4⅜ x 7½ in.
(11.1 x 19.1 cm)
James Peale Sketchbook, American Philosophical
Society, Philadelphia

PLATE 98
James Peale
The Ambush of Captain Allan McLane, 1803
or 1811
Oil on canvas, 28⅛ x 36⅛ in. (71.4 x 91.8 cm)
Utah Museum of Fine Arts, University of Utah

General Horatio Gates (see figure 7.7), *Washington at the Battle of Princeton* (1804; The Henry Francis du Pont Winterthur Museum, Delaware), and *The Ambush of Captain Allan McLane* (plate 98).

The *Ambush* was probably painted as a commission from the hero of the episode. The subject is known in two versions, one that has remained with the McLane family and the other in the collection of the Museum of Fine Arts at the University of Utah, Salt Lake City.[23] The paintings depict an episode from the American Revolution, in which the war hero, Captain Allan McLane, was ambushed by British infantrymen in the countryside near Philadelphia. After attempting to gallop away, McLane engaged in skirmishes with two British dragoons lying in wait for him. He extricated himself from the situation by almost simultaneously shooting and striking his attackers with his gun.

The two works are similar except for the arrangement of the figures of the protagonists in the foreground. There are two preparatory drawings in James Peale's sketchbook for these paintings. The drawings relate to the privately owned painting and lend strength to the assumption that it was the first of the two paintings executed. Figure 7.8 establishes the basic elements of the composition: the captain attacking a dragoon on horseback to the left while the second dragoon sits astride his horse at a short distance on the right. The loose line and generalized effect of this drawing suggests that it is an image created from imagination rather than direct observation. The other related drawing in the sketchbook is No. 31 (figure 7.9), which shows the upper torso of Captain McLane with his arm raised holding a gun as if to strike downward. This image strongly suggests observation of an actual model, possibly the aging captain himself, when he demonstrated to the artist how he fought off the ambushing soldiers. The painting was begun sometime before May 1803, when Charles Willson wrote to McLane that he had received the captain's journal and "My Brother [James] has made a beginning, and his design tells your adventure with the Horseman admirably."[24] In the second version of this painting the three central figures on horseback have been moved closer together, thus concentrating attention on them and making this a more sensational representation of the captain's account.

It was as a painter of miniatures that James achieved long-term success and acquired a reputation that lasted beyond his lifetime. His earliest miniatures were almost identical to Charles's, who was clearly his teacher and artistic master; by the mid-1790s, however, James had achieved a style clearly his own. His watercolor brush working over little pieces of ivory created jewel-like and graceful images of men, women, children, and mourning subjects. His miniatures during the decades before 1800 are noted for their characteristic colors, gracefulness, and distinctive treatment of facial features. Evidence from known examples and manuscript references indicate that James Peale probably produced over two hundred miniatures. One particularly lovely example from 1797 is the portrait of *Marcia Burns (Mrs. John) Van Ness* (see plate 99).

In the 1790s, the size of miniatures in general had increased from the earlier small scale to the more generous proportions found in this little portrait. James's own style had also reached maturity by this date, and may be seen here in such elements as the wispy hairs, the sweet bow lips, the attention to details of facial features and costume, and the slanting parallel

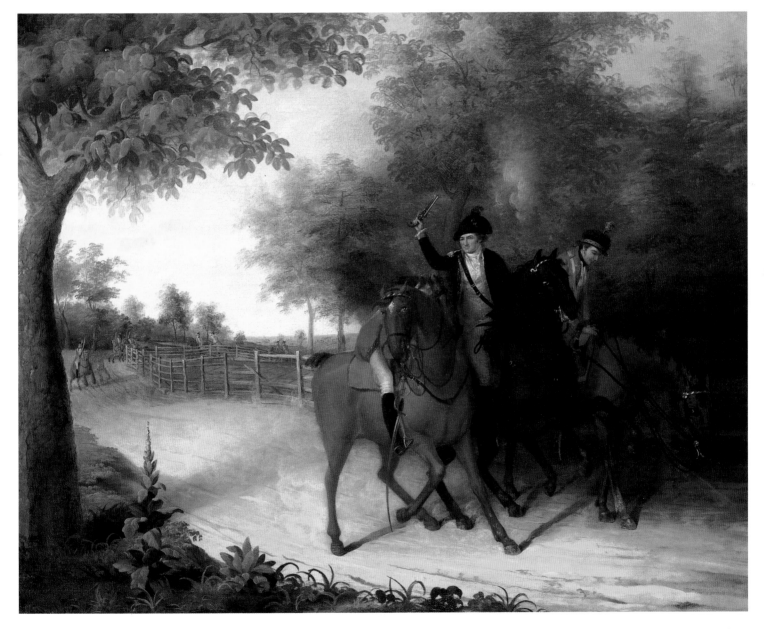

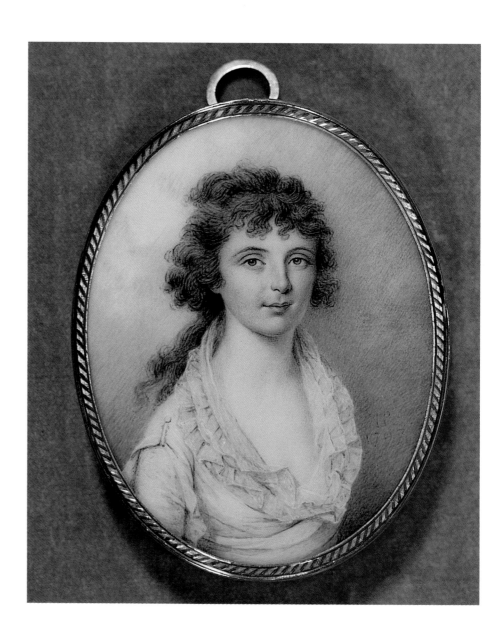

strokes used in the light background. Marcia was only fifteen years old when James painted her. She became a very wealthy young woman in 1799 when her father died. He had been one of the nineteen proprietors from whom the land for the federal city was purchased. She was pursued by many eager young men, but wed John P. Van Ness, Congressman from New York, in May 1802.

James Peale's miniatures are among the finest from this period and some of the most accomplished in the field of American miniature painting (plate 100). He continued to paint miniature portraits into the next century, when failing eyesight and frail health led him to defer this medium to his pupil and daughter, Anna Claypoole Peale.

James Peale painted oil portraits throughout his career. It is unclear which of the two mediums, oil on canvas or watercolor on ivory, he learned first. His earliest located signed and dated oil painting is from 1771 and the latest known was painted in 1823. By that year, either his style was influenced by the work of his daughter, Sarah Miriam, as indicated by the frequent presence of bright fabrics and embroideries, or she was assisting him in the studio (see plate 25).[25] Over the course of his career he produced far fewer oil portraits than watercolor miniatures, possibly less than seventy-five. A frequent group of sitters were subjects with military connections from the Revolutionary War, such as John White (c. 1783; Corcoran Gallery of Art,

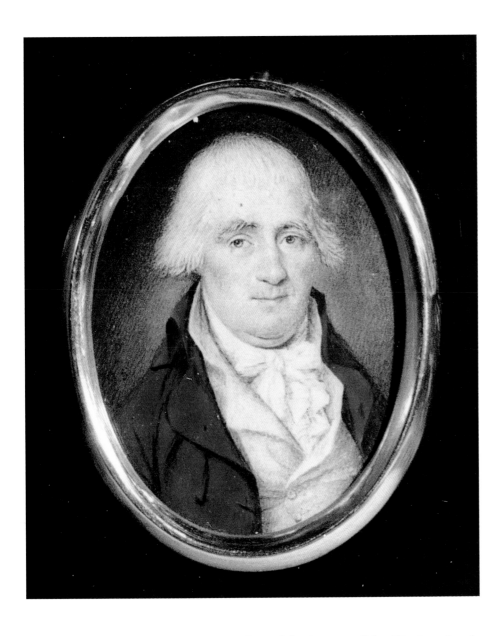

Washington, D.C.). James was a member of the Society of the Cincinnati and thus retained strong ties with his fellow officers.

In the first decade of the nineteenth century, French neoclassical influences become evident in some of James's portraits. In *Portrait of Marie Françoise Truchon de Lorrière Dubocq and Her Children* (see plate 101) the effect is dramatic: the canvas is large and the children numerous. As in his own family portrait, Peale has linked mother and children emotionally and physically through hand gestures and facial expressions. The whole is unified by the felicitous combination of colors, such as silvery grays and rosy maroons, as well as their placement and repetition. In his flesh tones, Peale used a hint of violet pink which may also be seen in other portraits he painted at the end of the eighteenth century. The Dubocq commission must have been significant for James; it indicates his contact with the culturally progressive French community in Philadelphia.[26] These contacts may account for his attention to their fashionable attire and coiffures, as well as the classical frontality, simplicity, and linearity with which they are depicted.

Although there are no preparatory studies for the Dubocq family in Peale's sketchbook, there are other portraits that clearly relate to drawings. One of the more interesting is the *Portrait of Ann Thompson* (see figure 7.10). Six sketches exist for this portrait. The young lady is shown seated at a harp

PLATE 100
James Peale
William Whetcroft, 1795
Watercolor on ivory, 2 ½ x 2 in. (6.4 x 5.1 cm)
Private collection

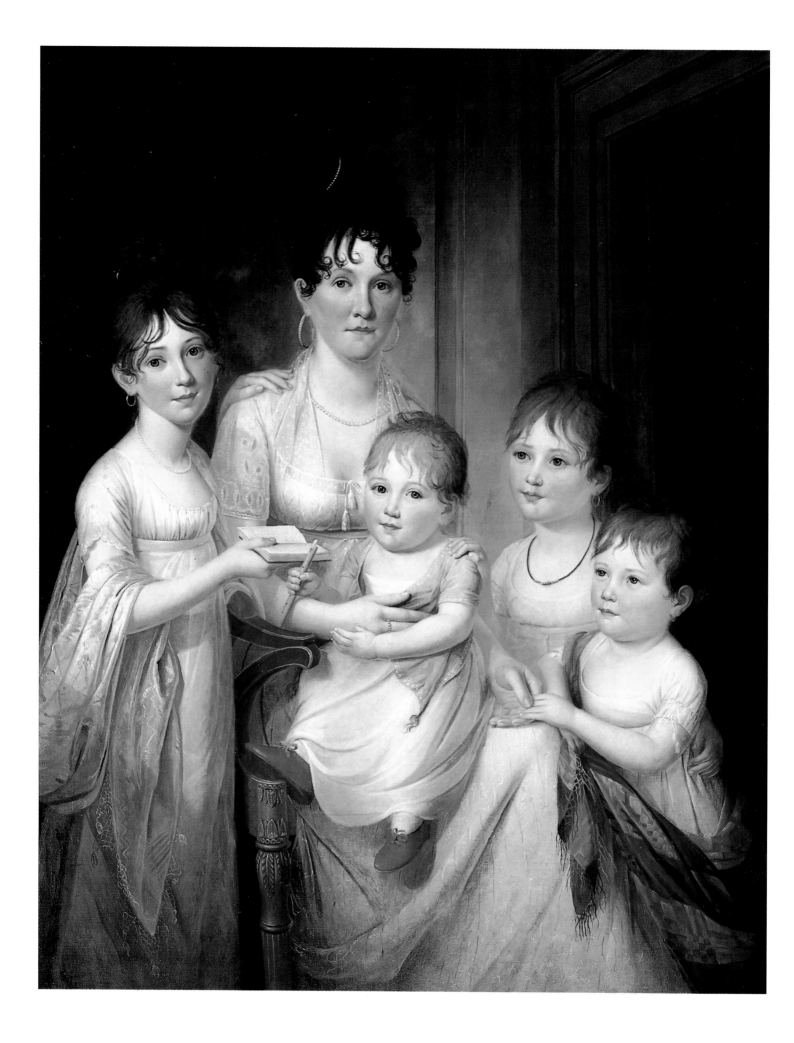

with her hand plucking the strings in the motion of playing. It is likely that the instrument was included at the request of the sitter or her parents. The drawings[27] depict elements of the Egyptian-style decoration of the harp, the carved and gilded rams' heads and the keys for the strings. They are truly sketches, made to record very specific details that could not be trusted to imagination or memory.[28]

The preceding year, Thomas Sully had painted a portrait of a lady with a harp, *Elizabeth Eichelberger Ridgely* (1819; National Gallery of Art, Washington, D.C.). The relationship between the two works is not known, but Sully's is the larger painting, and in its approach, seems to have been created for public display and impact. The Peale portrait is in the size James frequently used for portraits, 36½ by 28¼ inches, and presents the sitter more intimately, conveying a more private, personal impression.

By the 1790s, James Peale was firmly established as a miniature painter and had also produced some remarkable portraits in oil on canvas. At the Columbianum in 1795, he was listed as a miniaturist, but he also exhibited still-life subjects, as did his nephew Raphaelle. The works exhibited document the birth of the still-life tradition in America; the Peales were to be the principal practitioners of this art form for many decades to come.

After an early start, James did not publicly exhibit a still life for another twenty-eight years, until the Second Annual Exhibition at Rubens Peale's Baltimore Museum in 1823. The following year, his still-life paintings were shown at both the Pennsylvania Academy of the Fine Arts and the Boston Athenaeum. He continued to paint still-life works between 1795 and 1828 but possibly withheld them from exhibition in deference to his nephew— an act similar to that of the earlier division of mediums between himself and his brother, Charles Willson Peale, Raphaelle's father.

James's still-life paintings can generally be divided into two groups: early works up to the beginning of the 1820s, and later works from the years before his death in 1831. All are characterized by common elements of lighting, grouping of objects on a table or ledge, and the use of a limited selection of objects—fruit, vegetables, branches, foliage, flowers, flatware, and containers. There are none of the bottles or glassware, liquids, meats, baked goods, and exotic items, such as ostrich eggs, that appear in Raphaelle's paintings. The lighting is similar in both early and later works, usually coming from two sources and thus illuminating one side—the left—from above and in front, and the right side with a strong glow behind the objects, setting them off against the background space.

Stylistic changes took place between the two periods. James's earlier works show a tight control of brushstroke, a sharpness of focus, and a palette dominated by primary colors. His later paintings are executed more loosely, the forms are often less sharply defined, more objects are casually composed, and his palette has more ocher-to-green tonalities. Earlier works are painted on panel, in contrast to the canvas used for those done later. Characteristically sharp focused, precise painting is seen in works such as *Apples and Grapes in a Pierced Bowl* (see plate 102) of the early 1820s. This glowing image of fruit in a Chinese export porcelain bowl is complemented by the visual pun of a partially peeled apple. The rotund forms of the apples and ovoid shapes of

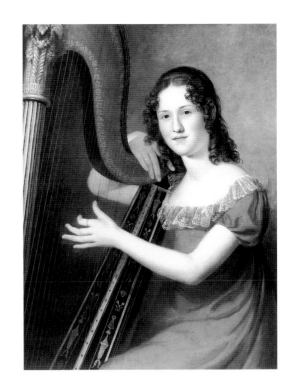

PLATE 101
James Peale
Madame Dubocq and Her Children, 1807
Oil on canvas, 51 x 41 in. (129.5 x 104.1 cm)
J. B. Speed Art Museum, Louisville, Kentucky;
Gift of Mrs. Algae Kent Bixby

FIGURE 7.10
James Peale
Portrait of Ann Thompson, 1819
Oil on canvas, 36 ¼ x 28 ¼ in. (97.1 x 71.8 cm)
Collection of Henry and Pearl Gerlach

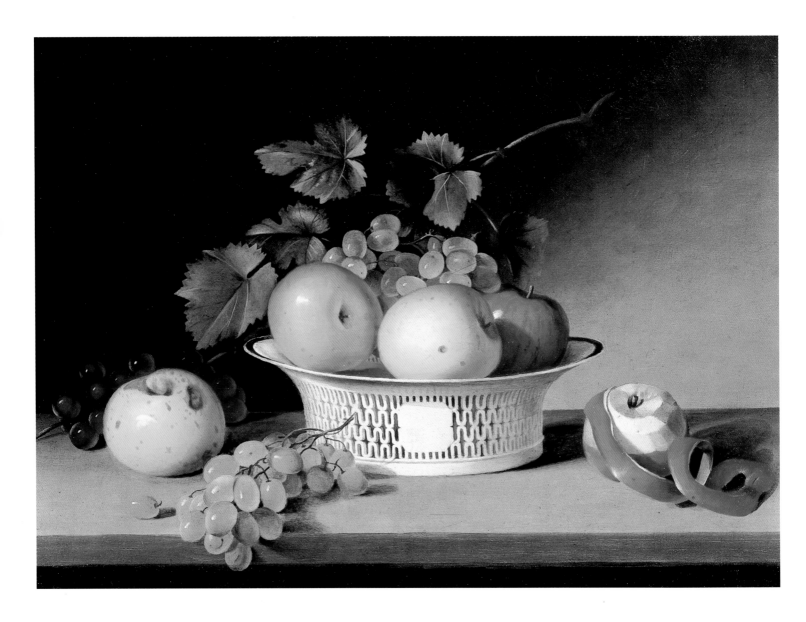

PLATE 102
James Peale
Apples and Grapes in a Pierced Bowl, c. 1820
Oil on canvas
Private collection

the grapes are reproduced with careful attention to their respective surface textures and transparencies. Even though their freshness is evident, the artist has included elements that represent the passage of time in the existence of these fruits, their origins in the bud or blossom on the branch and their eventual decay in the small blemish that has enlarged to an oval of rot on the leftmost apple.

James is not known to have shared the Peale family interest in the sciences. His depictions of natural objects seem to be based on direct observation and a perception of their interrelationships over time, not the geometry of their forms. Visual examination informs his hand in the depiction of the items before him, and his awareness of the passage of time is evident. His known, dated, still-life paintings begin in his seventieth year, and his blossoming as a still-life painter did not come until after Raphaelle's death in 1825. The coincidence of these dates strongly implies that James did not pursue his own interest in the medium in order not to compete with his nephew.

James returned to still-life painting in the years before his death, the autumn of his life. The fruits and vegetables he painted then seem to refer to his own time frame; they often evidence full ripeness, if not the start of decay.[29] It was at the end of his career that he produced a number of still-life settings composed almost entirely of vegetables, such as *Vegetables: Still Life*

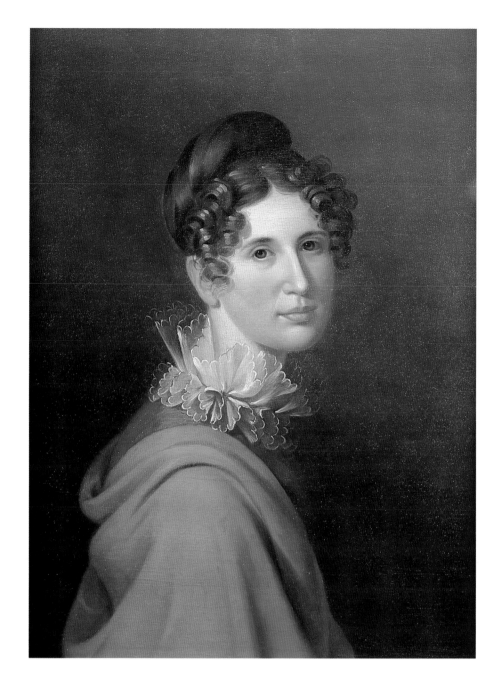

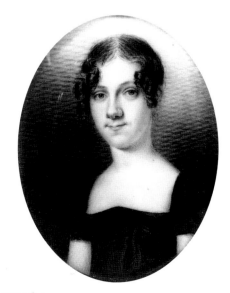

and had saved several lives. The story of Elizabeth Cromwell became an important part of the children's inheritance. Anna, the only child named after her mother's family, claimed the Claypooles' pride and persistence, which she noted in the inclusion of the initial "C" in the signature on her ivories. Sarah was just as interested in her descent from Oliver Cromwell, noting it as late as 1877.[1]

Like his brother Charles's, James Peale's studio served as a classroom and workshop, and as the nucleus of his family's life. It became a symbol of the family long after the children had matured and dispersed.[2] From about 1807 to 1819, the children assisted in a family-run business, excepting Jane Ramsay (plate 107) and James, Jr., the only son, who either rebelled or was unwilling to learn his father's profession, although he later did recreational painting. Anna began to draw seriously at about fourteen years of age, was apprenticed at sixteen, and accepted independent commissions within a few years. Her dated miniature portrait of *Helena Holmes Penington,* (figure 8.1), when compared with James Peale's miniature of *Anna Claypoole Peale* (plate 106) is sufficiently similar in pose and style to suggest their collaboration as

PLATE 109
Margaretta Peale, after Raphaelle Peale
Catalogue: A Deception, 1813
Oil on wood, 12 ½ x 9 in. (31.8 x 22.9 cm)
Collection of Jocelyn Peale Parker, Jennifer Peale,
and James Peale

well as Anna's influence on her father's later work. Anna's portrait of Helena, wife of Edward Penington, a member of the board of directors of the Pennsylvania Academy of the Fine Arts, was a youthful introduction to patronage.

The still life was a second manifestation of interactive interests in the James Peale family, bound into several levels of training and production across generations. From studies of common fruits, vegetables, a few flowers in season, the Peale students learned close observation, drawing, and composition. Maria Peale's only exhibited work, a still life of *Vegetables* (unlocated) was shown at the Pennsylvania Academy of the Fine Arts in 1811. Unfortunately, no works by Maria have been located. Attributed to her is *Still Life with Oranges, Pansies, and Liqueur,* which appealingly interprets the Peale tabletop tradition in a Victorian manner. Its high polish suggests that if it is her work, it is a late development in a continuous oeuvre.[3]

Influenced by Flemish still life actively collected in Philadelphia and prominent in the 1811 exhibition at the Pennsylvania Academy of the Fine

PLATE 110
Margaretta Peale
Still Life with Watermelon and Peaches, 1828
Oil on canvas, 13 x 19⅛ in. (33 x 48.6 cm)
Smith College Museum of Art, Northampton,
Massachusetts; Purchased with funds given
anonymously by a member of the Class of 1952

Arts, Margaretta began to produce independent work by about 1813 and continued to explore illusionism in the later *Catalogue: A Deception* (plate 109).[4] Her still-life paintings were stark variations on the domestic interior, the setting for her life. Their subjects are allied to the day-to-day concerns of domesticity. *Cake, Raisins, and Nuts* (c. 1829; private collection) is a study of varying textures in an elemental composition. The still life in general is closest to abstraction in reduction of forms, and this is evident in Margaretta's approach. John Wilmerding has commented on her built, almost architectural, forms, not unlike the clearly articulated shapes of Federal architecture.[5] Her *Still Life with Watermelon and Peaches* (plate 110) reveals such a structure. Margaretta's known work falls into two periods—the work of the 1820's and paintings of 1864–1866. In 1865, she exhibited at the Pennsylvania Academy four still lifes—three described only as "Fruit" and a fourth as "Cherries." She began to paint figures earlier, beginning about 1828; her "first attempt," a portrait of a lady, was exhibited at the Pennsylvania Academy that year and

was followed by a submission to the Boston Athenaeum in 1830. Some of Margaretta's portraits are bland, but a study of an aged, infirm James Peale (unlocated) is compelling.[6]

Sarah, the youngest daughter, was similarly employed. "On several occasions," Charles Willson Peale reported to his son Rembrandt, " she [Sarah] assisted her father in his pictures such as painting lace &c."[7] Sarah assisted James after her first works—two flower paintings—were exhibited at the Pennsylvania Academy of the Fine Arts in 1817. Her vital paintings of melons, grapes, and peaches were closer to James's lavish and inventive still lifes in their interpretations of the bounties of nature, which both explored in depth in the 1820s (plate 112). James's willingness to learn from his daughters as they were from him is illuminated in his variation of Sarah's lush *Peaches and Grapes* (plate 113). Her work inspired James's *Still Life with Watermelon* of 1829 (see figure 8.2). James replicated Sarah's composition from left through center, but substituted on the right a slice of green melon on a dish in place of Sarah's green grapes and peaches. Both artists' choice of a variety of green melon (possibly casaba or "musk melon") was also favored by Raphaelle Peale in *Fruit in a Silver Bowl* (1814; private collection).[8] When

PLATE 111
Margaretta Peale
Strawberries and Cherries, n.d.
Oil on canvas, 10 1/16 x 12 1/8 in. (25.5 x 30.8 cm)
Pennsylvania Academy of the Fine Arts, Philadelphia

PLATE 112
Sarah Miriam Peale
Fruits and Wine, 1822.
Oil on canvas, 11 3/4 x 16 in. (29.8 x 40.6 cm)
James Graham & Sons, New York

PLATE 113
Sarah Miriam Peale
Peaches and Grapes in a Porcelain Bowl, 1829
Oil on canvas, 11 3/4 x 15 in. (29.8 x 38.1 cm)
Montclair Art Museum, Montclair, New Jersey;
Bequest of Mrs. James A. Aborn, Mr. and Mrs.
George C. Densmore, Mrs. Maurice Emataz, and
Mrs. William H. C. Higgins Funds, by exchange

FIGURE 8.2
James Peale
Still Life with Watermelon, 1829
Oil on canvas, 20 ¼ x 26 ½ in. (51.4 x 67.3 cm)
Hirschl & Adler Galleries, Inc., New York

she was only twenty-two years old, Sarah's flair for still life was recognized by the eminent collector Robert Gilmor who purchased a *Fruit and Grapes* for his collection in 1822 for twenty dollars.[9]

Such still life paintings, a direct expression of the painterly impulse, were exchanged as gifts or were poignant mementos of elder family members. Margaretta, for instance, paid tribute to her aged, infirm father when she exhibited a *Still Life with Grapes after James Peale* (unlocated) at the Academy in 1828, a rare appearance for her; and she inscribed her handsome *Watermelon and Peaches* as a gift to Anna that year.

The Peale women made self-determined choices inherent to the processes of painting; unlike the majority of middle-class women whose education was segregated in girls' schools and who were limited by training to become wives, they also developed entrepreneurial skills. James's training of his daughters may be related to the influence of a vestigial apprentice system that he himself underwent during his youth and in his brother's studio. The artists may have intended to become specialists in a family-run business, but opportunities for small businesses owned by artisans that had driven an apprentice system prior to the Revolution declined with the dawning of the factory system. Similar methods continued to govern the training of artists, such as Jane Cooper Sully (1807–1879), later an academician of the Pennsylvania Academy of the Fine Arts, whose chores had included making "creditable copies of her father's works" or beginning commissioned works which Thomas Sully finished. Her sister, Rosalie Sully (1818–1847), exhibited a portrait miniature at an exhibition at the Boston Athenaeum in 1831, but neither of Sully's daughters pursued lives in the arts with the intensity of Anna and Sarah Miriam Peale.[10] In the 1820s Margaretta and Maria assumed responsibility for their aging parents, easing Anna's role as the financial mainstay of the family and making possible Sarah's commencement of a career in Baltimore.[11]

Anna Claypoole Peale was the first professional woman to emerge in the Peale family. Her earning ability was demonstrated at a young age; at fourteen, she submitted to a local auction two oil copies of paintings by the French master Claude-Joseph Vernet (1714–1789), for which she received a good price. The effort indicates not only her artistic precocity, interest in European art, and enterprise, but also her courage in exposing her work to public scrutiny.

Several motivations coalesced in Anna's decision to specialize in the portrait miniature, notably a sense of continuity with the old world, absorbed from her mother, that was associated with the venerable history of the miniature, and the idea of family continuity. Indeed, since the 1760s, the miniature had been practiced by Charles Willson Peale and his son Raphaelle, as well as by her father James.

From the Elizabethan period on, the miniature had been variously explored in watercolor on vellum, paper, or card, and in oil on metal; it was introduced into the American colonies in the eighteenth century as a portrait on ivory. Anna was influenced by perceptions of the miniature painter's profession, which, if not altogether accurate, were initially beguiling. Charles Willson Peale's portraits of *James Peale Painting A Miniature* (see plate 93),

shown with his miniature of Charles's first wife *Rachel Brewer Peale* (see figure 1), and *Mary (Polly) Wrench (Mrs. Jacob) Rush* (figure 8.3), posed with her portrait of an older man, express Charles's views on miniature painting. The painter's apparatus and procedures are accurately rendered in every detail, except for the artists' elegant apparel. With every movement of the hand, the dangling trimmings on their sleeves would have smeared the wet watercolors. As occupational dress, the artists' clothing was improbable but its elegance was central to Charles's discussion of the refinement of the miniature as an art form, and miniature painting as a profession that could attract the young artist as well as a conservative, affluent clientele to the Peales.[13]

The skills required to "hatch, stipple or wash" watercolors onto resisting ivory, expensive and easily fractured, soon separated amateurs, who abandoned the work after a few experiments, from professionals.[14] As to the portrait itself, the anatomical focus on the head rather than the body was inoffensive to American morality and, therefore, an appropriate study for women. A framed miniature of one's husband, often suspended from a gold chain or a tight ribbon worn around the neck, decorously emphasized woman's dependency. Men, who also carried portraits of their wives or friends, concealed these sentimental objects from view. Anna's genre was, therefore, socially acceptable, but her agenda was unconventional—to compete among male painters who had dominated the field from the Elizabethan period to 1810, the year when her career became possible.

Artistic and literary interests were expanding in America when Joseph Hopkinson, a founder and first president of the Pennsylvania Academy of the Fine Arts, announced plans for a first annual exhibition to the board of directors on November 13, 1810. He said, "The gardens of literature are now illumined with many a lamp trimmed by a female hand [and] . . . the arts of painting and engraving have softened under the hands of the female touch. I hope and trust the walls of our academy will soon be decorated with products of female genius; and that no means will be omitted to invite and encourage them."[15]

Anna and Maria were two of three local women to respond to Hopkinson's invitation. In 1811, Anna submitted a still life for exhibition, and in 1814, she sent her first group of three miniatures to the academy.[16] Philadelphia's cosmopolitanism, wealth, and size attracted numerous artists to academy exhibitions and to the city, but a perennial quest for the right sort of patronage was complicated by the social barriers faced by women painters, as Anna would learn. "Products of female genius" were accomplishments of a leisure class in the culture of Philadelphia's elite and middle classes influenced by British and French traditions. A young woman's art portfolio, preferably attained in one of Philadelphia's fashionable schools for women, was a sought-after expression of refinement, as noted by Margaret Bayard Smith in an anonymously published novel of 1828, *What is Gentility?* However, few respectable options were open to women who needed to work.[17]

In 1822, William Dunlap published an essay written by Philadelphia novelist Charles Brockden Brown (1771–1810) that told a much different story. Brown's analysis of social attitudes and options open to women is told in *Two Dialogues, The First on Music: the Second on Painting*, as a female accom-

FIGURE 8.3
Charles Willson Peale
Mary (Polly) Wrench (Mrs. Jacob) Rush, 1786
Oil on canvas
Private collection

plishment, or mode of gaining subsistence and fortune.[18] Brown carried on his dialogue on painting with a fictional middle-class woman, "L," who was faced with financial reverses (a fictional convenience was the loss of a male parent). "L" pondered, "I could not make myself lawyer, physician or divine . . . trades . . . were only to be followed by necessity" and "music, painting and needle-work were all that remained." Brown then compared the disadvantages of a musical career with the advantages of writing. Writing offered an easier method for women to retain dignity through privacy: "The implements and materials [of a writer] were cheap & to be wrought . . . with less exposure to the world, less personal exertion, less infringement of liberty." To gain a living in music, women had to "shew [themselves] at concerts . . ." and in so doing, "forfeit all esteem and trample upon delicacy."[19]

Portraiture, as a direct transaction between artist and subject, had similar disadvantages for women painters. They could impose neither the cloak of privacy nor the disguise by pseudonym available to writers. The social exclusion implied by Brown was experienced by a bewildered young Scottish painter Caroline Schetky (1790–1852), newly arrived in Philadelphia from London, whose work was accepted in the academy annual exhibition of 1818. Caroline observed her brother George's easy access to Philadelphia's musical

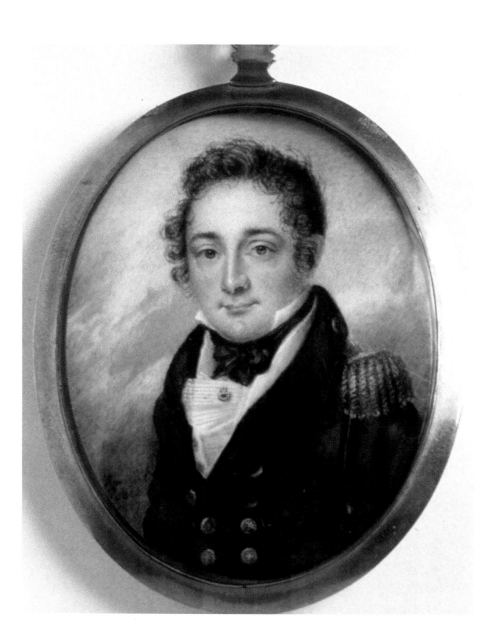

PLATE 114
Anna Claypoole Peale
Commodore Jonathan Dayton Williamson, 1817
Watercolor on ivory, 2 9/16 x 2 1/16 in. (6.4 x 5.1 cm)
Collection of the Montclair Art Museum; Gift of
the Estate of Constance Schermerhorn Skillim

circles while she was deprived of even "the soothing bosom of one Female Friend."[20] Fleeing to relatives in other cities as often as possible, Caroline found in Boston a more receptive intellectual circle, which included the prominent miniature painter Sarah Goodridge, and painter Jane Stuart.

Brown had traced a similar path for a woman who had turned to art as a "mode of subsistence" but was rescued from its consequences. His heroine, "L," traveled to London where she was instructed in the miniature by "Mrs. Eckstein," a Saxony widow. He might have been alluding to Mary Roberts (d. 1761), widow of the painter Bishop Roberts (d. 1740), who introduced the miniature on ivory into Charleston, South Carolina, in the 1740s and is known by three works; or to painter Henry Benbridge's wife, miniature painter Hetty (Esther) Sage Benbridge, also based in Charleston.[21] After three years of assiduous application confined to studies of women, "L's fortunes were magically restored; she was able to read for leisure and improvement instead of being compelled to make art for subsistence."[22]

The alternative to setting oneself apart was anonymity, which brought little practical advantage. Anna chose to be visible from the outset of her career, listing her vocation, name, and address in catalogues in Philadelphia, Boston, Baltimore, and New York, and traveling to those cities as well as occasionally to Washington. Anna's body of work is impressive, more than two hundred known miniatures, usually signed. Rather than disguise her singularity, Anna built an identifiable body of work that reinforced her artistic identity, thus emphasizing her refusal to limit her aspirations to those generally deemed appropriate to women. Glimmers of success became incentives that drove her to excel.[23]

Despite the social obstacles facing a professional woman painter and the lack of precedent to ease her way, in 1817 Anna became a seemingly overnight success in Philadelphia. The graceful precision that launched her reputation is evident in several compositions featuring a figure posed against a background of sky, a contemporary interpretation of a motif from neo-classical portrait miniatures. Sky backgrounds appear in Anna's portraits of 1817 of an *Unidentified Little Girl* (Victoria and Albert Museum, London) and *Dr. Jacob Randolph* (figure 8.4). Anna's sky in *Commodore Jonathan Dayton Williamson* (plate 114) is more closely allied to the atmospheric landscape details of English portraitist Robert Field, rather than the generalized airy puffs of cloud and sky rendered in pale washes revealing the ivory by Benjamin Trott or James Peale. It is this opacity of surface that becomes an important characteristic of her mature style.

Anna utilized her strong line to create dramatic effect in her well-known portrait of *Andrew Jackson* (figure 8.5), a treatment stimulated by her impressions of the political and social milieu of Washington in February 1819, while visiting the capital with Charles Willson Peale and his wife Hannah. In Washington, Anna experienced at firsthand the theatrical atmosphere surrounding the political process. She positioned Jackson low on the ivory against a cloud-filled sky, which is handled like a theatrical backdrop, evoking past battles and distant skies. A suggestion of contrapposto in the pose, and lines etched into Jackson's face, lend a dynamic tension and show Anna's wiry line to advantage. She has also portrayed the warrior: Jackson's lips are

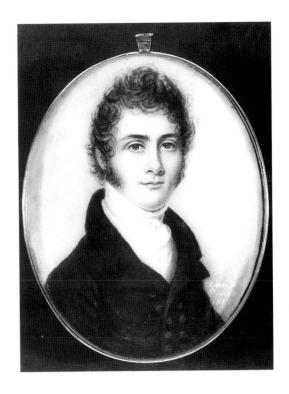

FIGURE 8.4
Anna Claypoole Peale
Dr. Jacob Randolph, 1817
Watercolor on ivory
Worcester Museum of Art, Worcester,
Massachusetts; Eliza S. Paine Fund

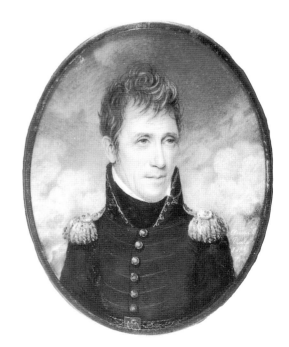

FIGURE 8.5
Anna Claypoole Peale
Andrew Jackson, 1819
Watercolor on ivory, 3 x 2 ½ in. (7.6 x 6.4 cm)
Yale University Art Gallery, New Haven,
Connecticut; Mabel Brady Garvan Collection

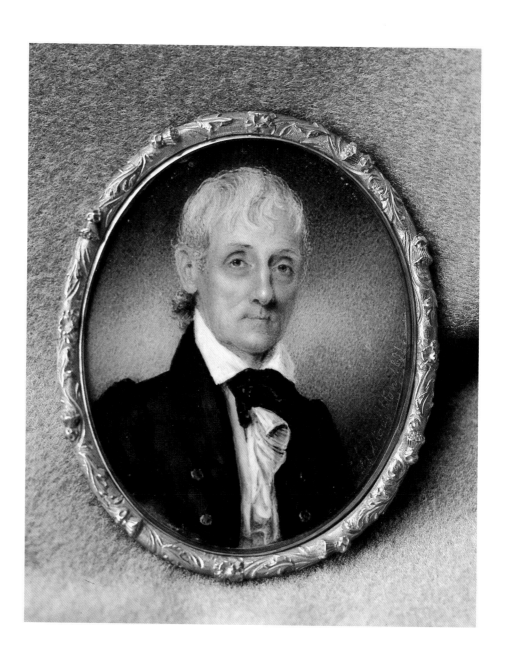

compressed in a rather cold smile, evoking the character of a man then under investigation by Congress for his brutal treatment of the Seminoles in Florida, even as he was making a triumphal sweep through the country. Jackson's portrait is an unabashed rendering of a hero for public presentation.

An ascending merchant class in Baltimore and Philadelphia was attracted by Anna's manner, while behind her facade was an overworked painter who wrote from the studio on April 7, 1819, to her cousin Titian Ramsay Peale, "I have so much work to do that I hardly know what to do with myself."[24] In her portraits, men and women were elevated to refined ladies and worthy gentlemen however they looked or behaved in life. Anna focused on the significance of physiognomy—on those physical traits that implied character (plate 115). In 1819 she had attended one of a series of medical lectures and announced her intention to attend all of them if possible.[25] However, her work was more culturally than scientifically or anatomically based. She focused on the cultural typing of the period, revealed in studies of facial features and complexion. James, she told an interviewer, had been known as the "flattering" painter. Anna took this further, creating a "frame" around the subject that described female beauty as it was equated with goodness, or the worth of men as delineated by specific physical traits.[26]

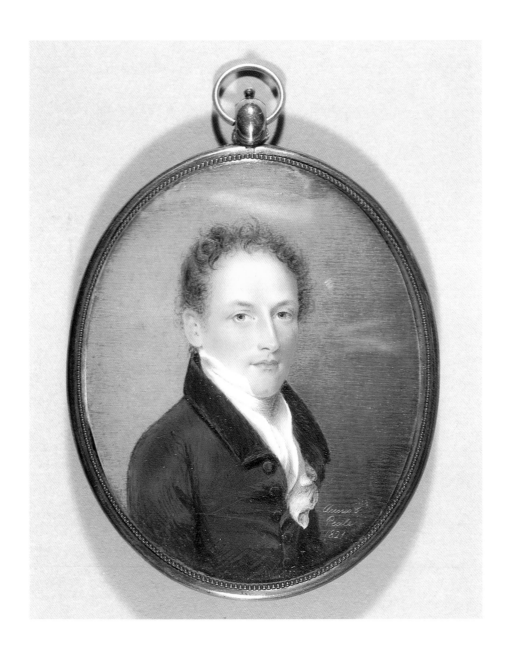

PLATE 116
Anna Claypoole Peale
Samuel Parkman, 1821
Watercolor on ivory, 2¾ x 2¼ in. (6.8 x 5.6 cm)
Cincinnati Art Museum; Fleischmann Collection

Throughout the 1820s, many of Anna's miniatures suggest a taxonomy of representation of the paradigmatic man and woman described in contemporary women's fictions. These ideas appear in fashion plates that projected the Romantic ideal and were popularized in magazines addressed to women readers. Literary historian Nina Baym has observed that in women's fictions "the man's face . . . [was studied] for evidence of his probity . . . The ruddy cheek, the frank, manly blue-eyed gaze, the high forehead, the clustering curls—these denoted intelligence and trustworthiness in the male."[27] A portrait of wealthy Bostonian Samuel Parkman (plate 116) points to the direction Anna began to emphasize in her miniatures of the late 1820s. Among these miniatures is that of Jared Sparks, theologian and biographer of George Washington (1827; private collection). Sparks's high forehead and dark curling hair springing from a slightly receding hairline, and his blue eyes that establish eye contact with the viewer denote "intelligence and trustworthiness." The open gaze of eyes under well-marked brows and heavy lids establish candor. The "ruddy cheek" is less obvious in this portrait and well may be a result of time and fading rather than the artist's intention, since several of Anna's male subjects possess a fresh, ruddy coloring.

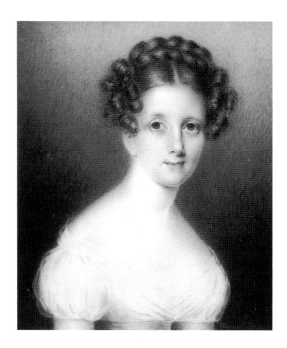

FIGURE 8.6
Anna Claypoole Peale
Mrs. John A. Brown (Grace Brown), 1827
Watercolor on ivory, 2 ⅞ x 2 ½ in (7.3 x 6.2 cm)
The Gloria Manney Collection at the Metropolitan
Museum of Art

Romantic conventions of beauty in fashion are pictured in a cabinet miniature of *Grace (Mrs. John) Brown* (figure 8.6), wife of Philadelphia merchant-banker John Brown. The Browns were typical of Anna's new patronage, and Anna painted four portraits of members of the Brown-Wilson families of Baltimore and Philadelphia between 1825 and 1827. In this miniature Grace Brown is a restrained model of Philadelphia fashion, depicted in a diaphanous evening dress of white muslin, emblematic of feminine modesty. Anna's strong line renders the tight tendrils of her hair like a twining plant, an analogy of a woman to a flower. Grace Brown's enlarged doe-eyes complete a successful image of youthful fragility and refinement.[28]

Anna's "character portraits," among them a masterful study of *Susannah Williams* (figure 8.7), are naturalistic. Unlike miniatures of an earlier era, whose scale and transparent color made a distinct statement about the medium and set them apart from portraits in the large, Anna's have the presence and high finish of full-scale portraiture, mimicking oils. This was a phenomenon of nineteenth-century taste that she fully exploited in this portrait of a woman in late middle age, emphasized by adroitly painted costume elements, a cap and paisley shawl. Such deeply colored, opaque miniatures were often framed as wall pieces.

Literary and intellectually questing, Anna was much less a rationalist than a romantic, attracted to the emotional and democratic expressions of her era—as in her choice of such themes as the tale of Beatrice Cenci, a Renaissance tragic heroine in a tale of abuse and revenge filtered through the romantic imagination. Museum exhibitions in Baltimore, New York, and Albany attempted to contextualize literature with the history of art, and Anna created at least this one work specifically for the Pennsylvania Academy. Her portrait of *Beatrice Cenci* "after Guido Reni," exhibited at the academy in 1828 and at the Boston Athenaeum in 1831, was inspired by Percy Shelley's play *The Cenci* (1819), which became widely known in the United States in the late 1820s, after the poet's death. Anna's choice of this work to exhibit at the Athenaeum must have seemed particularly appropriate to its collections of art and literature. Her interest in the story was shared by other American artists, including Thomas Sully, who confused the subject with a theater piece, and Anna's niece Mary Jane Simes, who studied miniature technique with her in Philadelphia. Romanticism is also the underlying mood of Anna's portrait of *Marianne Beckett* (plate 117), who is set against a soft sky that serves as a foil for a dark red velvet dress characteristic of an era. Marianne's features, coincidentally or deliberately, evoke the contours of Reni's portrait of *Beatrice Cenci*.

Anna was drawn to the Baptist religion about 1819 and was later a convert, deliberately rejecting the elitist values she often skillfully projected in her art. In 1829, her life expanded after marriage to Baptist educator and theologian William Staughton (1770–1829), but soon collapsed and was re-formed. Anna was attracted to Staughton's learning and by the contrast between his personal modesty and public persona as a brilliant pulpit orator. Born in England, trained at Bristol College and at Princeton, Staughton had served as President of Columbian College in Washington, D.C. In an era when one percent of the population was college trained, Staughton was a

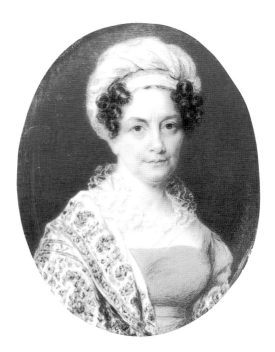

FIGURE 8.7
Anna Claypoole Peale
Susannah Williams, 1825
Watercolor on ivory, 3 x 2 ½ in. (7.6 x 6.4 cm)
Maryland Historical Society; Gift of Miss Elizabeth
Williams Burnap, Collateral Descendant, 1927

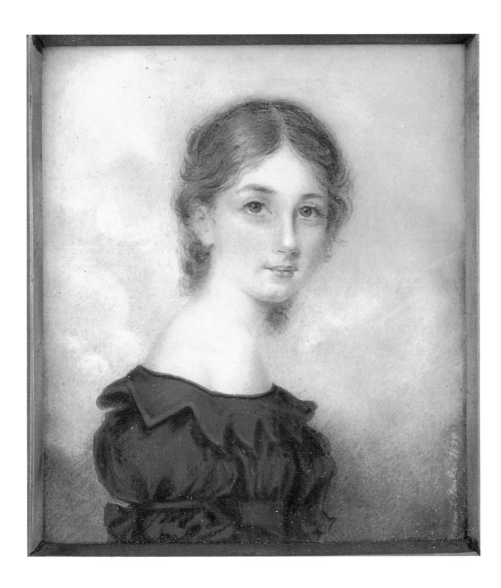

model scholar, known for his fluency in classical languages.[29] He was sympathetic to women who achieved national recognition, such as "Mrs. Hudson the Burmese missionary," whose portrait (*Ann Hasseltine Judson,* unlocated) Anna exhibited at the Boston Athenaeum in 1828.

They married when Staughton's appointment was confirmed as president of a new Baptist school, Georgetown College in Kentucky, but tragically, William fell ill in Washington, D.C., during a pause in their journey from Philadelphia to Kentucky and died. Scarcely three months after her marriage, the widowed Mrs. Staughton returned to Philadelphia. Driven by financial need and unresolved grief, Anna plunged into work, producing direct, naturalistic portraits. Sadness haunts a deftly painted sky, evoking sunset or an impending storm, in a background that is the primary subject of a portrait of *A Young Man from Baltimore* (1832; Metropolitan Museum of Art, New York). The number of miniatures or recorded works declined, and, in 1841, Anna married retired Brigadier General William Duncan (1772–1864) in Philadelphia. Presumably she turned to painting in oils on canvas. Now in her early fifties, Anna had pushed the physical limits for the exacting miniature and painted no others.

The miniature art form was in sharp decline in the United States until a brief, late nineteenth-century renaissance realigned it technically with modern painting and historically with the past. Anna Claypoole Peale's portraits of presidents *James Monroe* and *Andrew Jackson,* shown in United States centennial

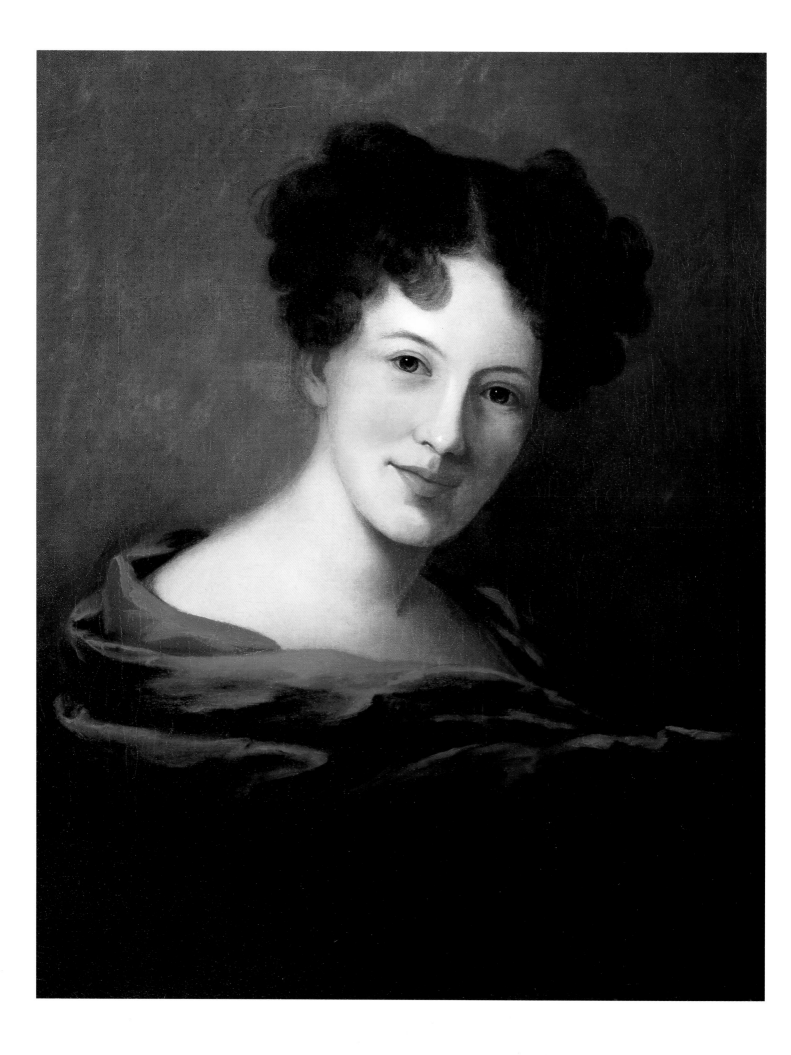

exhibitions in San Francisco in 1876 as well as in Louisville, Kentucky, in 1874, and her miniatures exhibited at the Philadelphia Centennial in 1876, reminded younger generations of portraits in miniature by one of the most accomplished American women painters of the nineteenth century.

It is altogether fitting that the earliest representation of Sarah Miriam Peale, from 1818 is a *Self-Portrait* (plate 118), because her life was the most self-created of the five Peale women. At eighteen, pretty, dark-haired Sarah has thrown a studio drape around her shoulders, its dark red color well suited to her ebullient style. Although her color and warmth remain, the informality of the studio has been replaced by the public persona of a composed and successful young painter in her *Self-Portrait* of about 1830 (figure 8.8). This portrait illuminates Sarah's mature style; she is richly clothed in a cape of turquoise velvet over a yellow dress similar to those worn by her fashionable Baltimore clientele. In the intervening years, Sarah and Anna had been elected academicians of the Pennsylvania Academy of the Fine Arts, in 1824, the first women accorded this recognition in the United States. Membership in this artistic community was important to Anna, but Sarah seldom used the letters "P. A." after her name, although she continued to exhibit at the academy through 1831.

Mainly because customs of the day inhibited them from traveling alone, Sarah and Anna traveled together from Philadelphia to Baltimore in the 1820s and soon experimented with collaborative sittings of public figures. At twenty-two, Sarah painted the first of twenty or more portraits of men in public life—*Commodore William Bainbridge* (Museum of the Constitution, Boston)—which was also the first of a few joint ventures with Anna in which they produced portraits for academy exhibitions. The two versions of Bainbridge, in miniature and in the large, were shown in Philadelphia in 1822. Each woman maintained a studio in season at the Peales' Baltimore museum, managed by their cousin Rubens.[30] Several Baltimore families— the Briens, Marriotts, and Jessops—commissioned works from each (see plates 119, 120); however, the image of "sister painters" became so onerous to both that by the mid-1820s they devised other travel arrangements. The final collaborative sittings of well-known men occurred about 1825, when both artists painted portraits of the Marquis de Lafayette and Daniel Webster (Anna's unfinished; all unlocated).

Sarah's exceptional cycle of portraits of the Jessop family extends through and beyond the years that she and Anna were close, and are handsome expositions of her technique. Charles Lavallen Jessop, a solemn child posed on his favorite rocking horse, is painted against a background of broadly painted lights and darks. At a preliminary stage, Sarah drafted and highlighted costume details, then built up the surface of the painting successively with a series of transparent glazes that tinted and blended fleshtones. This same technique lent brilliance to such detail as the glimmering medals against the dark green official uniform in her subtle portrait of the first Brazilian Chargé d'Affaires to the United States, *Jose Silvestre Rabello* (see plate 121). The portrait has been called the "only material link between the Embassy [of Brazil] and Brazil's first stirrings on the international scene as an independent

PLATE 118
Sarah Miriam Peale
Self-Portrait, c. 1818
Oil on canvas, 24 ¹⁄₁₆ x 19 in. (61.2 x 48.3 cm)
National Portrait Gallery, Smithsonian Institution, Washington, D.C.

FIGURE 8.8
Sarah Miriam Peale
Self-Portrait, 1830
Oil on canvas, 27 x 20 in. (68.6 x 50.8 cm)
The Peale Museum, Baltimore City Life Museums

PLATE 119
Sarah Miriam Peale
Charles Lavallen Jessop (Boy on a Rocking Horse), c. 1840
Oil on canvas, 35½ x 41¾ in. (90.1 x 106 cm)
Private collection

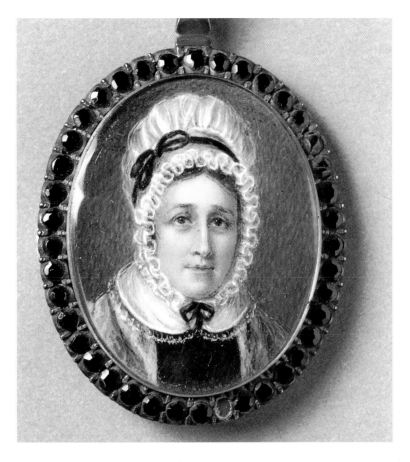

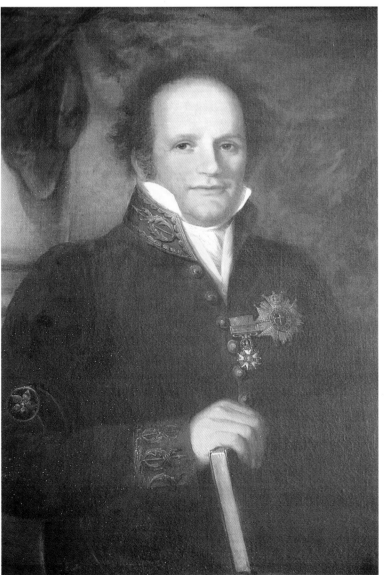

PLATE 120
Anna Claypoole Peale
Mary Gorsuch Jessop with Charles Jessop on Reverse, n.d.
Watercolor on ivory [double-sided miniature],
1 5/16 x 1 1/16 in. (3.3 x 2.7 cm)
Private collection

PLATE 121
Sarah Miriam Peale
Jose Silvestre Rabello, 1826
Oil on canvas, 27 3/4 x 35 1/8 in. (70.5 x 89.2 cm)
Brazilian Embassy Collection, Washington, D.C.

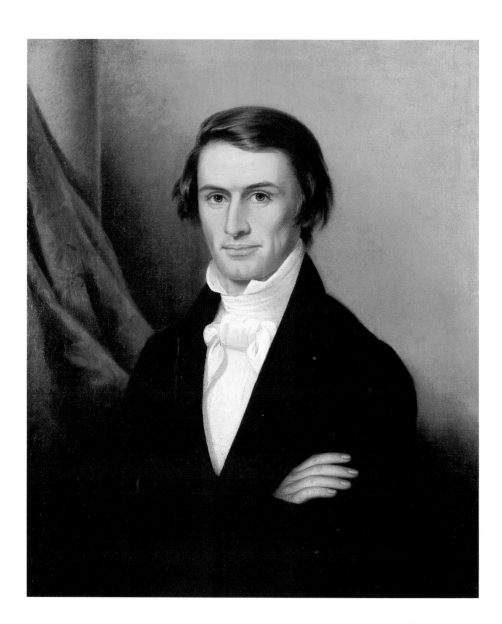

nation."[31] The ambassador's portrait was painted in 1826 at the initiation of his friend and Sarah's patron Edmund Coale, whose portrait (Maryland Historical Society, Baltimore) Sarah also painted that year.

In Washington in the early 1840s, Sarah attended sessions of Congress, adding portraits of politicians to her portfolio (plate 122), as well as soldiers, naval officers and their wives (plate 123), and diplomats. Some of these men were uncomfortable posing for a woman artist. Congressman Caleb Cushing, for instance, was stiff and ungracious at the first sitting, and Sarah sought to put him at ease with a flow of conversation while working. Cushing then responded by saying he "didn't know a woman could talk." When he looked at the portrait he commented that Sarah had made him too handsome, to which she replied, "I expect to make you a good deal handsomer." Later on, encountering Sarah quietly listening to proceedings at the House of Representatives, Cushing leaned familiarly over her chair, thereby attracting the attention of the entire Senate.[32] Sarah's interest in painting public figures was to be one of the few threads of continuity connecting her early life in the East with her later one on the western frontier.

Fatigued by overwork and enervated by the stratified, conventional society of the East, Sarah decided to leave Baltimore. It was not an impulsive decision. Sarah had tested receptivity to her work in Saint Louis as early as

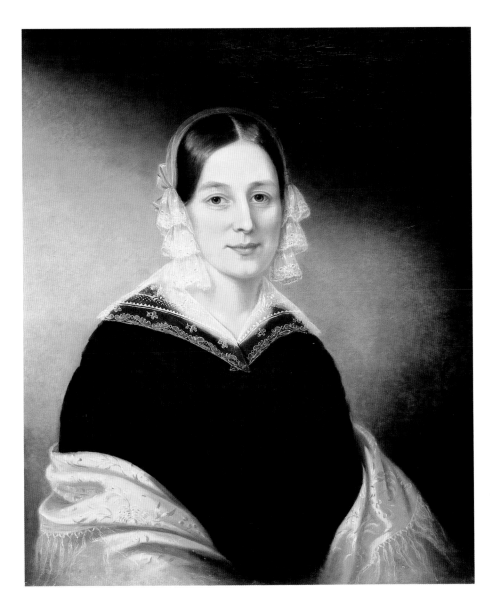

the summer of 1846, when she sent four portraits of western figures there to be shown at the Missouri Bank. On July 27, 1846, the paintings and their artist's impending arrival were noted in the Saint Louis press:

> We learn that Miss Sarah M. Peale, a grand daughter of the celebrated painter Rembrandt Peale, intends visiting our city the approaching fall, for the purpose of painting several portraits. Four specimens from the pencil of this lady are now in the Missouri bank, and they clearly prove her title to rank among the first of American artists. The portraits of T. H. Benton, Dr. L. F. Linn, and Caleb Cushing are not only finely finished paintings but are so strikingly correct in the delineation of feature that they are recognized immediately. Her portraits have indeed a living expression about them, only attainable by the highest order of artistical skill.[34]

She did not leave for St. Louis, however, until the winter of 1847; on January 4 that year, Rembrandt's second wife, Harriet Cany Peale, then visiting Philadelphia, wrote to Anna Sellers that Sarah would "soon take her departure for the West."[33]

 Linn, Cushing, and Benton were associated with contemporary Western events. Missouri Senator Lewis Fields Linn (c. 1795–1843) (figure 8.9) had

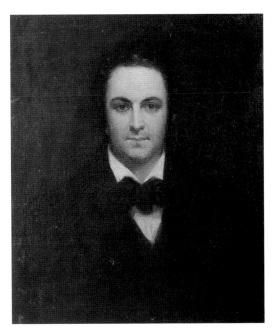

FIGURE 8.9
Sarah Miriam Peale
Senator Lewis Fields Linn
Oil on canvas
Missouri Historical Society, Saint Louis

PLATE 124
Sarah Miriam Peale
Senator Thomas Hart Benton, 1842
Oil on canvas, 30 x 25 in. (76.2 x 63.5 cm)
Missouri Historical Society, Saint Louis

been born and trained in medicine in Louisville, Kentucky; he adopted
Missouri as his home state and was an effective advocate for western territorial
interests. Sarah seems to have been impressed by Linn's gaze, which in her
portrait suggests a penetrating intelligence, emanating from a romantic like-
ness not unlike the work of her mentor, cousin Rembrandt. Caleb Cushing
(1800–1879) was a member of the House of Representatives from Massa-
chusetts when Sarah met him in Washington; in 1846 he returned from
diplomatic duties in Mexico and made an extended tour of the Northwest
territory "which he explored in every direction, sleeping in the woods and
obtaining his food by hunting and fishing."[35] The avuncular, outgoing,
and prosperous-looking Thomas Hart Benton (1782–1858) (plate 124) is
justly characterized in Sarah's portrait; his mansion on Washington Street was
as much a landmark in Saint Louis as he was—a durable, effective politician
for over thirty years. These men, sharing what Daniel Boorstin has called
the "boosterism" of the age, had doubtless encouraged Sarah in her venture,
if only by their enthusiasm for Missouri.[36] Of the three (Linn was deceased),
only Benton could conceivably have aided this endeavor through possible
sponsorship of the Missouri Bank exhibition. These positive newspaper
notices may have been decisive factors in her travel. Sarah's reception by the
town's civic and cultural leaders on her arrival associated her from the outset

with a small elite group in the community to whom she, in turn, would continue to represent the cultural values and heritage of the Northeast.

The city Sarah encountered on her arrival is described by historians as a rough frontier town, a gateway for frontiersmen en route to Washington, Oregon, and other points west at the height of the Gold Rush in 1848. The city drew artists as well as adventurers, such as the sensitive, able daguerrean Thomas Easterly (1809–1882), who, like Sarah, was born in the East, set up a temporary gallery in Saint Louis in 1847, and stayed for three decades. He described his inventory of photographs of "Distinguished Statesmen, Eminent Divines, Indian Chiefs, and Notorious Robbers and Murderers" without hyperbole.[37] In 1850, Sarah and Easterly both portrayed Father Theobald Mathew, a charismatic Irish priest associated with the temperance movement and efforts to impose order on the town's migrant and working population.

Scouts for the Mexican government and adventurers in search of land or gold also passed through town. Firearms were commonplace; citizens were distinguished from hunters or blackguards by the types of weapons they wore. A large French settlement in Carondelet was augmented by Cajun fur trappers, German immigrants, and Native Americans, recorded in Easterly's photographs and romanticized in the paintings of German-born Carl Wimar. Riverboat life and ordinary folk were captured in the paintings of George Caleb Bingham. The busy docks on the levee and stench of pelts piled on the wharf, the noise and debris of endless building as the town expanded, the keelboats and steamboats that plied the river—all were punctuated by slaughterhouses and a slave exchange.

Yet, this mixed commercial and residential area—the opulent Benton house was not far away—was the neighborhood that Sarah chose to inhabit for three decades.[38] It was similar to her childhood home in Philadelphia, and her later one in Baltimore, where she had shared quarters with her older sister Jane Ramsay Peale Simes; but the business district of Saint Louis was then sufficiently lacking in eastern amenities to intimidate all but the most adventurous. Sarah established a combined studio and residence on Fourth and Washington Avenue not far from the levee; at one time in the late 1850s, she lived on Pine Street opening onto the levee. Sarah arranged her first Saint Louis studio in Peale family fashion, utilizing the walls as an informal gallery to display copies of existing works.

Commissions came quickly. Several works in progress were observed by a local reporter who visited her studio and published a story in the Saint Louis *Republican* on January 10, 1849. He wrote: "MISS PEALE has completed or has in the course of completion, the portraits of several ladies and gentlemen of this city." Sarah brought with her several engravings by Samuel Sartain of her portrait of *Thomas Wildey, the Founder of the Order of Odd Fellows in the United States* shown "in the regalia of the Order." She advertised it as "available for purchase" from the artist or at an unidentified local shop on Market Street. She seems to have charmed the reporter who described her skills in lavish detail, and it was at this time that she may have begun her several portraits of the Owens family (private collection).

Six months later, two events shattered the lives of Saint Louisians: an epidemic of cholera and the Great Saint Louis Fire of 1849. The epidemic was unchecked and thousands of deaths were recorded in a few months' time.

The second catastrophe, the fire of 1849, destroyed approximately fifteen city blocks of property in the city's oldest area near the riverfront in Sarah's neighborhood. Instead of returning to the East, Sarah moved to a nearby address and continued to cope with the hardships of Western life. In this respect, Sarah was as determined as other newcomers who continued to pour into the town, its diverse ethnicity augmented by English, French, and German settlers.

The literary culture of the city was encouraged by the establishment of the Saint Louis Mercantile Library in 1846, a subscription library founded by local civic leaders. When Senator Thomas H. Benton died in Washington in 1858, Sarah's "faithful and spirited" portrait of Benton was loaned to the Mercantile Library.[39] Her portrait of the society's librarian, Edward Johnston (c. 1858), remains in the library's collection. Given Sarah's proximity to the library, it is likely that she attended lectures there as well.

Sarah continued to advertise in city directories as a portrait painter as late as 1872. Two fluent portraits in watercolors—*General Philip Henry Sheridan* and *General George Armstrong Custer* (National Museum of Women in the Arts, Washington, D.C.) were painted in Saint Louis, where Sheridan was stationed in 1861. A group of portraits painted in 1863 of Dr. John Shore, his wife Theodocia, and their children, Pocahantas and Harriet Shore, have remained together in a private collection, but few other figure studies or portraits have come to light from the Saint Louis period. An unidentified portrait owned by "Mrs. Mills," one of Sarah's few known patrons, was shown in the Missouri Valley Sanitary Fair of 1864 during the war. Over the years, visiting painters such as Chester Harding, local portraitist Manuel de Franca, and a growing number of photographers competed for the attention of a relatively small number of patrons.

Cultural expositions were increasingly ambitious components of annual agricultural and mechanics fairs held in Saint Louis in the late 1850s and 1860s, and became a stimulus to the arts. Sarah was an active and frequently a prize-winning artist in these expansive events, which included prizes for agricultural products, machinery, and an increasingly significant art section. Sarah's work was seen by the thousands of visitors who poured into Saint Louis. Attracted anew by still life, Sarah exhibited these in the agricultural fairs and at the Sanitary Fairs held during the Civil War. With few rivals, Sarah exhibited three still lifes and a fancy piece in the Western Academy of Art exhibition of 1860, an event that brought together loans of European paintings from private collectors and new American paintings and sculpture.[40] She continued to investigate the possibilities of still life in watercolors and oils through 1872.

Sarah responded to the West in intimate, naturalistic studies of nature, and in her late work, studies of a single botanical specimen. In the 1820s, her still lifes had been formal compositions, such as a jaggedly cut *Melon* (1825; Wadsworth Athenaeum, Hartford, Conn.), or a meticulous study of gemlike clarity, *Peaches and Grapes in a Porcelain Bowl* (see plate 113). We can only infer that her watercolor of "Fruit" or "Flowers" in the Third Annual Fair of 1858, and a painting of a sliced melon in oil on canvas, shown in 1859 at the Fourth Annual Fair, were similarly composed. The fulsome praise given in a description of the painting of a melon noted a shift to the naturalism of her

PLATE 125
Sarah Miriam Peale
Basket of Berries, c. 1860
Oil on canvas, oval, 12 x 10 in. (30.5 x 25.4 cm)
Private collection

earlier studies: "The premium article was a most exquisite painting," the *Report of the Fourth Annual Fair* indicated.

> It was the production of Miss Peale, of St. Louis, and to it was awarded the first premium, Diploma and fifteen dollars. It represented a Melon, freshly cut, and so natural—so tempting appeared its rosy heart, with the seed half-embedded, that we wondered why some of the thousands of visitors who examined it did not fall into the mistake of the birds, when they pecked the grapes of Zeuxis, and attempted to take a slice of the delicious fruit. The copy was as perfect as the prototype. The accomplished artist was happy in the selection of her subject, although the creation of her pencil was rather tantalizing to beholders.[41]

From 1858 through 1868, viewers and committees showed their appreciation of Sarah's still lifes. She won a second prize in 1858 for a fruit or flower painting in watercolors; a first prize for a sliced melon in 1859; and, in 1868, a second prize for a fruit piece in oils.

Sarah's study of raspberries in a *Basket of Berries* (see plate 125) is set in a landscape of leaves and grasses. The container for the fruit is neither precious porcelain nor silver, but a basket woven of grasses that is asymmetrically placed to the left in an outdoor composition. The raspberries escape and are heaped on the ground, redolent of earth and sunlight. Studied from several angles, the fruit evokes a Ruskinian specificity in each carefully enumerated detail. It is an implied narrative, an unusual device in Sarah's compositions. We sense the presence of an event: the act of picking the fruit and, for a moment, pausing to contemplate it.

Sarah's point of view expressed a contemporary preoccupation in American art, fostered by the activities of the English Pre-Raphaelite painters, a group much discussed in art periodicals that transmitted ideas compactly and quickly. The April 1854 issue of the *Illustrated Magazine of Art,* for example, included a seminal discussion of the English Pre-Raphaelites in the United States. Editions of works by John Ruskin, the British critic associated with the American and English Pre-Raphaelites, were readily available in the Mercantile Society Library's collections.

American Pre-Raphaelite attitudes are revealed in the titles of two works in watercolor that Sarah exhibited at the Mercantile Library in 1872— *Golden Lily of Japan* (unlocated) and *Magnolia* (unlocated). The works contrast the exotic, imported lily, as deeply colored as an oriental porcelain, with a pale magnolia, a native flower, symbolic of the grandeur of nature in the language of flowers, a language disseminated in many books known by mid-century to artists.[42] Sarah particularly liked the pale camellia or magnolia, which reappears in her work for decades, from the Baltimore through the Saint Louis years, at first as an accessory worn in the hair of *Mrs. William Jessop* (private collection), and later as a subject in its own right.

Although Sarah Miriam Peale chatted amiably to patrons and friends, she was reticent about her private life and we have no explanation or justification for her decisions. Paintings by other members of the Peale family were absent from Saint Louis exhibitions (except for a work by Rembrandt Peale from a Saint Louis collection) despite occasions to include them, as was a

Peale family custom. Furthermore, this was contrary to the way women usually presented themselves: buttressed by other well-known family members or their works. Both of these irregularities imply that Sarah had cut herself off from the family. In her maturity, the artist is enveloped in a cloak of a solitary "self-dependence." Only a late summons brought Sarah back to her sisters.[43]

Sarah had been a leading portraitist in Baltimore and continued her career in Saint Louis. A versatile painter, her incisive, sharply focused still lifes were vitally expressive and were an evolving, lifelong predilection that changed with her personal perceptions of nature. In examining Sarah's life in the West and the broad outlines of her late career in Saint Louis, much is revealed and much remains to be discovered. Sarah contributed Eastern traditions to the developing culture of the West and a substantial lexicon of portraits to American art.

Concerns of the Peale women painters reflected and transcended the limitations of their era. Margaretta insistently painted subjects drawn from the environment she knew, as did other realists. Anna was competitive in the best sense of the word, achieving esteem for artistic quality rather than status conferred by her family name. Sarah achieved what many seek, a self-determined life in art.

~

Politics, Portraits, and Charles Peale Polk

~

L I N D A C R O C K E R S I M M O N S

*T*HE ARTISTS OF THE PEALE FAMILY were as alert to the tenor and politics of their times as other contemporary artists. Various members of the family served in the military as well as in local militia companies during the Revolutionary War. Most held strong views about the course of events in the new nation and occasionally expressed their opinions in correspondence and other writings. Charles Peale Polk (1767–1822) (plate 126)—nephew of Charles Willson and James Peale, and son and second child of Robert Polk and Elizabeth Digby Peale[1]—like his uncle Charles Willson, intermingled his political and artistic life in an especially significant way.

The interrelationship of Polk's political and artistic ambitions is most clearly revealed in an examination of the events surrounding the commission and creation of the Hite and Madison family portraits and Polk's subsequent career change. Various members of the Hite-Madison family, most of whom resided in Frederick County, Virginia, in the northern end of the Shenandoah Valley, had their portraits painted in 1799 to hang with a specially commissioned portrait of Thomas Jefferson at the Hite residence, Belle Grove, today a property of the National Trust. Four of the paintings—*Isaac Hite* (see plate 127), *Colonel James Madison, Sr.* (see figure 9.2), *Eleanor Conway Madison (Mrs. Isaac) Hite* (see plate 128), and *Eleanor Rose Conway (Mrs. James) Madison, Sr.* (see figure 9.1)—have now returned to Belle Grove, the house near Middletown, Virginia, for which they were created. Magnificent portraits, they are acknowledged by scholars to be the artist's masterpieces.

The paintings present not only the physical appearances of the sitters, but, symbolically, the political positions of the male members of the family. How the paintings came to be painted and their importance to both the artist and the sitters can be partially reconstructed from the surviving records of Polk's career, the Hite-Madison family papers, and the history of the period.

Charles Peale Polk is regarded as an exceptionally fine limner or non-academic portrait painter.[2] His place in the history of American art is well established; works by him are in major museums, and appreciation of his work has grown in recent decades as his role in southern American painting has come to be recognized.

PLATE 126
Charles Peale Polk
Self-Portrait, c. 1816–20
Oil on fabric, 25 x 22 ¼ in. (63.5 x 56.5 cm)
Virginia Historical Society, Richmond, Virginia;
From Russell Hammach, descendant

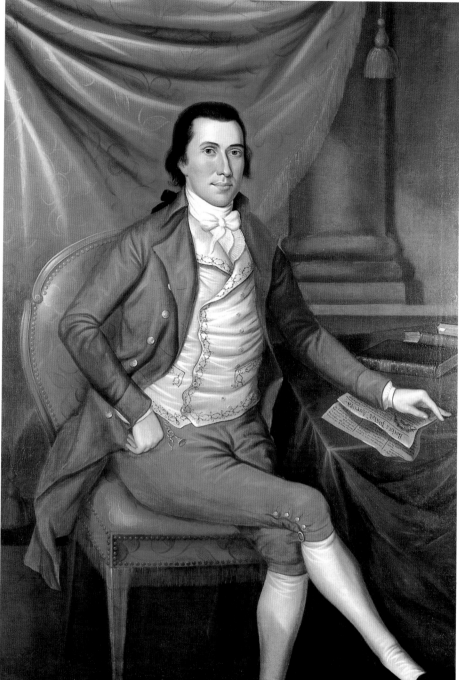

FIGURE 9.1
Charles Peale Polk
Nelly Rose Conway (Mrs. James) Madison, Sr., 1799
Oil on canvas, 59 ¾ x 40 ¹⁵/₁₆ in. (151.8 x 104.1 cm)
Belle Grove Plantation of the National Trust for
Historic Preservation

PLATE 127
Charles Peale Polk
Isaac Hite, 1799
Oil on canvas, 60 x 40 in. (152.4 x 101.6 cm)
Belle Grove Plantation of the National Trust for
Historic Preservation

Polk played an influential role as a portrait painter in western Maryland and the northwestern region of Virginia, the Shenandoah Valley. There he achieved artistic maturity and influenced the work of other limners; such as Jacob Frymire (1765/74–1822) and Frederick Kemmelmeyer (active 1788–1816), who were also active in the area.

Charles Peale Polk was orphaned at a young age and became a member of his uncle Charles's Philadelphia household. The house was filled with young Polks and Peales, but life in that home centered around the artistic interests of Charles Willson Peale. In such an environment, it was unlikely that Polk could have had any ambition other than to become a painter. Charles was, indeed, one of his uncle's first pupils and learned from Peale the rudiments of technique and style as well as the accepted conventions of portrait painting.

Trained in London in the conventions of eighteenth-century portraiture, Peale transmitted that tradition to Polk, who introduced his own modifications.

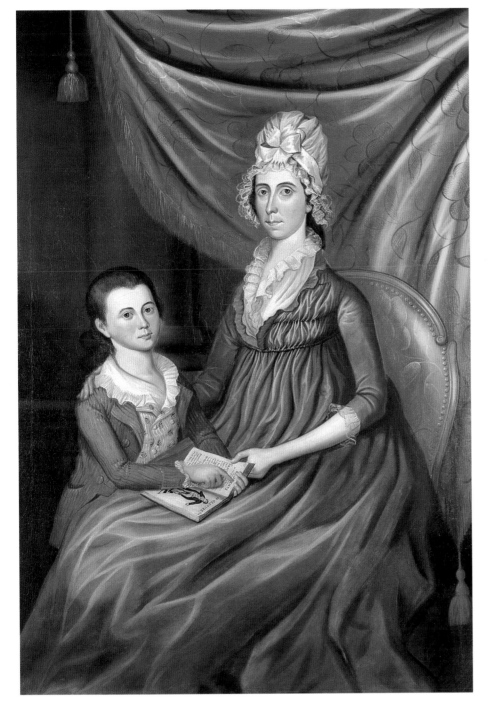

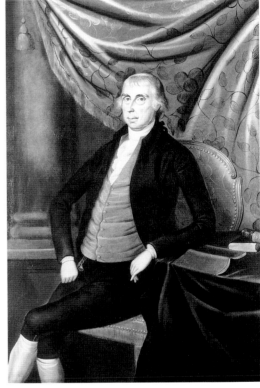

From these conventions came Polk's use of columns and other architectural elements, combined with a large draped curtain, usually fringed and tasseled, to create a fictional, theatrical setting for the portrait subject. Polk's manner of painting highlights on drapery and other fabrics became more and more pronounced; eventually the highlights assumed the shape of broadly brushed electric flashes with a life of their own quite separate from their purpose in modeling folds of cloth. This personal modification is an identifying mark of Polk's style.

Polk's work may be divided into three periods with transitional changes between them. First, his youthful paintings from 1783 to 1790, which include copies of Peale's 1782 portraits of Washington and Rochambeau as well as original compositions, are characterized by an imitation of Charles Willson Peale's style (see plate 129). Most of these works share a strong sense of organization, unity among objects, and spatial clarification. The three-

PLATE 128
Charles Peale Polk
Eleanor Conway Hite and son, James Madison Hite, 1799
Oil on canvas, 60 x 40 in. (152.4 x 101.6 cm)
Belle Grove Plantation of the National Trust for Historic Preservation

FIGURE 9.2
Charles Peale Polk
James Madison, Sr., 1799
Oil on canvas, 59 13/16 x 40 11/16 in. (152.1 x 103.2 cm)
Belle Grove Plantation of the National Trust for Historic Preservation

PLATE 129
Charles Peale Polk, in part after
C. W. Peale
George Washington, 1793–94
Oil on canvas, 36 x 29 in.
(91.4 x 73.7 cm)
Chrysler Museum, Norfolk, Virginia

FIGURE 9.3
Charles Peale Polk
Henry Knox, c. 1787–90
Oil on canvas, 23 x 19 in.
(58.4 x 48.2 cm)
National Portrait Gallery,
Smithsonian Institution,
Washington, D.C.

FIGURE 9.4
Charles Peale Polk
George Duffield
Oil on canvas
Courtesy, Independence National
Historical Park; Gift of George
Duffield, 1898

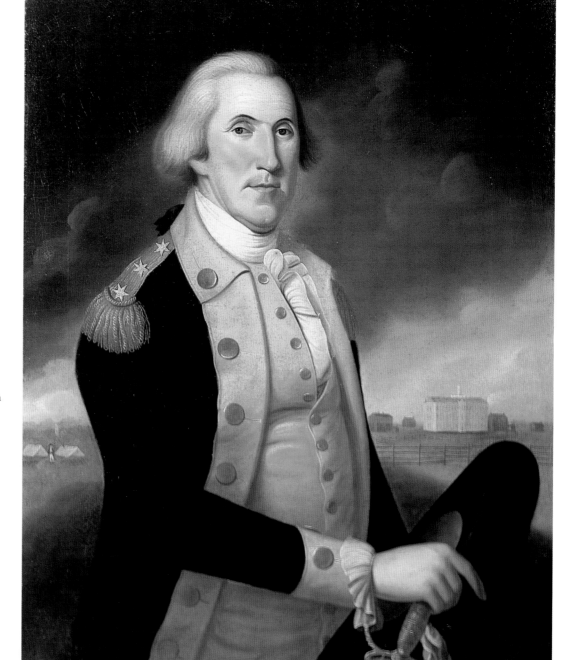

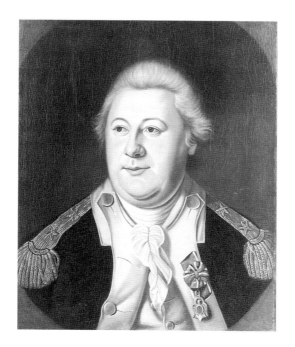

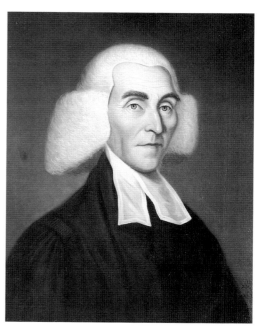

dimensional modeling of facial features in the portraits of Henry Knox (figure 9.3) and George Duffield (figure 9.4) are more conventional than the narrowly shaded outlines that characterize Polk's later paintings.

The strength of Polk's distinctive personal style emerges in both his life-size oil portraits and watercolor-on-ivory miniatures of the years 1791 to 1798. The modeling of forms becomes subordinate to draftsmanship. A pronounced interest in the decorative quality of the line is evident. All objects are presented with equal attention to detail, further enhancing the shallowness of the space and the decorative qualities of the whole. Polk's palette changed at this time from harmonious, soothing color combinations of olive green and salmon red, as appear in Charles Willson Peale's portraits, to vivid, eccentric colors of bilious greens and scarlet reds, colors frequently employed by Polk in the later 1790s. The paint is thinly applied to loosely woven canvas mounted on strainers. The figure or figures are centrally placed and usually represented three-quarter length, extending to between the waist and the knees. The shallow space occupied by the subject is often defined by a curtain or architectural elements, furniture being generally meager—a chair and a desk or table at most. All articles or props, as well as furniture and costumes, are depicted in sharp detail, with the titles of leather-bound books and the text of letters and receipts legible, and the wood grain exactly rendered (figure 9.5).

In his mature paintings, from 1799 to 1822, Polk fully realized a characteristic that had begun to emerge in the paintings of the mid-1790s—the exaggerated attenuation of the human form with the elongated parts of the human anatomy emphasized by electric highlights dancing across the fabrics. The portraits of the Hite, Madison, and White families are the most notable examples of this direction.

Charles Peale Polk married young and twice again in his lifetime. Burdened by an ever-growing family, he left Philadelphia in 1791 for Baltimore, where he resided until 1796 before moving to Frederick, Maryland. From that home base he made regular painting expeditions to Hagerstown, Maryland, in August of 1798 and to the northern end of the Shenandoah Valley during 1798 and 1799. Many portraits of this period are of members of the same family. Connections by birth and marriage among families such as the Whites, the Briscoes, and the Holmeses strongly suggest that Polk's commissions were often received through personal recommendations within extended family groups. How and when Charles Peale Polk and Isaac Hite met is not known, but in 1799 Polk came to Belle Grove some fifteen miles south of Winchester. Mrs. Hite was the sister of James Madison, who was then living at Montpelier and at the time not holding public office.

Polk painted at least seven family members, including Isaac Hite (1756–1836) and his wife, Eleanor (Nellie) Conway Madison (1760–1802), depicted with son James (1793–1850), as well as James Madison, Sr., (1721–1801) and Mrs. Madison (1739–1821). In addition, he did a portrait of two of Hite's daughters, Nellie Conway Madison (1789–?) and one of the Madisons' daughters, Frances Taylor Madison (both unlocated).

The number and size of these paintings have always amazed viewers. The portraits measure almost sixty inches high and forty inches wide.

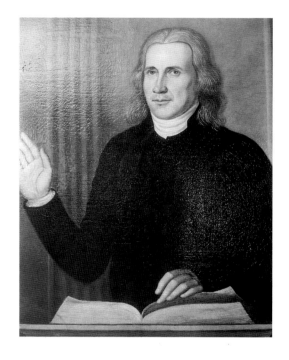

FIGURE 9.5
Charles Peale Polk
Francis Asbury, 1794
Oil on canvas, 38 x 32 in. (96.5 x 81.3 cm)
Lovely Lane Museum, Baltimore

Physically imposing, they make a strong visual impact, dominating the parlor at Belle Grove where they are hung. There is only one other work by Polk of nearly equal size.[4] Their dimensions do not appear to have been an accident, but probably resulted from discussions between artist and patron. For the artist, the commission offered an opportunity to produce life-size portraits of a family of regional importance; it was a choice commission. For Isaac Hite the portraits represented part of the fulfillment of his scheme to build and decorate an attractive, fashionable private residence.

In 1794 (five years before Polk's initial visit), Hite had sent his builder to discuss plans for "a large house" with Thomas Jefferson.[5] His brother-in-law, James Madison, Jr., the future president, had written to Jefferson requesting "any hints which may occur to you for improving the place."[6] Madison and his wife Dolley were on their honeymoon and had just visited the Hites in Frederick County when Madison drafted this letter. Isaac Hite clearly intended his home to be not only large in scale but grand in design and decoration. Surviving receipts from the next two years indicate that he had begun to furnish it in style. A brass knocker, draperies, curtains, books, alabaster figures, a chamber clock, and a silver tea service were purchased in Philadelphia.[7] The next addition to this elegant and stylish home would have to be portraits, but these required the services of a competent painter.

No discursive record has been found of Isaac Hite's artistic tastes or interests. No portraits are recorded or known of any earlier Hite family members. What could Isaac Hite have seen or known that suggested the size, number, and symbolic intent of the works he commissioned from Polk? Part of the answer to this question may be found in Hite's education and earlier life experiences while a student at William and Mary College in Williamsburg, Virginia, between 1774 and 1776.[8] Here he may have seen many portraits in private residences and public places, the most dramatic being the early life-size portraits of the king and queen—large, full-length figures, which hung, as they do today, in the Governor's Palace. William and Mary students and faculty were entertained at the Governor's Palace, and Hite must have seen this pair of portraits and others like them. As his education helped form his thoughts and develop his intellect, his visual experiences honed his understanding of artistic style and current culture. When he began to build Belle Grove, Isaac must have had not only a vision of his future home but also of the contents to fill it. Once he had decided to include paintings the subjects or sitters had to be selected. Isaac followed contemporary eighteenth-century practices by including his immediate family—wife, son, and daughter—but he added his in-laws, Colonel and Mrs. Madison and their daughter.

This group of portraits thus forms a continuum, a symbolic representation of the Hite family over time. The elder Madisons represent the past: conservative in dress, somber in expression, the root from which the trunk would grow. The Hites and Frances Madison, more fashionably dressed, are the present, representing the trunk from which would spring the branches of the future—their children. Here together and forever, Isaac and Nellie would occupy their home, achieving a type of immortality.

Probably of equal importance to Isaac Hite and to his family members was the visual depiction of their place in Shenandoah Valley society. In the

eighteenth century, portraits were not only a representation of the likenesses and costumes of the subjects, but were often intended to inform the viewer about the ideals and philosophy of the sitter. Artists must have discussed with their patrons what elements or details to include in a portrait, and certainly followed the suggestions of sitters who, after all, were paying for the process.

In this group, there is a distinct difference in content and import between the portraits of male and female sitters. Portraits of women and children contain politically neutral elements denoting their less influential role and more submissive relationship to men in society.[9] In contrast, the suffrage and political involvements of male citizens is symbolized by the objects included in portraits such as those of Colonel Madison and Isaac Hite.

Consider the image of Mrs. Madison, a matronly lady seated with an arm resting on an open volume. The clearly rendered print reveals that it is the Holy Bible open to Psalm 111. Such a song of praise would have been appropriate for a devout Christian woman and suited to the life and character of the daughter of an Episcopal bishop of Virginia. Nellie Conway Madison Hite is represented with her son James Madison Hite standing beside her. He submissively leans against his mother's knees and gestures to the open book she instructively holds.

Colonel Madison is also depicted with a book on the table beside him, but the symbolic importance of the volume is quite different from that shown with his grandson. The title, *The Rights of Man,* clearly indicates that the colonel shared not only his son James Madison's, but also his son-in-law's, patriotic views and political principles.

The Rights of Man by Thomas Paine, the first part of which was published in France in 1791, the second part in 1792, was the flashpoint of political controversy between the Federalists and the Republicans. Thomas Jefferson's preface, together with Paine's defense of certain specific measures taken in revolutionary France, incensed the Federalists, who considered it an attack on President John Adams. In *The Rights of Man,* Paine stated his view that certain rights were natural to man—equality, liberty, security of property, and resistance to oppression—and could be guaranteed only through a republican form of government. Such a government could only be maintained by a written constitution, which had to include a bill of rights assuring men's suffrage, short terms of executive officers and rotation in office, a judiciary responsive to the people, a popularly elected legislative body, and a citizenry undivided by artificial distinctions of birth, rank, religion, or financial status. This publication quickly became the center of the growing internal dispute over the relationship of the United States to France and Great Britain. Including this volume in Colonel Madison's portrait must have been intended as a declaration of the political affiliation of the sitter with Jefferson's Republican party, an affiliation artist Charles Peale Polk clearly shared.

In the portrait of Isaac Hite, symbolic representation for his views is found in the newspaper beneath his left hand. The front sheet of Benjamin Franklin Bache's *Philadelphia Aurora* is clearly visible to the viewer even though the banner headline is upside down. The *Aurora* was a Republican newspaper, the major organ of the opponents of the Federalists. Through the Alien and Sedition Acts, the Federalists had attempted to suppress opposition

to their policies. Republican Jefferson, then vice president, was a subscriber to the *Aurora* and a friend of its editors, who were charged with treasonous crimes under these acts.

The column heading of the newspaper—"Paris Oct 12," is a clear reference to the diplomatic situation that had given rise to the Alien and Sedition Acts. In the fall of 1797, President Adams had appointed a three-man commission to negotiate a treaty of commerce and amity with France. Charles Coatsworth Pinckney, Elbridge Gerry, and John Marshall arrived in Paris on October 4, and soon after met with the representatives of French foreign minister C. M. Talleyrand. The French agents, identified in American reports as X, Y, and Z, suggested that the United States lend money to France and provide for continued assistance from the foreign ministry through a personal bribe to Talleyrand. French and American relations had been strained as a result of various diplomatic maneuverings throughout the years of Franco-English warfare following the French Revolution. When the XYZ Affair became known in Congress, the information was used to swing public opinion against France. Fear of war with France and suspicion of the activities of alien supporters of that country residing in the United States led to the passage of a number of laws during the summer of 1798, including the Alien Act of June 25 and the Sedition Act of July 14. The Federalist majority in Congress used these laws to restrict the activities of citizens and European refugees, many of whom happened to be prominent supporters of Jefferson's party. Among those convicted, fined, and jailed for sedition were ten Republican newspaper editors, Benjamin Franklin Bache (1769–1798) among them.

James Madison, Jr., and his family were Republicans. Madison's reaction to the Alien and Sedition Acts came in the fall of 1798. With Thomas Jefferson, he was one of the framers of the Virginia and Kentucky Resolutions, passed by the legislatures of those states, that declared the acts unconstitutional and stated that it was the duty of the individual states in such cases to interpose their will to protect the rights of their citizens.

Isaac Hite, brother-in-law to James Madison and admirer of Thomas Jefferson, was surely aware of the political significance of the *Aurora* in current affairs, and thus was very likely making a public declaration of his own political views when he decided to include this newspaper in his portrait.

The next commission Polk received from Hite may be interpreted as a continuation of this visual statement of his political views. Sometime during the period of the execution of the Hite-Madison family portraits, Hite asked Polk to paint a portrait of Thomas Jefferson to hang at Belle Grove. Sadly, no written confirmation of the commission from Hite to Polk has been found.

Polk was probably delighted with this commission; indeed, there is the possibility that the idea for it may have originated with him, since he was politically sympathetic with the Republican party and Jefferson. While residing in Frederick, Maryland, Polk had served as the chairman of local Republican celebrations and political meetings. He had even raised money in an attempt to establish his own newspaper, soliciting funds from James Madison, but he never actually began the paper. In 1800, he returned the money to Madison, noting that it was to be delivered to Hite's home in the Valley.[10] It is not known when or how Polk met James Madison or Issac Hite. It is likely that

Polk came to Belle Grove with some sort of introduction from another patron in the Frederick County area, possibly members of the White or Briscoe families, whose portraits he had executed during 1799. When the idea for the portrait of Jefferson arose, Hite probably recruited his brother-in-law James Madison's help.

Polk arrived at Monticello in November 1799, bearing a letter from James Madison which introduced him as a "portrait Painter and a kinsman of Mr. Peale," and stating that he was visiting "Monticello with a wish to be favored with a few hours of your sitting to his pencil"[11]

The portrait was quickly finished and Polk left for Richmond, Virginia, where on November 22 and December 3 he advertised copies of the *Thomas Jefferson* (see plate 130) for sale. It was a common practice at the time for artists to produce many replicas of portraits of famous sitters, such as the presidents, for sale. Gilbert Stuart sold various versions of his "Athenaeum" portrait of George Washington. So it is not certain that the painting of Jefferson made at Monticello is the one Isaac Hite received. Today, five versions are known of this portrait, and it is difficult to determine which one Hite hung in his parlor in the year of Jefferson's election as third president of the United States. All five share the same composition, but one is clearly different from the other four. It is freshly painted, strongly brushed in the facial features, with a spark of animation usually seen in a life portrait. Jefferson's distinctive long, straight nose with its rectangular tip, his florid complexion and reddish hair, the strength of his character, and the importance of his role in the political life of the nation are all successfully captured with impressive maturity.

With the arrival of the Jefferson portrait, Hite's parlor would have been very full—presumably the effect Hite and Polk wanted to achieve. The ensemble would have graphically expressed Isaac Hite's personal political views. The image Polk produced is a highly democratic one, showing Jefferson as a man of the people, not in the trappings of royalty. The selection of Jefferson to join the Hites and Madisons in their home seems to have been intended to further accentuate the details of the other portraits, especially Isaac Hite's. Almost any politically astute visitor in the year 1800 viewing the portraits in the Hite parlor would thus have been immediately oriented to the political beliefs of the man of the house.

Although Polk continued his political activities in Frederick, his Republican sympathies seem to have antagonized other patrons in the state, and life in that town was undoubtedly not satisfying. Late in 1801, he moved his family to Washington, D.C. He sought patronage from Madison and Jefferson for a clerk's position, for which his abilities in draftsmanship seemed to render him suitable and which he felt he should receive as reward for his political efforts. Polk never fully abandoned his work as a painter, (his estate twenty years later would list art supplies) and he even began working in the medium of *verre eglomise* (see plates 131, 132), but he never again depended solely on his art to earn a living. Interestingly, the earliest surviving examples of his work in *verre eglomise* are portraits of government officials, Secretary of State James Madison and Secretary of the Treasury Albert Gallatin. Polk had used political contacts to receive a position in the federal government,

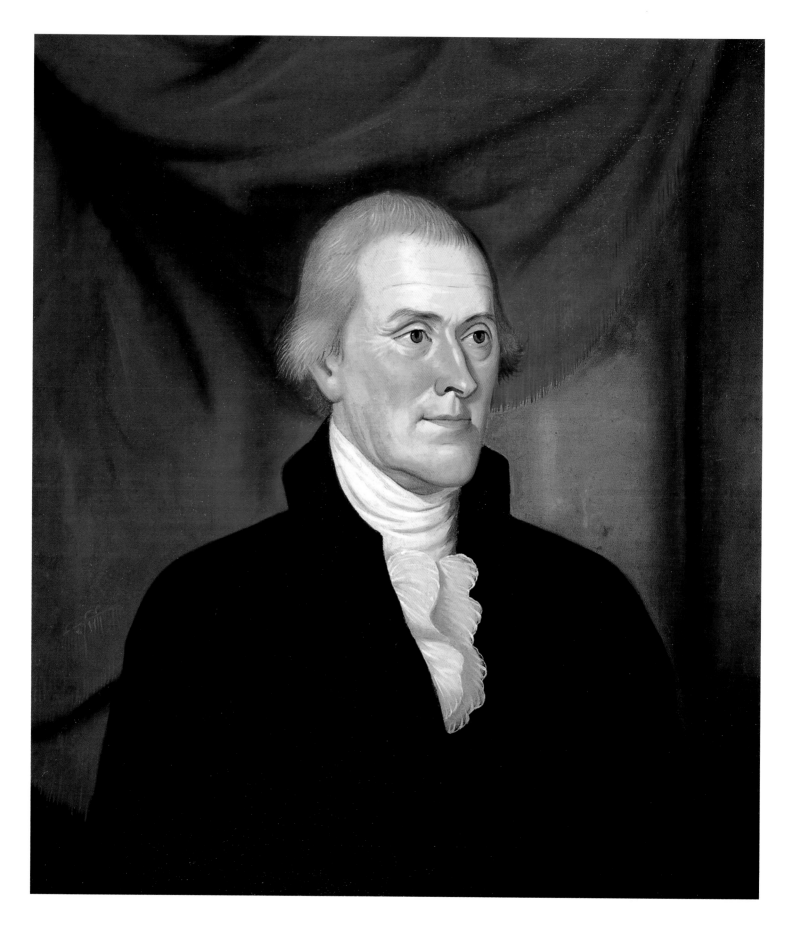

PLATE 130

Charles Peale Polk

Thomas Jefferson, 1799–1820

Oil on canvas, 27 ¼ x 24 in. (69.2 x 61 cm)

Mr. and Mrs. Robert M. Hicklin, Spartanburg,
South Carolina

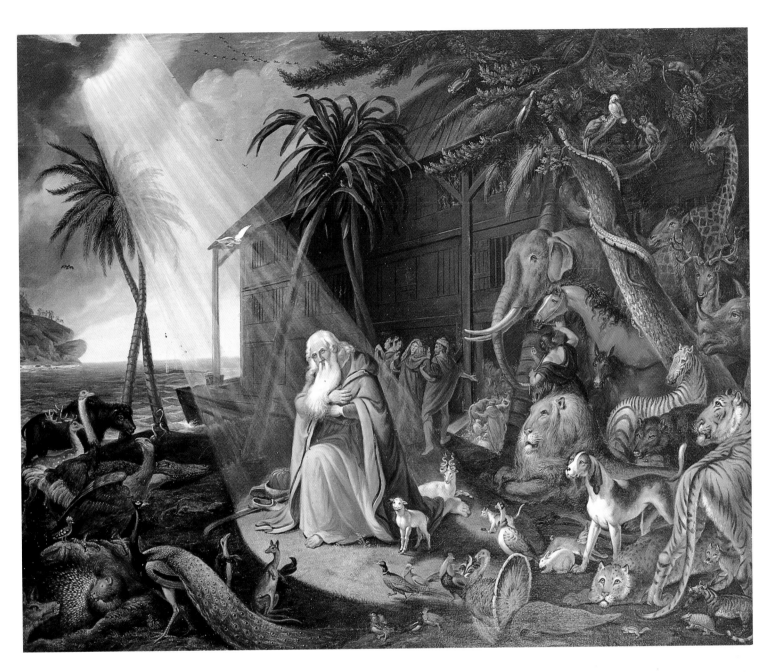

PLATE 134
Charles Willson Peale, after Charles Catton
Noah and His Ark, 1819
Oil on canvas, 40 ¼ x 50 ¼ in. (102.2 x 127.6 cm)
Pennsylvania Academy of the Fine Arts,
Philadelphia; Collections Fund Purchase

seven weeks of concentrated attention to complete—from late October to December 11, 1819. Central to the completed painting was the intact family of Noah supervising the animals' entrance into the ark. Its major feature was the careful, exact delineation of the ark's animals.

On finishing *Noah and His Ark,* Peale found he had purged war from his system. He returned to his war painting and completed the *Retreat* on February 20, 1820, but abandoned his original plan to develop the painting, which was intended as a compositional and thematic "sketch," into a large, landscape-sized canvas. Peale's decision to cut short this project indicates the triumph of peace and harmony, as depicted in *Noah and His Ark,* over war and chaos. As always fundamentally optimistic, Peale seems to have decided that the virtues of *Noah and His Ark* made a more positive statement than the negative message of *Retreat Across the Delaware.* Peale's antipodal movement from one painting to the other forms a self-revelatory commentary on the trajectory of Peale's own career.[6]

Peale "retired" from portrait painting in 1794 at least in part because his radical activities during the class warfare that marked Revolutionary Philadelphia made it difficult for him to secure postwar patrons among the city's upper classes. He also was looking for an institutional basis from which to support his family, one not dependent on the economic uncertainties of the artist's life. Whatever the proximate causes of his decision to found a museum, there was also a deep cause that followed logically from the world-view he had developed as an artisan and artist, one reflecting eighteenth-century Enlightenment and republican ideas about order, harmony, and civic virtue. For Peale, a museum would restore order to a disordered world; it would contribute, in other words, to the movement of American society from the anarchy of war to the all-inclusive, pacific structure represented by the ark. The museum marked an exponential leap in Peale's determination to order and represent both the social and the natural world. Peale's movement into a scientific career as a natural historian paralleled the expansion of his ideas of order and harmony, exemplified in his portraits, into the wider canvas of society. As Gordon Wood has written, the eighteenth century "made natural science the measure of all human truth. Natural science was neutral, value-free and objective, and as such it became the guarantor of progress and power in the West."[7]

When Peale retired from portraiture, he moved outward from the solitary career of an artist to involvement in civic life. He began a period of public activity and creativity in which he worked both to establish and improve the organizations which supported American art, science, and intellectual life. He became a mainstay of the American Philosophical Society, faithfully attending its meetings, contributing prize essays and papers, and serving as one of its officers. In the arts, Peale was instrumental in efforts—first with the abortive Columbianum (1795) and later successfully with the Pennsylvania Academy of the Fine Arts (1805)—to establish a permanent institution to improve, promote, and exhibit the work of American artists. Overshadowing all these, and a multiplicity of other activities, was Peale's most important contribution to American culture: the establishment and operation of the Philadelphia Museum. As Peale put it in his retirement announcement, he left

his artistic career because it was "his fixed determination to encrease the subjects of the Museum with all his powers, whilst life and health will admit of it." The museum would function to bring together and encapsulate all of the multifarious interests of its founder for presentation to the American public. As a young artisan, Peale had assembled watches. He now would assemble nothing less than the "world in miniature" and by doing so draw comparison between himself and the great eighteenth-century encyclopedists.[8]

In its philosophy, organization, and arrangement, Peale's Philadelphia Museum embodied the ideology of the eighteenth-century Enlightenment (figure 10.3), and demonstrated the basic tenets of its cosmology in graphic display. The Linnaean classification of species indicated the order, harmony, and regularity of nature, but also testified to man's ability to perceive nature's complexities and present them in a systematic way. The gridlike order of Peale's exhibit cases is suggestive of the effort of early nineteenth-century city planners to rationalize and order public space through the imposition of a grid pattern of city streets. Species were also exhibited as links in a Great Chain of Being which represented a static universe of ascending life forms from the simplest organism to man.[9] In Peale's conception of his museum, all of life, in its variegated but ultimately harmonious forms, would be on view. Peale had "no doubt" that his "assemblage of nature . . . when critically examined" would be "found to be a part of a great whole, combined together by unchangeable laws of infinite wisdom."[10] However, there was a tension in the seemingly authoritative organization displayed at the museum. Peale's own work in recovering and reconstructing the mastodon, essential to the history of early paleontology, undermined the older static vision that his museum espoused by raising the question of the extinction of species. While the Peales attempted to place the mastodon in existing cosmologies, they ultimately had to recognize the mutability of nature (see plate 135).

Dependent in its organization on the existing structure of scientific knowledge, the museum was, in a sense, "conservative" in its depiction of a static hierarchy of values, but in its operation the museum embodied the counter or centrifugal tendencies inherent in the new Republic's democratic revolution. While the Great Chain of Being was only just being challenged as a way of ordering nature, its hegemony as a way of ordering the political and social world had already been overthrown by the great democratic revolutions.[11] In its policies, Peale's museum was popular and democratic, reflecting the culture's and the proprietor's ideological and political views, even as his science reflected the old order. As heir to, and participant in, both the Enlightenment and the American Revolution, Peale believed that improvement in knowledge led necessarily to improvement in character and that republics could survive only with an educated and virtuous citizenry. Peale's major justification in seeking state support for his museum was predicated on the republican concept of civic virtue. In his memorial to the Pennsylvania legislature in 1795 he defined his museum as an educational institution and then pointed out what for the legislators surely would be a well-known republican formulation: "In a country where institutions all depend upon the virtue of the people, which in its turn is secured only as they are well informed, the promotion of knowledge is the First of duties."

FIGURE 10.3
Titian Ramsay Peale (over a drawing by Charles Willson Peale)
Interior of Front Room, Peale's Museum, State House, Philadelphia (The Long Room), 1822
Watercolor over graphite and ink on paper, 14 x 20 ¾ in. (35.6 x 50.8 cm)
The Detroit Institute of Arts, Founder's Society Purchase, Director's Discretionary Fund

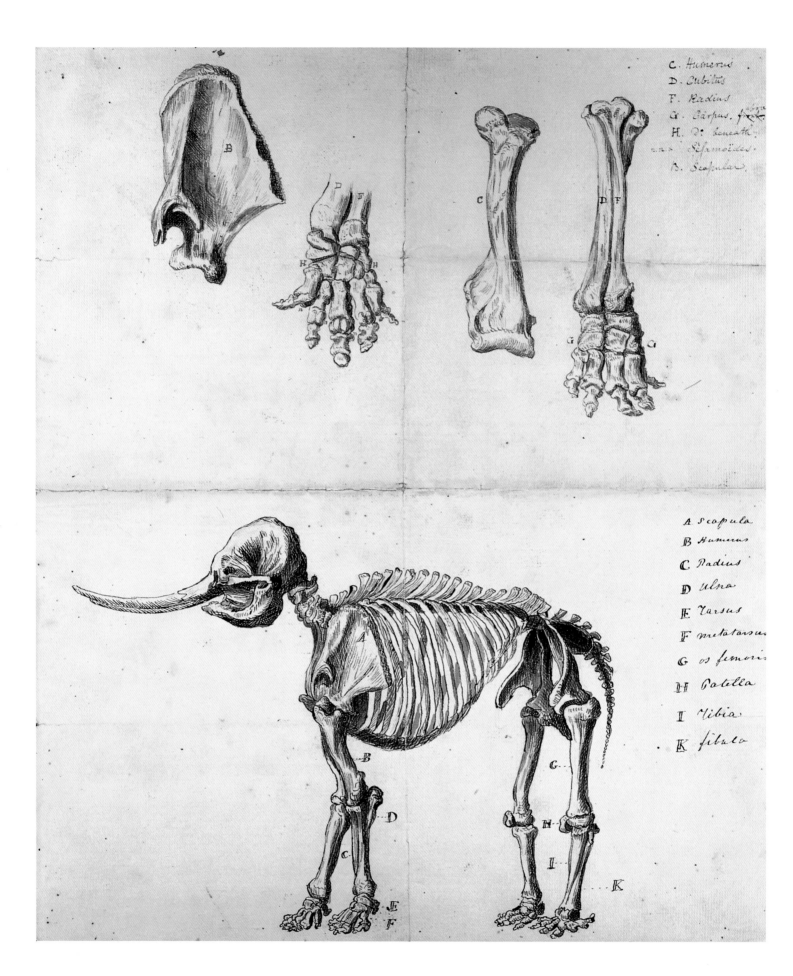

C. Humerus
D. Cubitus
F. Radius
G. Carpus f..
H. D: beneath
... Sesmoides.
B. Scapula.

A. Scapula
B. Humerus
C. Radius
D. Ulna
E. Tarsus
F. Metatarsus
G. Os femoris
H. Patella
I. Tibia
K. Fibula

PLATE 135
Rembrandt Peale
"Working Sketch of the Mastodon," 1801
Graphite on paper, 15 3/16 x 12 1/4 in.
(38.6 x 31.1 cm)
American Philosophical Society, Philadelphia

For men such as Peale the American Revolution provided the opportunity to create an intellectual and cultural renaissance, and perhaps even a secular millennium, in which ignorance and superstition would give way to reason and truth.[12]

Access to Peale's museum was open to the public with the payment of admission fees; the normal price was twenty-five cents (plate 136). Additional fees were required for special exhibits, such as the mastodon display, and events such as lectures and concerts. Peale also offered yearly and family tickets to encourage repeat visits. The museum was not a philanthropic or charitable institution: to achieve its wider cultural purpose, Peale had to receive a profit from his work. The museum was also not "free" in the sense that there was no direct charge or that attendance was unregulated or promiscuous. The price of admission, while small, did tend to exclude some social classes from Peale's audience. The very poor likely would not attend, neither would slaves, except when accompanying their masters and even then it probably was customary for servants or slaves to wait outside. There is slight evidence in surviving profile silhouettes taken of visitors that free blacks did enter the museum. While women may have had to have their admission fees paid by men, thereby reinforcing the patriarchal subordination of women, there was no discrimination by sex. As part of his efforts to center

PLATE 136
Charles Willson Peale
Museum Ticket, 1788
Mezzotint on paper, 5 ½ x 4 in. (14 x 10.2 cm)
Private collection; Courtesy of Hirschl & Adler
Galleries, Inc., New York

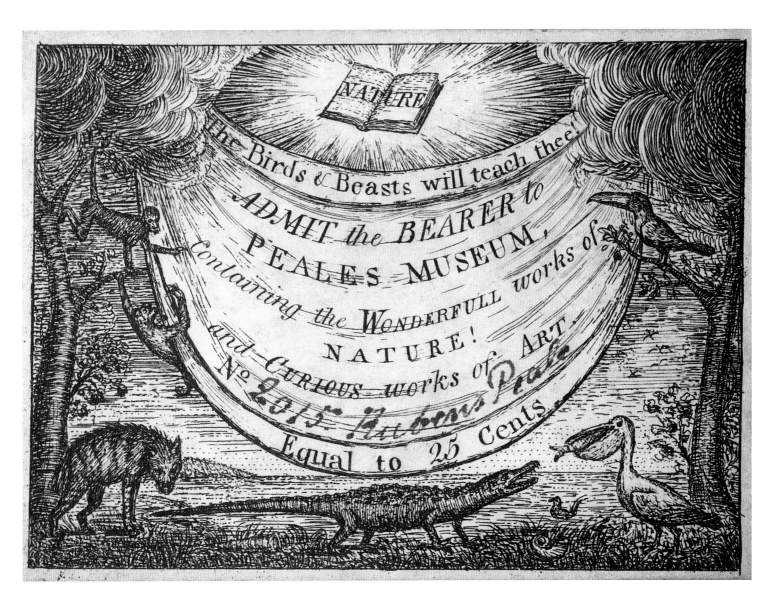

moral reform in the family, Peale was a keen advocate of the cultural and educational uplift of women. Some commentators have interpreted the astonished upraised hands of the woman in *The Artist in His Museum* as the product of Peale's gender bias: woman as representation of emotion and opposed to the rational, instructing man and his son. But *everyone* reacted with amazement to the discovery of the mastodon, at whose skeleton the woman gazes. While there may be an element of gender-typing in Peale's depiction, what needs emphasis is the very presence of a woman in Peale's audience. It is likely that the woman, man, and boy in *The Artist in His Museum* represent a family group and thus exemplify Peale's commitment to the education and acculturation which took place within the patriarchal family.[13]

By charging admission fees, Peale created some financial restrictions on attendance but the overall effect of this policy was to make the museum accessible to the public as a whole. Peale's open left-hand gesture in *The Artist in His Museum* ushered everyone in. No one was prohibited from attending Peale's museum even if economic and class realities meant that some groups would be underrepresented. By making the market relationship the basis for cultural and intellectual consumption, Peale broke decisively with restrictive European practice, based on prerogatives deriving from the absolutist state, in which participation in or attendance at cultural, scientific, and intellectual institutions was privileged. In turn, because the relationship between museum keeper and his audience was symbiotic—Peale had to respond to, even anticipate, his audience if he was to keep it—the configuration of the Philadelphia Museum contributed to the development of a vibrant popular culture in America, one that combined both professional science and popular entertainment.[14]

Peale made the contents of the museum accessible. In contrast to the private cabinets or state-run collections in Europe, at his museum the specimens and artifacts were not stored away and available only on application. They were ordered and exhibited in glass cases, habitat groups, and freestanding displays. Peale's overriding goal was to disseminate knowledge to as wide an audience as possible. Peale, his sons, and the museum workers were expert taxidermists and Peale pioneered the habitat group to display animals in realistic, three-dimensional settings. Peale noted his innovation when he wrote: "It is not the practice . . . it is said, in Europe to paint skys and landscapes in their cases of birds and other animals . . . but by showing . . . a particular view of the country from which they came, some instances of the habits may be given." While European museums used a plain white background against which to display specimens, the integration of the "open air" into the Peale Museum cabinets recapitulated Americans' confrontation with the wilderness. In creating his simulacrums of the natural world, Peale simultaneously referred the viewer outward into nature even as the habitat groups depicted nature as conquered or controlled. As such, the museum habitat groups encapsulated the dialectic between conflict and conquest that characterized America's expansion across the continent.[15]

Peale was materially and intellectually assisted in his construction of the museum's exhibitions by his son, Titian Ramsay Peale (see plate 90). The second son to be so named, Titian had replaced his predecessor (who had

died of fever in 1798) in more than name, as he assumed the earlier Titian's role of assistant to his father. Educated in the "school" of the museum, Titian became—beginning precociously in his late teens—a participant in major American exploring expeditions during the first half of the nineteenth century: to Florida in 1817–1818; as assistant naturalist on the Long Expedition to the Rocky Mountains, 1819–1820; collecting bird specimens for Charles Lucien Bonaparte in the South in 1824–1825; to Colombia, 1830–32; and finally, as naturalist on the Wilkes Expedition, 1838–1842. Titian's travels out of Philadelphia may have arisen from a degree of tension between himself and his father, as well as a desire to escape genteel Philadelphia society. But Titian's natural tendency toward autonomy was always counterbalanced by his service in his father's museum. Moreover, Titian never rejected his father's ideology or even, in a way, his artistic method. Titian collaborated with his father in the watercolor study for *The Artist in His Museum* (see figure 10.3) by making the perspective view of the museum's Long Room. Titian's work, in other words, undergirded his father's magisterial self-projection in the finished portrait, just as his fieldwork as a naturalist and artist furnished the museum with subjects and their representations (figures 10.4, 10.5).[16]

The linearity of Titian's Long Room perspective indicates his intentions and methods as an early American artist/naturalist. The grid of cabinet dioramas created an a priori ordering of nature itself, extending out into the infinity of the Western landscape; the abstract expansion into space, in other words, of Philadelphia's grid of streets. Nature was an idealistic construction. When Titian made his notebook sketches on the Long Expedition it seems likely that he arranged his views according to the format imposed by the Long Room's diorama cases. The confidence with which it was thought that nature could be mastered, wild animals turned into "specimens" and ordered according to a totalitizing schema, was also reflected in the belief that the artist/naturalist could render his subjects with absolute accuracy. In Titian's animal and ornithological artwork there is an insistence on empiricism that is not dissimilar from his father's purpose in and style of portrait painting.[17]

The diorama was also reproduced visually in Titian's illustrations for natural histories and ornithologies, such as Thomas Say's *American Entomology* (1824) and Charles Lucien Bonaparte's *American Ornithology* (vol. 1, 1824). In 1804, Charles Willson Peale had purchased a printing press for the museum's publications, advertisements, and handbills for direct appeal to the public. For visual images to complement the written word, both he and his sons showed an eagerness to learn and utilize new forms of technology, especially lithography, to reproduce images for an expanding market for books.[18]

Peale also provided written materials to supplement the visual displays of the museum. He did not assume that his audience would know about science and natural history; he posted labels and descriptions of the exhibits in order to facilitate the public's education. Patrons were not guided or shepherded through the museum. Peale probably believed that education would take place in the ordered fashion depicted in *The Artist in His Museum:* the patriarchal father, mimicking Peale's gesture of direction, instructing his son. Pedagogically, the layout of Peale's museum, and his conception of how people would use it, followed his belief in individual self-instruction made

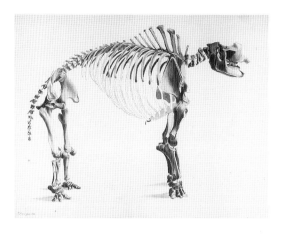

FIGURE 10.4
Titian Ramsey Peale
Mammoth, 1821
Watercolor on paper, 14½ x 19 in.
(36.8 x 48.3 cm)
American Philosophical Society, Philadelphia

FIGURE 10.5
Titian Ramsey Peale
Grey Squirrels, 1819–20
Watercolor and ink on paper, 8⅛ x 6¼ in.
(20.6 x 15.9 cm)
American Philosophical Society, Philadelphia

possible by reason and the assimilation of knowledge once it was assembled and "read." His *Guide to the Philadelphia Museum* was distributed free of charge so that visitors could educate themselves.[19]

The scholar was not neglected in the Philadelphia Museum. Peale's expert taxidermy and display of natural history specimens, all arranged in scientific and taxonomic order, were calculated to facilitate scientific observation and analysis. The museum was frequently used by science classes at the University of Pennsylvania as well as by prominent scientists, such as the ornithologist Alexander Wilson, possibly the male figure in the background of *The Artist in His Museum;* there is a similarity in the pose to the portrait of Wilson which Peale included in his *Exhumation of the Mastodon* (see plate 10). Wilson's encyclopedic entries in *American Ornithology* relied on Peale's museum to the extent that they included the reference number to their placement in the museum. Charles Lucien Bonaparte's successor volumes to Wilson's *Ornithology* similarly relied on the museum and followed the same practice. Thus the natural world became conflated with its verbal and visual representations at the museum and in the scholarship of early American natural historians.[20]

Peale's intention, besides universal education, was to make his museum a publicly supported as well as government-funded institution in a democratic state. This meant that he had to compel "the unwise as [well] as the learned to feel the importance of a well organized Museum, before . . . [he could have] any pretention or expectation of getting any aid from our Public bodies." From its inception the museum was highly popular among not only Philadelphians but all Americans and foreign visitors.[21]

One indication of the museum's national and international fame was the range and extent of the individuals who donated specimens and artifacts to it. Peale received items from local Pennsylvania artisans and farmers as well as the most eminent scientists in the United States and Europe. Geographically, donations came to the museum from the settled areas of the East Coast, the frontier regions of North and South America, the Pacific Islands, and the Orient. It was this far-flung network of donors, acting independently and voluntarily, that provided both the mundane and exotic items which made up the museum's collections. Peale was not passive in seeking such contributions. He advertised in the newspapers, sent circular letters to ship captains, and lobbied prominent individuals, including Jefferson. And while depending on gifts, Peale would occasionally purchase items for the collection. During the second decade of the nineteenth century, the museum contained (among other things) 269 paintings, 1,824 birds, 250 quadrupeds, 650 fishes, over 1,000 shells, and 313 books; according to one authority the total number of all objects was over 100,000.[22]

Evidence of the museum's popularity can also be found in its income and attendance. In the 1790s, the museum brought in revenues fluctuating from $1,172 to $3,301 a year. Income traced a continuously upward path during the first two decades of the nineteenth century, peaking at $11,924 in 1816. Rough estimates of annual attendance can be derived from the museum's receipts, since Peale depended solely on visitors for income; he received no subsidies and apparently did not accept (or was not offered) cash donations.

Although a precise figure for attendance cannot be known, from the basic admission price of twenty-five cents an estimate can be made of the number of visitors: 11,620 people in 1800, 16,862 in 1805, 33,520 in 1810, and 39,620 in 1815; 1816 may have seen 47,696 people enter the museum.[23]

Despite, or perhaps because of, the museum's popular success, Peale realized that his vision for it was beyond the capacity of any one person to realize. In 1792 he published an address "To the Citizens of the United States of America" expressing his gratitude to donors, indicating his desire to expand his collections, and admitting that his "design" was "so vast" as to be "far beyond the slender abilities of an individual." His hope was that the importance and magnitude "of the object" would attract more public support and "enable him to raise this tender plant, until it shall grow into full maturity, and become a *National Museum*." Peale's conception of the museum's contribution to the general welfare meant that state aid was imperative: it would ensure the museum's growth and prosperity as well as its continuity once he and his family were gone.[24]

Peale failed to obtain governmental backing for the Philadelphia Museum. He had based his appeals for such support in part on the traditional European practice of supporting cultural institutions. But European examples, referring as they did to the absolutist states of the early modern period, did not resonate in the new democracy, so Peale did not emphasize this parallel. Instead, he adapted eighteenth-century doctrines of political economy, in which distinctions between public and private enterprises were not strictly drawn, in order to justify state aid to his enterprise. Such doctrines allowed a blurring of these categories for activities and institutions regarded as promoting the general welfare. It was understood in post-Revolutionary America that enterprises that could be shown as eventually useful to the community, and that would not otherwise be undertaken, should be supported and encouraged by government as the guardian and promoter of the public interest. For example, projects in agriculture, manufacturing, commerce, the arts and science, and education were to be given careful consideration as promoting the public interest.[25]

Given this practice, it was reasonable that Peale should attempt to seek aid from both the state and national governments. Despite an intensive public and private campaign, however, he was unsuccessful in convincing Americans that his museum, conducted by a private citizen, was a public good. The Pennsylvania legislature rejected his appeals in the 1790s, and in 1802, when he turned to the federal government, he was rebuffed by a President Jefferson more concerned with maintaining political principle than aiding an old friend. Citing the constitutional principle of strict constructionism, Jefferson questioned "Whether Congress are authorised by the constitution to apply the public money to any but the purposes specially enumerated in the Constitution?" Bowing to political realities, Peale accepted Jefferson's judgment and the next month reopened his campaign to obtain state aid for a larger building for his museum. The Pennsylvania legislature granted Peale the free use of the vacant State House (later Independence Hall)—virtually the only state support he would receive and one for which he would continually have to lobby. In 1815 he was required to pay rent, a sum which

increased regularly and was the subject of much wrangling between the Peales and the state and, later, the city of Philadelphia. Ultimately, the rent became so onerous that Peale decided to move the museum to the Arcade, breaking the minimal connection that the institution had with the civic government.[26]

Peale never realized his dream to make his museum a public institution. He would not relinquish personal control and continued to operate it as a for-profit venture for himself and his family. At the onset of the Jacksonian era, Peale's argument that the universal goals of his museum deserved public support could not persuade a society sharpening its ideology of possessive individualism. Peale's universal vision, representative of the world of the eighteenth century, and his effort to meld private action and public good, could not succeed in a political economy which was busy trying to dismantle corporatist monopolies and privileges.[27]

When Charles Willson Peale decided to move the museum into the Arcade Building, the institution was organized as a joint-stock company, with Peale the only stockholder. Peale's status as sole owner expressed his absolute determination to hold the museum as a legacy for his children. From the outset the Philadelphia Museum was a family operation. While Peale did hire workers, the Peale sons, with the additional assistance on a less systematic basis of other family members, provided the core of managers and workers. There is a certain irony that, while Charles Willson Peale is well known for naming his first cohort of children after artists, it was as museum workers and proprietors that his sons Rubens, Rembrandt, both Titians, and occasionally Raphaelle worked. If the Peale children followed their father's career, it was as museum keepers as much as artists. Not only did the Peale sons help maintain the Philadelphia Museum, they branched out to found similar institutions in Baltimore and New York city.[28]

From 1810 to 1820, having retired to his farm, Belfield, in the rural suburbs of Philadelphia, Charles Willson Peale entrusted day-to-day control of the Philadelphia Museum to his son Rubens. Rubens managed the museum until 1821, paying his father an annual fee of four thousand dollars. In 1814, Rembrandt Peale, chafing at Philadelphia's rejection of his art and art gallery —the Apollodorian—founded a museum in Baltimore against his father's advice. Rembrandt ran the Baltimore Museum (housed in the first building ever constructed in America as a museum) until 1822. At that time Charles Willson Peale moved back to Philadelphia, taking charge of the Philadelphia Museum and displacing Rubens, who moved to Baltimore. Beset by financial and management problems, the Peale brothers divested themselves of the Baltimore Museum by the mid-1820s and Rubens moved to New York City, founding his museum in the Parthenon Building there in 1825. In his last years, Peale was assisted by Franklin Peale and the second Titian Ramsay, who managed the move to the Arcade after their father's death.

In their collections and exhibitions, Peale's sons' museums followed the lead of the Philadelphia Museum, frequently utilizing duplicate and excess items from the storerooms of the parent museum for their own exhibitions (figures 10.6, 10.7). The Baltimore Museum, for instance, held the second of the two reconstructed skeletons of the mastodon and it, like its counterpart in Philadelphia, was displayed in the museum's "Long Room." The sons'

different styles of management from their father's, however, indicate the changing status of museums and cultural institutions by the second decade of the nineteenth century.[29]

When Rembrandt founded the Baltimore Museum, he departed from his father's Philadelphia Museum by combining Charles Willson Peale's didacticism with a responsiveness to public taste for entertainment and cultural uplift. Both his and Rubens's management of their museums was less authoritative than their father's. However, while they desired to appear innovative, they were as much acted upon as actors in the creation of a new style of museum, one which coexisted uneasily with an audience whose tastes were changing. Their tenure as museum keepers was directly affected by the necessity to adapt both economically and culturally to the market forces which drove the expansion of American society from around 1820 on. While Charles Willson Peale maintained his control as the sole proprietor of the Philadelphia Museum, his sons encountered the problem of reconciling the intellectual and educational aspects of museum proprietorship with the necessity to turn a profit, both to remain in business and to satisfy stockholders. Rembrandt's Baltimore Museum was founded in consortium with a group of stockholders representative of the city's landed gentry and mercantile interests, including such prominent business and civic leaders as Robert Gilmor, Jr., and Henry Robinson. As the first generation of upper-class citizens who used their participation in cultural activities and institutions to construct a self-image as something more than money counters, they perceived their institution as a culturally valuable civic adornment, but one that had a practical utility for the city and themselves.[30]

The Baltimore Museum's history was marked almost from its inception by difficulties between the institution's stockholders and the Peales over finances. Initial cost overruns incurred for the construction of the building and the institution's inability to pay dividends to its investors led to increasingly acrimonious disputes between management, the board, and the stockholders. These influenced Rembrandt to quit the museum and made Rubens's tenure in Baltimore short and unhappy. Rembrandt commented bitterly on the corrupting impact of money and the market on cultural institutions, blaming the failure of the Baltimore Museum on "the GOD of this country—Money" and the "sordid calculations of shortsighted commercial avarice." Rembrandt's indictment of American values, while in part self-serving, also reflected dissatisfaction with his and the country's attempts to find an institutional basis for high cultural aspirations.[31]

In their programs, the Peale children also adapted to changing conditions. For example, Rubens Peale at the Baltimore Museum inaugurated a series of art exhibitions at which owners of artworks were invited to display their collections. This reflected the new focus on the collector and marked a reorientation of museum programs to integrate the social and cultural ambitions of the audience into public displays. While Charles Willson Peale or Rembrandt Peale at his Apollodorian gallery exhibited their own paintings, Rubens involved his audience by using the museum to display the collectors' artistic tastes as well as their social or material achievements. Rubens's exhibitions, by shifting the emphasis from the art producer to the art consumer,

FIGURE 10.6
Rembrandt Peale (attr.)
Man in a Feathered Helmet, c. 1805–13
Oil on canvas, 30 ¼ x 25 ¼ in. (76.8 x 64.1 cm)
Bernice Pauahi Bishop Museum, Honolulu, Hawaii

FIGURE 10.7
Feather Helmet of Hawaii
Feathers and hemp
Peabody Museum, Harvard University, Cambridge, Massachusetts

were an early indicator of later developments, in which the activities of the wealthy patron were celebrated.[32]

The Baltimore and New York Museums also responded to consumer demand by tapping the floating population of traveling exhibitors and entertainers, the popular culture of the streets. These entrepreneurs, about whom we unfortunately know little, were hired by the Peales as special attractions to supplement the museums' permanent collection. The incorporation of these freelancers into the museums' programs legitimized their activities by associating them with established, respected institutions. The Peales, however, acted as arbiters of taste in discriminating among the acts and entertainers. For instance, while agreeing to the display of a rhinoceros and an Egyptian mummy, Rubens decided against exhibiting some unfortunate "Esquimaux" as too exploitative of those indigenous people.[33]

Rembrandt's advertisement describing the Baltimore Museum as "an elegant rendezvous for taste, curiosity and leisure" indicated a shift from the didacticism of his father's museum to an emphasis on consumers' desires for stylish and amusing leisure activities. Similarly, Rubens Peale's decision in the 1820s to adopt a hairpiece to cover his balding Peale family pate was a small but nonetheless significant act, indicative of a changing American culture. In place of his father's republican simplicity, Rubens adapted and embellished his image to enhance the attractiveness of his own persona and, by extension, his museum; instead of internal character, the emphasis shifted to appearance and self-projection. So, elaborate hairstyles for men, including hairpieces and wigs as well as beards and mustaches, made a comeback in the 1820s, replacing the cropped republican severity of the Revolutionary generation.[34]

The New York Museum in particular had to confront the multiplicity of high and popular entertainments that flourished in America's most cosmopolitan city. John Vanderlyn's panorama *The Palace and Garden of Versailles* (1816–1819; Metropolitan Museum of Art, New York), Peter Stollenwerck's clockwork *Panorama of New York City* (1815), and existing museums, such as Scudder's, as well as the theater and the opera house—to say nothing of the theater of the street—all demonstrated the public's appetite for amusement, as well as the stiffness of the competition faced by Peale's New York Museum. As one of many, Rubens had to adapt the museum programs to public taste by offering such attractions as a "commodious lecture room, where there are frequent exhibitions of popular and striking experiments, accompanied by short and amusing explanations." The highlighting of "short and amusing" indicates an important shift from early museum practice in which, for example, Rembrandt Peale's entire *Disquisition on the Mammoth* (1803), each of its ninety-one pages framed separately, accompanied the display of the mastodon skeleton for the instruction of museum visitors. By the late 1820s, this confident expression of academic hieraticism, in which the focus was on the museum keeper, had reversed into a concern for the consumer of culture. In some ways this reorientation toward the individual was reflective of the self-assertion (and yet also the uncertainties) of the restructuring of American politics under Jacksonian democracy.[35]

As hierarchical structure, such as the established party system in politics, broke down, the emphasis in the museum world, as in the culture

generally, was increasingly on sensation, novelty, and subjectivity. While elites may have deplored this cultural devolution, any attempt at cultural control was illusory at best. New York's culture was too polyglot and multifarious for any single group to stamp its control over the cultural scene. Individual cultural entrepreneurs, including Rembrandt Peale with his traveling exhibition of *Court of Death,* expanded the terrain in a way that effectively ignored the claim-staking efforts of elite institutions. [36]

However, this receptivity or accommodation to popular taste threatened the unified vision and educational mission on which the Peale museums were founded. Charles Willson Peale, in particular, had been especially worried that his commitment to "useful knowledge" not devolve into sensationalism. While the Peales managed to balance their presentation of the permanent collection with popular attractions, the use of freelance exhibitors marked the beginnings of America's bifurcation between high, even elite, culture and popular, or low, culture. The sale of the Philadelphia Museum's collection to the flamboyant showman P. T. Barnum is emblematic of how these tensions split American culture into two camps. Ultimately, the encapsulating world of the Peale museums would be reconstituted in the Smithsonian Institution (founded in 1846) as part of the "sacralization" of American high culture. So long as knowledge and its visual organization in the museum continued to be hieratic, this trickle-down approach remained viable as an expression of national culture. However, the absence of any link between the museum and its audience came to pose considerable curatorial problems in a culture ever responsive to popular opinion. As museum keepers attempt to formulate an intellectual position and justification for the museum in the late twentieth century, they could do well to remember the Peale museums' fusion of high and popular culture, a fusion which did much to construct and enrich the democratic culture of the nation's formative years. [37]

Short Titles and Abbreviations

A(TS): The MS. Autobiography of Charles Willson Peale, 1826–27, transcribed by Horace Wells Sellers, Peale-Sellers Papers, American Philosophical Society, Philadelphia. F:IIC.

CWP: Charles Coleman Sellers, *Charles Willson Peale* (New York: Scribner's, 1969).

F: Microfiche edition, Lillian B. Miller, ed., *The Collected Papers of Charles Willson Peale and His Family* (Millwood, New York: Kraus Microform, 1980). This notation includes a series designation, followed by card number, row letter, and frame number(s).

Miller, *In Pursuit of Fame:* Lillian B. Miller, *In Pursuit of Fame: Rembrandt Peale, 1778–1860* (Seattle: University of Washington Press, 1992).

New Perspectives. Lillian B. Miller and David C. Ward, eds., *New Perspectives on Charles Willson Peale: A 250th Birthday Celebration* (Pittsburgh: University of Pittsburgh Press, 1991).

NUC. Library of Congress and American Library Association, *The National Union Catalog* (London and Chicago, 1968—).

OED. The Oxford English Dictionary. Second Edition. Prepared by J. A. Simpson and Edmund S. C. Weiner (Oxford, Engl. and New York: Oxford University Press).

P&M. Charles Coleman Sellers, *Portraits and Miniatures by Charles Willson Peale,* Transactions of the American Philosophical Society, n.s. vol. 42, pt. 1. (Philadelphia, 1952).

P&M Suppl. Charles Coleman Sellers, *Charles Willson Peale with Patron and Populace: A Supplement to* Portraits and Miniatures by Charles Willson Peale, *with a Survey of His Work in Other Genres.* Transactions of the American Philosophical Society, n.s. vol. 59. pt. 3 (Philadelphia, 1969).

P–S. Peale–Sellers Papers, American Philosophical Society, Philadelphia.

Selected Papers, 1: Lillian B. Miller, Sidney Hart, and Toby A. Appel, eds., *The Selected Papers of Charles Willson Peale and His Family,* vol. 1. *Charles Willson Peale: The Artist in Revolutionary America, 1735–1791* (New Haven: Yale University Press, 1983).

Selected Papers, 2: Lillian B. Miller, Sidney Hart, and David C. Ward, eds., *The Selected Papers of Charles Willson Peale and His Family.* vol. 2. *Charles Willson Peale: The Artist as Museum Keeper, 1791–1810* (New Haven: Yale University Press, 1988).

Selected Papers, 3: Lillian B. Miller, Sidney Hart, David C. Ward, and Rose Emerick, eds., *The Selected Papers of Charles Willson Peale and His Family.* vol. 3. *The Belfield Farm Years, 1810–1820* (New Haven: Yale University Press, 1991).

Selected Papers, 4: Lillian B. Miller, Sidney Hart, David C. Ward, and Leslie Reinhardt, eds., *The Selected Papers of Charles Willson Peale and His Family,* vol. 4. *Charles Willson Peale: His Last Years, 1820–1827* (New Haven: 1996).

ACP: Anna Claypoole Peale (1791–1878)
APR: Angelica Peale Robinson (1775–1853)
BFP: Benjamin Franklin Peale (1795–1870)
CPP: Charles Peale Polk (1767–1822)
CWP: Charles Willson Peale (1741–1827)
JP: James Peale (1749–1831)
PHi: Historical Society of Pennsylvania, Philadelphia
RaP: Raphaelle Peale (1774–1825)
ReP: Rembrandt Peale (1778–1860)
RuP: Rubens Peale (1784–1865)
SMP: Sarah Miriam Peale (1800–85)
TRP [1]: Titian Ramsay Peale (1780–98)
TRP [2]: Titian Ramsay Peale (1799–1885)

Notes

PART 1:

The Peales and Their Legacy, 1735–1885

LILLIAN B. MILLER

1. A(TS): 37. Original spelling has been maintained.
2. On April 20, 1771, CWP wrote to Benjamin West that "the Youngest [of his brothers, James] will be a painter, he coppys very well, and has painted a little from life" (P-S, in *Selected Papers*, 1:95).
3. For the obligation felt by eighteenth-century parents to "launch" their children, see Jan Lewis, "Domestic Tranquillity and the Management of Emotion among the Gentry of Pre-Revolutionary Virginia," *William and Mary Quarterly* 39, no. 1 (January 1982): 135–49; especially 137–39.
4. When Charles Peale died, his total estate after deductions for repayment of debts and funeral expenses amounted to between £101.6.4 and £139.19.3. These amounts included personal property. See Charles Peale, Inventories, 48/369–70, Maryland Historical Records Office, Annapolis, in *Selected Papers*, 1:30–31.
5. A(TS): 5. For quote, see John Thomas Scharf, *History of Maryland*, vol. 2 (1879; reprint, Hatboro, Pa.: Tradition Press, 1967): p. 27.
6. A(TS): 16.
7. A(TS): 8.
8. See A(TS): 10–12.
9. See Lance Lee Humphries, "Rachel Brewer's Husband, Charles Willson Peale: The Artist in Eighteenth-Century Maryland Society" (master's thesis, Department of Art History, University of Virginia, 1993), esp. pp. 11–33, for a detailed genealogy of the Brewer family and their relations.
10. A(TS): 15, 18. For Hesselius's influence on CWP, see CWP's portrait of Joshua Carter, painted in Newburyport, Massachusetts, in 1765 (*P&M*, p. 51).
11. A(TS): 23.
12. A(TS): 13. For Copley's influence on CWP, see portraits of James and Tabitha Arbuckle (1766, private collection), in *P&M*, pp. 25–26. Also see Jules David Prown, "Charles Willson Peale in London," in *New Perspectives*, pp. 29–32.
13. See Whitfield J. Bell, Jr., "Science and Humanity in Philadelphia, 1775–1790." (Ph.D. diss., University of Pennsylvania, 1947), pp. 3–9; quotation, p. 4.

14. Entry for August 9, 1776, Diary 2, P-S, in *Selected Papers*, 1:192.
15. For TRP (1), see below, p. 37; for "moving pictures," see *Selected Papers*, 1:428–37; for mezzotints, see Wendy Wick Reaves, "*His Excellency Genl. Washington*: Charles Willson Peale's Long-Lost Mezzotint Discovered," *American Art Journal* 24, nos. 1 & 2 (1992): 44–59, esp. 45–47; for portraits painted between 1784 and 1791, see *Selected Papers*, 1:634–42. During the years 1788–91, CWP's portraiture reached the height of its colonial expression.
16. For discussion of CWP's discovery and the paleontological debate involved, see *Selected Papers*, 2:308–13.
17. CWP to George Walton, January 15, 1793, P-S, in F:IIA/17F13–14.
18. George Escol Sellers (1808–1899), Raphaelle's nephew, in his "Reminiscences"—letters written to his nephew Coleman Sellers—wrote that "Uncle Raphael . . . was in reality the most talented of Grandpa's sons and it was the Revolution that made him the wreck he was" (MS. January 21, 1897, P-S.)
19. See Miller, *In Pursuit of Fame* pp. 20–22.
20. Ibid., pp. 28–29.
21. See *Selected Papers*, 2:105.
22. Miller, *In Pursuit of Fame*, pp. 36–39.
23. *Federal Gazette and Baltimore Daily Advertiser*, advertisement, October 15, 1796; *An Historical Catalogue of Peales' Collection of Paintings* (Philadelphia, 1795), in F:XIA/2C10–E1.
24. For ReP and RuP in England, see *Selected Papers*, 2:419, 454–64, 485–87, 584–86, 588–90.
25. Between 1799 and 1810, Patty gave birth to eight babies, seven of whom lived to maturity.
26. For a discussion of the cause of RaP's various illnesses, see Lillian B. Miller, "Father and Son: The Relationship of Charles Willson Peale and Raphaelle Peale," *The American Art Journal* 25, nos. 1 and 2 (1993): 4–61.
27. See Nicolai Cikovsky, Jr., *Raphaelle Peale Still Lifes* (Washington, D.C.: National Gallery of Art, 1988), pp. 101, 121–23.
28. Miller, "Father and Son," pp. 24–26, 27–28.
29. CWP to William and Elizabeth Peale Patterson, February 8, 1826, P-S, in *Selected Papers*, 4:508–10.
30. See Carol E. Hevner, "Lessons from a Dutiful Son," *New Perspectives*, pp. 103–18.

31. For a discussion of this short-lived venture, see Miller, *In Pursuit of Fame*, pp. 108–9; for quote, see Benjamin West to CWP, September 19, 1809, P-S, in *Selected Papers*, 2:1218–22, quote p. 1222; essay 4, below.
32. For a discussion of the Baltimore Museum's financial difficulties, see Miller, *In Pursuit of Fame*, pp. 126–27. Also see essay 10, below.
33. See Lillian B. Miller, *Patrons and Patriotism: The Encouragement of the Fine Arts in the United States, 1790–1860* (Chicago: University of Chicago Press, 1966, 1972), p. 114.
34. See essay 6, below.
35. Thomas Say, *American Entomology, or Descriptions of the Insects of North America*, 3 vols. (Philadelphia: Samuel Augustus Mitchell, 1824–28); Charles Lucien Bonaparte, *American Ornithology; or the Natural History of Birds Inhabiting the United States of America, not given by Wilson*, 4 vols. (Philadelphia: Carey, Lea, & Carey, 1825–33). Also see Jessie Poesch, *Titian Ramsay Peale, 1799–1885, and His Journals of the Wilkes Expedition* (Philadelphia: American Philosophical Society, 1961), p. 46.
36. See Miller, *In Pursuit of Fame*, pp. 191–206.
37. For ReP's last years, see Miller, *In Pursuit of Fame*, pp. 225–44.
38. See essay 5, below; also see Charles Coleman Sellers, *Mr. Peale's Museum: Charles Willson Peale and the First Popular Museum of Natural Science and Art* (New York: W. W. Norton, 1980), p. 304–305.
39. From October 1824 to April 1825, TRP traveled in Florida collecting specimens for the museum; in 1829 he went on a collecting trip to Maine, concentrating on Indian artifacts; and from the fall of 1830 to the spring of 1832, he traveled in South America. For details of his activities from 1822 to 1838, see Poesch, *Titian Ramsay Peale*, pp. 42–65.
40. TRP to Joseph Henry, October 5, 1859, P-S, F:VIIIA/13D4–8.
41. TRP's copies of CWP's letters are in the Manuscript Collection of the Morristown National Historical Park, New Jersey. His biography of CWP may be consulted on microfilm at the American Philosophical Society Library Manuscript Collection, Philadelphia.
42. See F:IXB/cards 1 and 2 for guitar compositions. For publications of BFP, see F:IXB/cards 8–13. For unpublished "Report" of his "Visit to Europe in the Mint Service" (1835),

see F:IXB/cards 3–8. *For Specimens of the Stone Age....,* see F:IXB, cards 14–19.

43. For a summary of the Peale collections either dispersed or destroyed, see Sellers, *Mr. Peale's Museum,* pp. 314–30. Also see p. 331.

44. For the relationship between Victorianism and the Enlightenment, see Daniel Walker Howe, "American Victorianism as a Culture," *American Quarterly* 27, no. 5 (December 1975): 507–321; Walter E. Houghton, *The Victorian Frame of Mind, 1830–1870* (New Haven and London: Yale University Press, 1957).

45. See Martin Postle, "The Golden Age, 1760–1790," in Roy Strong, ed., *The British Portrait, 1660–1960* (London: Antique Collectors' Club, 1991), pp. 185–242; Ellis Waterhouse, *Reynolds* (London: Phaidon Press Ltd., 1973), p. 23. According to Postle (p. 223), Reynolds's technique manifested serious flaws during the 1760s, the years that found CWP in London. Especially did Reynolds suffer from the use of a "faulty red" that faded and an unstable yellow pigment, along with "incompatible mixtures of oils and varnishes, water, gums, and beaten egg white." CWP also confronted similar color problems in his early paintings and had to retouch them at a later time. See *Selected Papers,* 1:592.

46. For the relationship between family and portraiture in eighteenth-century Britain, see Andrew Moore with Charlotte Crawley, *Family & Friends. A Regional Survey of British Portraiture* (London: HMSO Publications, 1992), pp. 31–38, 115; Kenneth Garlick, "Ancestral Piety," in *The British Face. A View of Portraiture, 1625–1850* (London: P & D Colnaghi & Co. Ltd., 1986), pp. 11–16; David Manning, "Portraiture and Social Class," in ibid., pp. 17–19. For Chesapeake gentry ideas about family harmony, see Daniel Blake Smith, *Inside the Great House: Planter Life in Eighteenth-Century Chesapeake Society* (Ithaca, N.Y.: Cornell University Press, 1980), pp. 22, 23, 291, and passim.; for the conversation piece, see Alice Winchester, "English Conversation Pieces from the Mellon Collection," *Antiques* 83 (April, 1963): 444.

47. For analysis of the Laming portrait, see Ellen G. Miles and Leslie Reinhardt, "'Art Conceal'd': Peale's Double Portrait of Benjamin and Eleanor Ridgely Laming," *Art Bulletin,* 78, no.1 (March 1996): 56–74 Miles and Reinhardt point out that CWP may have composed his painting not only from the description given in a translation of Tasso's epic *The Delivery of Jerusalem* (Dublin, 1761), but also from his memory of West's *Rinaldo and Armida* (1766; Jane Voorhees Zimmerli Art Museum, Rutgers University, New Brunswick, New Jersey), which, in turn, was influenced by Domenichino's 1620 interpretation of the story. Prints of other English artists' treatment of the story were also available to him.

For the *Edward Lloyd Family* and the *Cadwalader Family,* see Karol A. Schmiegel, "'Encouragement Exceeding Expectation': The Lloyd-Cadwalader Patronage of Charles Willson Peale," *New Perspectives,* pp. 51–72, esp. p. 62.

48. *Letters and Papers of John Singleton Copley and Henry Pelham, 1739–1776* (Boston: The Massachusetts Historical Society, 1914), p. 65. For discussion of the self portrait in Great Britain, see Ruthann McNamara, "The Theme of the Learned Painter in Eighteenth-Century British Self-Portraiture," Ph.D. diss., Bryn Mawr College, 1983. Hogarth, West, and Reynolds sought to provide a new definition for portraiture specifically, since in England at the time portraiture was regarded as an inferior art that demanded only mechanical skill. Because history painting required a wide range of knowledge in an extensive number of subjects, it was assumed to dignify the artist and elevate him to an equal status with the poet ("ut pictura poesis"). To raise portrait painting to the status of history, Jonathan Richardson argued early in the century that the portrait was "a sort of general history of the life of the person it represents." The good portraitist, he asserted, like the history painter, had to acquire extensive knowledge to convey that history adequately, and when he did, he elevated not only his work, but also his social position. The portrait painter, Richardson wrote, must "Think as a Gentleman, and a Man of Sense," since his business was "chiefly with People of Condition"; otherwise, it would be "impossible to give such their True and Proper Resemblances" (*An Essay on the Theory of Painting* [1715, 1725; reprint, Menston, Eng;: Scolar Press, 1971], p. 22).

In his later *Discourses on Art* (1769–91), Sir Joshua Reynolds underlined Richardson's argument that the artistic profession was ennobled by "intellectual dignity" and served valuable social and civic purposes, and he urged the artist to "nourish" himself by studying the great works of the old masters so that his art would address the mind rather than simply please the eye (*Discourses on Art,* ed. Robert R. Wark [San Marino, Calif.: The Huntington Library and Art Gallery, 1959], p. 43).

CWP may have seen self-portraits exhibited at the Society of Artists, the predecessor to the Royal Academy; from 1769 to 1800 at least eighty-one self-portraits were exhibited at the Royal Academy by painters in all genres, suggesting that this was a continuing interest of artists at the time. McNamara, "Theme of the Learned Painter," pp. 19–21.

49. The use of sculpted busts reflects a tradition going back at least to Rembrandt's use of the head of Homer in his *Aristotle with a Bust of Homer* (Metropolitan Museum of Art, N.Y.), whereby the painter includes a piece of statuary within the portrait to express a professional or personal relationship. For a discussion of Reynolds's self-portraiture, see McNamara, "Theme of the Learned Painter," p. 76.

50. For a more elaborate discussion of West's self-portraits and their prototypes, see McNamara, "Theme of the Learned Painter," pp. 113–44. Also see Ann C. Van Devanter, "Benjamin West's Self-Portraits," *Antiques* 103 (April, 1973): 764–73. West's *Self-Portrait* of 1792 was exhibited by Edward Savage in New York's Columbian Gallery sometime around 1802; the portrait of 1793 was published in an engraving in 1805, and CWP may very well have received a copy of the print just about the time he had decided to finish his *Peale Family* after allowing it to remain unfinished since 1772. See Rita Susswein Gottesman, *Art and Crafts in New York, 1800–1804* (New York: New-York Historical Society, 1965), pp. 32–33; Van Devanter, "West's Self-Portraits," p. 770.

51. In Hogarth's *Analysis of Beauty,* which CWP surely read because he so often referred to it, "Line of Beauty," Plate 1, depicts a statuary yard containing classical sculptures, which for Hogarth epitomized the use of the serpentine line. As McNamara points out, however, Hogarth's distorted sculptures were intended to amplify his criticism of contemporary art which copied these works blindly. Hogarth criticized eighteenth-century artists for copying other works of art rather than looking at nature directly. CWP's assertion that he would have to substitute nature for the absence of old masters in the United States may have been encouraged by Hogarth's aesthetic position. See McNamara, "Theme of the Learned Painter," p. 49; CWP to John Beale Bordley, 1770–1771, P-S, in *Selected Papers,* 1:86–87.

52. Richardson, "Essay on ... Painting," pp. 18, 92; quoted in McNamara, "Theme of the Learned Painter," pp. 6–7.

53. See essay 3, below, for a discussion of fruits available in the early nineteenth century and their meaning in still life. For an extended interpretation of *The Peale Family,* see David Steinberg, "The Characters of Charles Willson Peale: Portraiture and Social Identity, 1769–1776" (Ph.D. diss., University of Pennsylvania, 1993).

54. See essay 7, below.

55. Miller, *In Pursuit of Fame,* p. 24.

56. For an analysis of CWP's painting, see Roger B. Stein, "Charles Willson Peale's Expressive Design," *New Perspectives,* pp. 167–218.

57. Washington Allston's reputation in Boston is one of the better-known examples of the romanticization of the artist's profession. See William H. Gerdts and Theodore E. Stebbins, Jr., *"A Man of Genius": The Art of Washington Allston (1779–1843)* (Boston: Museum of Fine Arts, 1979), passim., but see esp. pp. 127, 162–70; also see, Margaret Fuller, "A Record of Impressions Produced by the Exhibition of Mr. Allston's Pictures in the Summer of 1839," *Dial* 1 (July 1840): 73–84.

58. An unsigned painting (private collection) of a family group, depicting a man with heavy features similar to RaP's, a wife fancily attired in

headdress, Renaissance dress, and much jewelry, with two children, has been attributed to RaP and has been described as "A portrait of the artist and his family." Until more research can be completed on Peale family images and on RaP's portrait technique, that attribution must remain in question (Photo, Peale Family Papers files, NPG).

59. CWP to TRP, July 20, 1819, P-S, in *Selected Papers*, 3:726.

60. Reynolds, *Discourses on Art*, p. 43.

61. CWP to Angelica Peale Robinson, March 17, 1803, P-S, in *Selected Papers*, 2:515–16. Also see CWP to William Mercer, February 21, 1784, P-S, in *Selected Papers*, 1:408; CWP to Angelica Peale Robinson, March 10, 1822, P-S, in F:IIA/66F12–14.

62. Rembrandt Peale, "Lecture on the Fine Arts," MS, National Academy of Design, pp. 15–16; quoted by Lillian B. Miller, "In the Shadow of His Father: Rembrandt Peale, Charles Willson Peale, and the American Portrait Tradition," *New Perspectives*, p. 99.

63. See Miller, *In Pursuit of Fame*, pp. 57–59.

64. See Miller, *In Pursuit of Fame*, pp. 65–66, and illus.

65. The existence of a copy of this work (or perhaps its original; private collection) by John Vanderlyn, who shared his Parisian studio with ReP at the time, leaves the question of compositional influence open.

66. ReP's essay was published in the *National Gazette and Literary Messenger* (Philadelphia), October 28, 1820; reprinted in *Selected Papers*, 3:847–52. His explanation came later, in a letter to an unknown inquirer; see ReP to "Dear Sir," December 1, 1845, in John McCoubrey, ed., *American Art, 1760–1960: Sources and Documents* (Englewood Cliffs, N.J.: Prentice-Hall, 1965), pp. 53–56. Also see Miller, *In Pursuit of Fame*, pp. 132–34.

67. ReP's rejection of allegorical symbolism in 1822 became a pronounced aesthetic canon in the United States by the midcentury when a theory of typology—the extrapolation of the ideal in nature from a depiction of the actual —guided aesthetic criticism. See James Collins Moore, "The Storm and the Harvest: The Image of Nature in Mid-Nineteenth Century American Landscape Painting" (Ph.D. diss., Indiana University, 1974), chap. 4.

68. ReP to Eleanor Short Peale, August 25, September 13, 16, 25, October 25, 1808. *Selected Papers*, 2:1122–24. For ReP's Parisian residencies, see Miller, *In Pursuit of Fame*, pp. 91–100.

69. Walter Friedlander, *David to Delacroix* (Cambridge, Mass.: Harvard University Press, 1952), p. 13.

70. See Miller, *In Pursuit of Fame*, pp. 146–47.

71. See essay 8, below.

72. In 1784, for instance, CWP planned "a design of making a Capital Historical picture. I mean Genl. Washington taking leave of Congress but alass, my finances at present will not permit me to think of such an undertaking" (CWP to Thomas Mifflin, March 29, 1784, P-S, in *Selected Papers*, 1:411).

73. See Sidney Hart, "A Graphic Case of Transatlantic Republicanism," in *New Perspectives*, pp. 73–81.

74. See essay 2, below.

75. See Brandon Brame Fortune, "Charles Willson Peale's Portrait Gallery: Persuasion and the Plain Style," *Word & Image* 6, 4 (October–December, 1990): 308–24.

76. The first American edition of Lavater's *Essays on Physiognomy: for the promotion of knowledge and love of Mankind* was published in Boston in 1794. A pocket edition of Lavater's work was also available. James Beattie's *Elements of Moral Science* was first published in Philadelphia in 1809, enjoyed wide popularity, and was republished in many editions. See NUC.

77. CWP to Governor Benjamin Harrison, October 30, 1784, PHi: Dreer Collection of Painters and Engravers, P-S, in *Selected Papers*, 1:422.

78. C. W. Peale and A.M.F.J. Palisot de Beauvois, *A Scientific and Descriptive Catalogue of Peale's Museum* (Philadelphia, 1796), pp. 107–8.

79. See Lillian B. Miller, "Charles Willson Peale as History Painter: *The Exhumation of the Mastodon*," *New Perspectives*, pp. 145–66.

80. CWP to George Bomford, May 1, 1819, P-S, in *Selected Papers*, 3:716. For discussion of this painting, see below, essay 10.

81. See Miller, *In Pursuit of Fame*, pp. 109–13.

82. See essay 4, below.

83. See *Selected Papers*, 1:263, 264n.

84. See CWP to John Beale Bordley, November, 1772, P-S, in *Selected Papers*, 1:127. Here CWP offered Bordley some drawings that he had made with the aid of his "painters Quadrant," which, he believed, "would do a Claud Lorain or a Salvator Rosa credit."

85. Among CWP's collection of engravings that he brought back from London was Claude Lorraine's *Landscape with the Father of Psyche Sacrificing at the Milesian Temple of Apollo*, which he gave to John Beale Bordley to copy. See *Selected Papers*, 1:191. See *The Origins of Landscape Painting in England* (London: Iveagh Bequest, Kenwood, 1967), pp. 4–6.

86. Richardson is quoted in ibid., p.6. On October 2, 1747/48, the Earl of Chesterfield wrote similarly to his son, who had sent him several drawings of "tolerably good" Swiss scenes that he had drawn. Lord Chesterfield expressed the hope that his son would "do as good [as] a portrait painter, which is a much more noble science" because it probed "the inside of the heart and mind of man" and required "more attention, observation, and penetration, than the other." Charles Strachey, ed., *The Letters of the Earl of Chesterfield to His Son* (London: Methuen & Co., 1901), 1:176–77; quoted in David Steinberg, "The Characters of Charles Willson Peale", p. 71.

87. CWP to Edmund Jenings, July 18, 1771, P-S, in *Selected Papers*, 1:101.

88. CWP to John Cadwalader, September 7, 1770, P-S, in *Selected Papers*, 1:82; CWP to John Cadwalader, March 22, 1771, P-S, in *Selected Papers*, 1:92.

89. See William Gilpin, *Three Essays: On Picturesque Beauty; On Picturesque Travel; and on Sketching Landscape* (1792; reprint, Ann Arbor: University of Michigan Press, 1980); Edmund Burke, *A Philosophical Enquiry into the Origin of our Ideas of the Sublime and Beautiful*, ed. J. T. Boulton (London: Routledge & K. Paul, 1958), p. xxii. Burke's *Enquiry* was first published in 1757 and reprinted almost every three years thereafter for thirty years.

90. Gilpin, "Poem on Landscape Painting," in *Three Essays*, p. 11, lines 300–310.

91. CWP to Geoffroy, June 1, 1797, P-S, in *Selected Papers*, 2:205.

92. See essay 2, below.

93. For a discussion of the *Pitt* and *Bordley*, see Hart, "A Graphic Case of Transatlantic Republicanism in *New Perspectives*," pp. 73–81.

94. This analysis of the portrait comes from Karol Ann Lawson, "A New World of Gladness and Exertion: Images of the North American Landscape in Maps, Portraits, and Serial Prints Before 1820" (Ph.D. diss., University of Virginia, 1988), chap. 5.

95. Brandon Brame Fortune, "From the World Escap'd': Peale's Portrait of William Smith and his Grandson," *Eighteenth-Century Studies* 25, no. 4 (1992): 587–615. For CWP's drawing of "Eutaw," see CWP, Diary 7 (Fordham University Library, Bronx, N.Y.), in *Selected Papers*, 1:540.

96. Gilpin, *Three Essays*, p. 85.

97. See Diary 7, entries of September 24 and October 3, 1788 (*Selected Papers*, 1:535, 537), for the perspective drawing made for the Laming portrait.

98. For CWP's machine, see *Selected Papers*, 1:493–94; for James's sketchbook, see essay 7, below.

99. See CWP to ReP, August 14, 1816, P-S, in *Selected Papers*, 3:435.

100. For CWP's description of his garden, see *Selected Papers*, 3:202, 216, 300; see also Therese O'Malley, "Charles Willson Peale's Belfield: Its Place in American Garden History," *New Perspectives*, pp. 267–82.

101. See CWP to ReP, October 1, 1818, P-S, in *Selected Papers*, 3:607.

102. See Miller, *In Pursuit of Fame*, pp. 107 (illus.), 137, for ReP's *Harper's Ferry*.

103. See Miller, *In Pursuit of Fame*, pp. 211–14, for discussion of Rembrandt's scenes of Niagara.

104. See essay 6, below.

105. See essay 5, below.

106. See essay 3, below.

107. For an analysis of this work, see Dorinda Evans, "Raphaelle Peale's *Venus Rising from the Sea*: Further Support for a Change in Interpretation," *American Art Journal* 14 (Summer 1982): 63–72. Raphaelle may have based his work on an engraving of West's *Venus Rising*. See Helmut von Erffa and Allen Staley, *The Paintings of Benjamin West* (New Haven: Yale University Press, 1986), p. 245.

108. CWP to Andrew Ellicott, February 28, 1802, P-S, in *Selected Papers*, 2:410.

109. See Sidney Hart, "'To encrease the comforts of Life'; Charles William Peale and the Mechanical Arts," *New Perspective*, pp. 237–65.

Part 11: The Artists

1: Charles Willson Peale and the Theory and Practice of the Eighteenth-Century Family

Sidney Hart

For their assistance and encouragement, I thank George A. Billias, Dru Dowdy, Leslie Reinhardt, David C. Ward, and Michael Zuckerman.

1. Allan Kulikoff, *Tobacco and Slaves: The Development of Southern Cultures in the Chesapeake, 1680–1800* (Chapel Hill: The University of North Carolina Press, 1986); Robert E. Shalhope, "Republicanism, Liberalism, and Democracy: Political Culture in the New Nation," in *The Republican Synthesis Revisited: Essays in Honor of George Athan Billias, Proceedings of the American Antiquarian Society,* vol. 102, pt. 1, 1992, pp. 99–152; Jack P. Greene, *Pursuits of Happiness: The Social Development of Early Modern British Colonies and the Formation of American Culture* (Chapel Hill: The University of North Carolina Press, 1988), pp. 81–100; Albert H. Tillson, Jr., "New Light On the Chesapeake," *Reviews in American History* 22, no. 3 (September 1994): 393–99.

2. For scholarship relating to the history of the family in America, see Bibliographical Essay. Also see Henry F. May, *The Enlightenment in America* (New York: Oxford University Press, 1976), pp. 197–222; for capitalism in Philadelphia, see Thomas C. Cochran, "Philadelphia: The American Industrial Center, 1750–1850," *Pennsylvania Magazine of History and Biography* 106, no. 3 (July 1982): 323–41; Joyce Appleby, *Capitalism and a New Social Order: The Republican Vision of the 1790s* (New York: New York University Press, 1984); Gordon S. Wood, *The Radicalism of the American Revolution* (New York: Knopf, 1992); David Hackett Fischer, *Growing Old in America* (New York: Oxford University Press, 1978), pp. 77–78.

3. Lawrence Stone, *The Family, Sex and Marriage in England, 1500–1800* (New York: Harper & Row, 1977), pp. 221–23.

4. Margaretta M. Lovell, "Reading Eighteenth-Century American Family Portraits: Social Images and Self-Images," *Winterthur Portfolio* 22, no. 4 (Winter 1987): 257; Stone, *The Family, Sex and Marriage,* pp. 221–23; Jay Fliegelman, *Prodigals and Pilgrims: The American Revolution Against Patriarchal Authority, 1750–1800* (New York: Cambridge University Press, 1982); Wood, *Radicalism of the American Revolution;* John Locke, *Some Thoughts Concerning Education,* in Peter Gay, ed., *John Locke on Education* (New York: Columbia University Press, 1964), pp. 28–29; Daniel Calhoun, *The Intelligence of a People* (Princeton, N.J.: Princeton University Press, 1973), pp. 134–44.

5. CWP to RaP, June 6, 1807, P-S, in *Selected Papers,* 2:1018–19; David C. Ward and Sidney Hart, "Subversion and Illusion in the Life and Art of Raphaelle Peale," *American Art* 8, nos. 3–4 (Summer/Fall 1994): 97–121; for CWP's reform impulse, see CWP to APR, September 23, 1818, P-S, in *Selected Papers,* 3:603–6; CWP to Deborah Jackson,. January 8, 1807, P-S, ibid., 2:998–99; CWP to ReP, May 10, 1804, P-S, ibid., 2:668–69; CWP to APR, September 23, 1818, P-S, ibid., 3:605; CWP to ReP, January 8, 1818, P-S, ibid., 3:557–59; CWP to RaP, February 2, 1818, P-S, ibid., 3:569–71.

6. *CWP;* Charles Coleman Sellers, *Mr. Peale's Museum: Charles Willson Peale and the First Popular Museum of Natural Science and Art* (New York: W. W. Appleton & Company, 1980); *P&M; P&M Suppl.*

7. CWP to APR, April 13, 1803. P-S, in *Selected Papers,* 2:521–22; CWP to ReP, May 10, 1804, P-S, ibid., 2:668–69; CWP to ReP, September 4, 1812. P-S, ibid., 3:167–68; CWP to ReP, October 11, 1822, P-S, in F:IIA/67E9–11; CWP to ReP, May 18, 20, 1823, P-S, in F:IIA/68F2–3; CWP to John Isaac Hawkins, July 30, 1824, P-S, in F:IIA/71A11–13; *CWP,* pp. 222–23, 364, 370, 404–5; Sellers, *Mr. Peale's Museum,* p. 22.

8. Ms. autobiography, p. 40; *OED* for definition of 'housekeeping.'

9. A(TS): 41.

10. By the terms 'nuclear' and 'extended family' what is meant here is not family structure, but family ties.

11. Karin Calvert, *Children in the House: The Material Culture of Early Childhood, 1600–1900* (Boston: Northeastern University Press, 1992), has pointed out that although not many American family portraits from the 1770s are extant, CWP's is still "the most striking to the general form of nuclear [family] portrait" (p. 163, n. 21). CWP's extended sense of family is also reflected in his dependence on the extensive kinship network of his first wife, Rachel Brewer, whose family possessed substantial economic, social, and political power in Maryland. For the political dimensions of this influential family and their considerable role in CWP's career, see Lance Lee Humphries, "Rachel Brewer's Husband, Charles Willson Peale: The Artist in Eighteenth-Century Maryland Society" (M.A. thesis, Department of Art History, University of Virginia, 1993).

12. This may account for CWP being influenced by Rousseau's *Emile,* which asserted that it was a father's duty to personally educate his children. Jean-Jacques Rousseau, *Emile or On Education,* trans., with notes and intro., Allan Bloom (New York: Basic Books, 1979), p. 171.

13. CWP to Benjamin West, April 20, 1771, P-S, in *Selected Papers,* 1:95; for Rousseauian manipulation of the pupil, see Rousseau, *Emile,* p. 120.

14. CWP to Thomas Allwood, March 1, 1773, P-S, in *Selected Papers,* 1:128–29; *CWP,* p. 438.

15. For CP's letterbook, see F:I/1–2.

16. CWP to "Captain Digby," September 25, 1763, P-S, in *Selected Papers,* 1:34.

17. A(TS): 1.

18. CWP to Jefferson, February 17, 1807, P-S, in *Selected Papers,* 2:1002.

19. Daniel Blake Smith, *Inside the Great House: Planter Family Life in Eighteenth-Century Chesapeake Society* (Ithaca, N.Y.: Cornell University Press, 1980), p. 285.

20. Kulikoff, *Tobacco and Slaves,* p. 166.

21. Inventory of the Goods and Chattels of Charles Peale, Maryland Hall of Records, Inventories, 48/369–70, in *Selected Papers,* 1:30–31. For a harsher evaluation and characterization of Charles Peale's financial status, see Humphries, "Rachel Brewer's Husband," p. 39. Based on the value of Peale's estate, Humphries placed him in "the lowest group" (p. 39). Humphries, however, ignores the considerable sum of collectable debts owed to Peale at his death. Of Charles Peale's less than successful financial record there is no doubt; even his son described him as "perhaps not the best Economist in the world" (A(TS): 1).

22. CWP to Jefferson, February 17, 1807, P-S, in *Selected Papers,* 2:1002; see also, *Selected Papers,* 1:6, 16, 11, 12, 19, 24, 29.

23. *Selected Papers,* 1:9.

24. Charles Peale to Rev. Joseph Digby, 1746, P-S, in *Selected Papers,* 1:19–20.

25. Charles Peale to Jane Peale Digby, May 21, 1747, P-S, ibid., 1:26–27.

26. Charles Peale to Jane Peale Digby, 1747, P-S, ibid., 1:27–28.

27. For the lack of privacy in the eighteenth century, see Nancy F. Cott, "Eighteenth-Century Family and Social Life Revealed in Massachusetts Divorce Records," *Journal of Social History* 10, no. 1 (Fall 1976): 22–24; Helena M. Wall, *Fierce Communion: Family and Community in Early America* (Cambridge, Mass.: Harvard University Press, 1990), pp. 10, 176, n.1; Carole Shammas, "The Domestic Environment in Early Modern England and America," *Journal of Social History* 14, no. 1 (Fall 1980): 3–24.

28. CWP to the Rev. Joseph Digby, March [?], 1767, P-S, in *Selected Papers,* 1:46.

29. A(TS): 1.

30. Smith, *Inside the Great House,* pp. 285–6, 290. Jan Lewis modifies Smith's picture of the "affectionate" family of the Chesapeake gentry in the second half of the eighteenth century. See "Domestic Tranquillity and the Management of Emotion among the Gentry of Pre-Revolutionary Virginia," *The William and Mary Quarterly* 39, no. 1 (January 1982): 135–49.

31. Mary Beth Norton, *Liberty's Daughters: The Revolutionary Experiences of American Women, 1750–1800* (Boston: Little Brown, 1980), pp. 228–50; Robert L. Griswold, *Fatherhood in America* (New York: Basic Books, 1993), pp. 11–14.

32. Smith, *Inside the Great House,* pp. 287–97.

33. Stone, *The Family, Sex and Marriage,* pp. 232–33.

34. Ibid.

35. Ibid., pp. 237–38. See also, Fliegelman, *Prodigals and Pilgrims,* pp. 26, 54–55, 60–66. For CWP's reading of Chesterfield and Sterne in 1776–77, see Diary 2; Diary 4, pt. 2, in *Selected Papers,* 1:170, 261.

36. Stone, *The Family, Sex and Marriage,* pp. 237–38.

37. An aspect of the development of more affectionate family relationships and the child-centered home, according to Stone, was a great increase in the expression of emotion at the death of a child. See CWP to TRP, February 21, March 21, 1820, P-S, in *Selected Papers,* 3:797–801.

38. *Selected Papers,* 1:193. Phoebe Lloyd, from the perspective of a late-twentieth-century American, severely criticizes Peale for publicly displaying *Rachel Weeping,* characterizing the painting as "the first native 'tearjerker.'" As John Adams's reaction makes clear, such displays of emotion among the wealthy, powerful, and influential were quite fashionable in late eighteenth-century Anglo-America. See Phoebe Lloyd, "A Death in the Family," *Philadelphia Museum of Art Bulletin 78* (Spring, 1982): 8.

39. Stone, *The Family, Sex and Marriage,* pp. 246–53.

40. Lovell, "Reading Eighteenth-Century American Family Portraits," p. 243.

41. See Elizabeth Mankin Kornhauser, *Ralph Earl: The Face of the Young Republic* (New Haven, Conn.: Yale University Press, 1991), pp. 40–41; Lovell, "Reading Eighteenth-Century American Family Portraits," pp. 260, 264.

42. See F:IIB/6.

43. Diary 5, Part 3, P-S, in *Selected Papers,* 1:300–301.

44. Diary 5, Part 3, P-S, ibid., 1:302.

45. CWP to John Beale Bordley, July 29, 1772, P-S, ibid., 1:123–24; CWP to John Beale Bordley, November 1772, P-S, ibid., 1:126–27.

46. Diary 2, P-S, ibid., 1:147–48.

47. Diary 2, P-S, ibid., 1:151.

48. Diary 2, P-S, ibid., 1:160.

49. Diary 2, P-S, ibid., 1:163–65.

50. Diary 2, P-S, ibid., 1:170–71.

51. Diary 2, P-S, ibid., 1:171.

52. Diary 2, P-S, ibid., 1:172, 178–79, 181, 184, 185.

53. If JP accompanied CWP to Philadelphia on December 18, he had to walk back to Charlestown almost immediately after arriving in Philadelphia to allow sufficient time for his letter to have reached CWP in Philadelphia by the twenty-ninth. If CWP had written

to his family during this time he would most likely have recorded it in his diary.

54. P-S, in *Selected Papers,* 1:260.

55. CWP to St. George Peale, January [21], 1778, P-S, ibid., 1:262–63.

56. P-S, ibid., 1:263–70. Also see P-S, ibid., 1:525, 541–44, for a third instance of CWP not being present at the birth of a child.

57. Carl Degler, *At Odds, Women and the Family in America from the Revolution to the Present* (New York: 1980), p. 56; Catherine M. Scholten, "'On the Importance of the Obstetrick Art': Changing Customs of Childbirth in America, 1760 to 1825," *William and Mary Quarterly,* 3d ser., vol. 34, no. 3 (July 1977): 431.

58. Degler, *At Odds,* p. 56; Scholten, "'On the Importance of the Obstetrick Art'," p. 432. Humphries, unaware that family behavior had changed over time, condemns CWP for leaving his wife Rachel in periods of difficulty ("Rachel Brewer's Husband: Charles Willson Peale," p. 71).

59. Zuckerman, "William Byrd's Family," *Perspectives in American History* 12 (1979), pp. 253–312; Daniel Blake Smith, "The Study of the Family in Early America: Trends, Problems, and Prospects," *William and Mary Quarterly,* 3d ser., 29, no. 1 (January 1982): 24.

60. Diary 2, P-S, in *Selected Papers,* 1:185; Diary 4, pt. 2, P-S, ibid., 1:264–65. There is also the tantalizing episode in which CWP left his family in a perilous situation in war-time Philadelphia to be with his dying brother St. George. See P-S, ibid., 1:276–81.

61. Edgar P. Richardson, Brooke Hindle, and Lillian B. Miller, *Charles Willson Peale and His World* (New York: Harry N. Abrams, 1982), p. 85.

62. Smith, *Inside the Great House,* pp. 140–50.

63. There is no evidence that CWP knew beforehand of the marriages of his two oldest sons, RaP and ReP, but he disapproved of the bride's family in the former (CWP to ReP, February 3, 1810, P-S, in *Selected Papers,* 3:6) and was upset that the latter had married too young (CWP to A.M.F.J. Palisot de Beauvois, June 16, 1799, P-S, ibid., 2:246). CWP put pressure on RuP in regard to his most dutiful son's selection of a wife, referring often to young women in his son's Philadelphia social

circle as "foolish flirts." See, for example, CWP to RaP, April 14, 1806, P-S, ibid., 2:955–56; CWP to Dr. Richard Bradford, February 14, 1818, P-S, ibid., 3:574–76; CWP to ReP, June 8, 1810, P-S, ibid., 3:42–47.

64. CWP to APR, July 8, 1816, P-S, ibid., 3:407–9; *CWP,* p. 442. For family members who knew, see Andrew Summers to CLP, November 16, 1815, P-S, in F:XD/1B8–9. CWP was told later that the marriage had to be kept a secret from Andrew's father (CWP to Philip DePeyster, August 9, 1816, P-S, in *Selected Papers,* 3:428–29).

65. CWP to CLP, February 20, 1816, P-S, ibid., 3:384–85.

66. CWP to RuP, May 5, 1822. P-S, in F:IIA/66G8–10; CWP to RuP, August 24, 1816, P-S, in *Selected Papers,* 3:444–45.

67. RuP to APR, November 1, 1813, P-S, in *Selected Papers,* 3:208–09.

68. CWP to Thomas Gilpin, April 2, 1820, P-S, ibid., 3:811.

69. CWP to Mrs. Greatrake, March 24, 1820, P-S, ibid., 3:807–8; CWP to Thomas Gilpin, April 2, 1820, P-S, ibid., 3:810–12, passim.

70. CWP, *An Essay on Domestic Happiness,* in *Selected Papers,* 3:140. Gilpin's testimony was on August 31, 1821; see "Papers relating to Petition of Benjamin Franklin Peale," arbitration proceedings in August 1821, which attempted to settle the suit in which the Peales were sued for Eliza's maintenance, PPAmP—J. K. Kane —Legal Papers, F:IXA/1A8–G7, pp. 50–52.

71. CWP, *An Epistle to a Friend,* in *Selected Papers,* 2:504.

72. See *CWP,* pp. 440–44 for the Peale family genealogy; for names as significant, especially as they relate to kinship, see Daniel Scott Smith, "Child-Naming Practices, Kinship Ties, and Change in Family Attitudes in Hingham, Massachusetts, 1641–1880," *Journal of Social History* 18 (1985): 541–66.

73. Lawrence Stone, "The Rise of the Nuclear Family in Early Modern England," in Charles E. Rosenberg, ed., *The Family In History* (Philadelphia, 1975), pp. 13–58; for amusement over Peale's names, see *CWP,* p. 262; Ward and Hart, "Subversion and Illusion," pp. 100–101.

74. CWP to ReP, December 7, 1822, P-S, in F:IIA/68A2–3.

75. Fliegelman, *Prodigals and Pilgrims,* p. 34.

2: Charles Willson Peale Portrays the Body Politic

DAVID STEINBERG

I thank Kenneth Haltman for valuable comments on drafts of this essay. I am grateful to Mark Denaci, Elisha Dumser, Daniel Horner, and Kimberly Phillips for illuminating diverse matters.

1. For a lucid statement of the relationship between images and beliefs, see Margaret Miles, *Image as Insight: Visual Understanding in Western Christianity and Secular Culture* (Boston: Beacon Press, 1985), pp. 141–45.

2. John Kasson, *Rudeness and Civility: Manners in Nineteenth-Century Urban America* (New York: Hill & Wang, 1990), pp. 9–33; Richard L. Bushman, *The Refinement of America: Persons, Houses, Cities* (New York: Knopf, 1992), pp. 63–69.

3. Lloyd's actions later in 1771 undercut these assertions of permanence. Only months after this sitting, he moved to London and joined the Coldstream Guards. CWP knew both the painter and sitter of *Thomas Sprigg:* John Hesselius gave him three lessons in portrait painting in 1763, while Sprigg, like Lloyd's cousin Robert, had been one of the sponsors of his London studies in 1767. See Robert J. H. Janson-LaPalme, "Generous Marylanders. Paying for Peale's Study in England," *New Perspectives,* pp. 14, 22 (n.19).

4. A(TS): 146.

5. For Buckland's career and professional identity, see William H. Pierson, Jr., *American Buildings and their Architects, Volume 1: The Colonial and Neoclassical Styles* (Garden City, New York: Doubleday, 1970), pp. 150–55. On prestige orders, see Jackson Turner Main, *The Social Structure of Revolutionary America* (Princeton, N.J.: Princeton University Press, 1965).

6. For class and politics in contemporary Philadelphia, see Gary B. Nash, "Artisans and Politics in Eighteenth-Century Philadelphia," in Ian M. G. Quimby, ed., *The Craftsman in Early America* (New York and London: W. W. Norton, 1984), pp. 62–88. Comparable work remains to be done on Annapolis, but see James Haw, "Maryland Politics on the Eve of the Revolution: The Provincial Controversy, 1770–1773," *Maryland Historical Magazine* 65, no. 2 (Summer 1970): 103–29.

7. Despite its sentimentalization of laborers, Ronald Schultz, *The Republic of Labor: Philadelphia Artisans and the Politics of Class, 1720–1830* (New York and Oxford, Eng.: Oxford University Press, 1993), chaps. 2 and 3, offers the best location of CWP in Philadelphia politics.

8. *Selected Papers,* 3: 628; see also A(TS): 421. The reluctant sitter was William Lowndes.

9. *Selected Papers,* 2: 706–7. These qualities include typical contemporary measures of good minds; see Lorraine Daston, "Enlightenment Calculations," *Critical Inquiry* 21 (Autumn 1994): 190–93.

10. For the former ideal, see Robert Rosenblum, *Transformations in Late Eighteenth Century Art* (Princeton, N.J.: Princeton University Press, 1967), pp. 50–106.

11. Thomas Jefferson, "A Bill for the More General Diffusion of Education" quoted in Gordon S. Wood, "Interests and Disinterestedness in the Making of the Constitution", in *Beyond Confederation: Origins of the Constitution and American National Identity,* ed. Richard Beeman, Stephen Botein, and Edward C. Carter II (Chapel Hill and London: University of North Carolina Press, 1987), p. 85.

12. On the contemporary habit of interpreting depicted faces, see David Steinberg, "Facing Paintings and Painting Faces before Lavater," in *Painting and Portrait Making in the American Northeast,* The Dublin Seminar for New England Folklife Annual Proceedings, vol. 19 (Boston, 1996).

13. Thomas Gainsborough to David Garrick, 1768, quoted in William L. Pressly, *A Catalogue of Paintings in the Folger Shakespeare Library: "As Imagination Bodies Forth"* (New Haven and London: Yale University Press, 1993), p. 265. Gainsborough may have been referring to either the Droeshout engraving or the Chandos portrait.

14. Quoted in Andrew Oliver, *The Portraits of John Quincy Adams and His Wife* (Cambridge, Mass.: Harvard University, Belknap Press, 1970), pp. 87–88.

15. A(TS): 97; see also CWP to ReP, October 28 1812, P-S, in F:IIA/51G2. Curiously, CWP believed that Steele came from a Maryland family and trained in Italy. For Steele's English career, see Mary Burkett, "Christopher Steele, 1733–1767," in *The Fifty-Third Volume of the Walpole Society 1987* (printed for the Walpole Society, London, 1989), pp. 193–225. For relationship between Steele and CWP, compare, for example, Steele's *John Wilson of Evening Hall* (1756; private collection) and CWP's *Self-Portrait with Angelica and Portrait of Rachel* (c. 1782–85; Museum of Fine Arts, Houston, Bayou Bend Collection).

16. Compare, for example, Hesselius's *Charles Calvert and Servant* (1761; Baltimore Museum of Art) and CWP's *Joshua Carter* (1765; private collection). See Richard Doud, "John Hesselius, Maryland Limner," *Winterthur Portfolio* 5 (1969): 137. Hesselius also provided Benjamin West with his first portrait types; see *Mrs. William Smith,* c. 1758, reproduced in Helmut von Erffa and Allen Staley, *The Paintings of Benjamin West* (New Haven and London: Yale University Press, 1986), p. 556.

17. *Portrait of a Child* (1768; Museum of Fine Arts, Houston; Bayou Bend Collection) shows that CWP continued to paint faces in the style of Hesselius a year after *Matthias and Thomas Bordley.* In a letter to John Beale Bordley from around March 1767, Peale mentioned that West planned to borrow miniatures for him to copy, but made no specific references to a course of study for easel painting (*Selected Papers,* 1: 48).

18. The State House steeple of CWP's boyhood had a viewing platform. CWP was so struck by the power of the State House (or Public) circle that he drew a panorama from the new State House steeple in 1788 and extolled the view twice in his autobiography; see *Selected Papers,* 1: 493; A(TS): 169–70, 345. On Francis Nicholson's novel town plan for Annapolis, see John W. Reps, *The Making of Urban America: a History of City Planning in the United States* (Princeton, N.J.: Princeton University Press, 1965), pp. 103–8.

19. Robert Dodsley, *The Preceptor: Containing A General Course of Education, wherein the first principles of polite learning are laid down in a way most suitable for trying the genius, and advancing the instruction of youth,* 7th ed. (London, 1783), 1: 403. *The Preceptor* had gone through five editions by the time of CWP's London stay.

20. See Joseph Rykwert, *On Adam's House in Paradise* (New York: Museum of Modern Art, 1972); Adam Smith, *An Inquiry Into the Nature and Causes of the Wealth of Nations,* ed. Bruce Mazlish (New York: Bobbs-Merrill, 1961), pp. 4–5.

21. He published his findings the next year; see David Rittenhouse, "Observations on the Comet," in *Transactions of the American Philosophical Society,* vol. 1 (Philadelphia, 1771): 37–45; Brooke Hindle, *David Rittenhouse* (Princeton, N.J.: Princeton University Press, 1964), pp. 75–77. I am grateful to Peter Pesch for discussing this point with me.

22. See E. H. Gombrich, "The Mask and the Face: The Perception of Physiognomic Likeness in Life and Art," in *Art, Perception, and Reality* (Baltimore and London: The Johns Hopkins University Press, 1972), pp. 1–46. This concern with creating animated images complements Susan Stewart's powerful argument in "Death and Life, in that Order, in the Works of Charles Willson Peale," in John Elsner and Roger Cardinal, eds., *The Cultures of Collecting* (Cambridge, Mass.: Harvard University Press, 1994), pp. 204–23.

23. *Selected Papers,* 1: 334.

24. *Selected Papers,* 1: 403.

25. Charles Rollins, *The Method of Teaching and Studying the Belles Lettres,* 6th ed. (London, 1769). William Gribbin, "Rollin's Histories and American Republicanism," *William and Mary Quarterly* 29, no. 4 (October 1972): 611–22, considers the relevance of Rollin's *Ancient History* to classical republican ideology in America.

26. Recorded in Alexander Garden, *Anecdotes of the Revolutionary War in America . . .* (Charleston, S.C., 1822), p. 427.

27. The portrait is reproduced in *City Art Museum of Saint Louis Bulletin,* n.s., vol. 5, 3 (September/October 1969). For Matlack's reputation, see Eric Foner, *Tom Paine and Revolutionary America* (New York: Oxford University Press, 1976), pp. 109–11. For his position in Philadelphia politics, see Schultz, *Republic of Labor,* chaps. 2 and 3.

28. Gordon S. Wood, *The Creation of the American Republic 1776–1787* (Chapel Hill: University of North Carolina Press, 1969), pp. 226–37.

29. On Paine's contemporary reputation, see Gordon S. Wood, "Disturbing the Peace," *The New York Review of Books* 1002, no. 10 (June 8, 1995): 19–22. The marine background indicates Paine's immigrant status. A hand supports a head in Peale's posthumous *Thomas Johnson* (1824; State House, Annapolis).

30. While the painting possibly dates to the sitter's days as secretary, he may have commissioned it as a defensive public relations maneuver following his dismissal in 1782 by the newly ascendant, rival Republican party, due to irregularities in his accounts. The canvas is not inscribed and no known primary document refers to it. *City Art Museum of Saint Louis Bulletin, op.cit,* suggests c.1780, a date when Matlack (b. 1736) would have been forty-four years old.

31. Wharton's portrait is reproduced in *P&M Suppl.* p. 119. CWP mentions *Mrs. Thomas Wharton* (unlocated) in correspondence from 1783 and 1785. See *P&M,* p. 247. On the significance of the pair-portrait format, see David R. Smith, *Masks of Wedlock: Seventeenth-Century Dutch Marriage Portraiture* (Ann Arbor, Mich.: UMI Research Press, 1982).

32. There is no record of a portrait of Mrs. Matlack; the fully frontal face in *Timothy Matlack* suggests that it was designed as a single composition.

33. To Anthony Wayne, April 2, 1777, May 19, 1777; to Charles Lee, October 24, 1779, L. H. Butterfield, ed., *Letters of Benjamin Rush,* vol. 1 (Princeton, N.J.: Princeton University Press, 1951), pp. 137, 148, 244.

34. Benjamin Rush, "Of the mode of Education proper in a Republic," in *Essays, Literary, Moral & Philosophical* (Philadelphia, 1798), p. 10.

35. *The Analysis of Beauty,* ed. Joseph Burke (Oxford, Eng.: Oxford University Press, 1955), p. 40.

36. CWP, Fragment A: 1; A(TS): 4.

37. Jonathan Richardson, *An Essay on the Theory of Painting,* 2d ed. (1725; reprint, Menston, Eng.: Scolar Press, 1971). This broadly evocative remark from the section 'Grace and Greatness' refers most specifically to the need to omit "joyless, turbulent passions" from the painting room.

38. *Selected Papers,* 3: 628. This passage immediately follows upon his statement of desire to represent "a good mind." See also A(TS): 421–22.

39. According to an essayist of 1792, 'disgust' was also the product of a woman's departure from modesty and delicacy: "as you depart from these very amiable companions . . . satiety will give birth to disgust." "On Modesty," *The Lady's Magazine* 1 (December 1792): 36; quoted in Mary Beth Norton, *Liberty's Daughters: The Revolutionary Experience of American Women, 1750–1800* (Boston and Toronto: Little Brown, 1980), p. 113.

40. See Linda K. Kerber, *Women of the Republic: Intellect and Ideology in Revolutionary America* (Chapel Hill: University of North Carolina Press, 1980), pp. 283–84.

41. Linda K. Kerber, "Daughters of Columbia: Educating Women for the Republic, 1787–1805," in Stanley Elkins and Eric McKitrick, eds., *The Hofstadter Aegis: A Memorial* (New York: Knopf, 1974), pp. 36–59.

42. Reprinted in Frederick Rudolph, ed., *Essays on Education in the Early Republic* (Cambridge, Mass.: Harvard University, Belknap Press, 1965), p. 28.

43. Created in 1764 before Peale's arrival, the painting hung in London and had been engraved. See von Erffa and Staley, *Paintings of Benjamin West,* pp. 31–2, 534–35.

44. CWP was familiar with portraits of military men with crossed legs in both London (Thomas Gainsborough, *3d Earl of Bristol,* exhibited at the Society of Artists, 1768) and the colonies (Benjamin West, *Richard Bennett Lloyd,* mentioned in CWP to West, August 31, 1775, *Selected Papers,* 1: 146). When painting a portrait of Benjamin Harrison of "Brandon" (1775; Colonial Williamsburg Foundation, Va.), Peale portrayed a Virginia planter in a pose identical to the 1779 *George Washington,* although the format of the *Harrison* limits the representation to the sitter's upper body.

45. Dodsley, *The Preceptor,* p. 404. Following this discussion is a long passage from DuFresnoy that begins, "The Ancients have commonly allowed eight Heads to their Figures, though some of them have but seven: but we ordinarily divide the Figures into ten Faces" (a face is defined as ¾ of a head); ibid, pp. 405–6. The juxtaposition of different systems in the same text puts the reader in the position of making choices in a heterogeneous field.

46. The point where the figure's right heel touches the ground has been defined as the lower extreme of the body. I thank Mark Bockrath, painting conservator, Pennsylvania Academy of the Fine Arts, for help with taking this measurement.

47. While references to Washington as Cincinnatus abounded in the 1780s and after, CWP's visual formulation is an early attempt to classicize the general. For a comparison between the entire military and "the greatest charectors of antiquity," see Benjamin West to CWP, June 15, 1783, *Selected Papers,* 1: 391. It might also be recalled that Peale named his horse Belisarius, his dog Argus, and his cudgel Hercules.

48. For a brief survey of the different ideas about equality circulating in Philadelphia, see Foner, *Tom Paine,* pp. 123–26.

49. *Freeman's Journal and National Intelligencer,* September 12, 1781, quoted in Charles Henry Hart, "Peale's Original Whole-Length Portrait of Washington—A Plea for Exactness in Historical Writings," Annual Report of the American Historical Association 1896, vol. 1 (Washington, D.C., 1897), p. 194.

50. *Selected Papers,* 1:634–35 reprints the notice from *Freeman's Journal,* October 13, 1784, listing the gallery portraits. A former printer's apprentice who had long since risen above his class origins, Benjamin Franklin appears to have been the only lowborn sitter in this group.

51. Mary Douglas, *Purity and Danger: An Analysis of the Concept of Pollution and Taboo* (New York: Praeger, 1966), pp. 120–24.

52. Quoted in Wood, *Creation of the American Republic,* p. 233.

53. See Schultz, *Republic of Labor,* pp. 51–68,

54. CWP to Samuel Chase, November 23, 1784, P-S, in *Selected Papers,* 1: 424.

55. James Madison, *The Federalist* (New York: Modern Library College Editions, n.d.), p. 407.

56. Quoted in Wood, *Creation of the American Republic,* p. 489. Perhaps the only exception to this generalization is *Arthur Lee* (1785; Independence National Historic Park Collection, Philadelphia).

57. See Brandon Brame Fortune, "Portraits of Virtue and Genius: Pantheons of Worthies and Public Portraiture in the Early American Republic" (Ph.D. diss., University of North Carolina at Chapel Hill, 1987).

58. This distinction can be cast in contemporary political terms: according to the former scenerio, the display represents all visitors virtually but not actually; according to the latter, the installation does not even virtually represent lowborn viewers. See Wood, *Creation of the American Republic,* pp. 173–85, 499.

59. *Selected Papers,* 3: 650.

60. *P&M,* p. 186.

61. On the currency of white people's ambivalent attitudes toward blacks, see George M. Fredrickson, *The Black Image in the White Mind: the Debate on Afro-American Character and Destiny, 1817–1914* (New York: Harper and Row, 1971).

62. CWP, Ms. Diary 11. Horace Wells Sellers Transcript, p. 18. P-S; see also A(TS): 168.

63. For a study of racial interdependence in eighteenth-century Virginia, see Mechal Sobel, *The World They Made Together: Black and White Values in Eighteenth-Century Virginia* (Princeton, N.J.: Princeton University Press, 1987).

64. This interpretation reprises remarks made by Bryan J. Wolf in his stimulating response to the session "Situating the Image" at the annual meeting of the American Studies Association, Boston, 1993.

65. See CWP to Thomas Jefferson, October 3, 14, 1811, P-S, *Selected Papers* 3:115–18; A(TS): 357–58: "It is well understood that when any public measure is in agitation that the whole business should be read *cut and dried,* previous to such meeting, as large bodies can never do business well, it must always be prepared for them."

66. William Dunlap, *A History of the Rise and Progress of the Arts of Design in the United States,* vol. 1 (1834; reprint, New York: Dover Publications, 1965), p. 140. See also Lillian B. Miller, *Patrons and Patriotism: The Encouragement of the Fine Arts in the United States 1790–1860* (Chicago and London: University of Chicago Press, 1966), pp. 108–9.

67. The windows on the right side of CWP's Long Room are those of the second floor of the State House in the middle distance and on the central axis of Krimmel's painting. For *Election Scene, State House in Philadelphia,* see William T. Oedel, "Krimmel at the Crossroads," *Winterthur Portfolio* 23, no. 4 (1988): 277–78.

68. David R. Brigham explores the discrepancies between Peale's goals for his museum and its actual usage in *Public Culture in the Early Republic: Peale's Museum and Its Audience* (Washington, D.C.: Smithsonian Institution Press, 1995).

3: A Delicate Balance: Raphaelle Peale's Still-Life Paintings and the Ideal of Temperance

BRANDON BRAME FORTUNE

I wish to express my gratitude to Lillian B. Miller for inviting me to participate in this project, and also to her colleagues David C. Ward and Sidney Hart of the Peale Family Papers office for sharing ideas and helpful conversation. I want to thank Susan Myers for invaluable aid in identifying the objects in the still lifes, and Anne Verplanck and Ellen Grayson for their helpful comments on an earlier draft. Finally, I wish to thank Carolyn K. Carr, Deputy Director of the National Portrait Gallery, for her continuing support and for making time possible for research and writing.

1. CWP to RaP, July 4 1820, P-S, in *Selected Papers*, 3:832–33. Italics are mine. Since only a few letters from RaP's hand exist today, we do not know what he thought about his own intemperance and bouts of illness. We have only his family's statements, particularly his father's. CWP's opinions about his son help to define the intergenerational tension between the two, but conclusions concerning RaP must remain a matter of conjecture, based on external evidence. Other Peale scholars have written recently about RaP's life and his relationship with his father. See Lillian B. Miller, "Father and Son: The Relationship of Charles Willson Peale and Raphaelle Peale," *The American Art Journal* 25, nos. 1 and 2 (1993): 5–61; and David C. Ward and Sidney Hart, "Subversion and Illusion in the Life and Art of Raphaelle Peale," *American Art* (Summer 1994): 3–27. Also see, Phoebe Lloyd, "Philadelphia Story," *Art In America* 76 (1988): 155–202; and Nicolai Cikovsky, Jr., et al., *Raphaelle Peale Still Lifes* (Washington and New York: National Gallery of Art, 1988).

2. Ward and Hart, "Subversion and Illusion," p. 5.

3. The Dutch word "pronk," derived from the verb "pronken," is difficult to translate. As applied to still-life painting, it expresses aspects of luxury, display, ostentation, and sumptuousness. See Sam Segal, *A Prosperous Past: The Sumptuous Still Life in the Netherlands 1600–1700*, ed. William B. Jordan (The Hague, 1988), p. 15.

4. On celery, see Susan Williams, *Savory Suppers and Fashionable Feasts: Dining in Victorian America* (New York: Pantheon Books, 1985), p. 110.

5. RaP was painting still-life pictures and deceptions as early as 1795, when he showed two deceptions and five still-life studies at the exhibition of the Columbianum in Philadelphia (see *Selected Papers*, 2:114, n. 5). Other members of the extended Peale family painted still life as well, or incorporated it into portraits, including CWP, JP, SMP, ACP, and RuP.

6. See A(TS): 337.

7. See Ward and Hart, "Subversion and Illusion," p. 14ff. On CWP's self-fashioning as an artist, see David Steinberg, "The Characters of

Charles Willson Peale: Portraiture and Social Identity, 1769–1776" (Ph.D. diss., University of Pennsylvania, 1993).

8. M. Kirby Talley, *The Art of Painting in All its Branches* (Translation from Samuel van Hoogstraeten's *Inleyding Tot de Hooge Schoole der Schilderkonst* [1678], London, 1738), p. 137; quoted in "'Small, Usuall, and Vulgar Things': Still-Life Painting in England 1635–1760," *Proceedings of The Walpole Society*, vol. 49 (1983): 133–66.

9. *Ibid.*, pp. 139–40. Gerard de Lairesse's 1707 *Groot Schilderboek* was translated into English in 1738 as *The Art of Painting in All its Branches* (London, 1738). There are more extant (or recorded) fruit and "dessert" pieces from RaP's hand than paintings of mundane foods, such as cheese and crackers, beef and root vegetables, or dried fish, which seem to exist in subtle counterpoise to the more elegant, carefully orchestrated "desserts."

10. See Jonathan Richardson, *An Essay On the Whole Art of Criticism* (London: W. Churchill, 1719), pp. 44–45. English eighteenth-century still-life painting was clearly derived from seventeenth-century Dutch and Flemish examples. See R. Brinsley Burbidge, *A Dictionary of British Flower, Fruit, and Still-Life Painters*, vol. 1, 1515–1849 (Leigh-on-Sea, Eng.: F. Lewis, 1974; and materials contained in the microform edition of *The Witt Library, Courtauld Institute of Art* (Haslemere, Eng.: Emmet Publications, 1990–). Extant works by American artists working during the period when RaP was most prolific continue this Anglo-Netherlandish tradition. American fruit and flower pieces, even those painted by Raphaelle's uncle JP, depict a much more abundant display of objects than is evidenced in any of RaP's paintings—cf. Thomas Badger's *Still Life with Fruit and Wine* (c. 1817; Richard York Gallery, N.Y.), illustrated in Richard York Gallery, *American Paintings from the Collection of James H. Ricau* (New York, 1993), n.p.; and Cornelius de Beet, *Still Life of Fruit, Flowers and Game* (1819; private collection), illustrated in Gregory R. Weidman, Jennifer F. Goldsborough, et al., *Classical Maryland, 1815–1845: Fine and Decorative Arts from the Golden Age* (Baltimore: Maryland Historical Society, 1993), p. 49. See also the still-life work done by John Archibald Woodside, Sr., illustrated in Lee Ellen Griffith, "John Archibald Woodside, Sr.," *Antiques* 140 (November 1991): 816–25.

Dutch, Flemish, and even Spanish still lifes were owned and exhibited in Philadelphia. For instance, Charles Graff, one of RaP's patrons, also owned a number of European still-life pictures. See Anna Wells Rutledge, comp., *Cumulative Record of Exhibition Catalogues: The Pennsylvania Academy of the Fine Arts, 1807–1870; the Society of Artists, 1800–1814; the Artists' Fund Society, 1835–1845* (Philadelphia: The American Philosophical Society, 1955), pp. 320–21. Visual comparisons have been made between RaP's paintings and Spanish still lifes by Juan Sánchez Cotán that were available to him in Philadelphia, but RaP's

spare and simple images are more like paintings within the Netherlandish tradition (See Lloyd, "Philadelphia Story," p. 168). On the Spanish still-life pictures in Philadelphia by 1818, see William B. Jordan, *Spanish Still Life in the Golden Age 1600–1650* (Fort Worth, Tex.: Kimball Art Museum, 1985), pp. 58–60. RaP's paintings resemble images from several of the seventeenth-century categories of Dutch still life, including the "breakfast-piece" (a simple meal, not necessarily to be eaten in the morning), or "fruit-piece." See Titia van Leeuwen, "Still-Life Painting in the Netherlands: Historical Facts and Facets," in E. de Jongh, et al., *Still Life in the Age of Rembrandt* (Auckland, New Zealand: Auckland City Art Gallery, 1982), p. 39.

11. See William Hogarth, *Apology for Painters* (c. 1753–1764), quoted in Talley, "Small, Usuall, and Vulgar Things," p. 151.

12. Sir Joshua Reynolds, *Discourses on Art*, ed. Robert R. Wark (New Haven and London: Yale University Press, 1975), pp. 50–52.

13. CWP to RaP, November 15, 1817, P-S, in *Selected Papers*, 3:548.

14. CWP to RaP, November 19, 1818, P-S, in F:IIA/61.

15. Both Dorinda Evans ("Raphaelle Peale's *Venus Rising from the Sea*: Further Support for a Change in Interpretation," *American Art Journal* [Summer 1982]: 62–72) and Roger B. Stein ("Charles Willson Peale's Expressive Design," *Prospects* 6 [1981]: 139–85) have related the Zeuxis and Parrhasius story to Raphaelle Peale and his father. Also see Lloyd, "Philadelphia Story," pp. 165–67; Norman Bryson, *Looking at the Overlooked. Four Essays on Still-Life Painting* (Cambridge, Mass., Harvard University Press, 1990); and Stephen Bann, *The True Vine: On Visual Representation and the Western Tradition* (Cambridge, Eng., Cambridge University Press, 1989). The story is recounted in an early English translation of Roger de Piles's *The Art of Painting and The Lives of the Painters* (London: 1706), pp. 79–81. For discussion of the frequency of the story in seventeenth- and eighteenth-century texts, see E. de Jongh, *Still Life in the Age of Rembrandt*, pp. 109–11, 145–47. The anecdote was used by Diderot in a description of Chardin's *Le Bocal d'olives*, exhibited at the Salon of 1763: "Ah! my friend, spit on Apelles' curtain and Zeuxis' grapes. One can easily deceive an impatient artist and animals are bad judges of painting. Haven't we seen the birds in the king's garden hitting their heads against the worst perspectives? But it's you, and it's me whom Chardin can fool when he wants" (cited by Lesley Stephenson in "Fruits of Illusion," *The Oxford Art Journal* 16, no. 2 [1993]: 82).

16. Pliny the Elder, *Natural History*, bk. 35, in K. Jex-Blake, trans., *The Elder Pliny's Chapters on the History of Art* (Chicago: Argonaut Publishers, 1968), pp. 107–17.

17. King painted portraits of both Smith and her husband. He also received a copy of *What is Gentility?* from the author, and later gave it

to the Redwood Library in Newport, Rhode Island. See Andrew F. Cosentino, *The Paintings of Charles Bird King (1785–1862)* (Washington, D.C.: Smithsonian Institution Press, 1977), p. 157.

18. [Margaret Bayard Smith], *What is Gentility? A Moral Tale* (City of Washington: Pishey Thompson, 1828), pp. 183–88.

19. *P&M*, p. 162; Brandon Brame Fortune, "Charles Willson Peale's Late Self-Portraits and the Authority of Old Age," paper delivered at the annual meeting of the College Art Association, New York City, February 17, 1994. Stein discusses the possible relationship between CWP's *Artist in His Museum* of 1822 and RaP's *Venus Rising from the Sea*. See Stein, "Charles Willson Peale's Expressive Design," pp. 173–75.

20. CWP to RuP, August 25, 1823, P-S, in F:IIA/69B6–7. See also CWP to RuP, September 19, 1823, P-S, in F:IIA/69B13–C1.

21. See CWP to RuP, August 5, 1823, P-S, in F:IIA/A13–B1; CWP to ReP, August 5, 1823, P-S, in F:IIA/67D9–11.

22. Giorgio Vasari, *Lives of the Most Eminent Painters, Sculptors, and Architects,* vol. 1, trans. Mrs. Jonathan Foster (London: George Bell & Sons, 1886), pp. 119–21. This anecdote is cited by William Kloss in *More Than Meets the Eye: The Art of Trompe-l'oeil* (Columbus, Ohio: Columbus Museum of Art, 1985), pp. 20–21. Janice G. Schimmelman indicates that a copy of Vasari's *Lives* was owned by the Library Company of Philadelphia by 1807; see "A Checklist of European Treatises on Art and Essays on Aesthetics Available in America through 1815," *Proceedings of the American Antiquarian Society*, vol. 93 (Spring 1983): 163, 187.

23. Flies also appear in Dutch still life. They have been interpreted not only as *trompe l'oeil* elements, but also as emblems of transience. See Charles Sterling, *Still-Life Painting from Antiquity to the Twentieth Century,* 2d ed. (New York: Harper and Row, 1981), p. 72, and pls. 8 and 25. See also Arthur K. Wheelock, Jr., "*Trompe-l'oeil* Painting: Visual Deception or Natural Truths?" in Joy Kenseth, ed., *The Age of the Marvelous* (Hanover, N.H.: Hood Art Museum, 1991), pp. 179–89. On RaP's wit and personality, see Ward and Hart, "Subversion and Illusion," pp. 8ff.

24. One of the time-honored definitions of genius is inspired rapture or a passionate seizure. Sometimes associated with the metaphor of intoxication, before the late eighteenth century, the idea of genius as mad intoxication was mitigated by the addition of education and diligent study. By the nineteenth century, however, the idea of a relationship between physical intoxication and the artful intoxication of poetic or artistic genius was more prevalent. See Peter Hyland, "'The Wild Anarchie of Drinke': Ben Jonson and Alcohol," *Mosaic* 19 (Summer 1986): 25–34; and

Nicholas O. Warner, "God's Wine and Devil's Wine: The Idea of Intoxication in Emerson," ibid., 55–68.

25. Benjamin Rush, *An Inquiry into the Effects of Ardent Spirits upon the Human Body and Mind* ([1784] 4th ed., Philadelphia: T. Dobson [18—]). The earliest "temperance" tract was probably the work of another Philadelphian, Quaker Anthony Benezet, who published *The Mighty Destroyer Displayed* in 1774. For summaries of the increasing interest in the consumption of "ardent spirits" as a moral and social problem in early nineteenth-century America, see Mark Edward Lender and James Kirby Martin, *Drinking in America: A History. The Revised and Expanded Edition* (New York: The Free Press, 1987); and Joel Bernard, "From Fasting to Abstinence: The Origins of the American Temperance Movement," in Susanna Barrows and Robin Room, eds., *Drinking. Behavior and Belief in Modern History* (Berkeley: University of California Press, 1991), pp. 337–53. For a slightly earlier period, see David W. Conroy, *The Public House: Drink and the Revolution of Authority in Colonial Massachusetts* (Chapel Hill: University of North Carolina Press, 1995).

26. This "Moral and Physical Thermometer" is also reproduced in the *Columbian Magazine* for January 1789, and in John Coakley Lettsom's *History of some of the effects of Hard Drinking* (London, 1789). Rush and Lettsom knew each other—the Thermometer may have been Rush's invention. See L. H. Butterfield, ed., *The Letters of Benjamin Rush. Volume 1: 1761–1792* (Princeton N.J.: Published for The American Philosophical Society by Princeton University Press, 1951): 500–501, n. 2. See also Terry Castle, "The Female Thermometer," *Representations* 17 (Winter 1987): 346.

27. Thomas Trotter, *An Essay, Medical, Philosophical, and Chemical, on Drunkenness, and its effects on the human body* (Philadelphia: Anthony Finley, 1813; London: Longman, Hurst, Rees, and Orme, 1804), p. 15.

28. See *Selected Papers*, 2:489–90; and Fortune, "Charles Willson Peale's Late Self-Portraits."

29. *Selected Papers*, 2:494.

30. Ibid., 2:508.

31. Ibid., 2:496–97.

32. See Miller, "Father and Son," pp. 50–53, nn. 62 and 116; and Richard P. Wedeen, *Poison in the Pot: The Legacy of Lead* (Carbondale: Southern Illinois University Press, 1984). I wish to thank Dr. Miller for this reference. Miller, citing Wedeen and others, has suggested that Raphaelle's "gout" may have been caused not only by his excessive drinking, but by poisoning from lead residue found in the containers used to house wine, particularly port.

33. George Cheyne, *An Essay on Regimen* (London: Rivington, 1740), p. lvii. Also see John Hill, *The Old Man's Guide to Health and Longer Life* (London; reprint, Philadelphia: John Dunlap, 1775); and CWP's favorite book, Sir John Sinclair's *The Code of Health and Longevity,* 4 vols. (Edinburgh: A. Constable & Co., 1807).

34. Rush, *An Inquiry into the Effects of Ardent Spirits,* Introduction, n.p.

35. See James Johnson, *The Influence of Civic Life, Sedentary Habits, and Intellectual Refinement, on Human Health, and Human Happiness* (Philadelphia: Thomas Hope, 1820), p. 39. According to Johnson, whose treatise was recommended to RaP by CWP, citizens with refined intellects who led sedentary lives must avoid luxurious living (See CWP to RaP, June 25, 1820, P-S, in *Selected Papers*, 3:828). Water was the preferred drink, Johnson advised, although madeira, brandy, or sherry diluted with water were acceptable, while port, claret, and spirits were the "least salubrious." According to Johnson, "the water drinker glides tranquilly through life," while "the wine-drinker experiences short, but vivid periods of rapture, and long intervals of gloom; he is also more subject to disease." This mistrust of wine, long thought to be acceptable in moderation, may reflect the growing concern for abstinence from all alcohol that developed by the third decade of the century.

36. See T. G. Coffey, "Beer Street, Gin Lane: Some Views of 18th-Century Drinking," *Quarterly Journal of Studies on Alcohol* 27 (1966): 669–92; and Peter Thompson, "'The Friendly Glass': Drink and Gentility in Colonial Philadelphia," *The Pennsylvania Magazine of History and Biography* 113 (October 1989): 549–76. On James Boswell's well-documented over-indulgence in claret and port, for example, and the results of this behavior, see Thomas B. Gilmore, "James Boswell's Drinking," *Eighteenth-Century Studies* 24 (Spring 1991): 337–58.

37. CWP to RaP, February 2, 1818; and CWP to RaP, March 1, 1818, P-S, in *Selected Papers,* 3:569, 580.

38. Peale reminded his son to "act the Man"— and yet, as Terry Castle has pointed out, those whose passions could not be governed—those who would have use of a moral thermometer or "monitor"—were thought in the eighteenth century to be linked to the irrational and female sensibilities. See Terry Castle, "The Female Thermometer," *Representations* 17 (Winter 1987): 1–27; and CWP to RaP, February 2, 1818, P-S, in *Selected Papers,* 3:569.

39. See, for example, Francis Russell, "The Hanging and Display of Pictures, 1700–1850," in Gervase Jackson-Stops, ed., *The Fashioning and Functioning of the British Country House* (Washington, D.C.: National Gallery of Art, 1989), pp. 135, 143.

40. Rutledge, *Cumulative Record of Exhibition Catalogues*, pp. 165–67.

41. Sometimes this last course—the true dessert or "banquet," to use the traditional term— was served in another room, but it was always seen as the closing of the meal and by implication, an extra, luxurious treat. See C. Anne Wilson, ed., *"Banqueting Stuffe": The Fare and Social Background of the Tudor and Stuart Banquet* (Edinburgh: Edinburgh University Press, 1991), pp. 1–5, 142–47. See also Barbara G. Carson, *Ambitious Appetites: Dining, Behavior, and Patterns of Consumption in Federal Washington* (Washington, D.C.: American Institute

of Architects Press, 1990), esp. p. 48. On the use of dining rooms and forms of food presentation, see Louise Conway Belden, *The Festive Tradition: Table Decoration and Desserts in America, 1650–1900* (New York: W. W. Norton, 1983); Mary Anne Hines, Gordon Marshall, and William Woys Weaver, *The Larder Invaded: Reflections on Three Centuries of Philadelphia Food and Drink* (Philadelphia: The Library Company of Philadelphia and the Historical Society of Pennsylvania, 1987); Elisabeth Donaghy Garrett, pt. 4 of "The Dining Room," "The American Home," *Antiques* 126 (October 1984): 910–22; James C. Jordan III, "The Neoclassical Dining Room in Charleston," *Journal of Early Southern Decorative Arts* 14 (November 1988): 1–25; and Feay Shellman Coleman, *Nostrums for Fashionable Entertainments: Dining in Georgia, 1800–1850* (Savannah, Georgia: Telfair Academy of Arts and Sciences, 1992).

42. See Jane C. Nylander, "Henry Sargent's *Dinner Party* and *Tea Party*," *Antiques* 121 (May 1982): 1172–83.

43. See, for instance, Ann Leighton, *American Gardens in the Eighteenth Century "For Use or for Delight"* (Amherst: University of Massachusetts Press, 1986), pp. 217–45.

44. See Sam Segal, "On Meaning and Interpretation: The Abundance of Life and Moderation in All Things," in *A Prosperous Past: The Sumptuous Still Life in the Netherlands 1600–1700,* ed. William B. Jordan (The Hague: SDU Publications, 1988), pp. 29–38. For a negative view, see E. de Jongh, "The Interpretation of Still-Life Paintings: Possibilities and Limits," in *Still-Life in the Age of Rembrandt,* pp. 27–38. See also Simon Schama, "Perishable Commodities: Dutch Still-Life Painting and the 'Empire of Things'," in John Brewer and Roy Porter, eds., *Consumption and the World of Goods* (London and New York: Routledge, 1993), pp. 478–88; and Lawrence Goedde, "A Little World Made Cunningly: Dutch Still Life and Ekphrasis," in Ingvar Bergström, *Still Lifes of the Golden Age: Northern European Paintings from the Heinz Family Collection* (Washington, D.C.: National Gallery of Art, 1989), pp. 35–44.

45. See U. P. Hedrick, *A History of Horticulture in America to 1860* (New York: Oxford University Press, 1950), pp. 221ff; Samuel Tolkowdky, *Hesperides: A History of the Culture and Use of Citrus Fruits* (London: John Ball Sons & Curnow, 1938), passim. On fruits and vegetables grown in and around Philadelphia, and on the construction and use of greenhouses, see Bernard McMahon, *The American Gardener's Calendar* (Philadelphia: T. P. M'Mahon, 1819), p. 306ff; and William Prince, *A Short Treatise on Horticulture* (New York: T & J Swords, 1828), pp. 166ff.

46. See Therese O'Malley, "Charles Willson Peale's Belfield: Its Place in American Garden History," *New Perspectives,* pp. 267–82; and David C. Ward, "Charles Willson Peale's Farm Belfield: Enlightened Agriculture in the Early Republic," ibid., pp. 283–301.

47. On the fashion for lemonade, see Belden, *The Festive Tradition,* and Carson, *Ambitious Appetites,* passim. See also Margaret Bayard Smith, *What is Gentility?,* p. 59 ("Mother if you wish to be genteel, you'll have small, very small punch glasses; and lemonade, instead of toddy"). While many of the objects in these pictures are identifiable, they are also not so rare as to be available only to a handful of elite families. Rather, these objects— the Chinese export porcelain, pearlware baskets, decanters and wine glasses, knives and other cutlery— could have been owned by many well-to-do families in Philadelphia, as well as some who would be termed "aspiring" by scholars of material culture. Raphaelle Peale, and his extended family, could have owned these objects. I wish to thank Susan Myers and her staff (Sheila Alexander and Bonnie Lilienfeld) in the Division of Ceramics and Glass of the National Museum of American History, Smithsonian Institution, for helping to identify the objects in Peale's still lifes, and for the use of their extensive library.

48. See Segal, "On Meaning and Interpretation," in Jordon, A Prosperous Past, pp. 29–38; and Sam Segal, *A Fruitful Past: A Survey of the Fruit Still Lifes of the Northern and Southern Netherlands from Brueghel till Van Gogh* (Amsterdam, 1983) for in depth discussions of traditional fruit symbolism. I have relied on Segal's exhaustive compilation of this iconography.

49. See Prince, *A Short Treatise on Horticulture,* p. 166, for whom the orange tree was "a happy emblem of genius, that magnificent and splendid boon of nature, which, like this tree is ever green, and which grows more and more beautiful beneath the hand of time." Prince also noted that the orange was a typical sign of the passion of love.

50. Mrs. H[annah] Glass[e] . . . with considerable additions and corrections by Maria Wilson, *The Complete Confectioner* (London: J. O. Dewick, 1800), pp. 222ff. See also [Eliza Leslie], *Seventy-five Receipts, for Pastry, Cakes, and Sweetmeats: By a Lady of Philadelphia* (Boston: Munroe & Francis, 1828), pp. 45–73; Duncan MacDonald, *The New London Family Cookbook* (London: J. Robins & Co., [1808]), pp. 44–90, 289ff.; [Rundell], *A New System of Domestic Cookery* (Philadelphia: B. C. Buzby, 1810); and G. (sic) A. Jarrin, *The Italian Confectioner; or, Complete Economy of Desserts* (London: W. H. Ainsworth, 1827). J. Laird, *The Complete Confectioner and Family Cook* (Edinburgh: J. Anderson, 1809), p. 136, mentions the proper icing and decoration for funeral cakes: "they are iced on the bottom and ornamented with gold leaf, nonpareils, etc." On funeral fare, see also Hines, Marshall, and Weaver, *The Larder Invaded,* p. 169.

51. Sotheby's, see *Important American Paintings, Drawings, and Sculpture* (sale held on December 3, 1987), lot no. 42. See also Mary Jane Peale, "List of pictures I own" (1884), P-S,

where she lists one of her father's [Rubens Peale's] copies: "Cake & Wine—Father copied for me from one which was presented to mother & Father when they were married by Raphael Peale." I wish to thank Leslie Reinhardt for this reference.

52. See Segal, *A Fruitful Past;* and Segal, "On Meaning and Interpretation," as well as Susanne J. Warma, "Christ, First Fruits, and the Resurrection: Observations on the Fruit Basket in Caravaggio's London *Supper at Emmaus*," *Zeitschrift für Kunstgeschichte* 53 (1990): 583–86.

53. For an account of the popularity of madeira and other fortified wines in Philadelphia, see S. Weir Mitchell, *A Madeira Party* (New York: The Century Company, 1895), p. 13.

54. See Harold Newman, *An Illustrated Dictionary of Glass* (London: Thames and Hudson, 1978), p. 244. See also Belden, *The Festive Tradition,* p. 113. Covered, footed sweetmeat containers made of glass would have been used to display the rich color of "wet" sweetmeats, or preserved fruits.

55. RaP to Mr. Graff [Charles Graff], September 6, 1816 (Archives of American Art, *Selected Papers,* 3:447–48). Graff owned several of RaP's still lifes. George Cheyne and many other writers on intemperance and gout mention that gout afflicted its victims periodically, at certain times of the month or year. See Cheyne, *An Essay of the True Nature and Due Method of Treating the Gout* (London: G. Strahan, 1738), p. 22, on the two seasons "to wit, Spring and Fall, when the Periodical Fits of regular *Gouts* commonly happen."

56. On mounted ostrich egg cups see Kenseth, *The Age of the Marvelous,* pp. 257–58; also, Ellenor M. Alcorn, assistant curator, Museum of Fine Arts, Boston, in letter to the author, February 7, 1995, discusses revivals of this sort of mounted egg during the Regency period.

57. Pasquin's *Frugality* is illustrated in Carson, *Ambitious Appetites,* p. 37. For the tradition of the rich man's and poor man's meals, see Segal, "On Meaning and Interpretation," pp. 33–34.

58. The tradition of the "Cries" is an old one. Eighteenth-century versions were done after drawings by Marcellus Laroon and Paul Sandby, but the best known was probably that illustrated by Francis Wheatley (1747–1801). Some of the original paintings were exhibited at the Royal Academy in the early 1790s, and the engravings were done in 1795. Inexpensive, pocket-sized "Cries of London" were published soon thereafter; see Timothy Ticklecheek [pseud.], *The Cries of London, displaying the manners, customs & characters, of various people who traverse London streets with articles to sell* (London: J. Fairburn, 1797). There were similar editions published in Philadelphia during the second decade of the nineteenth century, for instance, *The Cries of Philadelphia: Ornamented with Elegant Wood Cuts* (Philadelphia, 1810). Except for botanical prints, "fruits of the month," and images of the four seasons that make use of fruit imagery, prints that make use of fruit or food,

with moral verses, are quite rare. See
E. McSherry Fowble, *To Please Every Taste: Eighteenth-Century Prints from the Winterthur Museum* (Alexandria, Va.: Art Services International, 1991); and Gordon Dunthorne, *Flower and Fruit Prints of the 18th and Early 19th Centuries* (Washington, D.C.: Published by the author, 1938).

59. The verse attached to Peale's print reads: "The pye from Bake-house she had brought/But let it fall for want of thought/and laughing Sweeps collect around/The pye that's scatter'd on the ground." See Edgar P. Richardson, Brooke Hindle, and Lillian B. Miller, *Charles Willson Peale and His World* (New York: Harry N. Abrams, 1983), pp. 79, 249.

4: The Rewards of Virtue: Rembrandt Peale and Social Reform

WILLIAM OEDEL

1. "Obituary: Rembrandt Peale," *The Crayon* 7, pt. 11 (November 1860): 328; Board of Directors, Pennsylvania Academy of the Fine Arts," Minutes: October 8, 1860," PPAFA; *New York Tribune,* October 6, 1860, 4:4.

2. CWP to Thomas Jefferson, May 2, 1815, Library of Congress, Jefferson Papers, in *Selected Papers,* 3:324.

3. CWP betrayed peculiar animus when ReP announced his plan to relocate to Baltimore in 1812; see, for example, CWP to ReP, July 27, 1812, P-S, in *Selected Papers,* 3:155–58; CWP to Nathaniel Ramsey, March 13, 1813, P-S, in *Selected Papers,* 3:190–91; CWP to A.M.F.J. Palisot de Beauvois, June 16, 1799, P-S, in *Selected Papers,* 2:246. Also see C. Edwards Lester, *The Artists of America* (New York: Baker and Scribner, 1846), p. 205; Miller, *In Pursuit of Fame,* p. 42.

4. *Poulson's American Daily Advertiser* (Philadelphia), December 29, 1800. Also see William Dunlap, *History of the Rise and Progress of the Arts of Design in the United States,* vol. 2 (1834; reprint, New York: Dover Publications, 1965), pp. 52–53.

5. Peter J. Parker, "Notes and Documents; Useful Knowledge in Minute Particulars: Rembrandt Peale's Notes of the Painting Room," *Pennsylvania Magazine of History and Biography* 110, no. 1 (January 1986): 111–28; Elizabeth Johns, "Drawing Instruction at Central High School and Its Impact on Thomas Eakins," *Winterthur Portfolio* 15 (Summer 1980): 139–49; Paul J. Staiti, "Rembrandt Peale on Art," *Pennsylvania Magazine of History and Biography,* 110, no. 1 (January 1986): 91–109.

6. CWP to ReP, August 23, 1823, P-S, in F:IIA/69.

7. CWP to ReP, June 4, 8, 1815, P-S, in *Selected Papers,* 3:330–31.

8. CWP to Thomas Jefferson, July 3, 1820, Library of Congress, Jefferson Papers, in *Selected Papers,* 3:831. CWP wrote this, however, in praise of ReP's *Court of Death,* which was, he believed, a suitably moral picture.

9. ReP complained of "the difficulties of the times" on June 26, 1819, and began preparations for the *Court* soon after (ReP to ?, June 26, 1819, PHi, in F:VIA/3); CWP to ReP, July 31, 1819, P-S, in *Selected Papers,* 3:727; By August 28, 1820, ReP had finished the painting (ReP to BFP, P-S, in F:VIA/3). He sold his interest in the museum to RuP early in 1822, when he moved to New York City. His lawsuit against the Baltimore Gas Light Company dragged on for years, concluding unfavorably in 1834 (Miller, *In Pursuit of Fame,* p. 222). For the Apollodorian Gallery, see William T. Oedel, "After Paris: Rembrandt Peale's Apollodorian Gallery," *Winterthur Portfolio* 27 (Fall 1992); Lester, *Artists of America,* pp. 223–24. For the remodeling of the painting room, see ReP to Thomas Sully, July 4, 1820, PHi, Dreer Collection-Painters &

Engravers, in *Selected Papers,* 3:834–35; ReP to Robert Gilmor, Jr., January 5, 1822, P-S, in *Selected Papers,* 4:99–101; ReP, "Notes and Queries: The Court of Death," *The Crayon* 4, no. 9 (September 1857): 279.

10. Germinal in this context was Benjamin West's *Christ Healing the Sick at the Temple* (1815; Pennsylvania Hospital, Philadelphia), which raised four thousand dollars when exhibited in 1816. ReP "came up on purpose" to see the painting in 1817 (CWP to RaP, November 15, 1817, P-S, in *Selected Papers,* 3:547). Further influencing ReP was Washington Allston's *The Dead Man Restored to Life by Touching the Bones of the Prophet Elisha* (1814; Pennsylvania Academy of the Fine Arts, Philadelphia), which won a cash award at the British Institution in London in 1814. For Trumbull's exhibitions, see CWP's comments in Diary 23 ("Philadelphia to Baltimore to Washington"), P-S, in *Selected Papers,* 3:653–54. Also see Irma B. Jaffe, *John Trumbull: Patriot-Artist of the Revolution* (Boston: New York Graphic Society, 1975), pp. 241–48.

11. See Kevin J. Avery and Peter L. Fodera, *John Vanderlyn's Panoramic View of the Palace and Gardens of Versailles* (New York: Metropolitan Museum of Art, 1988), esp. pp. 24, 30–31. In the strictest terms, ReP was correct in claiming that the *Court of Death* "was the first large painting composed and executed in America, designed for popular exhibition, before there were any galleries suitable for such a display," but Vanderlyn's panorama enterprise afforded a precedent (ReP, "Notes and Queries," p. 278). For summary, see Harold E. Dickson, "Artists as Showmen," *The American Art Journal* 5, no. 1 (May, 1973): 4–17.

12. See Miller, *In Pursuit of Fame,* pp. 129–38; William T. Oedel, entry, in *Works by Artists Born Before 1816,* vol. 1 of *American Paintings in the Detroit Institute of Arts* (New York: Hudson Hills Press, 1991), pp. 160–63; *American* (Baltimore), September 23, 1820.

13. Roughly contemporaneous with ReP's painting, the poem was reprinted in Robert Walsh, ed., *The Works of the British Poets, with Lives of the Authors,* vol. 37 (Boston, 1822), pp. 373–83. In the United States, Porteus was also known by *Sermons on Several Subjects* (Hartford, 1806); *A Summary of the Principal Evidences for the Truth and Divine Origin of the Christian Revelation: Designed Chiefly for the Use of Young Persons* (Boston, 1820). Also see Lester, *Artists of America,* pp. 226–27.

14. Rep, "Notes and Queries," p. 278.

15. Miller, *In Pursuit of Fame,* pp. 131, 296 n.9, cites First Unitarian Church, Baltimore, Pew Records, c. 1814–22. Essential to the discussion of the Peales' commitment to Unitarianism is their under-researched relationship to Joseph Priestly. However, see Miller, ibid., pp. 136–37. For ReP and the Philadelphia church, see Elizabeth M. Geffen, *Philadelphia Unitarianism, 1796–1861* (Philadelphia: 1961), pp. 126, 131; ReP paid pew rent in 1825; Unitarian pastor William Henry Furness

presided over the burial of ReP's son Henry and performed the marriage ceremony for his daughter Eleanor to Unitarian merchant Thomas Jacobs. For the Baltimore church, see Robert L. Alexander, *The Architecture of Maximilian Godefroy* (Baltimore: Johns Hopkins University Press, 1974), pp. 132–42. ReP had assisted Godefroy with his Battle Monument in 1815 (ibid., p. 102). Also see Harold Kirker, "Charles Bulfinch and the Washington Unitarian Community, 1818–1830," in Francis Coleman Rosenberger, ed., *Records of the Columbia Historical Society of Washington, D.C., 1973–1974* (Washington, D.C., 1976): 65, 67. CWP admired the Baltimore Unitarian church. See CWP, Diary 13, P-S, entry for November 8, 1818, in *Selected Papers*, 3:613. Both CWP and ReP subscribed to the building fund of the Philadelphia Unitarian Church (Geffen, *Philadelphia Unitarianism,* pp. 78–81); the Baltimore sermon of Channing is reprinted in Sydney E. Ahlstrom and Jonathan S. Carey, *An American Reformation: A Documentary History of Unitarian Christianity* (Middletown, Conn.: Wesleyan University Press, 1985), pp. 91–117.

16. ReP to RuP, August 22, 23, 1814, P-S, in *Selected Papers*, 3:258–59. Although ReP insisted that he had never born arms before his move to Baltimore, he and RuP were listed in the Eighth Company, Fiftieth Regiment of the Pennsylvania Militia (*The Published Archives of Pennsylvania,* 6th ser., vol. 7 [Harrisburg, 1907]: 101, in F:VIA/2).

17. For Sully as Unitarian, see Geffen, *Philadelphia Unitarianism,* pp. 101–3. Also see CWP to CLP, January 9, 1820, P-S, in F:IIA/63.

18. See, for example, Robert Hooper, *The Physician's Vade-Mecum: Containing the Symptoms, Causes, Diagnosis, Prognosis, and Treatment of Diseases* (Albany, N.Y., 1809), pp. 84–86, 144, 157. 163–64, 217–31. In this context, the essential study on the subject of intemperance—*Inquiry into the Effects of Ardent Spirits upon the Human Mind and Body*—was published in 1785 by Benjamin Rush, physician, social scientist, signer of the Declaration of Independence, and Peale family friend.

19. See William T. Oedel, "Review Essay: Krimmel at the Crossroads," *Winterthur Portfolio* 23, no. 4 (Winter, 1988): 273–81; Annaliese Harding, *John Lewis Krimmel* (Winterthur, Del., 1994). For the temperance movement, see W. J. Rorabaugh, *The Alcoholic Republic* (New York: Oxford University Press, 1979); Ian R. Tyrrell, *Sobering Up: From Temperance to Prohibition in Antebellum America, 1800–1860* (Westport, Conn.: 1979); Joseph R. Gusfield, *Symbolic Crusade: Status Politics and the American Temperance Movement* (Urbana and Chicago: University of Illinois Press, 1986); and—of particular import for ReP—William Breitenbach, "Sons of the Fathers: Temperance Reformers and the Legacy of the American Revolution," *Journal of the Early Republic* 3 (Spring, 1983): 69–82.

20. Benjamin Franklin, "Rules of Health and Long Life" (from *Poor Richard's Almanac*), quoted in Gilbert Chinard, *Benjamin Franklin on the Art of Eating* (Princeton, N.J.: Princeton University Press, 1958), p. 44. The positivist authority in the early nineteenth century was Pierre-Jean-Georges Cabanis, whose *Rapports du physique et du moral de l'homme* (Paris, 1802) included "L'influence du regime sur les habitudes morales." Also see CWP, *An Epistle to a Friend on the Means of Preserving Health, Promoting Happiness, and Prolonging the Life of Man to Its Natural Period* (Philadelphia, 1803), pp. 11–12, 27–29; CWP to ReP, September 17, 1819, P-S, in F:IIA/62; ReP to BFP, August 28, 1820, P-S, in F:VIA/3.

21. CWP to RaP, February 2, 1818, P-S, in *Selected Papers*, 3:569–71; CWP to RaP, March 1, 1818, P-S, in *Selected Papers*, 3:579–81. In his *Epistle to a Friend,* CWP also characterized irrational behavior and suicide as criminal: "Wantonly to destroy our intellects (the only superior quality we possess above the brute creation) is a crime, perhaps of a blacker dye than even suicide, yet in spite of all that has been said or written, some men will be thus mad" (p. 3). Many other passages from the *Epistle* reverberate throughout CWP's letters to RaP, as, for instance, CWP to RaP, July 4, 1820, P-S, in *Selected Papers*, 3:832–33: "*taste* [i.e. excessive indulgence] shall not be superior to *reason.*"

22. See *American* (Baltimore), September 5, 1820; CWP to ReP, December 17, 1820, P-S, in *Selected Papers*, 3:856–57; ReP to Pendleton, March 3, 1821, Private Collection, in *Selected Papers*, 4:14–16; CWP to ReP, April 18, 1821, P-S, in *Selected Papers*, 4:246–48; *Poulson's American Daily Advertiser,* September 17, 1821; ReP to RuP, January 2, 1822, PHi, in *Selected Papers*, 4:97–98; ReP to John Pendleton, February 28, 1822, PC, F:VIA/3; [ReP] *Description of the Court of Death: An Original Painting, by Rembrandt Peale* (Baltimore, 1820); David Tatham, "The Pendleton-Moore Shop: Lithographic Artists in Boston, 1825–1840," *Old-Time New England* 62, no. 2 (October-December, 1971): 29–46; Lester, *Artists of America,* p. 209; ReP, "Notes and Queries," pp. 278–79; *Biographical Sketch of the Artist* (n.p.: 1846), Winterthur Library, Winterthur.

23. Thomas Jefferson to CWP, August 26, 1820, Library of Congress, Jefferson Papers, in *Selected Papers,* 3:845; *Biographical Sketch;* Lester, *Artists of America,* p. 209.

24. ReP, "Original Thoughts on Allegorical Painting," *National Gazette* (Philadelphia), October 28, 1820; Lester, *Artists of America,* pp. 209, 224. See also, J. J. Politt, *The Art of Greece 1400–31 B.C.: Sources and Documents* (Englewood Cliffs, N.J.: 1965), pp. 168–69; Pliny, *Natural History* (trans. H. Rackham, vol. 9 [Cambridge, Mass.: Harvard University Press, 1942–80]), bk. 35, chap. 36, sec. 69, p. 313; "A Friend to Justice; Allegorical Improprieties: Painters and Poets at Fault in their Delineation of Death and the Devil," *Port Folio,* n.s., vol. 6, no. 5 (November 1811): 493. ReP and others stressed his departure from the conventional in representing death as human.

See, for example, Lester, *Artists of America,* p. 225; John Neal, *Observations on American Art: Selections from the Writings of John Neal (1793–1876),* ed. Harold E. Dickson (State College, Pa., 1943), pp. 21, 75; CWP to Thomas Jefferson, July 3, 1820, Library of Congress, Jefferson Papers, in *Selected Papers,* 3:830–31. For the movement toward simplicity in American visual design in the 1820s to 1840s, see Neil Harris, *The Artist in American Society: The Formative Years, 1790–1860* (New York: George Braziller, 1966), esp. pp. 188–90. However, ReP could not dissociate the painting from the term *allegory.* At its opening show in 1820 it was called "a pure and natural allegory," and upon ReP's death in 1860 it was called "a large allegory" (*American,* September 5, 1820, quoted in Thomas S. Cummings, *Historical Annals of the National Academy of Design* [Philadelphia: G. W. Childs, 1865; reprint, New York, 1969], p. 290).

25. [ReP] *Description of the* Court of Death; Lester, *Artists of America,* p. 224; Wayne Craven, "The Grand Manner in Early Nineteenth-Century American Painting; Borrowings from Antiquity, the Renaissance, and the Baroque," *The American Art Journal* 11, no. 2 (April 1979): 4–43. For ReP's admiration for Rubens's Medici cycle in 1808, see Oedel, "After Paris," p. 3. In 1820, however, ReP was specifically critical of the elitist visual allegories of Rubens and Charles LeBrun (ReP, "Original Thought"). Among numerous other potential sources for the *Court of Death* are Nicolas Poussin's *The Plague at Ashdod* (1631; Louvre, Paris), Rubens's *The Horrors of War* (1638; Pitti Palace, Florence), and LeBrun's *Le Serpent d'Airain* (c. 1649; City Art Gallery, Bristol, Eng.).

26. Lester, *Artists of America,* p. 223. ReP referred mistakenly to the huge 1817 version of West's painting (Pennsylvania Academy of the Fine Arts, Phila.), which he had not seen but which was already making news (Charles Coleman Sellers, "The Pale Horse on the Road," *Antiques* 65, no. 5 (May 1954): 384–87). West's *Cave of Despair* (1772; Yale Center for British Art, New Haven, Conn.) also could have influenced ReP. See Oedel, "After Paris," esp. p. 3.

27. See Mabel Munson Swan, *The Athenaeum Gallery, 1827–1873: The Boston Athenaeum as an Early Patron of Art* (Boston: Boston Athenaeum, 1940), p. 7. RuP exhibited Sargent's "large picture . . . Christ riding on an Ass," in 1823 (CWP to Coleman Sellers, May 25, 1823, P-S, in *Selected Papers,* 4:274–75). The Peales marveled at the success of Granet's painting; see, for example, ReP to Thomas Sully, July 4, 1820, PHi, in *Selected Papers,* 3:834–35; CWP to ReP, July 23, 1820, P-S, in *Selected Papers,* 3:840–41; Dunlap, *History,* 1:290–305; Dorinda Evans, *Benjamin West and His American Students* (Washington, D.C.: Smithsonian Institution Press, 1980), p. 184; William H. Gerdts and Mark Thistlethwaite, *Grand Illusions: History Painting in America* (Forth Worth, Tex.: Amon Carter Museum, 1988), pp. 77–78; *American,* April 4, 1821, in Neal, *Observations on American Art,*

pp. 74, 78. At the same time, ReP finished his *Death of Virginia* (destroyed by fire), based on the 1820 play *Virginius* by James Sheridan Knowles, and *Mother and Child* (unlocated), reportedly a scene of a mother coaxing her child from the edge of the abyss. See Oedel, "After Paris," pp. 25–26; ReP to RuP, January 2, 1822, PHi, in F:VIA/3; ReP to Robert Gilmor, January 5, 1822, P-S, in *Selected Papers*, 4:99–101;; CWP to RaP, January 14, 1821, P-S, , in *Selected Papers*, 4:6–7.

28. ReP to Henry Brevoort, January 30, 1823, Fordham University Library, in F:VIA/3. In this letter, ReP refers to Uncle James as "only a feeble miniature painter." Also see ReP to Thomas Jefferson, January 8, 1824, Library of Congress, Jefferson Papers, in *Selected Papers*, 4:355–56. ReP attacked the "inaccuracy" and "deficiency" of Stuart's "Athenaeum" portrait in his letter to the Congressional Committee on the Portrait of Washington, March 16, 1824, Library Co. of Philadelphia, in *Selected Papers*, 4:385–87. He also claimed that the composite had been his "study for years" and that this was his seventeenth attempt (ReP to Bushrod Washington, January 12, 1824, Library of Congress, in *Selected Papers*, 4:357–58.) The literature on ReP's portraits of Washington, and the "national portrait" in particular, is vast. See, for example, Miller, *In Pursuit of Fame*, pp. 139–55, and bibliography; David C. Ward, "Celebration of Self: The Portraiture of Charles Willson Peale and Rembrandt Peale, 1822–27, *American Art* 7, no. 1 (Winter 1993): 9–27. Not established in the literature is that ReP may have ached to bury longtime rival Stuart, whose replicated *Washingtons* were far too popular and authoritative. The Peales may have been especially frustrated because they saw the ever-tipsy Stuart as unworthy of eternally cohorting with Washington, even though they fully admired his skill as a portraitist. Peale's production of seventy-nine "Porthole" copies in ensuing decades was a deliberate upstaging of Stuart's "factory" practice of disseminating the Washington visage.

29. Pliny, *Natural History*, vol. 9, bk. 35, chap. 3, sec. 12, and chap. 4., sec. 13, p. 269; Patricia A. Anderson, citing H. P. L'Orange, *Studies in the Iconography of Cosmic Kingship in the Ancient World* (Oslo, 1953), p. 90, establishes further that to ancient Romans the *clupeus* signified the cosmos and "immortal circle of God" (*Promoted to Glory: The Apotheosis of George Washington* [Northampton, Mass.: Smith College Museum, 1980], pp. 25–27).

30. ReP to the Congressional Committee on the Portrait of Washington, March 16, 1824, Library Company of Philadelphia, in *Selected Papers*, 4:385–87. CWP added Stuart's portrait to the synthesis; he also noted that ReP harbored the "expectation that Congress will purchase it, and give orders to paint the other four Presidents in the same manner" (CWP to RaP, February, 1824, P-S, in *Selected Papers*, 4:370–72).

31. Informative in this context is Michael Kammen, *A Season of Youth: The American Revolu-*

tion and the Historical Imagination* (New York: Knopf, 1978), pp. 47–48. In the 1850s, ReP was noted for his lecture on Washington portraiture: "Washington and His Portraits," in Gustavus Eisen, *Portraits of Washington*, vol. 1 (New York: R. Hamilton & Associates, 1932), pp. 297–323.

32. Jefferson and Adams both died on July 4, 1826; Carroll in 1832. For Lafayette's tour, see Stanley J. Idzwerda, Anne C. Loveland, and Marc H. Miller, *Lafayette, Hero of Two Worlds: The Art and Pageantry of His Farewell Tour of America, 1824–1825* (Hanover, New Hampshire, and London: University Press of New England, 1989).

33. CWP to TRP, February 21, March 21, 1820, P-S, in *Selected Papers*, 3:797–801. Parallel discussions include Mark E. Thistlethwaite, *The Image of George Washington: Studies in Mid-Nineteenth Century American History Painting* (New York: Garland Press, 1979); Gary Wills, *Cincinnatus: George Washington and the Enlightenment* (Garden City, N.Y.: Doubleday, 1984).

34. ReP's first avowed concern was that the portrait "satisfy my father that it will surpass everything intended as a representation of Washington." ReP to Thomas Jefferson, January 8, 1824, Library of Congress, Jefferson Papers, in *Selected Papers*, 4:355–56; ReP to Samuel Breck, April 24, 1824, PHi, F:VIA/4.

35. ReP knew the work of physiognomist Johann Caspar Lavater (who had published a characterization of Washington) and was acquainted with phrenologists Franz Joseph Gall (whose portrait he painted), George Combe, and Johann Gaspar Spurzheim. See ReP, "Reminiscences: Characteristics," *The Crayon* 1, no. 24 (June 13, 1855): 370–71. There was a large component of fortune-telling about physiognomics and phrenology, like palm-reading. As Pliny explained: Apelles "painted portraits so absolutely lifelike that . . . one of those persons called 'physiognomists,' who prophesy people's future by their countenance, pronounced from their portraits either the year of the subjects' death hereafter or the number of years they had already lived." Pliny, *Natural History*, vol. 9, bk. 35, chap. 36, sec. 88, p. 327. Also see CWP, *Epistle to a Friend*, p. 26. Combe analyzed ReP's portrait of Washington (in *Washington before Yorktown* [Corcoran Gallery of Art, Washington, D.C.]) on a visit to ReP's studio, finding emphasis placed on benevolence, a bilious-sanguine temperament, secretiveness, firmness, cautiousness, sagacity, prudence, and determination (*Notes on the United States of North America, During a Phrenological Visit in 1838–39–40* [Edinburgh, 1841], p. 339). For phrenology and social reform, see John D. Davies, *Phrenology: Fad and Science, a Nineteenth-Century American Crusade* (1955; reprint, Hamden, Conn.: Archon Books, 1971).

36. See Oedel, "Krimmel"; Harding, *Krimmel*.

5: Fruits of Perseverance: The Art of Rubens Peale, 1855–1865

PAUL D. SCHWEIZER

1. RuP, "Memorandum's of Rubens Peale and the events of his life etc.," p. 5, P-S, in F:IIB/1A7. RuP's reference in the last quarter of this narrative to the painting *The Garden at Belfield*, which he completed in December 1860, suggests that he wrote at least this part of his memoirs during the last five years of his life.

2. Around 1858, RuP began calling the log house he and Mrs. Peale lived in at the farm, Riverdale. This name change may have been occasioned by the construction at the farm around this time of a two-story frame house intended for his son Edward and daughter Mary Jane. Then, beginning around the spring of 1860, RuP renamed his home Riverside. Today, the frame house is still standing, but several decades ago the log house was torn down. I am grateful to Jean A. Dellock, Frackville, Pennsylvania, for her help in locating RuP's farm, and for the compilation she prepared of the Peale family documents located in Schuylkill County, Pennsylvania. Additional assistance was generously provided by John Joy, curator, Historical Society of Schuylkill County, Pottsville, Pennsylvania.

3. RuP, "Journal of Woodland Farm," October 22, 1855, in RuP, Diaries, 1855–65, Archives of American Art, Smithsonian Institution, Washington, D.C., microfilm D10 (also in F:VIIB/2A3–17G2). All subsequent references to passages in RuP's journal will be cited by date.

4. ReP's series of articles is listed in Miller, *In Pursuit of Fame*, pp. 311–12; also see F:VIB/13–14.

5. RuP to Mary Jane Peale, January 16, 1859, P-S, in F:VIIA/10F11–14.

6. See no. 59(a), "Flowers Father painted while I was at Shamokin to surprise me—his first picture," in Mary Jane Peale's 1884 "List of Pictures I own," Archives of American Art, Smithsonian Institution, Washington, D.C., microfilm 3904, frames G15ff, filmed from original on loan to American Philosophical Society.

7. In "Rubens Peale: A Painter's Decade" (*Art Quarterly* 43, no. 4 (Summer 1960), p. 144, Charles Coleman Sellers cited the date of this picture as possibly December 27, 1855. His numerical list of RuP's paintings in this article was based on references in RuP's journal and on the two lists RuP compiled of his paintings. The earlier list is found in RuP's journal, following the entry for April 24, 1858, and records RuP's first thirty-three pictures. A second list, in a notebook titled "List of Pictures painted by Rubens Peale at Riverside farm," P-S, in F:VIIB/18, which was probably begun sometime after the spring of 1860 because of the name Riverside in the title (see n. 2, above), originally included 131 numbered, and three unnumbered works. Today, the pages for pictures forty-seven through seventy-eight are missing.

8. In 1856, Mary Jane enrolled in a drawing class at the Pennsylvania Academy of the Fine Arts. See Christine J. Huber, *The Pennsylvania Academy and Its Women: 1850 to 1920* (Philadelphia: Pennsylvania Academy of the Fine Arts, 1973), p. 31. Two years later, on December 22, 1858, RuP noted in his journal that Mary Jane "is now studying at the Academy, modelling etc. and sitting to Rembrandt for her portrait."

9. ReP's *Pearl of Grief* (pl. 58). Mary Jane's copy, owned in 1967 by Robert Carlin, Philadelphia, is illustrated in Charles H. Elam, *The Peale Family: Three Generations of American Artists* (Detroit: Detroit Institute of Arts, 1967), p. 138.

10. In "Rubens Peale: A Painter's Decade," p. 140, Sellers suggested that Mary Jane's presence at the farm encouraged RuP to take up painting.

11. Mary Jane Peale, Diary, January 1, 1857.

12. Jessie J. Poesch, *Titian Ramsay Peale, 1779–1885, and His Journals of the Wilkes Expedition,* Memoirs of the American Philosophical Society, vol. 52 (Philadelphia, 1961), p. 107.

13. For European and American paintings RuP admired at the Pennsylvania Academy's 1857 annual exhibition, see his "Journal of Woodland Farm," July 7, 1857.

14. Peter C. Marzio, *The Art Crusade: An Analysis of American Drawing Manuals, 1820–1860* (Washington, D.C.: Smithsonian Institution Press, 1976), p. 7; Miller, *In Pursuit of Fame,* pp. 227–31.

15. For a discussion of RuP's poor eyesight, see John Wilmerding, "America's Young Masters: Raphaelle, Rembrandt, and Rubens," in Nicolai Cikovsky, Jr., *Raphaelle Peale Still Lifes* (Washington, D.C.: National Gallery of Art, 1988), pp. 83–86.

16. RuP's sketchbook is in P-S, in F:XIII.

17. RuP noted in his journal on April 17 and 19, 1858, that he was preparing no. 39 for the annual exhibition of the Pennsylvania Academy. On March 24, 1859, he wrote in his journal that he "prepared a packing box and put into it my picture of peaches, cantilope, cittern millon etc [no. 39?] to send to the spring Exhibition of the Academy of fine Arts which is to open the 18th of April." Also see Mrs. Rubens Peale to Mary Jane Peale, n.d., probably March 25, 1859, P-S, in F: VIIA/10B5–8. RuP's participation in the Pennsylvania Academy's 1858 and 1859 spring exhibitions is not corroborated in Anna Wells Rutledge, comp., *Cumulative Record of Exhibition Catalogues: The Pennsylvania Academy of the Fine Arts, 1807–1870; the Society of Artists, 1800–1814; the Artists' Fund Society, 1835–1845* (Philadelphia: The American Philosophical Society, 1955), nor is there any indication he participated in either of these shows in the academy's unpublished Minutes of the Committee on Exhibitions. However, Lillian B. Miller suggested in a letter to the author on May 8, 1995, that the picture, *Peaches and Grapes (Fruit),* which was shown at the PAFA's fall 1856 exhibition, and is listed in Rutledge's *Cumulative Record* under "R. Peale," could be by Rubens. If so, it may be Sellers no. 9, a "china basket of peaches, black and white grapes," which Rubens finished on December 9, 1856. On October 5, 1858, Rubens "prepared a fruit piece . . . for the [Schuylkill County Agricultural?] fair" in Orwigsburg, near Schuylkill Haven. On February 20, 1862, he noted in his journal that nos. 56, 60, and 61 were in Pottsville for sale.

18. RuP, "Journal of Woodland Farm," January 8, 1861.

19. RuP's copy, dated 1858–60, is at the Pennsylvania Academy. RuP believed that JP had painted this view, but in recent years it has been described as by an unknown hand. See Elam, *Peale Family,* pp. 21, 85; Edgar P. Richardson, Brooke Hindle, and Lillian B. Miller, *Charles Willson Peale and His World* (New York: Harry N. Abrams, 1983), fig. 111; and *Selected Papers,* 2, fig. 1.

20. RuP, "Journal of Woodland Farm," August 14, 1857.

21. The date 1858 inscribed on the back of the Munson-Williams-Proctor Institute's picture in what seems to be RuP's hand suggests that it is Sellers, "Rubens Peale: A Painter's Decade," no. 36, the only version RuP painted that year. After he completed this version, RuP gave it to his son, Edward Burd Peale. For an illustration of another version, possibly Sellers, ibid., no. 31, see Bruce Weber, *American Paintings VII* (New York: Berry-Hill Galleries, 1994), p. 101. A variant version, possibly either Sellers, "Rubens Peale: A Painter's Decade," no. 32 or no. 35, is illustrated in Lewis A. Shepard, *A Summary Catalogue of the Collection at the Mead Art Gallery* (Middletown, Conn.: Wesleyan University Press, 1978), p. 160.

22. In 1858, RuP and his niece Anna Elizabeth Peale worked jointly on a copy of a picture by RaP owned by a Peale family friend, the naturalist George Ord. See RuP, "Journal of Woodland Farm," July 29, 1858. In 1861, RuP made two copies of RaP's picture of *Fruit and Wine* (Sellers, "Rubens Peale: A Painter's Decade," nos. 53, and 55).

23. For a reference to RaP's painting, see RuP, "Journal of Woodland Farm," February 16, 1865. For the history of ownership of this work in RuP's family, see Sotheby's, *Important American Paintings, Drawings and Sculpture* (N.Y., December 3, 1987), lot 42. For an illustration of another, slightly different version of this composition by RaP, see Cikovsky, *Raphaelle Peale Still Lifes,* p. 54.

24. For the possibly five copies Rubens made of Raphaelle's *Cake and Wine,* see Sellers, "Rubens Peale: A Painter's Decade," nos. 115, 118, 125, 128, and the unnumbered "Cake and Wine" on p. 144. Sellers no. 125 may not be a copy of RaP's *Cake and Wine,* but a different work with the modern, misleading title *The Artist's Last Birthday,* illustrated in *Antiques* 118 (July 1980): 78. One copy of *Cake and Wine,* possibly no. 115, was listed as item no. 70 in Mary Jane Peale's 1884 "List of Pictures I own." The painting RaP gave to RuP and his wife when they were married was incorrectly described as a "fruit piece" in the "Last Will etc. of Mary Jane Peale, Deceased," June 16, 1903, Schuylkill County Courthouse, Pottsville, Pennsylvania.

25. See Sellers, "Rubens Peale: A Painter's Decade," no. 48, where the work was incorrectly recorded as having been painted on tin. According to Jessie Poesch ("Germantown Landscapes: a Peale Family Amusement," *Antiques* 72 [November 1957]: 439), the work had an inscription on the back noting it was painted for Mary Jane. In her 1884 "List of Pictures I own," RuP's copy is listed as no. 69: "the old Place at Germantown copied from Grandfathers by Rubens Peale." It is also mentioned in the "Last Will etc. of Mary Jane Peale, Deceased."

26. RuP to Benson J. Lossing, "May 1864," P-S, in F: VIIA/12C2–3.

27. RuP, "Journal of Woodland Farm," August 18, 1860.

28. Ibid., July 7, 1857.

29. Mrs. Rubens Peale to Mary Jane Peale, May 26, 1860, in a letter begun by RuP on May 21, 1860, P-S, in F: VIIA/11B2–5.

30. An illustration of what is probably Weber's lost work is the frontispiece of Edmund Hayes Bell and Mary Hall Colwell, comps. and eds., *James Patterson of Conestoga Manor and His Descendants* (Lancaster, Pa., 1925).

31. Sellers, "Rubens Peale: A Painter's Decade," nos. 43, 44, 96, 97, and the unnumbered "Landscape" on p. 144.

32. RuP gave James Burd Peale the unnumbered landscape listed in Sellers, p. 144; he gave Edward Burd Peale no. 43.

33. Bell and Colwell, *James Patterson of Conestoga Manor,* pp. 31–32, 222. Mary Jane Peale noted about the copy of Weber's *The Juniata* she owned, that "it was on this river border that Grandfather Patterson lived and Mother was born there." See her 1884 "List of Pictures I own," no. 76.

34. Carol Eaton Hevner, "Lessons from a Dutiful Son: Rembrandt Peale's Artistic Influence on His Father, Charles Willson Peale," *New Perspectives,* p. 112.

35. ReP, "Original Thoughts on Allegorical Painting," *National Gazette* (Philadelphia), October 28, 1820; as discussed by Hevner, "Lessons from a Dutiful Son," p. 114. ReP's article can be found in *Selected Papers,* 3:848–52.

36. This work is either Sellers, "Rubens Peale: A Painter's Decade," no. 88 or 91.

37. See, for example, the several depictions of a knife in L. Prang and Company's catalog of chromolithographic "Dining-Room Pictures," in Thayer Tolles Mickel, "Permanent Perishables: The Artist's Fruit Paintings," in Doreen Bolger et al., eds., *William M. Harnett* (Fort Worth, Tex.: Published for Amon Carter Museum by Harry N. Abrams, 1992), p. 215.

38. Sellers, "Rubens Peale: A Painter's Decade," no. 10. RuP worked on this picture intermittently over the next three years, finishing it in mid-January 1859. See also RuP to Mary Jane Peale, January 16, 1859, P-S, in F:VIIA/10F11–14.

39. The wire basket resembles those manufactured by Matthew Boulton in England after designs by Robert Adam. See Eric Delieb and Michael Roberts, *Matthew Boulton: Master Silversmith* (New York: C. N. Potter, distributed by Crown Books, 1971), pp. 41, 47, 134. In Mary Jane Peale's 1884 "List of Furniture from the Old House," the following items are mentioned: "An ostridge sugar bowl had by Father. . . . [and] a slop boat and cream jug belonged to Father before he married he kept house for ten years." Archives of American Art microfilm 3904, frame 613, filmed from the original on loan to the American Philosophical Society.

40. For the ownership of this painting and illustration, see Patricia Anderson, "Rubens Peale's Still Life Number 26: The Chronicle of a Painting," *Porticus: The Journal of the Memorial Art Gallery of the University of Rochester* 6 (1983): 34, 36, n.11.

41. On February 3, 1857, RuP's son, George Patterson, "dead coloured" the tin support.

42. Theodore E. Stebbins, Jr., *The Life and Works of Martin Johnson Heade* (New Haven, Conn.: Yale University Press, 1975), cat. nos. 171, 172, 173; Anthony F. Janson, *Worthington Whittredge* (Cambridge, Eng., Cambridge University Press, 1989), pp. 99–100, 201; Helen A. Cooper, "The Rediscovery of Joseph Decker, *American Art Journal* 10 (May 1978): 55–71.

43. Carol Troyen, associate curator of American Paintings, Museum of Fine Arts, Boston, in a letter to the author, January 9, 1995, noted that this painting was lined and that there is no record of an inscription on the back of the original canvas to confirm the likelihood that it is Sellers, "Rubens Peale: A Painter's Decade," no. 49, as suggested in Elam, *Peale Family*, p. 116. RuP began no. 49 almost immediately after he returned to Schuylkill Haven from ReP's funeral in Philadelphia in early October 1860; he finished it two months later.

44. Stevenson W. Fletcher, *Pennsylvania Agriculture and Country Life: 1840–1940* (Harrisburg: Pennsylvania Historical and Museum Commission, 1950–55), p. 274.

45. For Alfred Frankenstein's assumption of a connection between RaP and Harnett, see his *After the Hunt: William Harnett and Other American Still Life Painters, 1870–1900*, rev. ed. (Berkeley: University of California Press, 1969), p. 32. Early still lifes by Harnett that suggest RaP's influence include the 1875 *Still Life* (Reading Public Museum and Art Gallery, Pa.), and the 1876 *Wooden Basket of Catawba Grapes* (Frye Art Museum, Seattle, Wash.). These paintings are illustrated in Bolger, *Harnett*, pl. 1, and fig. 37.

46. Lillian B. Miller, "In the Shadow of His Father: Rembrandt Peale, Charles Willson Peale, and the American Portrait Tradition," *New Perspectives*, pp. 94–95.

47. Fletcher, *Pennsylvania Agriculture and Country Life*, p. 274.

48. Sellers, "Rubens Peale: A Painter's Decade," no. 107. There is a photograph of Warner's lock in Harry L. Rinker, *The Schuylkill Navigation: A Photographic History* (Berkeley Heights, N.J.: Canal Captains' Press, 1991), p. 17. On November 28, 1864, when Rubens began painting this work, he remarked in his "Journal of Woodland Farm" that he sketched the scene on canvas on October 12, 1864, the day before he moved from Schuylkill Haven to Philadelphia. Sellers, using the dates given in the "List of Pictures painted by Rubens Peale at Riverside farm" (P-S, in F:VIIB/18), noted that Rubens began this painting a day earlier, on Sunday, November 27, 1864, and that it was finished in February 1865. However, Rubens noted in his journal on June 3, 1865, that he was still working on the picture that summer. Another painting, also numbered "107" in Rubens's "List of Pictures," is described as "Landscape my first lesson under Mr. Moran, and Partridges," but this work probably is Sellers, "Rubens Peale: A Painter's Decade," no. 106.

49. See, for example, Charles Willson Peale's *Germantown Mill Scene,* illustrated in Poesch, "Germantown Landscapes," p. 436, fig. 3.

50. Lisa Fellows Andrus, *Measure and Design in American Painting, 1760–1860* (New York: Garland Publishers, 1977), pp. 292–97. For CWP's and JP's drawing devices, see *P&M Suppl.*, pp. 8, 24, 26. For passing references to CWP's "painter's quadrant," see Richardson, Hindle, and Miller, *Charles Willson Peale and His World*, pp. 90, 236, n.32. Also see *Selected Papers*, 1:119, n.5; 493, n.2.

51. Sellers, "Rubens Peale: A Painter's Decade," no. 130.

52. Rudolf B. Wunderlich and Lillian B. Miller, in letters to the author on September 29, 1983, and June 6, 1988. A different opinion was offered by Edgar P. Richardson (in letter from [?] Constance Richardson to the author, August 21, 1983), who examined a photograph of the Munson-Williams-Proctor Institute's painting and considered it to be by CWP. The scene does not match any landscape described by RuP in his journal or lists of pictures, but it does correspond in some respects to CWP's description of an 1818 work, *Armstrong's Mill Dam*, now unlocated; see *P&M Suppl.*, p. 42, cat. nos. 110–11.

53. For the first picture in this series, see Sellers, "Rubens Peale: A Painter's Decade," no. 47. There is a notation of questionable origin on *Bobwhite Quail in a Landscape* indicating it is no. 106 (also see n.48, above).

54. Sellers, "Rubens Peale: A Painter's Decade," no. 67. Arthur F. Tait (1819–1905) entitled at least two of his game pictures a "happy family," but both works were painted after RuP's death. See Warder H. Cadbury and Henry F.

Marsh, *Arthur Fitzwilliam Tait: Artist in the Adirondacks* (Newark: University of Delaware Press, 1986), pp. 228, 232. Currier & Ives published at least four lithographs of animal subjects called *The Happy Family*, but the three that are dated were issued after RuP's death. See *Currier & Ives: A Catalogue Raisonné*, vol. 1, intro. by Bernard F. Reilly, Jr. (Detroit: Gale Research, 1984), cat. nos. 2935, 2936, 2937, 2940, possibly 2938, and 2939.

55. Mary Jane Peale shared RuP's interest in game bird pictures. Two examples of her work in this genre, dated 1864 and 1868, are illustrated in *Kennedy Quarterly* 1 (June 1960): 98, 99. TRP painted at least one example in 1884. See Poesch, *Titian Ramsay Peale*, p. 116, fig. 55. See also fig. 38 herein.

56. RuP, "Journal of Woodland Farm," January 25, 27, 30, 1864; February 11, 1864.

57. William H. Gerdts, *Painters of the Humble Truth: Masterpieces of American Still Life, 1801–1939* (Columbia: University of Missouri Press, 1981), pp. 97–102.

58. Cadbury and Marsh, *Tait*, pp. 58, 327–28.

59. Sellers, "Rubens Peale: A Painter's Decade," nos. 96, 97, 100. See the Frick Art Reference Library study photographs: 136–11–b, *Quails in Landscape* (Sellers, no. 96); 136–11–c, *Male and Female Partridges* (illus. in *Kennedy Quarterly* 1 [June 1960]: 85); and 136-11-d, *Partridge Piece: Happy Family* (Sellers, no. 100, illus. in Elam, *Peale Family*, p. 120).

60. RuP to Mary Jane Peale, August 3, 1856, P-S, in F:VIIA/10C14-D3.

61. Flower subjects noted in Sellers, "Rubens Peale: A Painter's Decade," include nos. 8, 12, 14, 18, 30, the unnumbered "Pink Cactus" on p. 150, and another unnumbered flower painting cited n. 6, above. For popularity of flower subjects in midcentury, see Gerdts, *Painters of the Humble Truth*, pp. 119–23.

62. The title for *From Nature in the Garden* derives from an inscription on the back of the picture, presumably written by RuP. This title was used most recently in Alfred Frankenstein, *The Reality of Appearance: The Trompe L'oeil Tradition in American Painting* (Greenwich, Conn.: New York Graphic Society, 1970), p. 38. In his journal, RuP referred to this picture simply as a "flower piece" (Sellers, no. 12).

63. For Currier & Ives's floral still lifes, see William H. Gerdts and Russell Burke, *American Still-Life Painting* (New York: Praeger, 1971), pp. 68–69. For Harvey's and Roesen's floral paintings, see Gerdts, *Painters of the Humble Truth*, pp. 85–86, 121–23, and Judith Hansen O'Toole, *Severin Roesen* (Lewisburg, Pa.: Bucknell University Press, 1992), passim.

64. A different starting date of January 7, 1856, appears in Sellers, "Rubens Peale: A Painter's Decade," no. 12; and in both numerical lists of RuP's pictures (see n. 7, above).

65. I am grateful to Helen Gant, Utica, New York, who kindly helped me identify the flowers in

this painting. Even though RuP noted in his journal on September 7, 1856, that he had finished the picture, he worked on it several more times before varnishing it on December 23, 1856. In the "List of Pictures painted by Rubens Peale at Riverside farm," RuP noted that he had completed the work on December 10, 1857.

66. For an example of William Bartram's linear presentation of botanical specimens, see Ella M. Foshay, *Reflections of Nature: Flowers in American Art* (New York: Knopf, 1984), p. 30. For ReP's belief in the importance of line, see Marzio, *The Art Crusade,* p. 31; and Miller, "In the Shadow of His Father," *New Perspectives,* p. 99. ReP's call for students to draw "with accuracy and facility" appeared in his "Reminiscences," *The Crayon* 1 (January 10, 1855): 22.

67. In September 1855, RuP visited his son's colliery in Shamokin, Pennsylvania, and, in a letter to Mrs. Peale, noted: "I have been highly gratified with my examination of the works here, they are calculated to do a great business when the railroads are all completed." See RuP to Mrs. Rubens Peale, September 26, 1855, P-S, in F:VIIA/10C6–8. The following month the colliery was described as having a "Pea*lish* air—elegant, yet business-like; artistic, and yet natural." See "Peale, Cochran and Co.'s Lancaster Colliery, Shamokin," *Miners' Journal* (Pottsville, Pa.), October 20, 1855, p. 3.

68. It is not clear if RuP intended the flowers painted in this work to have symbolic connotations. Bruce Weber noted about a floral picture by Shepard Alonzo Mount (1804–1868) that there was a connection between the symbolism of its cut apple blossoms and the inscription, "Remember Me," on the vase in which they are displayed. See Bruce Weber, *The Apple of America: The Apple in 19th Century American Art* (New York: Berry-Hill Galleries, 1993), pp. 11–12. For mid-nineteenth-century American flower symbolism, see Gerdts, *Painters of the Humble Truth,* pp. 119–20, 123; and Foshay, *Reflections of Nature,* pp. 36, and 183, n.51.

69. Sellers, "Rubens Peale: A Painter's Decade," no. 45. James Burd married his first wife, Mary Clarissa McBurney, at St. Peter's Church, Philadelphia, on November 8, 1859. The next day his younger brother, Edward Burd, married Louisa Harriet Hubley in Reading, Pennsylvania. See Bell and Colwell, *James Patterson of Conestoga Manor,* pp. 229, 231.

70. Several discussions with Florence Marcus, New Hartford, New York, about this painting sharpened my thinking about it.

71. The possibility that Mary Jane finished the paintings that were in RuP's studio when he died was suggested by Sellers, "Rubens Peale: A Painter's Decade," p. 144. In Sellers's list, there are at least sixteen works (nos. 1, 3, 5, 6, 17, 31, 35, 37, 45, 46, 48, 50, 84, 92, 96, 127) that include references suggesting they were painted in collaboration with Mary Jane. Evidence of Mary Jane's collaboration with her father on other paintings can be found in entries in RuP's journal for August 28 and December 25, 1858, and April 8, 1863. Mary Jane probably worked on other pictures of her father's during his lifetime and after his death. RuP's son, George Patterson, also worked on some of his father's pictures. See, for example, RuP's journal for January 15, 16, 19, 31, 1857.

Another picture by Rubens (Sellers no. 41), illustrated in Wolfgang Born, *Still-Life Painting in America* (New York: Oxford University Press, 1947), fig. 34, may be a more reliable indication of RuP's limited ability at arranging a complex composition than the Munson-Williams-Proctor Institute's *Wedding Cake: Wine, Almonds, and Raisins,* on which he collaborated to some degree with Mary Jane.

72. Sellers, no. 130. James Burd Peale's wife's burial is recorded in William Bender Wilson, "A Condensed History of Emmanuel Church, Holmesburg, From 1832 to 1914, Together with an alphabetically arranged compilation of the Parish Register from July 6, 1844 to January 1, 1914," Emmanuel Episcopal Church, Holmesburg, Pennsylvania, p. 96.

73. Sellers, "Rubens Peale: A Painter's Decade," no. 50, gives December 26, 1860, as the starting date for this self-portrait.

74. Ibid., no. 51. This interior view and another that RuP subsequently painted (ibid., no. 127) are unlocated.

75. I am grateful to Anne Sue Hirshorn for the suggestion that the picture of a watermelon in RuP's painting resembles the work of SMP. See, for comparison, her *Slice of Watermelon* (1825; Wadsworth Atheneum, Hartford, Conn.), illustrated in Wilbur H. Hunter and John Mahey, *Miss Sarah Miriam Peale, 1800–1885: Portraits and Still Life* (Baltimore: The Peale Museum, 1967), fig. 41. In Mary Jane Peale's 1884 "List of Pictures I own," SMP's portrait of Mrs. Peale with her son is designated no. 30. The entry has an undated

addendum: "gave the original to Clara Mills[?] but made a copy for myself." Sarah Miriam's original and Mary Jane's copy (private collection) also are mentioned in the "Last Will etc. of Mary Jane Peale, Deceased."

76. Mary Jane had at least one game picture at the farm, as well as an assortment of portraits and still lifes (both originals and copies), a couple of fancy pieces after ReP, and the works she made at the Pennsylvania Academy. CWP's portrait of Mrs. Rubens Peale was probably at the farm, as was his portrait of Edward Burd. Early in 1858, RuP also had in his possession his father's portrait of *John P. De Haas* (1772; National Gallery of Art, Washington, D.C.). As noted, CWP's view of Belfield also was at the farm in 1860. Several of JP's still lifes were at the farm from time to time; namely, an unlocated picture of a watermelon and branch of blooming fuchsia; a "fruit piece" (versions at the Munson-Williams-Proctor Institute, Utica, New York, and the Corcoran Gallery of Art, Washington, D.C.); another "fruit piece" (one version of which is at the Museum of Fine Arts, Boston); an unlocated "white watermelon"; a version of *Still Life: Peaches and Grapes* (see Elam, *Peale Family,* p. 88); and, possibly, the *Fruit and Grapes* (fig. 11). The paintings of CWP's house in Philadelphia and ReP's *Rubens Peale with a Geranium* (see pl. 16) were probably at the farm, as were two portraits ReP painted of Mary Jane (both in private collections). In 1864 Mary Jane also had one of ReP's portraits of George Washington at the farm. Besides RaP's portrait of *Rubens as Mascot* (pl. 27) and the still life of 1813, *Cake and Wine,* RuP also had for a while at the farm another still life by RaP, which was owned by George Ord (see n.22, above).

77. Miller, "In the Shadow of His Father," p. 93.

78. Lillian B. Miller, "Charles Willson Peale as History Painter: The Exhumation of the Mastodon," *New Perspectives,* p. 153; Therese O'Malley, "Charles Willson Peale's Belfield: Its Place in American Garden History," *New Perspectives,* pp. 273–74.

79. RuP, "Journal of Woodland Farm," November 26, 1864.

80. David Rosand, "Style and the Aging Artist," *Art Journal* 46 (Summer 1987): 91–93.

81. Sellers, "Rubens Peale: A Painter's Decade," nos. 72, 105.

6: Titian Ramsay Peale's Specimen Portraiture; or, Natural History as Family History

KENNETH HALTMAN

I wish to acknowledge the assistance of the following individuals and institutions: Edward C. Carter II, Librarian, and Elizabeth Carroll-Horrocks, Archivist, American Philosophical Society; Susan Frankenbach, Registrar, and Richard S. Field, Curator of Prints, Drawings and Photographs, Yale University Art Gallery; and Erin Wright, for her careful reading of the manuscript.

1. For biographical information, the best sources remain two works by Jessie J. Poesch: "Titian Ramsay Peale, Artist-Naturalist" (master's thesis, University of Delaware, 1956), and *Titian Ramsay Peale, 1799–1885, and His Journals of the Wilkes Expedition,* Memoirs of the American Philosophical Society, vol. 52 (Philadelphia, 1961). For a more recent reconstruction of the artist's early career, see Kenneth Haltman, "Figures in a Western Landscape: Reading the Art of Titian Ramsay Peale from the Long Expedition to the Rocky Mountains, 1819–1820" (Ph.D. diss., Yale University, 1992).

2. CWP, "Diary of A Visit to New York," P-S, in *Selected Papers,* 3:506; entry for June 1, 1817.

3. See, for instance, CWP's accounting of his children to Hannah Moore, just prior to their marriage, where he repeats a view attributed to Sophonisba and RuP that TRP was on the road to becoming "a specimen of the worst," but predicts that the boy would be "very easily managed by some small attention." (CWP to Hannah Moore, August 2, 1805, P-S, in *Selected Papers,* 2:873). The first paternal reference to TRP's "talents for the fine Arts" dates to some years later; see CWP to George Howell, August 21, 1811, P-S, in *Selected Papers,* 3:99.

4. CWP to Henry Moore, March 9, 1811, P-S, in *Selected Papers,* 3:84.

5. CWP reported and explained this decision in a series of letters to friends and family. See, for example, CWP to Sybilla Miriam Peale and Elizabeth DePeyster Peale, September 20, 1813, and CWP to John DePeyster, November 12, 1813, P-S, in *Selected Papers,* 3:205, 212. On manufacture in the Brandywine in this period, with discussion of the Hodgson works and mention of Titian's stay, see Roy M. Boatman, "The Brandywine Cotton Industry, 1795–1865," unpublished manuscript, Hagley Museum and Library (Wilmington, Delaware, 1957), pp. 59, 94–96; Norman B. Wilkinson, "Brandywine Borrowings From European Technology," *Technology and Culture* 4 (1963): 3; and Anthony F. C. Wallace, *Rockdale: The Growth of An American Village in the Early Industrial Revolution* (New York: Knopf, 1978), p. 217.

6. CWP to John DePeyster, February 6, 1814, P-S, in *Selected Papers,* 3:233. Whereas discipline was central to CWP's design in TRP's case, his decision to apprentice BFP was based on his more practical desire to import the mill technologies of the Brandywine region to Germantown.

7. See *Selected Papers,* 3:209–11, 215, 217–18, 233, 248; CWP to A.F.M.J. Palisot de Beauvois, October 13, 1816, P-S, in *Selected Papers,* 3:453. On patterns of indenture along the Brandywine in this period, see Harold B. Hancock, "The Indenture System in Delaware, 1681–1921," *Delaware History* 16 (April 1974): 47–59.

8. CWP had experienced his own apprenticeship as an indignity even as he had made the most of it, moved by a passionate desire for freedom echoed ironically in the words he chose five decades later to describe the condition of indentured servitude into which he placed his son: "Titian will be free at 20 years of age, he is now 14" (CWP to John DePeyster, November 12, 1813, in *Selected Papers,* 3:212.) On CWP's desire for freedom from his own apprenticeship, which he eventually experienced as "like water to the thirsty, like food to the hungry, or like rest to the wearyed traveller, who has made a long and lonesome journey through a desert, fearfull wilderness," see *CWP,* pp. 22–23.

9. CWP to RuP, August 24, 1816, P-S, in *Selected Papers,* 3:445.

10. CWP to RuP, August 24, 1816, *Selected Papers,* 3:444. TRP, CWP opined, was "young & thoughtless and ha[d] too long been indulged in all his fancies." The strictness of the elder Peale's exercise of patriarchal authority is difficult to gauge, given the context of strict paternalism characteristic of the early modern period, but family letters unambiguously record a recurrent filial resistance to his will. TRP, in fact, appears to have been torn between natural desire to oblige his father's wishes, thereby earning the man's love, and resentment at the rather extreme presumptions of paternal authority—feelings all his male siblings seem to have shared to some extent.

11. An 1817 sketchbook devoted to lepidoptera subjects, now unbound, is held by the American Philosophical Society, Philadelphia.

12. Maclure, a wealthy Scot and important amateur naturalist, funded the trip himself under the auspices of the Academy of Natural Sciences of Philadelphia.

13. See Charlotte M. Porter, "Following Bartram's 'Track': Titian Ramsay Peale's Florida Journey," *Florida Historical Quarterly* 61 (April 1983): 431–44, with an annotated transcription of the MS, 434–44. The account appears to have been written by Louis Titian Peale, the naturalist's grandson, who later inherited his papers; see n.50, below.

14. For this earliest military reconnaissance of the trans-Mississippi West to be accompanied by professional scientists and artists, see the expedition's official report, *Account of an Expedition From Pittsburgh to the Rocky Mountains* (Philadelphia: H. C. Carey & I. Lea, 1822–23), compiled by Edwin James and published privately in two text volumes and an illustrated atlas; and Roger L. Nichols and Patrick L. Halley, *Stephen Long and American Frontier Exploration* (Newark, Del.: University of Delaware Press, 1980). On his father's efforts to have TRP named to the expeditionary command, see CWP to RuP, December 12, 1818, P-S, in *Selected Papers,* 3:666; A(TS): 427.

15. These materials were presented to CWP by Thomas Jefferson in March 1810. For the accession record, see "Memoranda of the Philadelphia Museum," Historical Society of Pennsylvania, in F:XI-A.

16. For more detailed discussion of TRP's Long Expedition activities and production, see Haltman, "Figures in a Western Landscape," pp. 75–246.

17. CWP to John C. Calhoun, December 24, 1820, in TRP, ed., "Charles Willson Peale, a Biography," TS (Philadelphia: American Philosophical Society, c. 1870), p. 965.

18. See TRP to CWP, June 21, 1821, P-S, in F:VIIIA/1D8–11: "It is with sincere regret I hear that I am not likely to get the situation at the Museum to which I think myself justly entitled, having laboured so long to make myself worthy of it."

19. CWP to RuP, 10 September 1822, P-S, in F:IIA/67E1–3.

20. CWP to RuP, August 24, 1816.

21. See, for example, *CWP,* p.23.

22. CWP, "An Essay, to Promote Domestic Happiness" (Philadelphia, 1812), 18, in *Selected Papers,* 3:129–47.

23. CWP to TRP, February 21, March 21, 1820, in *Selected Papers,* 3:801. A Commission of Lunacy called in Philadelphia found BFP's wife Eliza legally insane the following day; see *Selected Papers,* 3:808, n.1.

24. See TRP to CWP, June 21, 1821, P-S, in F:VIIIA/1D8–11.

25. CWP to RuP, August 4, 1822, P-S, in F:IIA/67D6–8.

26. Other aspects of this painting owed to TRP include the turkey in the foreground and a number of ornithological mounts visible at midground left. See Roger B. Stein, "Charles Willson Peale's Expressive Design: *The Artist in His Museum,*" in *New Perspectives,* pp. 171, 189.

27. This head has been mistaken for a death mask, despite its date of execution and its bloodied neck. In a recent article ("Invisible Killers: Heavy Metals, Saturnine Envy, and the Tragic Death of Raphaelle Peale," *Transactions and Studies of the College of Physicians of Philadelphia,* vol. 16 [December 1994]: 83–99), Phoebe Lloyd reattributes the image to Raphaelle based on style. For the original attribution, to which I hold, see Anna Wells Rutledge, *A Catalogue of Portraits and Other Works of Art in the Possession of the American Philosophical Society,* American Philosophical Society Memoirs, vol. 54 (Philadelphia, 1961): 73.

28. According to Edwin James, the Long Expedition's official chronicler, TRP removed the head of the black-tail deer only after his return to Philadelphia, finding the body too decayed to salvage. See *Account of an Expedition,* vol. 2, n. 88.

29. See Charles Coleman Sellers, *Charles Willson Peale,* vol. 1, Memoirs of the American Philosophical Society, vol. 23 (Philadelphia, 1947): 233.

30. The source of TRP (1)'s original exhibition mount may be an engraving of the "Loup tacheté" in François le Vaillant, *Second voyage dans l'intérieur de l'Afrique, par le Cape de Bonne-Espérance, dans les années 1783, 84 et 85,* vol. 2 (Paris: H. J. Jansen et compagnie, 1796), pl. 9, facing p. 84.

31. These watercolors seem to have been intended at once as works of art in their own right, as illustrations for a projected volume on *American Zoology,* and as designs for (or perhaps as copies after) Philadelphia Museum mounts. TRP exhibited the first four watercolors of zoological subjects at the Pennsylvania Academy in May 1822. For a useful overview of his production in this period, see Charlotte M. Porter, "The Lifework of Titian Ramsay Peale," *Proceedings of the American Philosophical Society,* vol. 129 (Philadelphia, 1985): 300–312.

32. For a fuller discussion of this image and the series of revisions which it culminates, see Kenneth Haltman, "Private Impressions and Public Views: Titian Ramsay Peale's Sketchbooks from the Long Expedition, 1819–1820," *Yale University Art Gallery Bulletin* (Spring 1989): 47–48.

33. See Amy R. W. Meyers, "Sketches From the Wilderness: Changing Concepts of Nature in American Natural History Illustration, 1680–1880" (Ph.D. diss., Yale University, 1985), pp. 244, 258, and passim.

34. For the history of the term *museum group* and its roots in practices first developed in the Peale Museum, see Frederic A. Lucas, *The Story of Museum Groups,* American Museum of Natural History, Guide Leaflet Series, no. 53 (November 1921).

35. For a compelling contextual and intertextual study of *The Peale Family,* see David Steinberg, "The Characters of Charles Willson Peale: Portraiture and Social Identity, 1769–1776" (Ph.D. diss., University of Pennsylvania, 1993), pp. 237–38; for the phrase cited, p. 204.

36. The previous year CWP had called off earlier plans for this wedding in a strongly worded letter to TRP (unlocated) in which he referred to his son's fiancée as "low-bred" and, in a reference to her Roman Catholicism, "bigoted." He had written a strong letter of disapproval to her mother at this time, as well (CWP to Bridget Laforgue, May 4, 1822,. P-S, in F:IIA/66G5–7. For the fullest account of the wedding itself, see CWP to ReP, October 11, 1822, P-S, in F:IIA/67E9–11. CWP later attempted to tidy the record, noting in a footnote to this letter that he had erred in disapproving the marriage, and that Eliza had shown herself to be a highly acceptable daughter-in-law.

37. See TRP, "Hunting Recollections," *The Cabinet of Natural History and American Rural Sports* 1 (1830): 19.

38. For what is known of this collecting expedition, which was apparently sponsored by Silas E. Burroughs of Philadelphia, see Poesch, "Titian Ramsay Peale, Artist-Naturalist," pp. 86–87.

39. TRP, *Circular of the Philadelphia Museum: Containing Directions for the Preparation and Preservation of Objects of Natural History* (Philadelphia, 1831).

40. For a perceptive discussion of the illustrations in the English edition of Vaillant's *Travels,* see David Bunn, "'Our Wattled Cot': Mercantile and Domestic Space in Thomas Pringle's African Landscapes," in W. J. T. Mitchell, ed., *Landscape and Power* (Chicago: University of Chicago Press, 1994), pp. 129–36; see also n. 30, above. As far as I am aware, TRP never acknowledged this borrowing, nor would doing so have been strictly necessary by the standards of the age. He did, however, work his monographic signature into the surface of the lithograph plate itself at center left.

41. Fourteen plates associated with this ambitious project survive. The fact that this *Prospectus* was published by Lehman and Duval explains the appearance of an engraving after another of Titian's Long Expedition sketches, the so-called *Buffaloe Hunt on the River Platte* of 1836 in the last number of a contemporary publication, the *Aboriginal Port-Folio* by James Otto Lewis, for which Lehman and Duval were also responsible. See Dolores M. Gall, "Titian Ramsay Peale: An American Lithographer and Naturalist," *Yale University Art Gallery Bulletin* 38 (Winter 1983): 12.

42. See, for example, *Pilot House* (graphite on paper, private collection) based on smaller field sketches, one at the American Philosophical Society and the other at the American Museum of Natural History, similarly labeled *Pilot's House, Rio Negro, Patagonia* but containing no figures. These appear to have been executed on January 25 or 26, 1839; see "Peale's Journals of the Wilkes Expedition," transcription in Poesch, *Titian Ramsay Peale,* pp. 135–36.

43. Two of these paintings are in the collections of the Bernice P. Bishop Museum in Honolulu, and two others in those of the American Museum of Natural History. Preparatory drawings are at the American Philosophical Society. See Edith Gaines, "Titian Peale's Paintings of Hawaii," *Antiques* (August 1960): 140–41.

44. See Charlotte M. Porter, "'Subsilentio': Discouraged Works of Early Nineteenth-Century Natural History," *Journal of the Society for the Bibliography of Natural History* 9 (1979): 109–19. Almost the entire run was lost in the Smithsonian fire of 1853. The text has recently been reissued, along with its original introduction, as Titian R. Peale, *Mammalia and Ornithology* (New York: Arno Press, 1978). On the contemporary controversy surrounding Titian's contributions to the Wilkes Expedition's public record, see William Stanton, *The Great United States Exploring Expedition of 1838–1842* (Berkeley: University of California Press, 1975), pp. 290–328; and George E. Watson, "Vertebrate Collections," in *Magnificent Voyagers: United States Exploring Expedition, 1838–1842* (Washington, D.C. Smithsonian Institution Press, 1985), pp. 47–58.

45. A number of TRP's unpublished Wilkes Expedition drawings are in the collections of the American Philosophical Society, Philadelphia.

46. For useful discussions of TRP's professional decline, see Poesch, "Titian Ramsay Peale, Artist-Naturalist," pp. 128–35; and Porter, "The Lifework of Titian Ramsay Peale," pp. 305–6.

47. TRP's original description of *Pandion solitarius* as a bird-eating hawk appeared in the 1848 edition of his *Mammalogy and Ornithology,* p. 62; Cassin's reidentification appeared on p. 97 of his 1858 revision of this text. For a perceptive discussion of the controversy, see Watson, "Vertebrate Collections," p. 53.

48. TRP and Eliza had eight children in all. A son, Louis Bonaventure Peale, died in infancy in 1844; a daughter, Mary Florida Peale, died at age 22 in 1847, following her mother by barely a year.

49. See Julie Link Haifley, *Titian Ramsay Peale* (Washington, D.C.: The Gilman Library, George Washington University, 1981).

50. Louis Titian Peale (1854–1896) arrived in Washington to stay with TRP and Lucy at his father's death in 1864; by the time this photograph was taken, he seems essentially to have been adopted by them. Trained as a printer and employed as an editor, Louis, at TRP's death in 1885, received all his grandfather's paintings, drawing materials, guns, tackle, cameras, and books on natural history (Philadelphia Register of Wills, bk. 121, p. 188).

51. Poesch, *Titian Ramsay Peale,* p. 111.

52. TRP and Lucinda MacMullen Peale, editors and compilers, "Charles Willson Peale, a Biography," p. 1. This enormous manuscript—it numbers more than one thousand pages—is held in the collections of the American Philosophical Society, Philadelphia. Due to a lack of funds, the manuscript was neither edited nor published as originally planned.

53. TRP intended his book to be both definitive and publishable. For evidence of his continued interest in disseminating information related to his entomological collections, see Porter, "The Lifework of Titian Ramsay Peale," pp. 304–5.

54. The American Museum of Natural History, New York City, owns three volumes of sketches and finished watercolors for this project.

55. The book is today in the American Philosophical Society, Philadelphia. Its title was unaccountably mistranscribed "Sea[son]s of Appearance" by Charles Coleman Sellers, whose intuition in such matters was generally excellent.

7: James Peale: Out of the Shadows

LINDA CROCKER SIMMONS

1. CWP to "Captain Digby," September 25, 1763, P-S, in *Selected Papers,* 1:35.
2. Charles Coleman Sellers, "James Peale: A Light in Shadow 1749–1831," in *Four Generations of Commissions, The Peale Collection of the Maryland Historical Society* (Baltimore, 1975), p. 29.
3. CWP to John Beale Bordley, March 29, 1772, P-S, in *Selected Papers,* 1:118–19. The contemporary meaning of the term batten is not clear. Battens in nautical use are wooden strips applied to strengthen the corners of sails; used in frames, they serve as a substitution for keying at the corners of the stretchers or strainers, or as a system of cradling across the back of the canvas. Neither process would have been visible from the front or sides, in contrast to the statement by CWP that they went "round it" almost like a frame.
4. CWP to Benjamin West, April 20, 1771, P-S, in *Selected Papers,* 1:95.
5. There are only a few dates written in the sketchbook (P-S, B/P31–11 [No. 1], in ink: "Sept 1786—of James Peale"; the range of dates is determined from the dates of the paintings to which the drawings relate.
6. The *New Guide to the Collections in the Library of the American Philosophical Society,* ed. J. Stephen Catlett (Philadelphia: American Philosophical Society, 1987) describes the volume as "1 vol. (60 pp.)/Sketches of scenes, animals, mills, machinery, persons, ships, furniture, etc.; also brief notes." The volume measures 4 ½ by 7 inches with bound covers over stitched pages of creamy white laid paper. For the purposes of identification, the sheets of this volume, on which the sketches are found, have been numbered sequentially following the front cover, as 1 through 81. The few loose sheets now separate from the sketchbook are included in the numbering except for a few discrete items (p. 216, entry 888).
7. "Compiled Service records: Revolutionary War, First Maryland Regiment, December 10, 1776," in F:III/1E2.
8. Some of the locations where JP served and fought as an officer in the Maryland battalion are recorded at the Maryland Hall of Records, Annapolis. His brother listed the battles where JP fought in a letter to ReP, December 7, 1822, P-S, in F:IIA/68A2–3.
9. George Washington to JP, June 2, 1779, private collection, in F:III/1C8–9.
10. JP to George Washington, June 3, P-S, 1779, in F:III/1C12–13.
11. List of items bought for Captain Muse and Christopher Richmond by "Capt. James Peale at Philadelphia," September 9, 1779, Maryland Historical Records Office, Annapolis. Also see John Randall, "Receipt for $1,600 . . . to Capt. James Peale . . . to account of Capt. Walker Muse of 1st Maryland Regiment, September 19, 1779," Maryland Historical Records Office, Annapolis, Revolutionary Papers 3/7–3, in F:III/1D13–14.
12. Charles Coleman Sellers, *Charles Willson Peale,* Memoirs of the American Philosophical Society, 23 (Philadelphia 1939), 2:415. The same date, 1782, appears on a slip of paper found in JP's only sketchbook, with a list of miniatures "painted since the 14 November 1782."
13. *Selected Papers,* 1:458. This would have been just over three weeks before JP's marriage.
14. City directories record JP residing at 81 Lombard Street from 1791 until 1800. His profession was variously given as "limner"(1791, 1795–98, 1800), "portrait painter" (1793 and 1794), "limner and painter" (1799), "limner and miniature painter" (1800–1801), and "portrait painter" (1802 until his death). James Hardie, *The Philadelphia Directory and Register* (Philadelphia, 1791; 1793; 1794); Edmund Hogan, *The Prospect of Philadelphia and Check on the Next Directory, Part I* (Philadelphia, 1796); Cornelius W. Stafford, *The Philadelphia Directory for 1797* (Philadelphia, 1797; 1798; 1799; 1800; 1801); James Robinson, *The Philadelphia Directory, City and County Register, for 1802* (Philadelphia, 1802).
15. The identification of the children is based on a comparison of eye and hair color in other portraits of the sitters, together with a general estimate of their age in relation to their dates of birth.
16. See Margaretta M. Lovell, "Reading Eighteenth-Century American Family Portraits, Social Images and Self-Images," *Winterthur Portfolio, A Journal of American Material Culture* 22, no. 4 (Winter 1987): 252–57, 259–64.
17. See Kathleen B. Miller in her entry for this work in Edward J. Nygren et al., *Views and Visions, American Landscape before 1830* (Washington, D.C.: Corcoran Gallery of Art, 1986), pp. 280–81.
18. The painting has a number of vanishing points that are probably derived from the various sketches utilized in creating the final composition in the studio. Miller observed their presence in her entry on this work in Nygren, *Views and Visions.*
19. Nygren, *Views and Visions.* Miller notes in her entry on this painting that, in contrast to Sellers's assertion, the style of dress for these figures is contemporaneous with the painting.
20. *Selected Papers,* 1:502, 504.
21. CWP to ReP, July 27, 1820, P-S, in *Selected Papers,* 3:842.
22. Miller, in Nygren, *Views and Visions,* pp. 280–81.
23. It is possible that there once was a third version titled either *Revolutionary Subject: Captain Allan McLane Attacking British Officers in a Park in Philadelphia,* or *John Bull Takes a Scotch Prize* (*Selected Papers,* 2:527, n.3).
24. *Selected Papers,* 2:526–27.
25. Charles H. Elam, *The Peale Family, Three Generations of American Artists* (Detroit: Detroit Institute of Arts, 1967), p. 27.
26. Beatrice B. Garvan, *Federal Philadelphia 1785–1825: The Athens of the Western World* (Philadelphia, Philadelphia Museum of Art and University of Pennsylvannia Press, 1987), p. 57.
27. JP, MS. sketchbook, nos. 19 and 21.
28. This painting may be item no. 38, "Portrait of a Lady playing on a Harp, 1819," which JP displayed in the 1819 exhibition of the Pennsylvania Academy of the Fine Arts.
29. See William H. Gerdts, *Painters of the Humble Truth, Masterpieces of American Still Life, 1801–1939* (Columbia: University of Missouri Press, 1981), p. 62.

8: Anna Claypoole, Margaretta, and Sarah Miriam Peale: Modes of Accomplishment and Fortune

ANNE SUE HIRSHORN

I particularly want to thank Reference Librarian Manon Theroux and Librarian James N. Green of the Library Company, Philadelphia; and in Saint Louis, Assistant Professor Elaine Tillinger of Lindenwood College and Librarian Charles E. Brown of the Saint Louis Mercantile Society Library.

1. James and Helena Mercer Claypoole, Mary Claypoole's ancestors, came from London to Philadelphia in 1683 and were closely associated with the activities of William Penn. One of their sons, the patriarch of Mary Claypoole's family, was Joseph Claypoole (1677–1744), whose son Josiah and grandsons Joseph and George were joiners. James Claypoole, Mary's father, collaborated with John Folwell on a painting on silk, *Standard of the Philadelphia Light Horse* (1775), called the "finest Revolutionary flag in existence" (Morrison H. Heckscher and Leslie Greene Bowman, *American Rococo, 1750–1775: Elegance in Ornament* [New York: Metropolitan Museum of Art and Harry N. Abrams, 1992], pp. 14–15.) For James Claypoole as high sheriff, see *History of St. Paul's Church* (Philadelphia: Colonial Society of Pennsylvania, 1917), p. 270. For Elizabeth Cromwell Claypoole, see *Dictionary of National Biography*, vol. 4 (London, 1922), pp. 467–68. For SMP's interest in Cromwell descent, see "Interesting Reminiscences by a Well-Known Lady Artist," *St. Louis Republican*, November 26, 1877.

2. In November 1819, the JP family moved from a small house on Lombard Street near the Delaware River to a commodious brick house at 228 Spruce Street above Sixth. Each woman listed her specialty and address in Philadelphia exhibition catalogues and in listings in Philadelphia City Directories (First Census of the United States taken in the Year 1790 [Washington, D.C.: Government Printing Office, 1908], p. 242). See also SMP to TRP, November 7, 1819, P-S, in F:lll/4G5–8.

3. This attribution was questioned by Edward Dwight in his annotations to a copy of the catalog, *The Peale Family: Three Generations of American Artists* (Detroit: Wayne State University Press, 1967) in the Peale Family papers office, National Portrait Gallery, Washington, D.C. Dwight believed that the signature on the painting was a forgery. On the back of the work is the signature "Anna Travers."

4. A collection of 169 Dutch and Flemish landscapes, still lifes, and genre paintings, listed in *A Catalogue of PAINTINGS*, was sold at auction in 1809 by Andrew Bayard at No. 15, South Front Street (Bayard broadside, collection of Michael Zinman, New York).

5. John Wilmerding, *American Art* (London: Penguin Books, 1976), p. 76.

6. See photograph, Frick Art Reference Library. Margaretta's portrait of JP was formerly owned by Horace Wells Sellers.

7. CWP to ReP, April 13, 1818, P-S, in *Selected Papers*, 3:589.

8. See Nicolai Cikovsky, Jr., Linda Bantel, and John Wilmerding, *Raphaelle Peale Still Lifes* (Washington, D.C.: National Gallery of Art, 1989), p. 23.

9. Gilmor noted that he purchased SMP's "A Fruit Piece with Malaga Grapes and Peaches" in Philadelphia in 1822 ("Catalogue of Paintings in the possession of Robert Gilmor, Baltimore, 12 July 1823." MS, Maryland Historical Society, Baltimore).

10. For Jane's study, see Edward Biddle and Mantle Fielding, *The Life and Works of Thomas Sully* (1921; reprint, New York: Kennedy Graphics, 1970), p. 39. For Rosalie Sully's exhibited work, "Indian Girl," see *Catalogue of the Fifth Exhibition of Paintings in the Athenaeum Gallery* (Boston: Eastburn, 1831), p. 8. A portrait miniature of actress Charlotte Cushing, attributed to Rosalie, is in the collection of the Folger Library, Washington, D.C.

11. ACP became head of the family after JP's death. See Coleman Sellers to Sophonisba Peale Sellers, June 18, 1831, P-S, in F:XC/1D5–8; "Anna Staughton has let the house to Mr. Neal and his Wife a quaker family," Sellers reported, indicating Anna's economic arrangements. Also see *Philadelphia Census of 1840*, Microfilm, PHi.

12. Quoted in Elizabeth Frances Ellet, *Women Painters in All Ages and All Countries* (New York: Harper & Brothers, 1859), p. 290.

13. For a discussion of the painter's tools shown in CWP's *James Painting a Miniature* (1822; Detroit Institute of Arts), see Anne Sue Hirshorn, "Legacy of Ivory: Anna Claypoole Peale's Portrait Miniatures," *Bulletin of the Detroit Institute of Arts* 4 (1989): 21, 25.

14. T. S. Cumming, "Practical Directions for Miniature Painting," in William Dunlap, *A History of the Rise and Progress of the Arts of Design in the United States*, vol. 2 (1834; reprint, New York: Dover, 1965): 10, 11. Of great concern to the miniature painter was maintaining "Ivory . . . free from grain . . . also thin and white." The cost of ivory was about a dollar per "plate" (piece); it was sold at fancy-goods stores or by ivory turners (Letter from Eliza Champlain to Mary Way [n.d., February, 1818], private collection; courtesy, Ramsay MacMullen).

15. Neil Harris, "The Pennsylvania Academy of the Fine Arts: Joseph Hopkinson, Annual Discourse," in Gordon S. Wood, ed., *The Rising Glory of America* (New York: George Braziller, 1971), p. 333.

16. *First Annual Exhibition of The Society of Artists of the United States* (Philadelphia, 1811), p. 9.

17. [Margaret Bayard Smith], *What is Gentility? A Moral Tale* (Washington, D.C.: P. Thompson, 1828), pp. 56, 57.

18. Charles Brockden Brown (1771–1810), three fragments: *The Paradise of Women: Two Dialogues, The First on Music; the Second on Painting, as a female accomplishment or mode of gaining subsistence and fortune,* in William Dunlap, *Memoir of Charles Brockden Brown* (London: H. Colburn, 1822), pp. 309–33. Library of Congress, Washington, D.C.

19. Ibid., pp. 329–30.

20. Caroline Schetky exhibited miniatures and drawings at the Pennsylvania Academy from 1818 to 1826, and at the Boston Athenaeum, from 1827 to 1841. RuP invited Caroline to show work at his first exhibition in the Baltimore Museum in 1822. Also see Caroline Schetky to Anna Johnson, August 5, 1818, in Laurence Oliphant Schetky, *The Schetky Family* (Portland, Maine: privately printed, 1942), p. 200.

21. See Robert Stewart, *Henry Benbridge 1743–1812: American Portrait Painter* (Washington, D.C.: Smithsonian Institution Press for the National Portrait Gallery), pp. 17–23.

22. Brown, *The Paradise of Women*, p. 331.

23. ACP's signature changed from "Anna Peale" to "Anna C. Peale" around 1815 and then to "Anna C. Staughton" after 1829. On women's status and their aspirations in the early nineteenth century, see Mary Beth Norton, *Liberty's Daughters: The Revolutionary Experience of American Women, 1750–1800* (Boston: Little Brown and Company, 1980), p. 296.

24. ACP to TRP, April 7, 1819, in *Selected Papers*, 3:714.

25. The lectures were presented by Dr. Samuel Calhoun (1787–1841), a staff physician at the Pennsylvania Hospital, Philadelphia, from 1816 to 1841. See P-S, in F:/III/4F9–12.

26. Ellet, *Women Painters*, p. 290.

27. Nina Baym, *Woman's Fiction: A Guide to Novels by and about Women in America (1820–1870)* (Urbana: University of Illinois Press, 1993), pp. xxxvii–xxxviii.

28. ACP was able to use the collections of the Library Company of Philadelphia; after 1823, her brother, James Peale, Jr., who owned shares in the company from 1823 to 1830, could have borrowed items for her. The Library Company's collections included current Philadelphia fashion magazines, such as the *Album and Ladies Weekly Gazette* of June 1827, the first to be illustrated with a fashion plate, or the *Ladies Literary Port Folio,* the next earliest plate, published in 1829.

29. For Sully and *Beatrice Cenci,* see Biddle and Fielding, *Sully,* p. 237; ACP's miniature was exhibited in 1829 as number 350 in the PAFA, and at the Boston Athenaeum in 1831 (number 240). See Peter Hastings Falk, ed., *The Annual Exhibition Record of the Pennsylvannia Academy of the Fine Arts, 1807–1890* (Madison, Ct: Soundview Press, 1988), p. 162; Robert F. Perkins, Jr. and William J. Gavin, III, eds., *The Boston Athenaeum Art Exhibition Index,*

1827–1874 (Boston, Ma.: The Library of the Bostom Athenaeum and MIT Press, 1980), p. 108.

30. Mary Kelley, in *Private Woman, Public Stage: Literary Domesticity in Nineteenth-Century America* (New York: Oxford University Press, 1984), writes "the eight [of twelve nineteenth-century women writers] who did marry looked to the fields of religion, science, and letters, and commerce and law for their spouses. The majority chose husbands whose education included college during years in which less than one percent of the population attended institutions of higher learning" (p. 354, n.19).

31. *Baltimore Daily and Commercial Advertiser,* October 11, 1822.

32. *Embaizada Do Brasil Em Washington* (no author, no date), p. 23.

33. "Interesting Reminiscences," *St. Louis Republican,* November 26, 1877.

34. Harriet Cany Peale to Anna Sellers, P-S, in F:VIA/15D8–E1; *Weekly Reveille,* Saint Louis, July 27, 1846, 3:3, p. 940 (a reprint of an earlier article that appeared on July 21, 1846). The misstated relationship of SMP to ReP may have arisen because of the acquisition in 1846 by the Saint Louis subscription library of a copy of ReP's *Notes on Italy* (Philadelphia, 1831). The volume passed into the collections of the Saint Louis Mercantile Society Library.

35. *National Cyclopedia of American Biography,* vol. 4 (New York: James T. White & Co., 1897), p. 151; *St. Louis Republican,* November 26, 1877.

36. Daniel Boorstin, *The Americans, the Democratic Experience* (New York: Vintage Books, 1974), pp. 296–98.

37. Dolores Kilgo, "'Sunbeam Art': The Daguerreotypes of Thomas M. Easterly," in *Gateway Heritage,* vol. 14, 4 (Saint Louis, 1994): 54–63. For a photograph of Father Theobald Mathew, see ibid., p. 58.

38. SMP moved several times during these years as Saint Louis changed and expanded. She is listed in Saint Louis directories as a "portrait painter" at 116 N. Fourth Street, in 1848, and her last address in the 1870s was a studio near Lucas Place.

39. No. 20, in *A Guide to the Sculpture, Paintings and Other Objects of Art in the Halls of the St. Louis Mercantile Library Association* (Saint Louis, 1859), p.59. SMP's portrait of Benton was purchased by the Missouri Historical Society from John Rice in 1877.

40. *Catalogue of the First Annual Exhibition of the Western Academy of Art* (Saint Louis: Missouri Democrat Book and Job Office, 1860), pp. 6, 8, 13.

41. *Report of the Fourth Annual Fair of the St. Louis Agricultural and Mechanical Association of September, 1859* (Saint Louis, 1860), pp. 9–10.

42. John Wilmerding, *An American Perspective: Paintings from the Ganz Collection* (Washington, D.C.: National Gallery of Art, 1981), p. 99. For American Pre-Raphaelites, see William H. Gerdts, "Through a Glass Brightly: The American Pre-Raphaelites and their Still Lifes and Nature Studies," in Linda S. Ferber and William H. Gerdts, *The New Path: Ruskin and the American Pre-Raphaelites* (New York: Schocken Books for the Brooklyn Museum, 1985), pp. 39–77.

43. *St. Louis Republican,* July 9, 1878: "Miss Sarah M. Peale, the artist . . . left last night to join her sisters in Philadelphia." ACP died on December 25, 1878; Margaretta, in 1882; and SMP, in 1885.

9: Politics, Portraits and Charles Peale Polk

Linda Crocker Simmons

1. Elizabeth and Robert Polk had three children: Margaret Jane, born 1766; CPP, born 1767; and Elizabeth Bordley, born 1770. After their mother's death, the three Polks resided with Peale relatives in Charlestown, Maryland. They later lived with Charles Willson and Rachel Peale in Philadelphia and were with them when their father, Robert, was killed in a sea battle in 1777. Charles Coleman Sellers, *The Artist of the Revolution: The Early Life of Charles Willson Peale* (Philadelphia: American Philosophical Society, 1939), pp. 6, 91, 178–79.

2. The terminology for the field of study of what was once defined as folk art has been clarified following its first usage in the decades after World War I. Initially "folk art" was applied to American art forms produced during the eighteenth and nineteenth centuries by artists with less training who worked in the non-traditional styles then coming into favor with the modernists. The terms *primitive* and *naive* were variously employed to describe the styles of these artists. In recent decades, scholars and anthropologists, such as John Michel Vlach, have objected to the confusion arising from the appropriation of terms previously used in the fields of anthropology and art history to designate the art produced by structured societies or "folk." The art that folk societies produced was determined in style and function by the dictates of the society and were not initially the creative efforts of individual artists. Recently the suggestion has been made to clarify the terminology and call artists such as Polk "limners," consistent with late eighteenth- and nineteenth-century usage, or nonacademic or "plain painters," as proposed by Vlach. See John Michel Vlach, *Plain Painters: Making Sense of American Folk Art* (Washington, D.C.: Smithsonian Institution Press, 1988).

3. *Maryland Herald and Elizabeth-Town Advertiser,* August 23, 1798.

4. *T. E. Anna Maria Cumpston,* c. 1790, oil on canvas, 57 ⅞-by-37 ⅝ inches (National Gallery of Art, Washington, D.C.; Gift of Edgar William and Bernice Chrysler Garbisch, 1953).

5. James Madison to Thomas Jefferson, October 7, 1794, Madison Papers, Library of Congress, Washington, D.C.

6. Ibid.

7. Pasquier and Co., Philadelphia, to Isaac Hite, [May 1796?], Olmstead Papers, Belle Grove, Frederick County, Virginia.

8. Hite Family Papers for Isaac Hite, Jr. [Major], Belle Grove, Frederick County, Virginia.

9. See Margaretta M. Lovell, "Reading Eighteenth-Century American Family Portraits: Social Images and Self-Images," *Winterthur Portfolio, A Journal of American Material Culture* 22, no. 4 (Winter, 1987): 252–57, 259–64.

10. CPP to James Madison, June 20, 1800, Madison Papers, Library of Congress, Washington, D.C.

11. James Madison to Thomas Jefferson, November 2, 1799, Knox College Library, Galesburg, Illinois.

12. For a detailed account of Polk's career, see Linda Crocker Simmons, *Charles Peale Polk, A Limner and His Likenesses* (Washington, D.C.: Corcoran Gallery of Art, 1981).

10: Democratic Culture: The Peale Museums, 1784–1850

David C. Ward

1. In addition to the documents contained in F: and *Selected Papers,* 2, for basic texts on the museum see Bibliographical Essay.

2. John Adams to Abigail Adams, May 12, 1780, in Charles Francis Adams, *Familiar Letters of John Adams and His Wife Abigail Adams* (New York: Hurd & Houghton, 1876), pp. 380–81. Also see Lillian B. Miller, *Patrons and Patriotism: The Encouragement of the Fine Arts in the United States, 1790–1860* (Chicago: The University of Chicago Press, 1966), chaps. 1 and 2.

3. On the cycles of expansion and contraction which have driven American society, see John Higham, *From Boundlessness to Consolidation: The Transformation of American Culture, 1848–1860* (Ann Arbor: University of Michigan Press, 1969); Robert H. Wiebe, *The Opening of American Society: From the Adoption of the Constitution to the Eve of Disunion* (New York: Knopf, 1984), pp. 127–68. For the effect of these changes on the museum, see Roger Stein, "Charles Willson Peale's Expressive Design," *New Perspectives,* pp. 203–8; David C. Ward, "Celebration of Self: The Portraiture of Charles Willson Peale and Rembrandt Peale, 1823–27," *American Art* 7 (Winter 1993): 14–15.

4. CWP's account of his founding of the museum is in A(TS):107–8; for discussion of *The Artist in His Museum,* see Stein, "Charles Willson Peale's Expressive Design," and Ward, "Celebration of Self," pp. 10–15.

5. CWP to Thomas Jefferson, August 21, 1819, P-S, *Selected Papers,* 3: 71.

6. *P&M Suppl.,* pp. 43–5; *Selected Papers,* 3:589–90, 687–88, 715–20, 771, 789, 791, 793, 795. David R. Brigham, *Public Culture in the Early Republic: Peale's Museum and Its Audience* (Washington, D.C.: Smithsonian Institution Press, 1995), pp. 44–45, discusses *Noah and His Ark* but does not relate it to the *Retreat.*

7. Gordon S. Wood, "The Losable Past," *The New Republic* 211 (November 7, 1994): 47; also see Henry May, *The Enlightenment in America* (New York: Oxford University Press, 1976), pp. 153–277; Laura Noelle Rigal, "An American Manufactory: Political Economy, Collectivity, and the Arts in Philadelphia" (Ph.D. diss., Stanford University, 1989), pp. 45–185; Joel J. Orosz, *Curators and Culture: The Museum Movement in America, 1740–1870* (Tuscaloosa: University of Alabama Press, 1990), pp. 48–50; Charles C. Gillispie, "The Natural History of Industry," in E. Musson, ed., *Science, Technology, and Economic Growth in the Eighteenth Century* (London: Methuen, 1972), esp. pp. 131–32. For CWP's own statements on natural history and social harmony and hierarchy, see his "Lectures on Natural History," Academy of Natural Sciences, Philadelphia, in F:IID/3–26.

8. *Dunlap and Claypoole's American Daily Advertiser,* April 24, 1794, in A(TS):272. For CWP's role in Philadelphia's cultural life, see *CWP;* for the intellectual environment of Philadelphia, see Daniel Boorstin, *The Lost World of Thomas Jefferson* (1948; reprint, Boston: Beacon Press, 1960), pp. 8–25; Edgar P. Richardson, "The Athens of America, 1800–1825," in Russell F. Weigley, ed., *Philadelphia: A 300–Year History* (New York: W. W. Norton, 1982), pp. 208–57.

9. For the bourgeois order of public space, see Dell Upton, "The City as Material Culture," in Anne Elizabeth Yentsch and Mary C. Beaudry, *The Art and Mystery of Historical Archaeology: Essays in Honor of James Deetz* (Boca Raton, Florida: CRC Press, 1992), pp. 51–74, esp. pp. 53–54, for the urban grid.

10. C. W. Peale to Isaac Weaver, February 11, 1802, in *Selected Papers,* 2:396–98.

11. See Arthur O. Lovejoy, *The Great Chain of Being: A Study of the History of an Idea* (Cambridge, Mass.: Harvard University Press, 1936). The absolutism which produced the ideology of the "great chain" was destroyed in the revolutionary era of 1776–1848; see Eric J. Hobsbawm, *The Age of Revolution, 1789–1848* (New York: New American Library, 1962).

12. The sources of CWP's scientific knowledge are discussed in Robert E. Schofield, "The Science Education of an Enlightened Entrepreneur: Charles Willson Peale and His Philadelphia Museum, 1784–1827," *American Studies* 30 (Fall 1989): 41–68; see also, May, *The Enlightenment in America,* pp. 338–40. C. W. Peale, "Memorial to the Pennsylvania Legislature," December 26, 1795, in *Selected Papers,* 2:136–38; C. W. Peale to Andrew Ellicott, February 28, 1802, P-S, in F:IIA/25C3–6; C. W. Peale to Isaac Weaver, February 11, 1802, op. cit..

13. For analysis of the museum's audience derived from surviving silhouettes, see Brigham, *Public Culture in the Early Republic,* pp. 68–82; Anne A. Verplanck, "Facing Philadelphia: The Social Functions of Silhouettes, Miniatures, and Daguerreotypes, 1760–1860" (Ph.D. diss., College of William and Mary, 1996); Orosz, *Curators and Culture,* pp. 50–51; Rigal, "An American Manufactory," pp. 53–54, 142–43.

14. Stein, "Charles Willson Peale's Expressive Design," esp. pp. 198–204; Ward, "Celebration of Self," p. 12; David C. Ward and Sidney Hart, "Subversion and Illusion in the Life and Art of Raphaelle Peale, 1790–1825," *American Art* 8, nos. 3–4 (Summer/Fall 1994): 25; Toby Anita Appel, "Science, Popular Culture, and Profit: Peale's Philadelphia Museum," *Journal of the Society for the Bibliography of Natural History* 9 (April 1980): 619–34; Lawrence W. Levine, *Highbrow/Lowbrow: The Emergence of Cultural Hierarchy in America* (Cambridge, Mass.: Harvard University Press, 1988), pp. 147–49.

15. *P&M Suppl.,* p. 23; Ann Shelby Blum, *Picturing Nature: American Nineteenth-Century Zoological Illustration* (Princeton, N.J.: Princeton University Press, 1993), pp. 91–112; Elsa Guerdrum Allen, "American Ornithology before Audubon," *Transactions of the American Philosophical Society,* vol. 41 (Philadelphia, 1951): 387–591; Richard D. Altick, *The Shows of London* (Cambridge, Mass.: Harvard University Press, 1978), pp. 26–27; Edward Miller, *That Noble Cabinet: A History of the British Museum* (Athens: Ohio University Press, 1974), pp. 62–63, 92.

16. For a biography of TRP, see Jessie J. Poesch, *Titian Ramsay Peale and His Journals of the Wilkes Expedition, 1799–1885* (Philadelphia, 1961); a good short account is in the *Dictionary of Scientific Biography.*

17. For the transmutation of the wild turkey in the foreground of CWP's *The Artist in His Museum,* from nature to specimen to "portrait," see Stein, "Charles Willson Peale's Expressive Design," p. 190. Also see Kenneth Haltman, "Private Impressions and Public Views: Titian Ramsay Peale's Sketchbooks from the Long Expedition, 1819–1820," *Yale University Art Gallery Bulletin* (Spring 1989): 44.

18. *Selected Papers,* 2:771; for the Peales and especially ReP's involvement in lithography, see ReP to W. W. Boardman, May 10, 1826, in F:VIA/15B12–C1; John A. Mahey, "Lithographs by Rembrandt Peale," *Antiques* 97 (1970): 236–37, 341–42.

19. *Guide to the Philadelphia Museum* (Philadelphia: Philadelphia Museum, 1804 and subsequent editions), P-S, in *Selected Papers,* 2:759–66.

20. See Rigal, "An American Manufactory," pp. 142–43, and Brigham, *Public Culture in the Early Republic,* pp. 6–7, 9; Alexander Wilson, *The American Ornithology,* 9 vols. (Philadelphia: Bradford & Inskeep, 1808–13), and Charles Lucien Bonaparte, *American Ornithology or the Natural History of Birds Inhabiting the United States,* 4 vols. (Philadelphia: Carey, Lea & Carey, 1825–33). Wilson's and Bonaparte's volumes were consulted at the Dibner Library, Smithsonian Institution, Washington, D.C., courtesy of Ellen Wells, librarian. Also see Blum, *Picturing Nature,* pp. 38–46.

21. See CWP to William Findley, February 18, 1800, P-S, in *Selected Papers,* 2:276–80; A(TS): 318. CWP to Phillipe Rose Roume, December 25, 1803, P-S, in *Selected Papers,* 2:628–30.

22. Peale's Museum, 1803–1842 Records & Accessions, F:XIA/3–5. For totals of the museum's collection, see Sellers, *Charles Willson Peale,* p. 346; Brigham, *Public Culture in the Early Republic,* pp. 107–44 surveys the museum's donors.

23. Museum attendance is calculated from the tables of museum income in 1808–19, Peale's Museum, Current Expenditures, F:XIA/5; Sidney Hart and David C. Ward, "The Waning of an Enlightenment Ideal. Charles Willson Peale's Philadelphia Museum, 1790–1820," in *New Perspectives,* pp. 401–2; Brigham, *Public Culture in the Early Republic,* pp. 26–27.

24. CWP, "To the Citizens of the United States of America," *Dunlap's American Daily Advertiser,* January 13, 1792, in *Selected Papers,* 2:9–11; Hart and Ward, "The Waning of an Enlightenment Ideal," pp. 389–418; Brigham, *Public Culture in the Early Republic,* pp. 33–75; Ruth Helm, "Peale's Museum: Politics, Idealism and Public Patronage in the Early Republic," in William T. Anderson, ed., *Mermaids, Mummies, and Mastodons: The Emergence of the American Museum* (Baltimore: Baltimore City Life Museums, 1992), pp. 67–78.

25. For European support of cultural institutions, see CWP, Diary 20, P-S, in F:IID/19–20; and Phillipe Rose Roume to CWP, January 4, 1802, P-S, in *Selected Papers,* 2:381–86. For government aid to cultural institutions in the evolving American political economy, see Oscar Handlin and Mary Flug Handlin, *Commonwealth, A Study of the Role of Government in the American Economy: Massachusetts, 1774–1861* (New York: New York University Press, 1947), pp. 53–56, 104; George Rogers Taylor, *The Transportation Revolution, 1815–1860* (White Plains, N.Y.: M. E. Sharpe, 1951), pp. 378–83; Brooke Hindle, *The Pursuit of Science in Revolutionary America, 1735–1789* (Chapel Hill: University of North Carolina Press, 1956), p. 140.

26. CWP to Dr. Edward Stevens, June 28, 1804, P-S, in F:IIA/35All–13; *Selected Papers,* 2:19, 24, 83, 85, 138; CWP "Address to the Public," *Aurora General Advertiser,* January 27, 1800, in *Selected Papers,* 2:274–75; CWP's letters soliciting state support include those to: William Findley, February 18, 1800, P-S, in *Selected Papers,* 2:276–81; Thomas McKean, March 3, 1800, P-S, in *Selected Papers,* 2:281–82; and Timothy Matlack, March 9, 1800, P-S, in *Selected Papers,* 2:282–84. On Jefferson and state support, see Thomas Jefferson to CWP, January 16, 1802, P-S, in *Selected Papers,* 2:389–90; CWP to Thomas Jefferson, January 21, 1802, in *Selected Papers,* 2:390–91; CWP to Thomas Jefferson, December 13, 1806, P-S, in *Selected Papers,* 2:990–91; Dumas Malone, *Jefferson the President: Second Term, 1805–1809* (Boston: Little Brown, 1974), pp. 554–55; Edward M. Riley, "The Independence Hall Group," in American Philosophical Society, *Historic Philadelphia: From the Founding Until the Early Nineteenth Century,* Transactions of the American Philosophical Society, n.s., vol. 43 (Philadelphia, 1953): 30–33.

27. For public opposition to Peale's universal claims for the museum, see Brigham, *Public Culture in the Early Republic,* pp. 48–9. For the legal and cultural changes accompanying the expansion of American capitalism, see Morton J. Horwitz, *The Transformation of American Law, 1780–1860* (Cambridge, Mass.: Harvard University Press, 1977); for the roots of this transformation, see Joyce Appleby, *Capitalism and a New Social Order: The Republican Vision of the 1790s* (New York: New York University Press, 1984), pp. 79–105.

28. See *Selected Papers,* 3:784–85; 4:531–33. The early history of the Arcade is summarized in an anonymous note in *The Pennsylvania Magazine of History and Biography* 41 (1917): 378–80. See also Ward, "Celebration of Self," p. 15; Ruth Helm, "'For Credit, Honor, and Profit': Three Generations of the Peale Family in America" (Ph.D. diss., University of Colorado, 1991) for an interpretation of the "business" careers of the Peales.

29. A description of the New York Museum, including its "Long-Room" and painting collection may be found in *Peale's New-York Museum and Gallery of the Fine Arts: In the Parthenon* (New York, n.p., 1825), pamphlet in the collections of the Library Company, Philadelphia.

30. ReP, "Prospectus of a Museum of Arts and Sciences, to be Established in Baltimore," c. 1813, F:VIA/4D3–5; Hunter, "Rendezvous for Taste," pp. 3–11; John W. Durel, "In Pursuit of Profit," in *Mermaids, Mummies, and Mastodons,* pp. 41–65.

31. ReP to Charles Mayer, October 12, 1830, P-S, in F:VIA/6E3–6; Wilbur Harvey Hunter, Jr., "The Tribulations of a Museum Director in the 1820s," *Maryland Historical Magazine* 49 (1954): 214–22; ReP's problems were compounded by his association in the Baltimore Gas Light Company with many of the same stockholders in his museum; see David P. Erlick, "The Peales and Gas Lights in Baltimore," *Maryland Historical Magazine* 80 (Spring 1985): 9–18.

32. The catalogues of RuP's four annual exhibitions (subtitled "A Selection from the Various Cabinets of Old Masters in this City and its Vicinity") at the Baltimore Museum, 1823–26, are at the Archives of American Art, Smithsonian Institution; also in F:XIB/1. For ReP's policies, see William Oedel, "After Paris: Rembrandt Peale's Apollodorian Gallery," *Winterthur Portfolio* 27 (Spring 1992): 1–27.

33. For the mummy, the rhinoceros, and the "Esquimaux," see *Selected Papers,* 4: 25, 26, 416, 417, 432, 437, 560, 561. The floating population of showmen, animal trainers, exhibitors, musicians, actors, and "freaks of nature" is evidenced in newspaper advertisements, but the subject has yet to receive serious historical treatment. Some glimpses of this "street theater" can be found in Sean Wilentz, *Chants Democratic: New York City and the Rise of the American Working Class, 1788–1850* (New York: Oxford University Press, 1984), pp. 54–56.

34. ReP, "Elegant rendezvous," quoted in *Mermaids, Mummies, and Mastodons,* p. 24; for RuP's adoption of a hairpiece, see CWP to RuP, December 7, 1824, P-S, in *Selected Papers,* 4:476–77.

35. For the breakdown of hierarchy in the arts and the popularity of the panorama (including

Vanderlyn's), see Nicolai Cikovsky, Jr., et al, *Raphaelle Peale Still Lifes* (Washington, D.C.: National Gallery of Art, 1988), pp. 60–61; for Stollenwerck's panorama, see Wilentz, *Chants Democratic,* pp. 3–4; for description of the New York Museum, see A. T. Goodrich, *The Picture of New York and Stranger's Guide to the Commercial Metropolis of the United States* (New York: n.p., 1828), p. 441; ReP, *An Historical Disquisition on the Mammoth* (London, 1803), P-S, in F:VIB/1. For the dialectic between individual self-assertion and its anxieties, see Ellen H. Grayson, "Social Order and Psychological Disorder: The 1840s Tour of Rembrandt Peale's *Court of Death*" (paper delivered at the American Studies Association, Annual Meeting, October 10, 1994), pp. 8–11.

36. Rachel N. Klein, "Art and Authority in Antebellum New York City: The Rise and Fall of the American Art-Union," *The Journal of American History* 81 (March 1995): 1560, sees the dissolving of "shared culture" occurring after the Civil War. I am arguing here that this process began to work itself out early in the antebellum period.

37. For Barnum, see Neil Harris, *Humbug! The Art of P. T. Barnum* (Boston: Little Brown, 1973). "Sacralization" is Lawrence Levine's term for the evolution of a high, if not actually official, culture and its separation from popular culture (Levine, *Highbrow/Lowbrow,* pp. 83–168). For a sharp statement that historians need to consider market relations in historical context, see Gordon Wood, "Equality and Social Conflict in the American Revolution," *The William and Mary Quarterly* 3d ser., vol. 51 (October 1994): 714. Anecdotal evidence that there is little or no connection between the culture of the museum and even the museum-going public is provided by a Duracell battery television advertisement (1994–95), which shows a museum-going family imposed upon by a pompous scholar, whose language mystifies them and whom they ridicule. The scholar lurches out of control (he is an automaton using an inferior battery), destroying several exhibitions and leading the Generation X son to conclude: "Gee, mom, you're right. Museums are fun!"

Bibliographical Essay

The main manuscript source for members of the Peale family is the microfiche edition, with Guide and Index, of *The Collected Papers of Charles Willson Peale and His Family,* ed. Lillian B. Miller (Millwood, New York: Kraus Microform, 1980). From this collection, selections have been made for the seven-volume edition of *The Selected Papers of Charles Willson Peale and His Family,* of which the following volumes have been published: vol. 1, *Charles Willson Peale: The Artist in Revolutionary America, 1735–1791,* ed. Lillian B. Miller, Sidney Hart, and Toby A. Appel (New Haven: Yale University Press, 1983); vol. 2, *Charles Willson Peale: The Artist as Museum Keeper, 1791–1810,* pts. 1 and 2, ed. Lillian B. Miller, Sidney Hart, and David C. Ward (New Haven: Yale University Press, 1988); vol. 3, *The Belfield Farm Years: 1810–1820,* ed. Lillian B. Miller, Sidney Hart, David C. Ward, and Rose S. Emerick (New Haven: Yale University Press, 1992); vol. 4, *Charles Willson Peale: His Last Years, 1820–1827,* ed. Lillian B. Miller, Sidney Hart, David C. Ward, and Leslie Reinhardt (New Haven: Yale University Press, 1996).

Since the publication of *Collected Papers,* many scholarly studies of members of the Peale family have been written, either as dissertations, articles, or books. Recent articles on Charles Willson Peale are included in *New Perspectives on Charles Willson Peale: A 250th Anniversary Celebration,* ed. Lillian B. Miller and David C. Ward (Pittsburgh: University of Pittsburgh Press, 1991).

Recently published books on the Peales include William T. Alderson, ed., *Mermaids, Mummies, and Mastodons: The Emergence of the American Museum* (Washington, D.C.: American Association of Museums for the Baltimore City Life Museums, 1992); David R. Brigham, *Public Culture in the Early Republic: Peale's Museum and Its Audience* (Washington, D.C.: Smithsonian Institution Press,

1995); Nicholas Cikovsky, Jr., with contributions by Linda Bantel and John Wilmerding, *Raphaelle Peale Still Lifes* (Washington, D.C.: National Gallery of Art, 1988); Joseph Ellis, *After the Revolution: Profiles of Early American Culture* (New York: W. W. Norton, 1979), pp. 41–71; Carol Eaton Hevner, with a biographical essay by Lillian B. Miller, *Rembrandt Peale, 1778–1860: A Life in the Arts* (Philadelphia: The Historical Society of Pennsylvania, 1985); Lillian B. Miller, with an essay by Carol E. Hevner, *In Pursuit of Fame: Rembrandt Peale, 1778–1860* (Washington, D.C. and Seattle: University of Washington Press for the National Portrait Gallery, 1992); *The Pennsylvania Magazine of History and Biography.* vol. 110, no. 1 (January, 1986) (issue devoted to essays on Rembrandt Peale, by Carol E. Hevner, Lillian B. Miller, Lois Marie Fink, Paul J. Staiti, Peter J. Parker, and Carrie H. Scheflow); Jessie J. Poesch, *Titian Ramsay Peale, 1799–1885: and His Journals of the Wilkes Expedition,* Memoirs of the American Philosophical Society, vol. 52 (Philadelphia: American Philosophical Society, 1961); Edgar P. Richardson, Brooke Hindle, and Lillian B. Miller, *Charles Willson Peale and His World* (New York: Harry N. Abrams, 1983); Charles Coleman Sellers, *Charles Willson Peale* (New York: Charles Scribner's Sons, 1969); Charles Coleman Sellers, *Mr. Peale's Museum: Charles Willson Peale and the First Popular Museum of Natural Science and Art* (New York: W. W. Norton, 1980); Linda Crocker Simmons, *Charles Peale Polk, 1767–1822: A Limner and His Likenesses* (Washington, D.C.: Corcoran Gallery of Art, 1981).

Recent doctoral dissertations on the Peales include David R. Brigham, "'A World in Miniature': Charles Willson Peale's Philadelphia Museum and Its Audience, 1786–1827" (Ph.D. diss., University of Pennsylvania, 1992); Brandon Brame Fortune, "Portraits of Virtue and Genius: Pantheons of Worthies and Public Portraiture in the Early American Republic, 1780–1820" (Ph.D. diss., University of North Carolina, Chapel Hill,

1987); Kenneth Haltman, "Figures in a Western Landscape: Reading the Art of Titian Ramsay Peale from the Long Expedition to the Rocky Mountains, 1819–1820" (Ph.D. diss., Yale University, 1992); Beverly Orlove Held, "'To Instruct and Improve . . . To Entertain and Please': American Civic Protests and Pageants, 1765–1784" (Ph.D. diss., University of Michigan, 1987); Ruth Helm, "'For Credit, Honor, and Profit': Three Generations of the Peale Family in America" (Ph.D. diss., University of Colorado, 1991); David Steinberg, "The Characters of Charles Willson Peale: Portraiture and Social Identity, 1769–1776" (Ph.D. diss., University of Pennsylvania, 1993).

During the last three decades there has been a vast scholarship on the Anglo-American family. For a good introduction to the major concepts and historiography, see Carl Degler, *At Odds: Women and the Family in America from the Revolution to the Present* (New York, Oxford University Press, 1980); John Demos, *Past, Present, and Personal: The Family and the Life Course in American History* (New York, Oxford University Press, 1986); Tamara K. Hareven, "The History of the Family and the Complexity of Social Change," *American Historical Review,* 96, no. 1 (February 1991): 95–124; E. Anthony Rotundo, *American Manhood: Transformations in Masculinity from the Revolution to the Modern Era* (New York, Basic Books, 1993); Daniel Blake Smith, "The Study of the Family in Early America: Trends, Problems, and Prospects," *The William and Mary Quarterly,* 3d Series, vol. 39, no. 1 (January, 1982): 3–28; Helena M. Wall, *Fierce Communion: Family and Community in Early America* (Cambridge, Mass., Harvard University Press, 1990); Michael Zuckerman, "William Byrd's Family," in *Perspectives in American History,* vol. 12 (1979): 253–312.

Lenders to the Exhibition

The Academy of Natural Sciences of Philadelphia, Pennsylvania

The Addison Gallery of American Art, Phillips Academy, Andover, Massachusetts

American Antiquarian Society, Worcester, Massachusetts

American Philosophical Society, Philadelphia, Pennsylvania

Anonymous Private Collectors

The Art Museum, Princeton University, Princeton, New Jersey

Belle Grove Plantation, Middletown, Virginia

Berry-Hill Galleries, Inc.

The Brooklyn Museum, Brooklyn, New York

The Carpenters Company of the City and County of Philadelphia, Pennsylvania

The Chrysler Museum, Norfolk, Virginia

Cincinnati Art Museum, Ohio

College of Physicians of Philadelphia, Pennsylvania

The Colonial Williamsburg Foundation, Williamsburg, Virginia

The Corcoran Gallery of Art, Washington, D.C.

Davenport Museum of Art, Iowa

The Embassay of Brazil, Washington, D.C.

The Fine Arts Museums of San Fransisco, California

Ms. Elise Peale P. Gelpi

Gibbes Museum of Art, Charleston, South Carolina

The James W. Glanville Family Interests

James Graham and Sons, Inc.

The Hendershott Collection

Hirschl & Adler Galleries, Inc., New York

Historical Society of Pennsylvania, Philadephia

Independence National Historical Park, Philadelphia, Pennsylvania

J.B. Speed Art Museum, Louisville, Kentucky

The Kennedy Galleries, Inc.

Library Company of Philadelphia, Pennsylvania

Bernard & S. Dean Levy, Inc., New York

Los Angeles County Museum of Art, California

The Maryland Historical Society, Baltimore

Maryland State Archives, Annapolis

Masonic Library and Museum of Pennsylvania, Philadelphia

Mr. Robert L. McNeil, Jr.

Lys McLaughlin Pike and Ian Malcolm Watson McLaughlin

Mead Art Museum, Amherst College, Amherst, Massuchusetts

The Metropolitan Museum of Art, New York City

Milwaukee Art Museum, Wisconsin

Missouri Historical Society, Saint Louis

The Honorable Jay P. Moffat

The Montclair Art Museum, New Jersey

Monticello, Thomas Jefferson Memorial Foundation, Inc., Charlottesville, Virginia

Munson-Williams-Proctor Institute Museum of Art, Utica, New York

Museum of American Art of the Pennsylvania Academy of the Fine Arts, Philadelphia, Pennsylvania

Museum of the City of New York, New York City

Museum of Fine Arts, Boston

Museum of Fine Arts, Houston

National Gallery of Art, Washington, D.C.

National Museum of American Art, Smithsonian Institution, Washington, D.C.

National Portrait Gallery, Smithsonian Institution, Washington, D.C.

The Nelson-Atkins Museum of Art, Kansas City, Missouri

The Neville-Strass Collection

The New-York Historical Society, New York City

Peabody Museum of Archaeology and Ethnology, Harvard University, Cambridge, Massachusetts

Mr. James Peale, New York

The Peale Museum, Baltimore City Life Museums, Maryland

Philadelphia Museum of Art, Pennsylvania

The R. W. Norton Art Gallery, Shreveport, Louisiana

Reading Public Museum and Art Gallery, Reading, Pennsylvania

Richard York Gallery, New York City

Mr. and Mrs. Stanley P. Sax

The San Diego Museum of Art, California

The Schwarz Gallery, Philadelphia

The Smith College Museum of Art, Northampton, Massachusetts

Mrs. Deen Day Smith

Mr. and Mrs. Michael E. Stinchcomb

John H. Surovek Gallery, Palm Beach, Florida

United States Department of State, Washington, D.C.

Utah Museum of Fine Arts, University of Utah, Salt Lake City

The Virginia Historical Society, Richmond, Virginia

Virginia Museum of Fine Arts, Richmond, Virginia

The White Collection, Tennessee

The Henry Francis du Pont Winterthur Museum, Winterthur, Delaware

Checklist of the Exhibition

Most of the works in this checklist appear at all three of the exhibition's museums. Those appearing only at selected locations are marked with these symbols:

* * shown at The Corcoran Gallery of Art, Washington, D.C.
* ‡ shown at The Philadelphia Museum of Art
* ‡‡ shown at The Fine Arts Museums of San Francisco

Introductory Foyer

1
Charles Willson Peale
View of Several Public Buildings in Philadelphia, 1790
Engraving from *Columbian Magazine,* January 1790, 4 ⅞ x 8 ¼ in. (12.4 x 21 cm)
The Library Company of Philadelphia

2 (plate 4)
William Russell Birch (1755–1854)
State House Gardens, Philadelphia, 1799
Color engraving, 12 ¾ x 15 ⅜ in. (32.4 x 39.1 cm)
The Library Company of Philadelphia

3
James Trenchard (1747–?), after Charles Willson Peale
A N.W. View of the Statehouse in Philadelphia taken 1778, 1787
Engraving, 5 ⅛ x 7 ⅛ in. (11.8 x 17.1 cm)
Private collection

4
William Birch
Back of the State House, 1800
Color engraving, 8 ½ x 11 ⅛ in. (21.6 x 28.3 cm)
The Library Company of Philadelphia

5
William Birch
Third and Market Streets, Philadelphia, 1800, n.d.
Color engraving, 12 ¾ x 15 ⅜ in. (32.4 x 39 cm)
The Library Company of Philadelphia

The Peale Family Portrayed

6 (plate 63)
Charles Willson Peale
Rachel Weeping, 1772 and probably 1776
Oil on canvas, 37 ⅛ x 32 ¼ in. (94.3 x 81.9 cm)
Philadelphia Museum of Art; Given by the Barra Foundation, Inc.

7 (plate 62)
Charles Willson Peale
The Artist's Mother, Mrs. Charles Peale, and her Grandchildren, c. 1783
Oil on canvas, 30 x 25 in. (74.3 x 63.5 cm)
Private collection

8
Charles Willson Peale
Self-Portrait, 1822
Oil on canvas, 29 ¼ x 24 ⅛ in. (74.3 x 61.3 cm)
The Fine Arts Museums of San Francisco, Gift of Mr. and Mrs. John D. Rockefeller III

9 (plate 93)
Charles Willson Peale
James Peale Painting a Miniature, c. 1795
Oil on canvas, 30 x 25 in. (76.2 x 63.5 cm)
Mead Art Museum, Amherst College, Amherst, Massachusetts; Bequest of Herbert L. Pratt, Class of 1895

10 (plate 23)
Charles Willson Peale
"The Staircase Group": Raphaelle and Titian Ramsey Peale, 1795
Oil on canvas, 69 x 39 ½ in. (175.3 x 100.3 cm)
Philadelphia Museum of Art; The George W. Elkins Collection

11 (plate 74)
Rembrandt Peale
Self-Portrait, 1856
Oil on canvas, 21 x 17 in. (53.3 x 43.2 cm)
Mead Art Museum, Amherst College, Amherst, Massachusetts; Gift of Edward S. Whitney, Class of 1890

12 (plate 29)
Rembrandt Peale
Portrait of Rosalba Peale, c. 1820
Oil on canvas, 20 x 14 ⅝ in. (50.8 x 37.1 cm)
National Museum of American Art, Smithsonian Institution, Washington, D.C.

13 (plate 31)
Rembrandt Peale
Michael Angelo and Emma Clara Peale, c. 1826
Oil on canvas, 30 x 25 in. (76.2 x 63.5 cm)
Richard York Gallery, New York

14 (plate 79)
Rembrandt Peale
Rubens Peale, 1807
Oil on canvas, 26 ⅛ x 21 ⅜ in. (66.4 x 54.3 cm)
National Portrait Gallery, Smithsonian Institution, Washington, D.C.; Museum purchase and gift of Mrs. James Burd Peale Green

15 (plate 27)
Raphaelle Peale
Rubens Peale as Mascot, 1795
Oil on canvas, 26 x 22 in. (66 x 55.9 cm)
Private collection

16
Raphaelle Peale
Rubens Peale, c. 1800
Watercolor on paper, 3 ¾ x 2 ⅝ in. (9.5 x 6.7 cm)
National Museum of American Art, Smithsonian Institution, Washington, D.C.; Gift of Edwin Kirk

17 (plate 107)
James Peale
Jane Ramsay Peale, c. 1802
Oil on canvas, 28 ⅛ x 20 ⅞ in. (71.4 x 53 cm)
Addison Gallery of American Art, Phillips Academy, Andover, Massachusetts; Gift from the Collection of Waldron P. Belknap, Jr.

18 (plate 104)
James Peale
Anna and Margaretta Peale, c. 1805
Oil on canvas, 29 x 24 in. (73.7 x 61 cm)
Museum of American Art of the Pennsylvania Academy of the Fine Arts, Philadelphia; Pennsylvania Academy Purchase

19 (plate 118)
Sarah Miriam Peale
Self-Portrait, c. 1818
Oil on canvas, 24 1/16 x 19 in. (61.2 x 48.3 cm)
National Portrait Gallery, Smithsonian Institution, Washington, D.C.

20
Peale Family Bible
9 ½ x 6 in. (24.1 x 15.2 cm)
Private collection

21
Tea Caddy,
Wood, 5 ⅛ x 9 x 5 in. (13 x 22.9 x 12.7 cm)
Private collection

22 (plate 1)
Charles Willson Peale
The Peale Family Group, 1770–1783, and 1808
Oil on canvas, 56 ½ x 89 ½ in. (143.5 x 227.3 cm)
Collection of The New-York Historical Society

23 (plate 94)
James Peale
The Artist and His Family, 1795
Oil on canvas, 31 ¼ x 32 ¾ in. (79.4 x 83.2 cm)
Pennsylvania Academy of the Fine Arts,
Philadelphia; Gift of John Frederick Lewis

24
Baptismal Bowl, c. 1790
Chinese export porcelain, diameter 10 in.
(25.4 cm)
Private collection

25 (plate 21)
Charles Willson Peale
*Mother Caressing her Convalescent Daughter
(Angelica Peale [Mrs. Alexander] Robinson and her
Daughter Charlotte)*, 1818
Oil on canvas, 30 x 24 ⅞ in. (76.2 x 63.2 cm)
Private collection

26 (plate 126)
Charles Peale Polk
Self-Portrait, c. 1815–1818
Oil on fabric, 25 x 22 ¼ in. (63.5 x 56.5 cm)
Virginia Historical Society, Richmond, Virginia;
From Russell Hammach, descendant

27‡ ‡‡ (plate 90)
Titian Ramsay Peale, possibly with the help of
Rembrandt Peale
Sketch for a Self-Portrait, c. 1845
Graphite on paper, 16 ⅛ x 12 ½ in. (41 x 31.8 cm)
National Portrait Gallery, Smithsonian Institution,
Washington, D.C.; Gift of Edgar L. Smith, Jr.

28
Rembrandt Peale
Portrait of Artist's First Wife, Eleanor May Short,
c. 1811
Oil on canvas, 28 ⅜ x 23 ¼ in. (72.1 x 59.1 cm)
Mead Art Museum, Amherst College Gift of
Edward S. Whitney, Class of 1890

29 (plate 37)
Anna Claypoole Peale
Rembrandt Peale, 1823
Watercolor on ivory, 2 ⅞ x 2 ¼ in. (7.3 x 5.7 cm)
The R.W. Norton Art Gallery, Shreveport, Louisiana

30
Compiled by Ann Sellers at Mill Bank
Silhouettes from the Peale Family Album. Top row:
Elizabeth De Peyster Peale (1765–1804), Charles
Willson Peale (1741–1827), Hannah Moore Peale
(1755–1821). Bottom row: Raphaelle Peale
(1774–1825), Rubens Peale (1784–1865),
Sophonisba A. Peale (1786–1859) Angelica K.
Peale (1775–1853), c. 1805
Paper, 10 ¼ x 7 ¾ x 1 ⅜ in. (26 x 19.7 x 3.5 cm)
Private collection

31
Unknown
Silhouettes of Mr. and Mrs. Rubens Peale (2), n.d.
Paper, 4 ½ x 3 ½ in. (11.4 x 8.9 cm)
Private collection; Courtesy of Berry-Hill
Galleries, Inc., New York

32 (plate 2)
Charles Willson Peale
Mrs. Elizabeth Digby Peale (Mrs. Robert) Polk, c. 1771
Watercolor on ivory, 2 x 1 ⅜ in. (5.1 x 3.5 cm)
Private collection; Courtesy of Earle D. Vandekar
of Knightsbridge, Inc.

33
Anna Claypoole Peale
*James Peale with Mary Claypoole (Mrs. James) Peale
on reverse*, c. 1823–24
Watercolor on ivory, 1 ⅜ x 1 ⅛ in. (3.5 x 2.9 cm)
The N.W. Norton Art Gallery, Shreveport, Louisiana

34 (plate 106)
James Peale
Anna Claypoole Peale, 1805
Watercolor on ivory, 2 ⅝ x 2 ¼ in. (6.7 x 5.7 cm)
Cincinnati Art Museum; Fleischmann Collection

35 (plate 105)
James Peale
Maria Peale, c. 1802
Watercolor on ivory, 2 ⅞ x 2 ¼ in. (7.3 x 5.7 cm)
Cincinnati Art Museum; Fleischmann Collection

Friends and Neighbors

36 (plate 123)
Sarah Miriam Peale
Mrs.William Crane, c. 1840
Oil on canvas, 29 ¾ x 24 ¾ in. (75.6 x 62.9 cm)
San Diego Museum of Art, California; Gift of
Mary Vivian Conway

37 (plate 64)
Charles Willson Peale
The John Cadwalader Family, 1772
Oil on canvas, 51 ½ x 41 ⅛ in. (130.8 x 104.4 cm)
Philadelphia Museum of Art; The Cadwalader Col-
lection; Purchased for the Cadwalader Collection,
funds contributed by the Pew Memorial Trust and
the gift of an anonymous donor

38 (plate 69)
Charles Willson Peale
Portrait of Julia Stockton (Mrs. Benjamin) Rush, 1776
Oil on canvas, 49 ½ x 39 ¼ in. (125.7 x 99.7 cm)
The Henry Francis du Pont Winterthur Museum,
Delaware

39 (plate 66)
Charles Willson Peale
Mrs. John Dickinson and Daughter, Sally, 1773
Oil on canvas, 49 x 39 in. (124.5 x 99.1 cm)
Historical Society of Pennsylvania, Philadelphia

40 (plate 22)
Charles Willson Peale
William Smith and His Grandson, 1788
Oil on canvas, 51 ¼ x 40 ⅜ in. (130.2 x 102.6 cm)

Virginia Museum of Fine Arts, Richmond; Muse-
um Purchase with Funds provided by The Robert
G. Cabell III and Maude Morgan Cabell Founda-
tion, and The Arthur and Margaret Glasgow Fund

41 (plate 20)
Charles Willson Peale
Thomas and Henry Sergeant, c. 1787
Oil on canvas, 35 ½ x 29 in. (90.2 x 73.6 cm)
Lent by Jay Pierrepont Moffat, Courtesy Museum
of Fine Arts, Boston

42 (plate 128)
Charles Peale Polk
Nelly Conway Hite and Son James Madison Hite,
1799
Oil on canvas, 60 x 40 in. (152.4 x 101.6 cm)
Belle Grove Plantation of the National Trust for
Historic Preservation

43 (plate 127)
Charles Peale Polk
Isaac Hite, Jr., 1799
Oil on canvas, 60 x 40 in. (152.4 x 101.6 cm)
Belle Grove Plantation of the National Trust for
Historic Preservation

44 (plate 30)
Rembrandt Peale
George Taylor of Philadelphia, c. 1820–28
Oil on canvas, 57 ⅜ x 36 ¼ in. (145.8 x 92.1 cm)
The Brooklyn Museum, New York; Gift of the
Estate of Eliza Herriman Griffith 12.85

45 (plate 32)
Rembrandt Peale
Portrait of Jacob Gerard Koch, c. 1817
Oil on canvas, 34 x 29 in. (86.4 x 73.7 cm)
Los Angeles County Museum of Art; Museum
purchase with funds provided by Mr. and Mrs.
William Preston Harrison Collection, Mary D.
Keeler Bequest, and Dr. Dorothea Moore

46 (plate 26)
Rembrandt Peale
*Alida Livingston (Mrs. John) Armstrong and
Daughter*, c. 1810
Oil on canvas, 31 ½ x 25 in. (80 x 63.5 cm)
Neville-Strass Collection

47 (plate 12)
Raphaelle Peale
Matthew McGlathery, 1795
Oil on canvas, 26 x 22 in. (66 x 55.9 cm)
Carpenters' Company of Philadelphia

48 (plate 28)
Raphaelle Peale
Osborne Sprigg, 1820
Oil on canvas, 30 ¼ x 24 ½ in. (76.8 x 62.2 cm)
Maryland Historical Society, Baltimore

49 (plate 25)
James Peale
Mrs. Heberton, 1816
Oil on canvas, 29 ½ x 24 ½ in. (74.9 x 62.2 cm)
Private collection

50 (plate 24)
James Peale
Mr. Heberton, 1816
Oil on canvas, 29 ½ x 24 ½ in. (74.9 x 62.2 cm)
Private collection

51 (plate 33)
Rembrandt Peale
Jane Griffith (Mrs. Jacob Gerard) Koch, c. 1817
Oil on canvas, 34 x 29 in. (86.4 x 73.7 cm)
Los Angeles County Museum of Art; Museum
purchase with funds provided by Mr. and Mrs.
William Preston Harrison Collection, Mary D.
Keeler Bequest, and Dr. Dorothea Moore

52‡ (plate 65)
Charles Willson Peale
Robert Goldsborough and Family, 1789
Oil on canvas, 40 ¾ x 63 in. (103.5 x 160 cm)
Private collection

53 (plate 99)
James Peale
Marcia Burns (Mrs. John) Van Ness, 1797
Watercolor on ivory, 2 ¾ x 2 ½ in. (7 x 6.4 cm)
Corcoran Gallery of Art, Washington, D.C.;
Gift of Mrs. Philip Hinkle

54 (plate 100)
James Peale
William Whetcroft, 1795
Watercolor on ivory, 2 ½ x 2 in. (6.4 x 5.1 cm)
Private collection

55
Anna Claypoole Peale
Howard Malcolm, 1818
Watercolor on ivory , 3 x 2 ⅜ in. (7.6 x 6 cm)
Lys McLaughlin Pike and Ian Malcolm Watson
McLaughlin

56 (plate 68)
Charles Willson Peale
Matthias and Thomas Bordley, 1767
Watercolor on ivory, 3 ⅝ x 4 ⅛ in. (9.2 x 10.5 cm)
National Museum of American Art, Smithsonian
Institution, Washington, D.C.; Museum purchase
and gift of Mr. and Mrs. Murray Lloyd
Goldsborough, Jr.

57 (plate 36)
Raphaelle Peale, after Charles Willson Peale
Henry Moore, 1809
Watercolor on ivory, 2 ¼ x 1 ¹³⁄₁₆ in. (5.7 x 4.5 cm)
White Collection

58 (plate 117)
Anna Claypoole Peale
Marianne Beckett, 1829
Watercolor on ivory, 3 x 2 ½ in. (7.6 x 6.4 cm)
Historical Society of Pennsylvania, Philadelphia

59 (plate 115)
Anna Claypoole Peale
Unidentified Man, 1831
Watercolor on ivory, 2 ½ x 2 in. (6.4 x 5.1 cm)
White Collection

60 (plate 116)
Anna Claypoole Peale
Samuel Parkman, 1821
Watercolor on ivory, 2 ¾ x 2 ¼ in. (6.8 x 5.6 cm)
Cincinnati Art Museum; Fleischmann Collection

61
Charles Peale Polk
Colonel James Madison, Sr., 1799
Oil on canvas, 58 ½ x 39 ½ in. (148.6 x 100.3 cm)
Belle Grove Plantation of the National Trust for
Historic Preservation

62
Charles Peale Polk
Nelly Rose Conway (Mrs. James) Madison, 1799
Oil on canvas, 58 ½ x 39 ½ in. (148.6 x 100.3 cm)
Belle Grove Plantation of the National Trust for
Historic Preservation

63 (plate 14)
Raphaelle Peale
Thomas Jefferson, 1804
Silhouette on paper, 4 ½ x 3 ⅞ in. (11.4 x 9.8 cm)
Monticello, Thomas Jefferson Memorial Founda-
tion, Inc., Charlottesville, Virginia

64 (plate 5)
Charles Willson Peale
George Washington, 1779
Watercolor on ivory, 2 x 1 ⅝ in. in. (5.1 x 4.1 cm)
Private collection

65 (plate 114)
Anna Claypoole Peale
Commodore Johnathon Dayton Williamson, 1817
Watercolor on ivory, 2 ⁹⁄₁₆ x 2 ¹⁄₁₆ in. (6.4 x 5.1 cm)
Collection of the Montclair Art Museum; Gift of
the Estate of Constance Schermerhorn Skillim

Figures in the Public Eye

66 (plate 35)
Charles Willson Peale
Friedrich Heinrich Baron von Humboldt, 1804
Oil on canvas, 23 ½ x 19 in. (59.6 x 48.2 cm)
The College of Physicians of Philadelphia

67 (plate 42)
Rembrandt Peale
John C. Calhoun, 1834
Oil on canvas, 30 ⅞ x 25 ⅞ in. (78.4 x 65.7 cm)
Gibbes Museum of Art, Carolina Art Association,
Charleston, South Carolina; Bequest of Eugenia
Calhoun Frost

68 (plate 124)
Sarah Miriam Peale
Senator Thomas Hart Benton, 1842
Oil on canvas, 30 x 25 in. (76.2 x 63.5 cm)
Missouri Historical Society, St. Louis

69* (plate 6)
Charles Willson Peale
*His Excellency George Washington Esquire,
Commander in Chief of the Federal Army*, 1780
Mezzotint, 14 x 10 ⅛ in. (35.5 x 25.7 cm)
National Portrait Gallery, Smithsonian Institution,
Washington, D.C.; Gift of the Barra Foundation

70* (plate 8)
Charles Willson Peale
His Excellency Genl. Washington, c. 1778
Mezzotint, 5 ⁹⁄₁₆ x 4 ⁵⁄₁₆ in. (14.1 x 11 cm)
National Portrait Gallery, Smithsonian Institution,
Washington, D.C.; Gift of Robert L. McNeil., Jr.

71 (plate 9)
Charles Willson Peale
*His Excellency G. Washington, Esq.: L.L.D. Late Com-
mander in Chief of the Armies of the U.S. of America
and President of the Convention of 1787*, 1787
Mezzotint, 7 ³⁄₁₆ x 5 ⅞ in. (18.3 x 14.9 cm)
The Metropolitan Museum of Art, New York;
Bequest of Charles Allen Munn, 1924 (24.90.185)

72 (plate 7)
Charles Willson Peale
The Marquis de Lafayette, 1787
Mezzotint, 6 ⅛ x 5 ³⁄₁₆ in. (15.6 x 12.9 cm)
Private collection

73
Charles Willson Peale
George Washington, 1787
Oil on canvas, 24 x 19 ⅛ in. (61 x 48.6 cm)
Museum of American Art of the Pennsylvania
Academy of the Fine Arts, Philadelphia;
Bequest of Mrs. Sarah Harrison (The Joseph
Harrison, Jr. Collection)

74 (plate 40)
Charles Willson Peale
Thomas Jefferson, 1791
Oil on canvas, 25 ½ x 20 ⅛ in. (64.8 x 51.1 cm)
Diplomatic Reception Rooms, United States
Department of State; Replica of Independence
National Historical Park portrait; Gift of Mrs. Henry
S. McNeil, in memory of Mr. Henry S. McNeil

75 (plate 19)
Charles Willson Peale
Governor Thomas McKean and His Son, Thomas, Jr.,
1787
Oil on canvas, 50 ⅝ x 41 ⅛ in. (128.6 x 104.5 cm)
Philadelphia Museum of Art; Bequest of Phebe
Warren McKean Downs

76 (plate 39)
Charles Willson Peale
General Joseph Bloomfield, 1777
Oil on canvas, 30 x 25 in. (76.2 x 63.5 cm)
The Hendershott Collection

77
Rembrandt Peale
Portrait of John Caldwell Calhoun, 1834
Charcoal and white chalk on paper, 18 x 14 ½ in.
(45.7 x 36.8 cm)
Private collection

78 (plate 41)
Rembrandt Peale
Thomas Jefferson, 1805
Oil on canvas, 28 x 23 ½ in. (71.1 x 59.7 cm)
Collection of The New-York Historical Society;
Gift of Thomas J. Bryan

79 (plate 77)
Rembrandt Peale
Chancellor James Kent, c. 1834–35
Oil on canvas, 30 x 25 in. (76.2 x 63.5 cm)
National Portrait Gallery, Smithsonian Institution,
Washington, D.C.

80
Rembrandt Peale
Patriae Pater, 1827
Lithograph, 23 ½ x 17 ½ in. (59.7 x 44.5 cm)
Private collection

81 (plate 34)
Rembrandt Peale
Horatio Greenough, 1829
Oil on canvas, 30 ⅛ x 23 ½ in. (76.5 x 59.7 cm)
National Portrait Gallery, Smithsonian Institution,
Washington, D.C.

82 (plate 129)
Charles Peale Polk, in part after C. W. Peale
George Washington, 1793–94
Oil on canvas, 36 ⅛ x 29 in. (91.4 x 73.7 cm)
Chrysler Museum, Norfolk, Virginia

83 (plate 121)
Sarah Miriam Peale
Jose Silvestre Rabello, 1826
Oil on canvas, 27 ¾ x 35 ⅛ in. (70.5 x 89.2 cm)
Brazilian Embassy Collection, Washington, D.C.

84 (plate 122)
Sarah Miriam Peale
Henry Alexander Wise, c. 1842
Oil on canvas, 29 ½ x 24 ½ in. (74.9 x 62.2 cm)
Virginia Museum of Fine Arts, Richmond; Gift of
the Duchess of Richelieu in memory of James M.
Wise and Julia Wise

History and Those Who Made It

85 (plate 67)
Charles Willson Peale
*Washington After the Battle of Princeton, January 3,
1777*, 1779–82
Oil on canvas, 96 ½ x 61 ½ in. (245.1 x 156.2 cm)
Princeton University Art Gallery, Princeton, New
Jersey; Bequest of Charles A. Munn

86 (plate 44)
Charles Willson Peale
Nancy Hallam as Fidelius in Shakespeare's
Cymbeline, 1771
Oil on canvas, 50 x 40 ½ in. (127 x 102.9 cm)
The Colonial Williamsburg Foundation, Virginia

87 (plate 10)
Charles Willson Peale
The Exhumation of the Mastodon, 1805–06
Oil on canvas, 50 x 62 ½ in. (127 x 158.8 cm)
The Peale Museum, Baltimore City Life Museums

88 (plate 57)
Rembrandt Peale, after Cristofano Allori
Judith with the Head of Holofernes, 1830
Oil on canvas, 55 ⁵⁄₁₆ x 44 ⅛ in. (140.5 x 112 cm)
The Art Museum, Princeton University, Princeton,
New Jersey; Gift of Mr. and Mrs. Stuart P. Feld

89 (plate 134)
Charles Willson Peale, after Charles Catton
Noah and His Ark, 1819
Oil on canvas, 40 ¼ x 50 ¼ in. (102.2 x 127.6 cm)
Museum of American Art of the Pennsylvania
Academy of the Fine Arts, Philadelphia;
Collections Fund Purchase

90 (plate 78)
Rembrandt Peale
George Washington as Pater Patriae, 1859
Oil on canvas, 37 x 30 in. (94 x 76.2 cm)
The Hendershott Collection

91
Rembrandt Peale
The Court of Death, 1859
Lithograph, 15 ¼ x 26 ¾ in. (38.7 x 68 cm)
American Antiquarian Society, Worcester,
Massachusetts

92 (plate 76)
Charles Willson Peale, after Rembrandt Peale
"Court of Death," 1819
Drawing, graphite on paper, 7 ⅝ x 14 ½ in.
(19.4 x 36.8 cm)
Private collection

93 (plate 98)
James Peale
The Ambush of Captain Allan McLane, 1803 or 1811
Oil on canvas, 28 ⅛ x 36 ⅛ in. (71.4 x 91.8 cm)
Utah Museum of Fine Arts, University of Utah

94 (plate 96)
James Peale
The Generals at Yorktown, n.d.
Oil on canvas, 20 x 29 in. (50.8 x 76.2 cm)
The Colonial Williamsburg Foundation, Virginia

95 (plate 97)
James Peale
Sir Peter Parker's Attack Against Fort Moultrie, n.d.
Oil on canvas, 20 x 30 in. (50.8 x 73.7 cm)
The Colonial Williamsburg Foundation, Virginia

Nature, Naturalists and the Land

96*
Titian Ramsay Peale
7 Mile Beach, Aug 2 / 73 (Looking SW, 10 am), 1873
Oil on canvas
American Philosophical Society, Philadelphia

97* (plate 11)
Charles Willson Peale
View of the Garden at Belfield, 1816
Oil on canvas, 11 x 16 in. (27.9 x 40.6 cm)
Private collection

98‡ ‡‡
Charles Willson Peale
Country Lane near Belfield,
Oil on panel, 11 x 16 in. (27.9 x 40.6 cm)
Private collection

99 (plate 48)
Charles Willson Peale
Mill Bank, 1818
Oil on canvas, 15 x 21 in. (38.1 x 53.3 cm)
Private collection

100 (plate 49)
Charles Willson Peale
*Landscape Looking toward Sellers Hall from
Mill Bank*, c. 1818
Oil on canvas, 15 x 21 in. (38.1 x 53.3 cm)
The James W. Glanville Family Interests

101 (plate 45)
Charles Willson Peale
View of West Point from the Side of the Mountain
(in sketchbook, "Highlands of the Hudson"), 1801
Pen and watercolor on paper, 6 ¼ x 7 ⅝ in.
(15.9 x 19.4 cm)
American Philosophical Society, Philadelphia

102 (plate 51)
Rembrandt Peale
The Canadian Side of Niagara Falls, Platform Rock,
1831
Oil on canvas, 18 ¼ x 24 ¼ in. (46.4 x 61.6 cm)
Private Collection

103 (plate 46)
James Peale
View on the Wissahickon, 1830
Oil on canvas, 20 ⅛ x 27 in. (51.1 x 68.6 cm)
Philadelphia Museum of Art; Gift of T. Edward
Hanley

104 (plate 47)
James Peale
Landscape, c. 1830
Oil on canvas, 25 ½ x 31 ½ in. (64.8 x 80 cm)
Private collection

105 (plate 95)
James Peale
Pleasure Party by a Mill, c. 1790
Oil on canvas, 26 ³⁄₁₆ x 40 in. (66 x 101.6 cm)
The Museum of Fine Arts, Houston; The Bayou
Bend Collection; Gift of Miss Ima Hogg

106
Titian Ramsay Peale
Quails in a Landscape, 1884
Oil on canvas, 15 ¾ x 20 in. (40 x 50.8 cm)
Private collection, Courtesy of Berry-Hill
Galleries, Inc., New York

107*
Titian Ramsay Peale
Great Falls, Potomac, 1858
Oil on board, 7 ⅞ x 10 in. (20 x 25.4 cm)
American Philosophical Society, Philadelphia,
Pennsylvania

108 (plate 50)
Rembrandt Peale
Falls of Niagara, Viewed from the American Side, 1831
Oil on canvas, 18 ¼ x 24 ⅛ in. (46.5 x 61.5 cm)
Collection of Mrs. Deen Day Smith

109 (plate 86)
Charles Willson Peale
Titian Ramsay Peale, 1819
Oil on canvas, 24 ¼ x 20 ¼ in. (61.5 x 51.4 cm)
Private collection

110 (plate 81)
Rubens Peale
Landscape, after Second Lesson with Edward Moran, n.d.
Oil on canvas, 10 x 12 in. (25.4 x 30.5 cm)
Private collection; Courtesy of Berry-Hill
Galleries, Inc., New York

111 (plate 71)
Charles Willson Peale
Portrait of Raphaelle Peale, 1817–18
Oil on canvas, 29 x 24 in. (73.7 x 61 cm)
Private collection

112‡
Titian Ramsay Peale
7 Mile Beach, Aug 5/73, 1873
Oil on canvas
American Philosophical Society, Philadelphia

The Fruits of Nature

113 (plate 80)
Rubens Peale
Cake and Wine Glass, 1865
Oil on canvas, 8 x 12 in. (20.3 x 30.5 cm)
Schwarz Gallery, Philadelphia

114
Pierced Porcelain Basket, n.d.
Porcelain
Private collection

115 (plate 102)
James Peale
Apples and Grapes in a Pierced Bowl, c. 1820
Oil on canvas, 15 x 21 ¾ in. (38.1 x 55.3 cm)
Private collection

116 (plate 82)
Rubens Peale
Still Life with Grapes, Watermelon and Peaches, 1863
Oil on canvas, 18 ½ x 27 ¼ in. (47 x 69.2 cm)
Davenport Museum of Art, Davenport, Iowa; Six-
tieth Anniversary Museum Purchase through funds
provided by Friends of Art Permanent Endowment

117 (plate 83)
Rubens Peale
*Basket of Peaches with Ostrich Egg and Cream
Pitcher*, c. 1856–59
Oil on tin, 14 x 20 in. (35.6 x 50.8 cm)
Private collection

118 (plate 85)
Rubens Peale
Wedding Cake, Wine, Almonds, and Raisins, 1860
Oil on canvas, 17 x 29 in. (43.2 x 73.7 cm)
Munson-Williams-Proctor Institute Museum of
Art, Utica, New York

119 (plate 70)
Raphaelle Peale
Lemons and Sugar, c. 1822
Oil on wood panel, 12 x 15 in. (30.5 x 38.1 cm)
Reading Public Museum, Reading, Pennsylvania

120 (plate 110)
Margaretta Peale
Still Life with Watermelon and Peaches, 1828
Oil on canvas, 13 x 19 ⅛ in. (33 x 48.5 cm)
Smith College Museum of Art, Northampton,
Massachusetts; Purchased with funds given anony-
mously by a member of the Class of 1952.

121 (plate 111)
Margaretta Angelica Peale
Strawberries and Cherries, n.d
Oil on canvas, 10 ¹/₁₆ x 12 ⅛ in. (25.4 x 30.8 cm)
Museum of American Art of the Pennsylvania
Academy of the Fine Arts, Philadelphia.

122* (plate 112)
Sarah Miriam Peale
Fruit and Grapes, 1822
Oil on canvas, 11 ¾ x 16 in. (29.9 x 40.6 cm)
James Graham & Sons, New York

123 (plate 113)
Sarah Miriam Peale
Peaches and Grapes in a Porcelain Bowl, 1829
Oil on canvas, 11 ¾ x 15 in. (29.9 x 38.1 cm)
Montclair Art Museum, Montclair, New Jersey;
Bequest of Mrs. James A. Aborn, Mr. and Mrs.
George C. Densmore, Mrs. Maurice Emataz, and
Mrs. William H. C. Higgins Funds, by exchange

124 (plate 73)
Raphaelle Peale
Still Life with Orange and Book, c. 1817
Oil on panel, 9 x 11 ⅝ in. (22.9 x 29.5 cm)
Private collection

125 (plate 15)
Raphaelle Peale
Cheese with Three Crackers, c. 1813
Oil on wood panel, 7 x 10 in. (17.8 x 25.4 cm)
Schwarz Gallery, Philadelphia

126 (plate 103)
James Peale
Vegetable Still Life, c. 1825
Oil on canvas, 16 x 22 in. (40.6 x 55.9 cm)
Private collection

127 (plate 55)
Raphaelle Peale
Still Life with Jug and Fish, c. 1810
Oil on canvas, 12 x 13 in. (30.5 x 33 cm)
Hirschl & Adler Galleries, Inc., New York

128‡‡ (plate 89)
Titian Ramsay Peale
*Dusky Wolf [Lupus Nubilus] Devouring a Mule-Deer
Head*, c. 1820
Watercolor and ink over graphite on paper,
7 ½ x 9 ¼ in. (19.1 x 23.5 cm)
American Philosophical Society, Philadelphia

129 (plate 61)
Sarah Miriam Peale
Cherries, c. 1860
Oil on canvas, 12 x 10 in. (30.5 x 25.4 cm)
Private collection

130 (plate 84)
Rubens Peale
Magpie Eating Cake, 1865
Oil on canvas, 19 x 27 in. (48.3 x 68.6 cm)
Private collection

131 (plate 125)
Sarah Miriam Peale
Basket of Berries, c. 1860
Oil on canvas, 12 x 10 in. (30.5 x 25.4 cm)
Private collection

The Museum

132‡ (plate 91)
Titian Ramsay Peale
Sandhill Cranes, c. 1822
Watercolor over graphite on paper, 7 ⅜ x 9 ⅛ in.
(18.7 x 23.2 cm)
American Philosophical Society, Philadelphia

133*
Titian Ramsay Peale
American Antelope, 1821–1822
Watercolor on paper, 11 x 13 ⅜ in. (27.9 x 34 cm)
American Philosophical Society, Philadelphia

134* ‡
Charles Willson Peale
Joseph Brant (Thayendanegea), 1797
Oil on canvas, 25 ½ x 22 ¼ in. (64.8 x 56.5 cm)
Independence National Historical Park Collection,
Philadelphia, Pennsylvania

135‡
Titian Ramsay Peale
Moths and Butterfly Mounts: Collection 320, c. 1817
Butterflies, 9 ¾ x 11 ¾ x 2 ⅛ in.
(24.8 x 29.9 x 5.4 cm)
Academy of Natural Sciences of Philadelphia

136
Vessel in the Form of a Beaver, c. 1797
Wood, 15 ⅝ x 6 ¼ x 5 ¾ in.
(39.5 x 15.8 x 14.6 cm)
Peabody Museum of Archaeology and Ethnology,
Harvard University, Cambridge, Massachusetts

137
Charles Willson Peale
*Pamphlet: "An Epistle to a Friend on the Means of
Preserving Health . . . ,"* March 1803
Paper, 9 ⅝ x 5 ¾ (closed) in. (24.5 x 14.6 cm)
Private collection

138
Charles Willson Peale
*Pamphlet: "Introduction to a Course of Lectures on
Natural History,"* 1800
Paper, 9 x 5 ½ in. (22.9 x 14 cm)
Private collection

139 (plate 92)
Titian Ramsay Peale
Caligo Martia (Butterflies), 1878
Gouache on paper, 12 ½ x 10 ½ in. (31.8 x 26.7 cm)
Private collection

140 (plate 88)
Titian Ramsay Peale
Prairie Dog, 1819–21
Watercolor on paper, 9 ½ x 12 in. (24.1 x 30.5 cm)
Private collection

141 (plate 87)
Titian Ramsay Peale
White Squirrel, 1819–21
Oil on canvas, 8 x 10 in. (20.3 x 25.4 cm)
Private collection

142
Alexander Lawson (1773–1846), after Titian
Ramsay Peale
Wild Turkey, Male and Female, 1825
Colored engraving, 14 x 10 ⅞ in. (35.6 x 27.6 cm)
Private collection

143
Charles Willson Peale
General Andrew Jackson, 1819
Oil on canvas, 28 x 22 ⅜ in. (71.1 x 56.8 cm)
Collections of the Grand Lodge F. & A.M. of
Pennsylvania, on deposit with The Masonic
Library and Museum of Pennsylvania

144 (plate 13)
Rembrandt Peale, after Charles Willson Peale
Nathaniel Greene, 1795–96
Oil on canvas, 23 ⁵⁄₁₆ x 19 ⁷⁄₁₆ in. (59.2 x 49.4 cm)
Maryland Historical Society, Baltimore

145
Alexander Lawson, after Titian Ramsay Peale
Three Birds (Flycatcher, Anteater, and Warbler), 1825
Colored engraving, 14 ½ x 10 ⅝ in. (36.8 x 27 cm)
Private collection

146 (plate 136)
Charles Willson Peale
Museum Ticket, 1788
Mezzotint on paper, 5 ½ x 4 in. (14 x 10.2 cm)
Private collection; Courtesy of Hirschl & Adler
Galleries, Inc., New York

147 (plate 135)
Rembrandt Peale
"Working Sketch of the Mastodon," 1801
Graphite on paper, 15 ³⁄₁₆ x 12 ¼ in. (38.1 x 31.1 cm)
American Philosophical Society, Philadelphia

148
*A Scientific and Descriptive Catalogue of Peale's
Museum*, 1796
Paper, 8 ½ x 5 ⅜ in. (21.6 x 13.7 cm)
American Philosophical Society, Philadelphia,
Pennsylvania

149 (plate 109)
Margaretta Peale, after Raphaelle Peale
Catalogue: A Deception, 1813
Oil on wood, 12 ½ x 9 in. (31.8 x 22.9 cm)
From the Collection of Jocelyn Peale Parker,
Jenifer Peale, and James Peale

150 (plate 133)
Charles Willson Peale
Self-Portrait (Study for *The Artist in His Museum*),
1822
Oil on canvas, 25 ⅝ x 21 ½ in. (65.1 x 54.6 cm)
Private collection

The Legacy

151 (plate 38)
Sarah Miriam Peale
Charlotte Ramsay Robinson, c. 1840
Oil on canvas, 38 x 26 in. (96.5 x 66 cm)
The Peale Museum, Baltimore City Life Museums

152 (plate 60)
Sarah Miriam Peale
Veil of Mystery (Veiled Woman), c. 1830
Oil on canvas, 24 x 20 in. (61 x 50.8 cm)
The Peale Museum, Baltimore City Life Museums

153 (plate 58)
Rembrandt Peale
Pearl of Grief, 1848
Oil on canvas, 24 ⁵⁄₁₆ x 18 ¼ in. (61 x 46.4 cm)
Milwaukee Art Museum, Milwaukee, Wisconsin;
Gift of Mr. Frederick L. Pierce

154 (plate 59)
Rembrandt Peale
Day Dreams, 1837
Oil on canvas, 28 ½ x 36 ½ in. (72.4 x 92.7 cm)
Collection of Mrs. Deen Day Smith

155‡ (plate 56)
Raphaelle Peale
*Venus Rising from the Sea—A Deception (After the
Bath)*, c. 1822
Oil on canvas, 29 ¼ x 24 ⅛ in. (74.3 x 61.3 cm)
Nelson-Atkins Museum of Art, Kansas City, Missouri; Purchase Nelson Trust

156 (plate 52)
Titian Ramsay Peale
Bright House, Rehobeth Beach, 1882
Oil on board, 8 ½ x 12 in. (21.6 x 30.5 cm)
Private collection

157 (plate 18)
Charles Willson Peale
Benjamin and Eleanor Ridgely Laming, 1788
Oil on canvas, 42 x 60 ¼ in. (106.7 x 153 cm)
National Gallery of Art, Washington, D.C.; Gift of
Morris Shapiro

158 (plate 101)
James Peale
Madame Dubocq and Her Children, 1807
Oil on canvas, 51 x 41 in. (129.5 x 104.1 cm)
J.B. Speed Art Museum, Louisville, Kentucky; Gift
of Mrs. Algae Kent Bixby

159 (plate 119)
Sarah Miriam Peale
Charles Lavellen Jessop (Boy on a Rocking Horse),
c. 1840
Oil on canvas, 35 ½ x 41 ¾ in. (90.2 x 106.1 cm)
Private collection

160 (plate 43)
Rembrandt Peale
General Samuel Smith, c. 1817
Oil on canvas, 37 ¾ x 30 ⅜ in. (95.3 x 77.2 cm)
The Peale Museum, Baltimore City Life Museums

161 (plate 75)
Rembrandt Peale
The Roman Daughter, 1811
Oil on canvas, 84 ¾ x 62 ⅞ in. (215 x 159.8 cm)
National Museum of American Art, Smithsonian
Institution, Washington, D.C.; Gift of the James
Smithson Society

162 (plate 16)
Rembrandt Peale
Rubens Peale with a Geranium, 1801
Oil on canvas, 28 ¼ x 24 in. (71.8 x 61 cm)
National Gallery of Art, Washington, D.C.;
Patrons' Permanent Fund

163 (plate 72)
Raphaelle Peale
*Fruit Piece with Peaches Covered by a Handkerchief
(Covered Peaches)*, c. 1819
Oil on wood panel, 12 ½ x 18 in. (31.8 x 45.7 cm)
Private collection

164 (plate 54)
James Peale
Still Life: Balsam Apples and Vegetables, n.d.
Oil on canvas , 20 ¼ x 26 ½ in. (51.4 x 67.3 cm)
The Metropolitan Museum of Art, New York;
Maria DeWitt Jesup Fund, 1939 (39.52)

165 (plate 131)
Charles Peale Polk
James Madison, 1802–03
Verre eglomise, 3 ½ x 2 ⅜ in. (8.9 x 6 cm)
American Antiquarian Society, Worcester, Massachusetts

166 (plate 53)
Rubens Peale
Landscape with Quail—Cock, Hen, and Chickens, 1861
Oil on canvas, 19 ⅛ x 27 ¼ in. (48.6 x 69.2 cm)
Private collection; Courtesy of Berry-Hill
Galleries, Inc., New York

167 (plate 132)
Charles Peale Polk
Albert Gallatin, 1802–03
Verre eglomise, 3 ¾ x 2 ¾ in. (9.5 x 7 cm)
American Antiquarian Society, Worcester, Massachusetts

168 (plate 108)
James Peale
Portrait of Margaretta Peale, n.d.
Oil on canvas, 27 ¼ x 20 ⅜ in. (69.2 x 51.8 cm)
Private collection

About the Authors

LILLIAN B. MILLER is Historian of American Culture at the National Portrait Gallery, Smithsonian Institution, and Editor of the Peale Family Papers. Dr. Miller has devoted almost two decades to studying and writing about the Peale artists. A cultural and intellectual historian with an informed understanding of American art, she is the author of the now classic study *Patrons and Patriotism* (1966, 1974), along with many other books and articles on American art, society, and culture. Her most recent recognition comes from the Athenaeum of Philadelphia, which has elected her a lifetime fellow for her "outstanding contributions to nineteenth-century studies."

SIDNEY HART has been a historian on the Peale Family Papers staff since 1976. He presently serves as Senior Associate Editor and Deputy to the Editor. With a Ph.D. in American social history, Dr. Hart has devoted his scholarly efforts to the study of communities and their institutions, particularly Philadelphia.

DAVID STEINBERG is Assistant Curator, Paintings Department, Cleveland Museum of Art, and Assistant Professor of Art History, Case-Western Reserve University. He holds a Ph.D. from the University of Pennsylvania.

BRANDON BRAME FORTUNE is Assistant Curator, National Portrait Gallery, Smithsonian Institution. Her Ph.D. dissertation, "Portraits of Virtue and Genius: Pantheons of Worthies and Public Portraiture in the Early American Republic, 1780–1820," (University of North Carolina, 1986) addressed the relation of Peale's portrait gallery to the eighteenth-century concern for virtue, a subject she also treated in a number of articles in *Word & Image* and *Eighteenth-Century Studies.*

WILLIAM OEDEL, Associate Professor of Art History, University of Massachusetts, Amherst, worked extensively on Rembrandt Peale at the Historical Society of Pennsylvania before returning to graduate school and enlarging his sphere of scholarly interest to include William Sidney Mount, John Krimmel, and John Vanderlyn. He has published articles on Rembrandt Peale in *Winterthur Portfolio* and *American Paintings in the Detroit Institute of Arts,* vol. 1: *A Catalogue of Works by Artists Born Before 1816.*

KENNETH HALTMAN is Assistant Professor of American Studies and Art History at Michigan State University in Lansing. Dr. Haltman studied the western art of the younger Titian Ramsay Peale in his American Studies dissertation "Figures in a Western Landscape: Reading the Art of Titian Ramsay Peale from the Long Expedition to the Rocky Mountains, 1819–1820" (Yale University, 1992). He has extended his study to encompass all of Titian Ramsay's work in a book to be published by Princeton University Press.

PAUL D. SCHWEITZER, Director of the Munson-Williams-Proctor Institute and Museum of Art, began to give special study to the work of Rubens Peale when his museum acquired some paintings by the artist. His understanding of art in museums and public places is reflected in his study of Thomas Cole's public paintings as well as *Panoramas for the People* (Utica, N.Y., 1984), a subject important for an understanding of Rubens's work both as a museum keeper and latecomer to landscape and animal painting.

LINDA CROCKER SIMMONS, Curator for American Art and Research at the Corcoran Gallery of Art, Washington, D.C., has devoted many years to her study of the art of James Peale, the subject of her dissertation research at the University of Virginia, Charlottesville. Her exhibitions, essays, and lectures at the Corcoran and elsewhere have established her as a careful and meticulous scholar of southern art in the antebellum period, especially the work of Charles Peale Polk and early folk artists.

ANNE SUE HIRSHORN, Program Officer for Exhibitions in Latin America and the Near East, Bureau of Educational and Cultural Affairs, United States Information Agency, Washington D.C., has studied the miniatures of Anna Claypoole Peale for many years and is the acknowledged expert on that artist's work and on miniature painting generally.

DAVID C. WARD, Associate Editor, Peale Family Papers, National Portrait Gallery, Washington, D.C., is a Social and Economic Historian who has served on the Peale Family Papers staff for almost fifteen years. He has given special study to the Peale museums, studying Peale's records of admission, annual fees, expenditures, acquisitions, and programs.

P

~

Photograph Credits

~

Plate 5: Dirk Bakker, Detroit Institute of the Arts.

Plates 7, 8, 9, 10, 11, 12, 13, 14, 15, 16, 17, 18, 19, 20, 21, 22, 23, 24, 25, 26, 27, 28, 29, 30, 31, 32, 33, and figure 36: Will Brown.

Plates 12, 35: Rick Echelmeyer, Thornton, Pennsylvania.

Plate 14: Edward Owen.

Plate 26: Gregory Staley.

Plate 59: Mike McKelvey, Atlanta.

Plate 64: Graydon Wood, 1993.

Plate 74: Stephen Petegorsky.

Plate 90 and figures 8, 11, 1.3: Rolland White.

Plate 107: Greg Heins, Boston.

Plate 122: Katherine Wetzel.

Figure 4.10: Photograph courtesy of National Graphic Center.

Figures 5.5, 5.7: Photographs courtesy of Kennedy Galleries, Inc., New York.

Figure 7.9: Photograph courtesy of Schwarz Gallery.

Figure 8.5: Joseph Szaszfai; courtesy of the Mabel Brady Garvan Collection.

Figures 10.1, 10.7: Hillel Burger, 1982.

This exhibition was made possible in part from generous grants from:
The Henry Luce Foundation, Inc.
The National Endowment for the Humanities, a federal agency.

Exhibition Itinerary:

Philadelphia Museum of Art
November 3, 1996–January 5, 1997

The Fine Arts Museums of San Francisco,
M. H. De Young Memorial Museum
January 25–April 6, 1997

The Corcoran Gallery of Art
April 26–July 6, 1997

Front cover: Detail from *The Peale Family Group,* by Charles Willson Peale,
oil on canvas, c. 1770–1783 and 1808, accession number 1867.298.
Collection of the New-York Historical Society

Back cover: Detail from *George Washington as Patriae Pater,* by Rembrandt Peale,
oil on canvas, 1859. The Hendershott Collection.

Frontispiece: Detail from *Rubens Peale with Geranium,* by Rembrandt Peale, oil on
canvas, 1801. National Gallery of Art, Washington D.C.; Patron's Permanent Fund.

Editor: Lillian B. Miller
Abbeville Project Editors: Abigail Asher and Leslie J. Bockol
Designer: Maria L. Miller
Production Editor: Ann Shields
Production Manager: Lou Bilka

First edition
10 9 8 7 6 5 4 3 2 1

Library of Congress Cataloging-in-Publication Data

The Peale family : creation of a legacy 1770–1870 / edited by Lillian B. Miller. —
 1st ed.
 p. cm.
 Exhibition catalog.
 "In association with the Trust for Museum Exhibitions and the National
Portrait Gallery."
 Includes bibliographical references and index.
 ISBN 0-7892-0206-9 (hardcover).—ISBN 0-7892-0248-4 (pb)
 1. Peale family—Exhibitions. 2. Painting, American—Exhibitions. 3. Painting,
Modern—18th century—United States—Exhibitions. 4. Painting, Modern—
19th century—United States—Exhibitions.
I. Miller, Lillian B.
ND237.P269A4 1996
759.13—dc20
 96-13975